LIKE A FILM

Ideological fantasy on screen, camera and canvas

Timothy Murray

London and New York

First published 1993
by Routledge
11 New Fetter Lane, London EC4P 4EE

Simultaneously published in the USA and Canada
by Routledge
29 West 35th Street, New York, NY 10001

Typeset in 10/12pt Palatino by
Florencetype Ltd, Kewstoke, Avon
Printed and bound in Great Britain by
Butler & Tanner Ltd, Frome

British Library Cataloguing in Publication Data
Murray, Timothy
Like a Film: Ideological Fantasy on Screen, Camera and Canvas
I. Title
791.43

Library of Congress Cataloging in Publication Data
Murray, Timothy.
Like a film : ideological fantasy on screen, camera, and canvas /
by Timothy Murray.
p. cm.
Includes bibliographical references and index.
1. Motion pictures and the arts. 2. Motion pictures—Social
aspects. 3. Motion pictures—Political aspects. 4. Homosexuality
in motion pictures. I. Title.
PN1995.25.M87 1993
791.43′75—dc20 93-17147

ISBN 0-415-077338 (hbk) ISBN 0-415-07734-6 (pbk)

LIKE A FILM

In this stimulating collection of theoretical writings on film, photography and art, Timothy Murray examines relations between artistic practice, sexual and racial politics, theory and cultural studies.

Like a Film investigates how the cinematic apparatus has invaded the theory of culture, as a way of weaving together the disparate 'psychopolitical' fabrics of cultural production, psychoanalysis and politically-marked subject positions. Murray analyses the impact of cinematic perceptions and productions on a wide array of cultural practices: experimental art, from the film-making of Yvonne Rainer and Derek Jarman to the art of Helen and Newton Harrison; social and political narratives of feminism, homosexuality, race and ecology; the representational and visual theory of Lyotard, Torok, Barthes, Ropars-Wuilleumier, Žižek, Silverman and Laplanche; articulations of history from the Renaissance visions of Shakespeare and Caravaggio to modern sexual and political fantasy. Murray suggests that the many destabilising traumas of culture remain accessible to us because they are structured so much like film.

In direct response to multicultural debates over the value of theory and the aim of artistic practice, the book addresses questions of cultural identity, the role of Continental psychoanalysis and philosophy and the ideological importance of artistic form. *Like a Film* will be essential reading to students of film, art and art history, theory, cultural studies and gay studies.

Timothy Murray is Professor of English at Cornell University. A former editor of *Theatre Journal*, he is the author of *Theatrical Legitimation: Allegories of Genius in Seventeenth-Century England and France*.

In Memory of Louis Marin
(1931–1992)

–Et in Arcadia ego

CONTENTS

FIGURES

ACKNOWLEDGEMENTS

When Joe Louis was asked shortly before he died whether he would like to see a film of his greatest triumph (the second fight with Max Schmeling), he tersely declined: 'I was there'.

<div align="right">– Kimberly W Benston</div>

A great many people can say, 'I was there', during the numerous preliminary takes of this book. I dedicate *Like a Film* to the memory of Louis Marin, a mentor without parallel. I was fortunate at the outset of my career to catch the bug of his uncanny comparisons and contagious humor. Yes, he was always there for me as a teacher and friend, just as the insight and warmth of his texts will welcome my readers within. I have tried steadfastly to live up to the rigorous standards of his critical productions. So too do I cherish the many contributions of Maureen Turim, Jean-François Lyotard, Réda Bensmaïa, Herbert Blau and Neil Saccamano whose readings, exchanges, and encouragements have been important to this work from its first takes. And I owe a special debt to Richard Herskowitz, Director of Cornell Cinema, for his curatorial expertise and limitless generosity.

For their readings, dialogues, support, and good cheer, I deeply appreciate the support of David Bathrick, Mandy Merck, Phil Lewis, Juliet Flower MacCannell, Henry Sussman, Greg Bredbeck, Roddey Reid, Laura Mulvey, Kim Benston, Sabrina Barton, Georges Van Den Abbeele, Tom Conley, André Bourassa, Sharon Willis, Julianna Schiesari, Elin Diamond, Andrew Benjamin, Geoffrey Waite, Naoki Sakai, Chris Pye, Eliane Dal Molin, Biodun Jeyifo, Scott McMillin, Werner Goehner, Hal Foster, Mark Seltzer, Dan and Mária Brewer, and Cynthia Koepp. I also profited from many suggestions made by my graduate students studying film theory, particularly Rebecca Egger, Timothy Billings, Michelle Strah, and Phillip Johansen.

I could not have completed the research and writing of this book without grants, release time, and services provided by the Cornell University Common Learning Program, The Camargo Foundation in

Cassis, France, and The Society for the Humanities at Cornell University. Special thanks go to Michael Pretina, Director of The Camargo Foundation, Jonathan Culler, Director of The Society for the Humanities, and their staffs.

My warmest gratitude goes to Janice Price of Routledge. During her earlier days of traversing the States, she encouraged me to think creatively and confidently about the possibilities of such a book. At Routledge, thanks also go to Rebecca Barden for her confidence in the manuscript and, especially, to Nick Thomas who has made the production process sane, efficient, and sometimes even fun. At Cornell, Naomi Morgenstern and Andrea Dustin provided help with the manuscript and correspondence.

Andrew Gillis contributed immeasurably to the production of this book's still images. Jill Hartz and Tom Leavitt, of the Herbert F. Johnson Museum of Art, Cornell University, encouraged and supported my work on Chapter 7. And I am thankful to the following artists for their help in acquiring photographs and/or permission to include reproductions of their work: Derek Jarman, Gerald Incandela, Yvonne Rainer, Arakawa and Madeline Gins, Ruth Francken, Helen Mayer Harrison and Newton Harrison, Renée Green, and Nancy Spero.

The one artist who can truly say, 'I don't need to see it, I was there', is my wife, Renate Ferro. With her, I share my delight in contemporary art and film, and from her, I learn the nuances of feminist art and its materials. Finally, I would hope that this book bears some traces of the many hours of play, movies, and hugs I've shared with my two young children, Ashley and Erin. Maybe someday they will want to read some of this only because they were there.

A shorter version of Chapter 4 appeared as: 'Le cliché taché: rétrospection et décomposition cinématographique', trans. Eliane Dal Molin, in *Le Théâtre du Québec: mémoire et appropriation*, L'annuaire théâtral, 5/6 (Fall 1988/Spring 1989): 307–18. Earlier portions of Chapter 6 appeared as 'What's Happening?', *Diacritics*, 14, 3 (Fall 1984): 100–10; and as a Review of Jean-François Lyotard, *Que peindre? Adami, Arakawa, Buren* and *Duchamp's TRANS/formers*, *L'Esprit Créateur*, 31, 1 (Spring 1991): 164–67. A slightly different version of Chapter 8 is included in the artist book, *Blank Page* 4 (London: B4 Publishing, 1990). My thanks to the publishers for permission to reprint these materials. Although extensive efforts have been made to contact the copyright holders of images reproduced in this book, the author and publisher apologize in advance for any unintentional omission or neglect and will be pleased to insert the appropriate acknowledgment in any subsequent edition of this book.

1

INTRODUCTION
Ideological Fantasy in Reverse Projection

The cultural elites respect neither tradition nor standards. They believe that moral truths are relative and all lifestyles are equal. They seem to think the family is an arbitrary arrangement of people who decide to live under the same roof, that fathers are disposable and that parents need not be married or even of opposite sexes.

(Dan Quayle)

We work within the realm of fantasy, and in that realm there are a number of things we can do against the grain of stereotypical representations and discourses.

(Isaac Julien)

Imagine a script for a horror movie about a fragile, American urban environment teetering on the brink of collapse. The film centers on a slice of time from life in an urban park in which conflicting cultures have learned to maintain a fragile coexistence in semi-indifference to one another. Modeled after Washington Square Park, the cultural center of Greenwich Village, this multiblock square is portrayed as the gathering-place of homeless families, gay parents, senior citizens, drug dealers, students, musicians, political activists, and the multicultural peoples who now constitute the lifeblood of America's cities. A large crowd's celebration of the first warm day of spring is disrupted by the sudden appearance of a gray, 1987 Delta 88. No, it does not bring Dan Quayle to attack the cultural elite. Instead, it jumps the curb and careers out of control through a crowded end of the park. Sounding like an exploding bomb, the car slams through the Park's gates and heads right toward the audience from the upper left of the screen. The spectators are confronted by a wave of terror as park benches topple and screaming pedestrians fly through the air. Once the battered Olds comes to a rest, the camera pans its flat tires and shattered windshield. The film then cuts to a tight shot of two spring jackets lying on the bloodied pavement next to the car. Next, the camera zooms in even closer to catch sight of an open textbook crumpled under the right front tire. Finally, the spectator views an eery shot of freshly splattered blood dripping slowly

1

from the hood. All of this is followed by a contrasting sequence in which onlookers pull a 71-year-old woman from the car as people explode in rage, yelling and cursing at the dazed driver. They violently accuse her of driving the Olds in excess of sixty miles an hour straight into the crowd, killing three people instantly and critically injuring many more. She looks confused by the spectacle of the man next to her, who moans while bleeding profusely from the head.

But rather than a horror film, *Crash in Washington Square: A Scene of Death and Chaos* would be advertised as a docudrama of an event that shocked New York City on the first warm day of spring, April 23, 1992.[1] This was an event tailor-made for Hollywood with ironic urban subplots and sinister connotations. As Javier Ipurralde recounts his sunny afternoon stroll with his injured friend, 21-year-old Nadine Hachuel, 'I was looking at her and we were talking, believe it or not, about the apocalypse, because New York seems very apocalyptic right now. The car went under my friend and my friend was gone. She was first picked up by the fender and bounced several times on the windshield, and the last time she flew and ended up in front of the car' (Kleinfeld 1992: B2). Stressing the paradox of this tragedy, a reporter from the *New York Times* suggests that the arbitrary event similarly brought the apocalypse now to the shocked and bewildered driver, 'her life irrevocably changed in one horrible instant' (Schemo 1992: B2).

I open this collection of essays on film, photography, and art with this gruesome scenario to provide a cinematic introduction to the concept of ideological fantasy that holds these chapters together. The imaginary film script of this traumatic accident could easily serve as a blueprint for what Christian Metz terms the (ideological) 'problems of denotation in the fiction film' (Metz 1986). Such a script exemplifies the crucial semiological aspects of docudrama's analogical realism. On one level, it capitalizes on Metz's notion of the analogical motivation of cinematic denotation. The fictional adaptation of an historical event depends first on film's technical ability to portray a literal sense based upon perception. In 'Problems of denotation in the fiction film', Metz clarifies how the medium of film is motivated by the partial equations of visual and auditory analogy, by the perceptual similarity of signifiers and signifieds. That is, the ghoulish nightmare of a stroll through the Park here would be matched by the apocalyptical likeness of one horrible instant of film. On another, more complex level, Metz stresses how the symbolic nature of cinematic connotation overtakes perceptual analogy as the latter accrues value through the additional meaning it receives from sociocultural codes. Connotating the ideological fantasy of the apocalyptic future of urban culture, *Crash in Washington Square Park* reveals, for instance, the brutal irony of the death of a brave elderly woman who had survived the daily onslaughts of New York's downtown drug

2

culture: 'Esther Rintel, a seventy-one-year-old lifelong resident of the area, had narrowly missed death. A park acquaintance who had been sitting near her, however, was hit. "My poor Ruthie is gone", Ms Rintel said sadly, "She's gone"' (Kleinfeld 1992: B2). A further ironic analogy could be said to deepen the specifically cinematographic codification of this scene (the meaning of each visual element taken separately). For Ruthie met death arbitrarily at the hands of a respected Yonkers senior citizen who was 'active in church functions, charities and the anti-abortion movement' (Schemo 1992: B2). One might also acknowledge Hollywood's tendency to overaccentuate sociocultural analogies by imagining the tragic twist of an additional subplot about a young woman shown to have been lobbying in the Park for 'Freedom of Choice' just prior to her untimely death at the hands of an elderly 'Right to Lifer'.

But what fascinates me more is that the scenario of *Crash in Washington Square Park* exemplifies how cinematographic analogy is itself a mixture of two important signifying organizations: what Metz calls 'specialized codes' and 'cultural codes'. Specialized codes are said to be purely cinematographic signifying features: 'montages, camera movements, optical effects, "rhetoric of the screen", interaction of auditory and visual elements, and so on' (Metz 1986: 38). Cultural codes constitute the iconographical, perceptual, and other codes of given social groups. These cultural codes are 'so ubiquitous and well "assimilated" that the viewers generally consider them to be "natural"' (ibid.: 38). Of particular importance to me is not so much the distinction between these codes as the implications of the 'modulation' of the two analogical systems. For Metz's distinction seems open to the possibility that *the specialized codes of cinema can themselves become, or always already are, 'naturalized' or 'cultural'.*[2] In this sense, they 'return' to cinema not as 'specialized' but as cultural codes that function for the most part '*within* photographic and phonographic analogy' (ibid.: 38–9). These would be the sorts of cinematic codes that 'intrude to the film by means of perceptual analogy each time an object or an ordering of objects (visual or auditory) "symbolizes" within the film what it would have symbolized outside of the film – that is to say, within culture' (ibid.: 39). To emphasize such a modulating relation in which the specialized discourse of film is folded back upon itself as 'naturalized', I would like to introduce this book with one more suggestive detail from the script of *Crash in Washington Square Park*. It takes place within a sequence following the crash that depicts the feeble efforts of news reporters to assemble the *facts* of a story which are available, as Brecht might say, only through the *impressions* of benumbed witnesses. At the heart of this segment would be the account of Evie Hantzopoulos, an NYU graduate student who described the scene to the *New York Times*: 'It was like a surreal experience. We

3

couldn't believe what was happening. It was like a movie' (Baquet 1992: B2).

'Like a movie', 'like a film'. This collection dwells on the various ways the cinematic experience has pervaded contemporary cultural production only to return to itself 'im-segno'. This is the concept coined by Pasolini to suggest how different basic elements of filmic discourse 'carry with them, before even "cinematographic language" can intervene, a great deal more than their simple identity' (Metz 1986: 39). *Like a Film* reflects on the broad impact of the cinematic apparatus on interdisciplinary experimentations in the arts (Rainer, Jarman, the Harrisons), on social and political narratives (the discourses of feminism, homosexuality, race, and ecology), on representational and visual theory (Barthes, Lyotard, Silverman, Torok, and Laplanche), on perceptions and articulations of history (from the Renaissance of Shakespeare and Caravaggio to the modernity of military cartography and global rings of fire) and, ultimately, on the subsequent return of the procedures and results of interdisciplinary experimentation itself to the cinema and its language. A startling example of the complexity of such a composite return occurs at the end of Yvonne Rainer's film *Journeys from Berlin/1971* (1979), a film I discuss in Chapter 2. Converted video footage portrays Rainer herself (see figure 2.8) performing a tearful monologue, 'Dear Mama', which recounts her viewing of a film, *Morgen Beginnt das Leben*, directed by Werner Hochbaum in Berlin in 1933. 'She describes the gasps and murmurs she heard as young members of the audience identified the street signs of neighborhoods that were otherwise unrecognizable. The film is their link to pre-war Berlin, a city "that is no more"' (Rainer 1989: 168). Here the video-montaged ending of Rainer's experimental, feminist film is enveloped in an uncanny acknowledgement of contemporary cinema's traumatic debts to its cinematic and/or phantasmatic precursors. What is more, this example suggests the degree to which the traumas of historical fantasy are enveloped in film and the sites of its projections.

IDEOLOGICAL FANTASIES / CINEMATIC DIFFERENDS

This book reflects my ongoing interest in how differing cultural milieux are caught up, bound up, with the schemata of visual theory and artistic practice. I reflect, to borrow a notion from Jean Laplanche, on how the theoretical enterprises of philosophy and psychoanalysis 'invade' the cultural 'not only as a form of thought or a doctrine, but as a *mode of being*' (Laplanche 1989: 12). From this perspective, theories of sexuality and trauma, such as the Oedipus and the castration complexes, would be seen as 'possible variations on culturally determined scenarios' (ibid.: 163).[3] Conversely, *Like a Film* reflects on how the cinematic apparatus itself has invaded the theory of culture as a mode of weaving together

4

the disparate 'psychopolitical' fabrics of cultural production, psycho-analysis, and politically marked subject positions.

The reporting of *Crash in Washington Square Park* makes especially apparent how the analogical relation inscribed in the formula 'like a film' can now be said to constitute the foundational fabric of cultural narra-tive, rather than being a mere fictional by-product of film's distanced depictions of urban ecology and its tragedies. For what makes *Crash in Washington Square Park* describable, if not also comprehensible, to the readers of the *New York Times* is its almost necessary translation into the surreal experience of cultural fantasy, 'like a movie'. Suggested by Evie Hantzopoulos is the complex way that 'what is happening' in culture remains inscribed in the denial of its belief or, similarly, in the analogical modulation of belief and fantasy: 'We couldn't believe what was hap-pening. It was like a movie.' Otherwise put, the cinematic 'happenings' of culture – of identity, identification, and politics – are often believable precisely because they are structured so much like film. They are *virtual* constructs related to the plane, screen, or mirror of their personal and communal projections.

To explain this relation, I turn to my book's subtitle and the concept of 'ideological fantasy'. I loosely appropriate this notion from Slavoj Žižek's *The Sublime Object of Ideology* (1989a) where it signifies the belief supporting the fantasy that regulates social reality.[4] With this term, Žižek turns his attention away from the received notion of ideology as 'false consciousness' to the complex strata of fantasy-construction itself:

> ideology is not a dreamlike illusion that we build to escape the insupportable reality; in its basic dimension it is a fantasy-construction which serves as a support for our 'reality' itself: an 'illusion' which structures our effective, real social relations and thereby masks some insupportable, real, impossible kernel (con-ceptualized by Ernesto Laclau and Chantal Mouffe as 'antagon-ism': a traumatic social division which cannot be symbolized). The function of ideology is not to offer us a point of escape from our reality but to offer us the social reality itself as an escape from some traumatic, real kernel (Žižek 1989a: 45).[5]

What appeals to me is Žižek's reconfiguration of ideology as a doubled phantasmatic screen of the pleasure of illusions and the fetishistic pres-ervation of the residues of trauma. For Žižek, a key feature of this function is that the social realities of late capitalism – the social 'relations between things, between commodities – instead of immediate relations between people' (ibid.: 33) – themselves believe for the subject, act on its behalf. Countering the commonplace that belief is something interior and knowledge something exterior, Žižek adopts the Lacanian prop-osition that 'the most intimate beliefs, even the most intimate emotions

5

such as compassion, crying, sorrow, laughter can be transferred, delegated to others without losing their sincerity' (Žižek 1989: 34). He explains such a claim analogically by citing the example of television's 'canned laughter', which relieves fatigued viewers of what he calls the 'duty to laugh':

> So even if, tired from a hard day's stupid work, all evening we did nothing but gaze drowsily into the television screen, we can say afterwards that objectively, through the medium of the other, we had a really good time. . . . The lesson to be drawn from this concerning the social field is above all that belief, far from being an 'intimate', purely mental state, is always *materialized* in our effective social activity: belief supports the fantasy which regulates social reality.
>
> (ibid.: 35–6).

But the fact that this example of 'canned laughter' could appear trivial or insignificant to many readers suggests that Žižek's notion of 'materialized belief' need remain somewhat more open to the shifting transferential nature of 'good times' and 'effective social activity'. Does not the mixed appeal of television itself contest any universal response to its effectiveness as a thing, a commodity, an 'apparatus'? Just such an emphasis on how subjects are often positioned differently, and also position themselves (for what is 'pernicious' to some is empowering to others), in relation to the lure of 'appeal' motivates my analyses of film, art, photography, and theory. For it is the very 'appealing' nature of the phantasmatic relation, the polymorphous web of interpellation, which I think contests any trust in, say, a universal response to the media, on the one hand, or a blurred, but still distinct 'inside' and 'outside' of representation, on the other. Following Žižek's own lead, might not we say that more emphasis on what Laclau and Mouffe call the 'contingency' of interpellation itself will work to cloud the distinction between 'immediate relations between people' and 'social relations between things'? Why not claim that relations between people can only ever have been as immediate and universal as they have appeared on the screen? Universality and immediacy, that is, can be structured only like a film – as materializations of the many contingencies of enunciation and its social conditions.

The consequences of filmic contingency are brought home by the example of another horror show from American popular culture. I am thinking of the Associated Press report of the sensational White Plains, NY, trial of Carolyn Warmus for the murder of Betty Jean Solomon. When asked by a reporter what it was like to sit through the trial, Joyce Green, the sister of the victim, replied: 'it doesn't seem real. You can detach yourself. . . . It's like being in a movie or some horrible book.

You don't think it will ever happen to you' (*Ithaca Journal*, April 22, 1991). Green's filmic analogy refers less to what she believes is (not) happening 'to her', being in a movie, than to what the prosecution maintains happened to Carolyn Warmus, who was fingered by the police for committing the murder. Fingered, that is, instead of the other prime suspect, Paul Solomon, the victim's husband and Warmus's former lover. What happened, so the prosecution claimed, was that Warmus 'was motivated by her obsession with the victim's husband and her desire to have him to herself' (ibid.). Otherwise put, what actually happened is that the prosecution strategically charged Warmus with acting like the ghoulish murderer of a popular film, *Fatal Attraction* (1987). Crucial to this analogical formation is the fact that the gender-specific scenario of *Fatal Attraction* is what made Warmus a more likely murderer than the other prime suspect, Solomon, the husband/lover. For only the woman, Warmus, could be charged with having this film act on her behalf, since only she, the spurned woman, could be guilty of duplicating the sadomasochistic violation of domestic space so memorable in *Fatal Attraction* (Corrigan 1991: 178). Similarly, to extend the analogy across the spectrum of juridical practice, only the woman could be found guilty by the jury which is similarly relieved by the film from thinking on its own behalf (I wonder whether any of the potential jurors were dismissed by the defense for having seen the film, that is, for already *being in the film*). What is made clear by this trial, like a film in so many ways, is that the universality of ideological fantasy can make itself known only in symbolically specific ways. Otherwise put, things act on behalf of some subject positions in significantly different ways than they do for others.

This is what the American public learned in 1991 from yet another national media spectacle, the televised 'Judge Clarence Thomas–Anita Hill hearings'. Glued to television sets until the wee hours of the morning, an unusually large percentage of the American public followed the Senate's feeble investigation of Anita Hill's accusation that she had been sexually harassed by Clarence Thomas, the conservative, Black nominee to the Supreme Court. The cinematic analogies generated by this hearing produced *for* television are especially complex, from allusions to specific films to assumptions about the construction of character. Senator Joseph Biden could not have summarized the latter any better than when, very late one night, he revealed his exasperation with the simplistic testimony of a pricklish witness who was defending Thomas by claiming intimate knowledge of Hill's *modus operandi*. In an emotional appeal to the television cameras, Biden uttered the unforgettable aphorism: 'Nobody's reputation's a snapshot, it's a motion picture.' Ironically he was reprimanding the witness for his simplistic portrayal of Anita Hill as a scorned woman intent on destroying the

character of her former mentor. But here too *Fatal Attraction* thought on behalf of the judiciary when the younger–Black–woman was determined in the end to have acted most like a film. For Clarence Thomas was exonerated by his ultimate confirmation to the Supreme Court – even though the judge himself was accused of acting like the sleezy pornographic movies he was said to have devoured. Score another blow for *Fatal Attraction*.

I cannot overemphasize the significant power differential that can exist between analogical relations, between markedly different subject positions in ideological fantasy. The juridical results of the Thomas Confirmation Hearings underscore how an all-White–powerful–male committee toyed, sometimes caustically, with the unwavering assertions of a younger Black woman that her psyche had been violated by the cinematic, sexual fantasies of the judge, himself subject ironically to an attendant set of public fantasies sustaining the myth of the insatiability of the Black male.[6] The differential of the complex power relations in this spectacle, itself deeply enveloped in a number of stereotypical representations and cinematic analogies, attests, I want to insist, to the radical disjunction of positions of interlocution. This is what Jean-François Lyotard calls the 'differend': 'a case of differend between two parties takes place when the "regulation" of the conflict that opposes them is done in the idiom of one of the parties while the wrong suffered by the other is not signified in that idiom' (Lyotard 1988a: 9). Especially important to the critical strategy of this book is consideration of the crucial role of the differend within the shifting scenes of cultural and theoretical production.

As a critic sensitive to the historical privilege of my own subject position as a heterosexual, white male, I rely throughout on the rhetorical force of posing the question of the differend. In terms of portrayals of racial and ethnic difference, I question the significance of Laurence Olivier's cinematic wish 'to possess' the image of black Othello. While admiring the politics of the Harrisons' ecological art, I ponder the cultural implications of their artistic appropriation of Sri Lankan culture for the figural purposes of Occidental political metaphor. Regarding gender difference in the work of Rainer and Silverman, I query 'the profound import for man to promote "penis envy" in the other sex and to transmit it in his institutions' (Torok 1987: 170). And on the related plane of sexual preference in Jarman's *Caravaggio*, I question how the idiom of homosociality (hetero-social relations between men) might differ from, if not fail to signify, the false analogy of 'homosexuality'. The agonistic tensions joining many of these inquiries in the web of their differences further attest to the impact of the differend on my own critical regulations.

Regarding my choice of subject matter, I wish to note the incomplete

results of my regulation of the contents of this collection. My decision to divide a much lengthier manuscript into two books has left this collection without the sustained readings of recent work by artists of color which I include in the sequel, *Performance Reading: Theatre in a Multi-Cultural Age* (Routledge, forthcoming). Still, the critical sensibilities of those artists – like Ntozake Shange and Adrienne Kennedy – continue to inform *Like a Film*'s discussion of the uncertain terrain of multicultural identity. For it is my sense, in keeping with a recent essay by Kobena Mercer (1992), that their theatrical work of the 1970s and 1980s dramatizes the way that knowledge of cultural identity is rendered frail by acknowledgement of the vicissitudes of cultural identification (Murray 1990). This distinction is crucial to the critical aims of this book. Although the following discussions of feminist theory, race, and homosexuality may well touch on the 'wrong suffered by the other', they in no way attempt to account fully for, to stand in completely for, the identity of the other. But this is not merely out of respect for and deference to the other, but also in consideration of the incomplete, phantasmatic terrain of otherness itself. A significant point of *Like a Film* is that the confident, political 'identity' of any subject position must be understood in relation to the much less certain hybrid of 'identification' constituting subjectivity *per se*. So in reiterating and, thus, repositioning articulations already made by the other primarily for the other, the chapters to follow dwell on various ways in which identification with the other image or other text can act consequentially on many different readers' behalf – through both the negations and the affirmations of the differend.

I have in mind here the kind of catalytic distinction discussed by Lyotard in his book *The Differend*:

> What is at stake in a literature, in a philosophy, in a politics perhaps, is to bear witness to differends by finding idioms for them. In the differend, something 'asks' to be put into phrases, and suffers from the wrong of not being able to be put into phrases right away. This is when the human beings who thought they could use language as an instrument of communication learn through the feeling of pain which accompanies silence (and of pleasure which accompanies the invention of a new idiom), that they are summoned by language, not to augment to their profit the quantity of information communicable through existing idioms, but to recognize that what remains to be phrased exceeds what they can presently phrase, and that they must be allowed to institute idioms which do not yet exist.
>
> (Lyotard 1988a: 13)

My own attempt to bear witness to the differend weaves together two

sometimes disparate procedures of cultural discourse. First, I dwell through close readings on the internal pressure exerted by the differend on the seamlessness of hegemonic films and art objects. The painful rupture of the silence of oppression is frequently evident, for example, in mixtures of cultural forms that summon the critic to distinguish and analyze them and their shifting ideological effects. In my reading of Jarman's *Caravaggio*, for instance, I dwell on the homosexual characters' contradictory identifications with the heterosocial norms oppressing them – identifications that the film ultimately transfigures for homosexual gain. Similarly, stress on the inevitable hybridity of high and low cultural forms, say Rainer's video incorporation of audience response to *Morgen Beginnt des Leben*, attests to the potential of fantasy-effects as a means of 'recognizing what remains to be phrased' within the painful site of hegemonic culture itself. Second, my attempt to clarify the contamination of hegemonic cultural forms has led me to juxtapose many recent idioms in cinema, art, and theory, many of which might choose not to acknowledge the legitimacy of the other. This book's exploration of various psychopolitical facets of the visual, for instance, aims to build on both the difference and the differend of recent visual-discourse positions. Consider, for example, the curiosity of the recent proliferation of books in France (an influential source of my own discourse) which reconsider the visual, often in relation to the many Continental sides of deconstruction. I am thinking of a fragile dialogue between such differing texts from the 1980s as *La chambre claire: note sur la photographie* (1980) by Roland Barthes, *Le texte divisé: essai sur l'écriture filmique* (1981) by Marie-Claire Ropars-Wuilleumier, *Cinéma 1: L'image-mouvement* (1983) and *Cinéma 2: L'image-temps* (1985) by Gilles Deleuze, *Mélancolie de l'art* (1984) by Sarah Kofman, *Eléments de l'interprétation* (1985) by Guy Rosolato, *Que peindre? Adami, Arakawa, Buren* (1987) by Jean-François Lyotard, *Soleil noir: dépression et mélancolie* (1987) by Julia Kristeva, *L'origine de la perspective* (1987) by Hubert Damisch, the revised edition of *L'écorce et le noyau* (1987) by Nicolas Abraham and Maria Torok, and *Perdre de vue* (1988) by J. B. Pontalis. Responding to the call of earlier work by writers like Lyotard, Marin, Damisch, Lascault, and Derrida,[7] these texts produce a tenuous common ground for a wide variety of otherwise incommensurable positions in contemporary philosophy and psychoanalysis. They urge critics to take an especially serious look at the image-actions of art, film, photography, video, and even performance. This is the important cultural terrain which, I believe, deserves as much critical attention as that paid to the 'literary' by certain circles of American theoretical studies.[8]

SUMMER'S HEAT: DOUBLE VISION

The common approach to the visual taken by the theoretical texts with which I dialogue is concerned less with mapping out aesthetic hierarchies and truths, the psychological conditions of the artist, and the symbolism of visual culture or sociocultural identity than with analyzing the often contradictory procedures of imaging that shape and lend form to individual and cultural identifications, incorporations, and resistances. They thus pay especially close attention to the significant differences of varying cinematic and theoretical articulations of the virtuality of identification and their relation to ideological fantasy. In *The Freudian Body in Psychoanalysis and Art*, for instance, Leo Bersani asserts that 'a psychoanalytically oriented criticism not only repeats those representational identifications of desire already present in art, but should also articulate the "de-forming", or "dis-formulating", effects of desire within those identifications' (Bersani 1986: 111). It is particularly significant that the 'de-forming' identifications already present in art are understood by Bersani to be transcultural: 'the artifacts of art are material metaphors for moves of consciousness which do not intrinsically "belong" to any particular cultural domain but rather traversely cross, as it were, the entire range of cultural expression' (ibid.: 5).

By contrast to such an investment in transcultural universality (subsequently dis-formulated or not), my work traces the lines and figures of 'belonging' and 'alliance' inscribed in particular cultural artifacts.[9] I see the artifacts of cinema, art, and visual theory to function as virtual figures of identification which may send different signals to viewers from different cultures about the potential reciprocity of transcultural exchange. To emphasize how artworks themselves call attention to the shifting nature of identification and cultural exchange, I would like to spend a few moments reflecting on the psychohistorical commentary made by Thierry Kuntzel (himself an influential theoretician of film) in his recent video installation, *Eté – double vue*.[10] This piece includes a video-projected close-up scan of a lounging Black man who is shown in the contrasting landscape scenario of an adjoining monitor to be naked, except for a bright red cloth covering his lap. The cloth is appropriated from a painting in Poussin's 'Four Seasons' series, *Summer, or Landscape with Ruth and Boaz* – a reproduction of which is semi-visible in a book sitting on the subject's lap. Or, more precisely, the book sits on the piece of appropriated cloth which is made poignantly enigmatic by its purloined status. How might we read Kuntzel's reference to Poussin through this piece of borrowed loincloth? While Kuntzel's double vision of summer suggests an obvious revision of the landscape tradition in the age of video, its reference to the sexual thematics of Poussin's painting is much less clear. Poussin's depiction of the meeting of Ruth and Boaz

11

leaves unchallenged the biblical narrative of magnanimous paternalism sustained by phallocratic threats and domination (Book of Ruth ii. 1–iv. 22). In granting Ruth's request to gather the remains of wheat left by his reapers, Boaz sets in motion a sequence of events that leaves Ruth willing to be his wife by purchase. This all begins when he enriches his initial gesture of generosity by declaring his fields something of a 'sex-free zone' where Ruth can be safe from the threat of molestation by his and his neighbors' men. She is warned that she would be vulnerable, were she to leave his fields, to the sexual threat always already troubling the pastoral scene. What, then, can be made of Kuntzel's allusions to the narrative of Ruth's willed slavery as a defense against more frightful phallic aggression? It could be argued, no doubt, that Kuntzel's quiet reference to this story (his title censors the Ruth and Boaz subtitle) aligns his piece with the complex artistic tradition celebrating the patriarchal entrapment of women. This is the convention so violently displayed by one of Poussin's more memorable paintings – *Rape of the Sabine Women*.

But such a feasible reading is complicated by the installation's double vision. For the spectator is made aware of the visual strategies of this tradition when shown computer-guided close-ups of enlarged fragments of the model's objectified black body – fingers, toes, lips, the line of a thigh. In describing the installation, Christopher Phillips suggests that Poussin's 'classical perspectival frame is shattered by the modernist close-up view. The twist here is that Kuntzel wholly identifies this modernist vision with an erotic gaze that is fetishizing and obsessively calculating' (Phillips 1991: 110). To render even more complex Kuntzel's reference to the fetishizing gaze, Phillips could also turn to the source picture, *Summer, or Landscape with Ruth and Boaz*. In addition to the sizeable scarlet robe lying on a handcart to the left of the painting, a red Phrygian cap rests on the head of the lute player sitting on the right. In this context, Kuntzel's citation of one piece of red cloth calls to mind yet another, the Phrygian cap, analyzed by Neil Hertz (1985: 179–91) as representing the inscription of patriarchy in the threat of its impotence or castration. The trace of red, here removed by Kuntzel from player's cap to reader's lap, thus works to dis-play or deconstruct the history of the fetishistic gaze on which it depends.

But this represents only one view of the sexual economy of *Eté – double vue*, let's call it the transcultural desire for Kuntzel's close-ups to traverse 'the entire range of cultural expression'. What of the fact that the Phrygian cap is an attribute of two competing sexual economies, not only that of Paris but also that of Ganymede (Hertz 1985: 183)? It could well suggest that 'the fetishizing gaze' and its psychopolitical implications will be different for the sons of Paris from what it will be for the lovers of Ganymede. This will pertain especially well to the viewers who recognize the subject of Kuntzel's close-ups to be Ken Moody, the Black

model featured in Robert Mapplethorpe's *Black Book*. Otherwise put, in the terms developed in Part II of this collection, it is of considerable importance that not all viewers are likely to recognize Moody and that those who do will position him differently within the intermixed references of White/Black, homosocial/homosexual identities that have made *Black Book* such a controversial source of cultural debate.[11] Indeed, these video close-ups of Moody and their appeal to homosexual desire will joyfully dispel for some, while defensively strengthening for others, the calculating, heterosexual logic of the fetish. This is the logic, returning to the double view of the Phrygian cap, that stabilizes the trauma of castration anxiety troubling the advanced stage of male infantile growth – the stage said by Freud to be arrested for the homosexual trapped in the prior stage of narcissistic identification with the mother.[12] Otherwise put, traces of the cap which can only weaken some are placed by Kuntzel on the lap which can only harden others.

Sustaining all of these traces is the technological form of *Eté – double vue*, experimental video – a point important to my forthcoming analyses of artistic 'belonging'. In response to a growing emphasis in film and art criticism on the political priority of 'content', I will insist throughout that artistic form, its histories and aberrations, must be understood to play a significant role in delivering the goods of any political message. In relation to many recent exhibitions emphasizing the impact of film and video on social and political narrative, Kuntzel's installation could be evaluated for sustaining a dialogue with, say, the mixed-media work of influential multicultural artists, like Trinh T. Minh-ha, Ray Navarro, and Robbie McCauley, whose challenging representations have experimented with the instability of video and narrative 'resolution'.[13] At stake is how the 'immaterial', technological experimentation of artists working toward cultural 'self'-definition corresponds to the virtuality, the immateriality of cinematic form. Consider, for instance, Lyotard's formulation of the conceptual aim of 'Les Immateriaux', the show he curated for the Centre Pompidou in 1985. This exhibition of hyperreal works from the mediums of video, computer graphics, laser, and synthetic sound was organized around a 'principal question':

> 'Man's' anxiety is that he is losing his (so-called) identity as a 'human being.' One aspect of 'immaterials' . . . is that they imply just such a dis-identification. Just as material is the complement of a subject who masters it to attain its ends, so also the 'immaterial' signifies through its contradictory concept a material which is no longer a matter ('primary' or not) for a project. And it reveals for 'Man' a dissolution correlative to what he tames . . . the ideas associated with 'material' and that sustain the primary sense of a

human identity are weakened by this fact – experience, memory, work, autonomy (or liberty), even 'creation'.

(Lyotard 1985: 2)

Such a formulation of 'the principal question' faced by visual practice today prompts me to reflect on its import for artists and theorists who turn to film and video for their 'imaging'. It seems important to acknowledge how carefully the technological dissolutions of video and film are reinscribed in alternative work aiming to imagine and stage performative 'resolutions' of differend racial, sexual, and social identities.[14]

INTERNAL COLONIZATION . . .

It is significant, however, that many cultural activists have challenged the difference of such 'resolutions' when cast primarily in relation to the discourse of Continental theory. French-oriented philosophical and psychoanalytical rereadings of visuality and virtuality have received especially pointed criticism from practitioners of cultural studies concerned with empirical matters of oppression. In film circles, for instance, polemical essays by Jane Gaines (1990 – initially published in 1986) and Barbara Klinger (1988) have been embraced by many critics for questioning the value of poststructural and psychoanalytically based criticism in the analysis of class and race. African–American cultural circles have spawned similar disavowals of the immaterial demystifications of poststructural theory. The charge is that such theory delimits acknowledgement of the material diversity of culture and its makers. In 'Modernism, postmodernism and the problem of the visual in Afro-American culture', Michele Wallace castigates postmodernism (poststructuralism) for

the reinscription of Modernism's apartheid. Although the negation of their former powers to explain the world is potentially useful to counter-hegemonic strategies, invariably European-influenced theorists are so preoccupied with the demise of the Hegelian dialectic that they never really get to anything other than white men who share similar feelings.

(Wallace 1990: 49)

Cornel West develops a similar point in 'Black Culture and postmodernism' when he discusses the philosophical legacy of Lyotard, Derrida, and Foucault. In a statement more polemical than reflective of his work's abiding interest in Continental thought (which aligns it with the work of African–American cultural theorists, such as Hortense Spillers and Henry Louis Gates, Jr, who creatively dialogue with poststructuralism), West critiques the postmodernism debate for being

first and foremost a product of significant First World reflections upon the decentering of Europe that take such forms as the demystification of European cultural predominance and the deconstruction of European philosophical edifices [all of which] . . . remain rather parochial and provincial – that is, narrowly Eurocentric.

(West 1989: 88)

Underlying this critique is a wish to locate and defend multicultural positions lying cleanly 'outside' the internalized edifices defining the 'inside' of European culture. Speaking of the difficulty of maintaining such a clearcut distinction within diasporan studies, Gayatri Chakravorty Spivak cautions her readers about the pitfalls of recent theoretical work in postcolonial studies dependent on 'system[s] of representation negotiated by internal colonization' (Spivak 1989: 281). It is just such a forceful drive of internalization that Adrian Piper identifies as a source of 'The triple negation of colored women artists'. In her polemical essay by the same title, Piper insists that such internal colonization leads only to the preservation of Eurocentric norms blind to their collapse of essential differences.

> The underlying ideological commitment of the Euroethnic mainstream is to its own perpetuation, in whatever guise. . . . In postmodernism, it is manifested in a dissolution of faith in intellectual progress, and a corresponding attitude of mourning for the past glories and achievements of all previous stages of Euroethnic history, which are memorialized and given iconic status through appropriation into contemporary art world artifacts.
>
> (Piper 1990: 17)

Piper easily could cite two films I discuss, Jarman's *Caravaggio* and the Burge/Dexter *Othello*, as prime examples of the cinematic mournings and memorializatons of the past glories of Europe. *Othello* glorifies not only Shakespeare's mostly pernicious commentary on colonization and race but also the iconic status of Laurence Olivier's dramatic transformation in black face. Proud mourning is itself the topic of *Caravaggio*, a film that dwells on the death of 'the most homosexual of painters' in Euroethnic art history (Jarman 1984: 22). A striking cinematic contrast to such Eurocentric mourning is provided by Julie Dash's cinematic reflection on the heritage of African–American women, *Daughters of the Dust* (1991). An emotionally charged moment of the film is when Yellow Mary rejects her historical appropriation by the Eurocentric mainstream. In a rebellious twist on 'internal colonization', she declares that she had 'put all bad memories in that case and locked them dead. I didn't want them inside of me. Don't let nobody in that case or out of the case tell me who I am.' Still, this example points as much to the likeness as to the

difference of these contrasting examples of cryptography. Ironically, Dash's Yellow Mary and Piper's mournful postmodernist rely on similar mechanisms of encasing their memories, of psychic incorporation, to protect and preserve their contrasting subjective and cultural positions. Both examples of incorporation foreground the enigmatic terrain of what Kobena Mercer terms 'the unconscious identifications at stake in ideological struggles over representations of "self" and "other"' (Mercer 1992: 77). It is Yellow Mary's mother, moreover, the matriarch of *Daughters of the Dust*, who speaks wisely to her offspring about the need to respect the longevity and psychic independence of incorporated material: 'never forget who we is and how we come – we carry these memories inside of we; we don't even know where the recollections come from'.

Aiming to render *productive* the many *internal instabilities* of cultural memories, this book reflects on just where such recollections might come from. It gives a good deal of consideration, for example, to one particularly fertile response to the question of female incorporation. I refer to the fascinating work currently situating visuality within the purview of melancholia. In *Soleil noir: dépression et mélancolie* (1987), to cite a well-known instance, Julia Kristeva notes that aesthetic creation provides a faithful semiological representation of the subject's battle with the collapse of the symbolic. The work of art is said to integrate successfully its artificial language with the unnameable emotions of an omnipotent ego which is always left somewhat saddened or orphaned by everyday social and linguistic practice. In this regard, aesthetic creation can be said to mimic satisfactorily the activity of the unconscious whose dreams provide not the sign but the index of the untranslatable death drive threatening symbolic containment. In a book more directly treating the fine arts, *Mélancolie de l'art* (1985), which follows the lead of Philippe Lacoue-Labarthe's *Portrait de l'artiste en général* (1979), Sarah Kofman goes much farther than Kristeva toward a reconsideration of the visual *per se*, by reflecting on the threat of art to the stability and mastery of speculative philosophy. 'The aim of the philosophical discourse on art', she writes, 'is to make us forget art, to obscure it, to secure it in the masterful adornment of the benefits of reason and truth' (Kofman 1985b: 15). Yet, the power of art respected by Kofman positions aesthetic speculation and occultation on the uncanny precipice of the madness and death wrought by fascination: 'why such an occultation if it is not because art strangely disquiets and deranges the "Mind", like a spirit, an uncanny phantom ('un fantôme *unheimlich*') which would not allow it to retain its position in the too too familial (*heimlich*) sojourn of the mind' (ibid.: 15).[15]

In the chapters to come, I pay special attention to how art similarly disquiets the speculative procedures of Lyotard and the Harrisons. I also

16

consider how the uncanny procedures of melancholic incorporation haunt and inform Rainer and Jarman's cinematic work, Roland Barthes's mournful study of photography, and Kaja Silverman's challenging analysis of female subjectivity. But rather than rely on the provocative writings of either Kristeva or Kofman, I lean more on critical connections linking the theories of Laplanche, Abraham, and Torok to understand how the work of incorporation *preserves*, rather than erodes, the differend enigmas of memory so valued by the ageing matriarch of *Daughters of the Dust*. These and similar reflections on the *productive instabilities* of Euroethnic fascination with the visual (Other) aim to discuss the indistinct psychic borders of intellectual and cultural differends. Otherwise put, the readings of this book attempt to forge methods of opening particular cultural domains, sexualities, or races to something verging on a reciprocal reflection on ideological fantasy. This is the kind of 'cultural ex-change', to appropriate the language of Dan Quayle, that *can* be effected by the fantasy work of the 'cultural elite'.

To close on the analogical theme specific to this project, *Like a Film*, I would like to clarify how the instability of such cultural ex-change might be understood psychoanalytically to constitute the structure of visuality *per se*. Insisting on the analogical gap opened by Lacan's formula, 'the unconscious is structured *like* a language', Laplanche stresses that language functions in the unconscious only, at best, as materialized bits of 'representation-things' – either as visual sensorium (imago) or as partial operators of other primitive, but not necessarily visual, modes of 'action', such as 'the eating, incorporating, retaining, expelling, and cutting at the heart of unconscious fantasies' (Laplanche 1981: 119). Laplanche further opens the way to non-verbal exchange and development by reflecting on what he calls 'the enigmatic signifier'. This is a non-verbal, as well as a verbal, signifier that provides the first indication of perception or the first inscription in the psychical apparatus. Initially a sexual signifier of the attentions given by the mother to the infant – cleaning, handling, care, sentiment – it remains imperfectly understood by the infant. Laplanche attributes this to the lack of either continuity or pure and simple interiorization between 'the comportment-discourse-desire of the mother' and 'the unconscious representation of the subject' (ibid.: 126).

Although Laplanche insists that this 'strange metabolism' is equivalent to neither 'the desire of the mother' nor 'the discourse of the Other', he does derive the 'enigmatic signifier' from Lacan. In *New Foundations for Psychoanalysis*, a summary of his *Problématiques* (1981–3), Laplanche turns to the moment in Lacan's analysis of the gaze that distinguishes between a signifier *of* and a signifier *to* ('signifié au sujet'). This is a signifier that signifies *to* someone without its addressee knowing necessarily *what* it signifies:

Lacan suggests the image of hieroglyphs in the desert, or of cuneiform characters carved on a table of stone; we know that they signify and that, as such, they have their own kind of existence, an existence which is phenomenologically different [from] that of things; they are intended to signify something to us, but we do not necessarily have a signified which we can ascribe to them. This does not imply that we have to agree with the doctrine of the primacy of the signifier or, *a fortiori*, with the doctrine of the hegemony of the signifier or even the hegemony of the signifier in analytic treatment. It simply means that we have to place considerable stress on the possibility that the signifier may be *designified*, or lose what it signifies, without thereby losing its power to signify *to*.

(Laplanche 1989: 45)

Such a powerful appeal of the call of designification is what Laplanche believes to prepare the way for the expression of individual and cultural fantasies extending far beyond the recognizable limits of hegemonic centrisms of any cast.

Through such an acknowledgement of ongoing psychic 'decomposition' and 'recomposition', both Laplanche and Pontalis return their recent investigations of visual and non-verbal signifiers to their earlier analysis of fantasy, whose home turfs might now be understood to be more multicultural than universal. As Pontalis phrases it anew in *Perdre de vue*, 'we don't have memories *of* childhood but only memories *on* our childhood, which don't arise out of the past but are formed on the run (*sur le tard*); our memory is a retroactive fiction, retroactively anticipatory, which belongs with no need of sanction to the realm of *Fantasy*' (Pontalis 1988: 289). Pontalis adds that the production of the ongoing mechanisms of visual fantasy correspond neither to the perverse colonializing fetishism of artificial perspective (the cinematic apparatus?) nor to 'those uncontrolled, antagonistic movements which the disorder of our thoughts sometimes presents us a sampling' (the dis-formulating effects of Bersani?) (ibid.: 282). Rather, this mechanism permits the subject 'to unlearn to see so that the horizon and the distances of the thing can lend themselves to sight' (ibid.: 282). Ultimately at issue in such an unlearning, so Pontalis emphasizes, is a putting in check of the unidirectional, colonialist procedures besetting both psychoanalysis and philosophy, not only those of the masterly translation of figure, line, and language, but also those of faith in the speaking-cure's counter-strategy of transcription. In their place, Pontalis proposes reflection anew on 'the overaccentuation of visual elements'. This is what occurs on the four-dimensional plane of fantasy when the return of the repressed signals a shift in 'belonging', 'a change', he adds, 'of regime, a violent mutation, metamorphosis, and exile in Other spaces which

have, like the body, their own erogenous zones' (ibid.: 291). While this theorizing of the visual might include the kinds of artistic artifacts traversing 'the entire range of cultural expression', their shifts of representational register and arrest can be said to leave along the way those imprints of psychic and cultural exile that continually signify *to* particular states of belonging.

I close by noting that it is Laplanche who specifically relates the enigmatic signifier to the analogical theme of this book. He imagines it to work something like what he calls 'metaboles' or catachresis in film:

the function of etymology is to protect the evidence of the 'metaboles', these transports, whose origin is forgotten. . . . That the transport of catachresis [what passes from one language to another] never happens without leaving its residue is made evident in a thousand ways; and when one speaks of a 'dead metaphor', one ignores the degree to which 'metaboles' are ready to reappear (*à renaître*) at any moment. It is amusing to follow this renaissance in witticisms, like a film projected in reverse.

(Laplanche 1981: 138)

NOTES

1 This is the same title used by the *New York Times* for its special coverage of the Washington Square accident.
2 'Modulation' is the term coined by Gilles Deleuze to signify an analogical function other than resemblance (through which analogy has been associated traditionally with metaphor). He sees modulation as 'a putting into variation of the [cinematic] mould, a transformation of the mould at each moment of the [cinematic] operation. If it refers to one or several codes, it is by grafts, code-grafts that multiply its power (as in the electronic image). . . . For modulation is the operation of the Real, in so far as it constitutes and never stops reconstituting the identity of image and object' (Deleuze 1989a: 41). On the modulation of cinematic analogy, also see Roland Barthes's remarks on digital analogy, in *Elements of Semiology* (1968: 27–8).
3 For various analyses of the impact of trauma on cultural interpretation, see the special issue of *American Imago* edited by Cathy Caruth, *Psychoanalysis, Culture, and Trauma* (1991).
4 The 'looseness' of my appropriation of Žižek's concept also stems from his strict loyalty to the Lacanian system. While the writings of Lacan, especially those on the scopic drive, are influential to me, I am quite prepared to adopt the positions of his critics, from Irigaray to Laplanche, when they help to analyze the many critical allegories to which Lacan's method remains blind.
5 Laclau and Mouffe describe 'antagonism' as a fundamental feature of analogical expression: 'antagonism constitutes the limits of every objectivity, which is revealed as partial and precarious *objectification*. If language is a system of differences, antagonism is the failure of difference: in that sense, it situates itself within the limits of language and can only exist as the disruption of it – that is, as metaphor. We can thus understand why sociological

and historical narratives must interrupt themselves and call upon an "experience", transcending their categories, to fill their hiatuses: for every language and every society are constituted as a repression of the consciousness of the impossibility that penetrates them. Antagonism escapes the possibility of being apprehended through language, since language only exists as an attempt to fix that which antagonism subverts' (Laclau and Mouffe 1985: 125). Laclau, Mouffe, and Žižek also might reflect on the relation of 'the nodal point' – the privileged discursive points of the social's partial effort to construct the impossible object (ibid.: 1985: 112) – and the 'nodal points implicit in the ideological system' earlier traced by Jameson. For Jameson, 'nodal points' constitute the semiotic entry into 'the structure of a particular political fantasy, as the mapping of that particular "libidinal apparatus" in which Balzac's political thinking becomes invested – it being understood that we are not here distinguishing between fantasy and some objective reality on to which it would be "projected", but rather, with Deleuze or with J.-F. Lyotard, asserting such fantasy or protonarrative structure as the vehicle for our experience of the real' (Jameson 1981: 48).

6 I recommend Alice Walker's story 'Advancing Luna and Ida B. Wells' (1990), for its memorable account of the complexities of the Black woman's response to rape and sexual oppression.

7 See, for example, *Des dispositifs pulsionnels* (1973) and *Discours, figure* (1974) by Lyotard, *Etudes sémiologiques: écritures, peintures* (1971) and *Détruire la peinture* (1977) by Marin, *Théorie du nuage: pour une histoire de la peinture* (1972) by Damisch, *Ecrits timides sur le visible* (1979) by Lascault, and *La vérité en peinture* (1978) by Derrida. Norman Bryson's collection *Calligram: Essays in New Art History from France* (1988) includes a wide selection of similar work from France.

8 One example is the privilege given to 'the literary' by American proponents of the Yale School of Deconstruction. By contrast, other collaborative groupings of American deconstructionists, like those of *Glyph* (out of Johns Hopkins) and *enclitic* (out of Minnesota) have given much greater attention to the critical weight of imagistic and cinematic issues.

9 'Alliance' is what Kobena Mercer emphasizes in response to Stuart Marshall's Bad Object Choices presentation: 'Alliances are based on an imaginary identification. . . . What determines the political identity is where it comes from, not its "essence"; rather it's the relationship to other struggles, the alliances that are made possible by certain forms of imaginary identification. And I think it might be helpful to bring those other historical analogies to bear on the current situation' (Mercer 1991b: 101).

10 I am indebted to Christopher Phillips's (1991) detailed description of Kuntzel's piece and its place in the exhibition 'Passages de l'image'.

11 I find myself challenging the universality of Phillips's claim (1991: 110) that Ken Moody is 'instantly recognizable from Robert Mapplethorpe's photographs' (1991: 110). For astute discussions of the various ways that *Black Book* positions itself along so many divides, see Mercer (1987; 1991), Shange (1986), and Yingling (1990).

12 See Lewes's helpful summary of Freud's early views on homosexual attachment to the mother, in *The Psychoanalytic Theory of Male Homosexuality* (1988). In contrast, see Edelman's fascinating account (1991: 101) of male heterosexuality as a later narcissistic compromise of the first instance of the primal scene, which 'is always perceived as sodomitical'.

13 I am thinking of the performative experimentations with video in *Shoot for the*

Contents (1991) by Trinh, *Indian Blood* (1990) by McCauley, and Navarro's (1989) ACT UP performance as the television host, Jesus Christ, which I discuss in more detail at the conclusion of Chapter 3. For related discussions of work in mixed-media performance, see Herskowitz (1985), Foster (1985: 79–96), Riley (1986: 107–12), Sims (1988).

14 I have in mind the kind of strategy suggested by Teresa de Lauretis (1984: 46–7, 67–8) in her proposal for a feminist approach to film: 'I propose that the question of imaging – the articulation of meaning to image, language, and sound, and the viewer's subjective engagement in that process – must be reformulated in terms that are themselves to be elaborated, recast, or posed anew . . . not [she adds] so much "to make visible the invisible" . . . or to destroy vision altogether, as to construct another (object of) vision and the conditions of visibility for a different social subject.'

15 Acknowledging that 'painting has been the activity of mourning throughout this century', Bois (1986: 47) suggests that the future of painting – Eurocentric and African–American – depends on the working-through of cultural melancholia: 'Painting might not be dead. Its vitality will only be tested once we are cured of our mania and our melancholy, and we believe again in our ability to act in history: accepting our project of working through the end again, rather than evading it through increasingly elaborate mechanisms of defense (this is what mania and melancholy are about) and settling our historical task: the difficult task of mourning.' See also Michelson (1990), Trippi and Sangster (1990) as well as Blau's discussion of the critical and performative activities of 'ghosting' in the wake of Hamlet (Blau 1982: 72–94). For historical overviews of the theory of melancholia and its relation to more recent discussions of subject formation, see Schiesari (1992), Lambotte (1984), Rickels (1986), Schwarz (1991), and Murray (1991).

Part I

PICTURES OF THE LIVING DEAD

2

LIKE A FILM
Reopening the Case of the Missing Penis
with Rainer, Silverman and Torok

My cunt is *not* a castrated cock. If anything, it's a heartless *asshole*!
(Patient, in Yvonne Rainer's *Journeys from Berlin/1971*)

In reflecting on common themes, relations, and anxieties troubling the dreams and psyches of her female patients, the French psychoanalyst Maria Torok asks 'why do the sentiment of castration and its corollary, "penis envy" constitute the almost universal lot of the feminine condition? Why does woman so frequently disavow activity, creativity, her own means of "making the world"; why does she agree to enclose herself in the gynaeceum?' (Torok 1987: 166). One of her responses to this enigmatic question pertains to the complex discursive conditions which help shape woman's conceptualization of her somatic and psychic virtuality. In her essay 'La signification de "l'envie du pénis" chez la femme', originally published in 1964, Torok surmises that

> it is the lure of the phallus that opens the way to the institutional relations of the two sexes. The entire problem of missed identifications are camouflaged by means of the fetish behind active and passive fascination. . . . One understands the profound import for man to promote 'penis envy' in the other sex and to transmit it in his institutions.

> (ibid.: 169–70)

My purpose here will be to dwell on this import; however, not so much with the aim of understanding our human and psychoanalytic institutions, 'les sciences de *l'homme*', as with the hope of acknowledging the discursive windows opened by women for the better comprehension of their cultural relation to them.

To do so I aim to return to the gynaeceum, that is, to the space, the enclosure, the case of the missing penis. This will entail, initially, a short overview of the history of this case, beginning with a reminder of the links of the modern institution of psychoanalysis to the mixed discourses of premodern and postmodern popular culture.

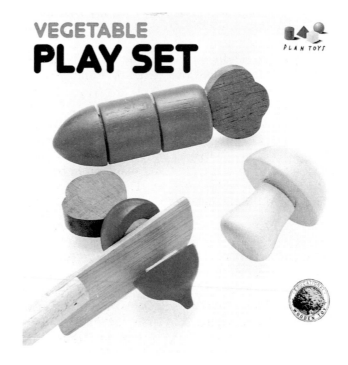

Figure 2.1 Plan Toys, 'Vegetable Play Set'

MARIE-GERMANE INCORPORATED

A family experience on Christmas Day provided me with an opportune example of the pressure of castration on the postmodern infant. My 1½-year-old nephew received from his uncle, who is a dentist, a 'Vegetable Play Set', billed by its German manufacturer as an 'Educational Wooden Toy' (figure 2.1). The set includes a wooden knife and three vegetables whose velcro seams allow the infant to cut them apart with ease. In addition to a rather benign mushroom, the set contains two other startling objects. A plump radish, carefully crafted to enhance its resemblance to the nipple, could have been used by Melanie Klein as a visual aid in her lectures on object-relations. Even more interesting was my nephew's immediate attraction to a somewhat wobbly but extremely phallic carrot. He then delighted in cutting this apart, an action foreseen by the German toy company, no doubt, to imitate the actions which he either observes or projects in relation to the mother. The dissemination of this toy, not to mention the dentist–uncle's own purchase of it, certainly works to guarantee 'the lure of the phallus that opens the way to the institutional relations of the two sexes'. This lure is clearly

materialized by the 'Vegetable Play Set' in a way that literalizes the splitting inherent in the toy's more simple predecessor, the *Fort/Da* game.

A similar linkage of childhood games and the case of the missing penis is made especially evident by Michel de Montaigne in a much earlier essay, 'De la force de l'imagination'. This is the essay, you may recall, which he concludes by casting doubt on the veracity of the evidence sustaining it, by writing 'So in the studie wherein I treat of our manners and motions, the fabulous testimonies, alwaies provided they be likely and possible, may serve to the purpose, as well as the true, whether it happned or no . . . I see it and reape profit by it, as well in shadow as in bodie' (Montaigne 1893: 40). The fabulous testimony with which I begin is that of Montaigne himself, and it goes like this:

> My self traveling on a time by Vitry in France, hapned to see a man, whom the Bishop of Soissons had in confirmation, named Germane, and all the inhabitants therabout have both knowne and seene to be a woman-childe, untill she was two and twentie yeares of age, called by the name of Marie. He was, when I saw him, of good yeares, and had a long beard, and was yet unmarried. He saith, that upon a time, leaping, and straining himself to overleape another, he wot not how, but where before he was a woman, he suddenly felt the instrument of a man to come out of him; and to this day the maidens of that towne and countrie have a song in use, by which they warne one another, when they are leaping, not to straine themselves overmuch, or open their legs too wide, for feare they should bee turned to boies, as Marie Germane was. It is no great wonder, that such accidents doe often happen, for if imagination have power in such things, it is so continually annexed, and so forcibly fastened to this subject, that lest she should so often fall into the relaps of the same thought, and sharpnesse of desire, it is better one time for all to incorporate this virile part unto wenches.
>
> (Montaigne 1893: 36)[1]

Little did Montaigne know that his advice to incorporate this virile part into wenches would later be enacted 'in Germane' as a founding law of psychoanalysis. For, in the Freudian system, the little girl initially starts out sharing with the little boy the same sexual history which Freud terms 'masculine.' Both begin by desiring the mother, which also means, in fantasy, possessing the phallus which is the object of the mother's desire.[2]

This initial 'phallic phase' is then followed by the poor little girl's abrupt visual astonishment over her lack and by the subsequent envy to be filled that defines her sexuality and her desire. As put succinctly

by the father of psychoanalysis, the pre-oedipal girl 'has seen it and knows that she is without it and wants to have it' (Freud, 1953–74: XIX, 252). The effects of the girl's knowledge are twofold. First is her inability from the outset of subjectivity to develop narcissistically. 'After a woman has become aware of the wound to her narcissism', writes Freud in a passage firmly implanted in the modern cultural unconscious,

> she develops, like a scar, a sense of inferiority. When she has passed beyond her first attempt at explaining her lack of a penis as being a punishment personal to herself and has realized that that sexual character is a universal one, she begins to share the contempt felt by men for a sex which is the lesser in so important a respect.
>
> (ibid.: 675)

A second consequence of penis-envy is a loosening of the girl's relation with the mother as a love-object, to the extent that 'the girl's mother, who sent her into the world so insufficiently equipped, is almost always held responsible for her lack of a penis' (ibid.). Thence comes the Oedipus complex, which for girls, unlike for boys, is said to be a secondary formation preceded and prepared by the castration complex. 'Now the girl's libido slips into a new position along the line . . . of the equation "penis-child". She gives up her wish for a penis and puts in [its] place a wish for a child: and with that purpose in view she takes her father as a love-object. Her mother becomes the object of her jealousy' (ibid.: 256). What could be gleaned, then, from Freud's incorporation of the virile part unto wenches is that Montaigne failed to recognize, or did not want to see, that the verse sung by the little girls of Vitry spoke not really of fear but of envy, the sharpness of desire for the instrument of leaping and straining they were desirous to have.

Nor did Montaigne appear to recognize the prophetic tone of his own essay, 'Of the Force of Imagination'. For the psychoanalytic understanding of this very incorporation would prove, at least when Freud's story of woman was retold in England and later in France, to split along the same axis of body and shadow outlined by Montaigne. In England, the Jones–Klein nexus of object-relations and concentric female sexuality centers around the self-sufficiency of the maternal phallic body. Here all future splits and divisions refer back to the corporeal origins of what might be called an instinctual, feminine subject, which, it could be said, the little girls of Vitry sustain through the spectacle of performance and choric ritual. By contrast, the French Lacanian school and even its eventual feminist detractors, from Luce Irigaray to Michèle Montrelay, situate the incorporated virile, or 'part' object not so much in relation to facticity, to the essential status of the body *per se*, as in terms of the enigmatic status of its 'shadow', its signifier, that is, the Phallus and

28

those phantasms of guilt and reproach which belittle the ego in the site of incorporation.[3]

In reopening the case of the missing penis, I would like to use the prop of Marie-Germane Incorporated as a screen on which to project further variations of the wide shadow cast by the Phallus, especially as it figures prominently in feminist cônstructions of female subjectivity in film and psychoanalysis. I wish to establish in this essay an environment, something like a film, in which these reflections can be sustained on different but interrelated levels. Montaged on to the backdrop of Marie-Germane Incorporated will be visual and aural fragments from two films by Yvonne Rainer, *Kristina Talking Pictures* (1976) and *Journeys from Berlin/1971* (1980). Mnemonic specters of these fragments, to be described at the moments of their invocation, will be screened like rear and side projections. In the foreground will be a discussion of two specific psychoanalytical theorizations which share the challenge of reshaping their contrasting Lacanian and Kleinian foundations to accommodate the female difference occluded by phallic posturing. It is in this context that I wish to juxtapose Kaja Silverman's cinematic account of female narcissism, in her provocative book *The Acoustic Mirror: The Female Voice in Psychoanalysis and Cinema* with the differing description of cinematic incorporation espoused by yet another Marie, one with the proper name of Torok.

IDANTIFICATION

But first a few introductory words about Maria Torok, her essay, and its relation to Marie-Germane Incorporated. Although Torok is known primarily for her later work with Nicolas Abraham, her essay, 'La signification de "l'envie du pénis" chez la femme' (Torok 1987: 132–71), marks her as an influential forerunner of the French feminist psychoanalytical movement of the seventies. This essay was included in the 1964 Payot collection edited by Janine Chasseguet-Smirgel, *Recherches psychanalytiques nouvelles sur la sexualité féminine*.[4] While the collection itself turns to Klein to reexamine the Freudian theory of female sexuality, Torok's essay is singled out in Michèle Montrelay's review of the book for its stress on virtual subjectivity in contrast to Kleinian biological essentialism.[5] I hope to demonstrate, by the conclusion of this essay, how vital the link which Torok inserted between the seemingly incompatible positions of the followers of Klein and Lacan continues to be.

Torok's analysis of penis envy in women turns around the case history of a patient named Ida who had developed a phobia regarding the two related economies of sex with her husband and her unspecified work. I will not dwell on the coincidental fact that the patient's name, I/da, could be said to encrypt the game which Freud suggests

foregrounds 'Ida'ntification; that is, the game of *Fort/Da*, in which the *Fort* signifies the narcissistic ego (*I*) always split by its specular relation which lies 'there', *Da*.[6] But I will stress the uncanny way in which the case history of I/da is marked by narrative accounts which could be said to resituate the enigmatic fantasy of Marie-Germane into the more contemporary arena of female performance, the space of film. As a sort of prologue to the enigma of female subjectivity as theorized from the realm of cinema, I now would like to recount a fragment from one of Ida's sessions with Torok:

> I dreamed that night. It was like a film. Also like going to the office. Wearisome and pleasant. There was an arena. . . . The lion should have been inside, but, in fact, he was on the outside. He was running, running around the arena. . . . I was with a friend and I asked him to protect me. I was beside him and we were running as well. The lion was running in the same direction as us. He was like a man. How odd. I turned around and saw that he was doing leaps like a dancer, he was doing splits in the air . . . you know I always thought that it was dead in me, quite dead. And then, now, I felt something . . . that my vagina was responsive. It's astounding. I knew that I would be able to feel pleasure! Before, I was very frightened. Now, 'it' is coming. I can't be afraid. Certainly. I feel that it is going to come. That it's already there.
>
> (Torok 1987: 155)

My aim in citing this fragment is to establish a transhistorical link between the popular cultural fantasy of Marie-Germane and its disjointed traces which figure so prominently in the dreams and memories of Ida. But at issue here is less a thematic emphasis on the common traits between Ida and Marie-Germane – from the fantasy of the phallic effects of female dance and performance to their attendant prohibition – than the cross-cultural mapping of female identity within the mixed parameters of performance, mirroring, and exhibition – feminine fantasy-borders perhaps associated in the sixteenth century with choric ritual and dionysian excess but more recognizable in the twentieth century as the scene of projection and subjection common to the theatres of cinema and psychoanalysis.

Indeed, I cannot help but imagine that Yvonne Rainer might have incorporated bits of the case history of Ida in constructing her character, Kristina, the female lion-tamer who survived the Holocaust to become a choreographer in New York City (owing to the combined influence of Jean-Luc Godard and Martha Graham). *Kristina Talking Pictures* is a film that maps out the desirable fantasy of female self-control on the topography of phallocratic oppression. As B. Ruby Rich sums up the dilemma posed by the film:

the image of the lady lion tamer is a charged one, crying out to us immediately on the level of metaphor: the lady in a cage, the woman in danger, Daniella in the lion's den. She's the supreme embodiment of the paradox of the public persona: invulnerability endangered. . . . Though Kristina has tamed the wild beasts, her conquest of the physical world cannot help her escape a woman's fate of emotional risk. The lesson posed by the Beauty and the Beast fable is an enduring one: danger may be posed as a lion but will be revealed as a man.

<div align="right">(Rich 1989: 11–12)</div>

I wish to note that I cite Rich not merely to suggest that Kristina's mate, Raoul, is the double of Ida's unhelpful partner who fails in his promise to protect her from the lion. Rather, I mean to emphasize that the constitution of female subjectivity, from its control to its pleasure, is intricately related in these narratives to woman's ambivalent historical incorporation of the phallic tale as it masquerades as female *jouissance*.

Although I will soon turn to feminist readings of psychoanalysis and film to develop such a broad claim, I now wish merely to complicate the rear-projection of the woman with lion by introducing into this chapter some curious bits of disynchronous soundtrack. First comes the female voice-off which opens *Kristina Talking Pictures*:

I almost dared to breathe. Is it finally ending, this crab-like groping along the bottom? I almost don't believe it, but it must be so. I've dared not focus directly upon that possibility for the past few days. I keep telling myself that if I look directly into the light I'll be thrust back to the bottom. You heard me. I mean, those depths wherein the body turns to gelatin and the brain lies in collodial helplessness, listening to its own muffled cries. Now the single bright shaft angling towards me from above remains fixed and clear. So I know I'm rising, or have started to rise, to the foreseeable surface. 'You're like an old fashioned diver', she used to tell me. 'You hit the bottom and bounce back.' There was almost no bouncing this time. A scuttled diver doesn't bounce. Yet a familiar excitement is rising with me, like the brightness of imminent discovery.

<div align="right">(Rainer 1989: 98)</div>

Now imagine this uncanny tale as being interwoven with bits of another soundtrack spoken by a different female voice that narrates this fragment from the case-history of Ida:

I had a dream: people are dancing, I agree to dance, then the room becomes an amphitheatre, I am sitting down. Then the amphitheatre changes into a kitchen. A woman offers me a crab, something gelatinous, slightly disgusting for me to eat. I hesitate. Then I

<div align="center">31</div>

accept. I cut off a little bit of it and give her back the rest. . . .
Everyone belittled my father, I was the only one to love him. When
you get down to it, my mother must have been under the influence
of her parents. . . . That woman . . . what stories she could tell
about my husband! . . . I dreamed that I had binoculars, and then
my baby had a little detachable penis, one could remove it, put it
back on, handle it.

(Torok 1987: 160)

To this voice-off linking Ida and Kristina, dream and dance, crab-eater
and crab-walker, mother's desirable voice and mother's ambivalent
story, single bright shaft and little detachable penis, add ongoing side-
projections of footage of the two aerial trackings, one circular (figure
2.2), the other linear (figure 2.3), interspersed throughout Rainer's film
Journeys from Berlin/1971. I again turn to B. Ruby Rich for description of
this footage:

The first shows Stonehenge, mute mysterious witness to pre-
history, interpreted sardonically as standing for 'flight, romantic
agony, futility of effort, history as impenetrable'. The second, man-
made, is the Berlin Wall. Not one unified structure at all, but a
series of barriers laid end to end across rural and urban landscapes,
dividing the natural terrain with political rigor. The circle of stones
is an analogue for the psychoanalytic session, that circling and
probing of essential mysteries removed from time, space, and
social context. The wall dividing east and west, in turn, is an
analogue for the march of history as embodied in the terrorist
debate and, more graphically, in the rolling titles detailing the
history of state repression in Germany. . . . The human psyche
must somehow relate to the social body politic. Psychoanalysis
must be made to acknowledge history.

(Rich 1989: 19)

In viewing this footage shot from the vantage-point of a roving heli-
copter, the spectator might add to Rich's somewhat reductive, dialectical
description the attendant fantasy of woman's common relation to both
scenes. The two sets of aerial panoramas share the ambivalence of the
omniscient, tracking shot embodying both distance and contemplation.[7]
While Stonehenge, to focus on one site, can be seen by Rich to signify its
removal from the mysteries of history, it can be connected just as
convincingly by Jan Dawson 'with monolithic power systems and their
architectural expression' (1980: 197). Both trackings, moreover, include
repeated shots of intersecting divisions, boundaries, and paths, both
circular and linear – shots which trace the cultural markings of the
labyrinth, that mythological site portrayed by Mulvey and Wollen's

Figure 2.2 Yvonne Rainer, *Journeys from Berlin/1971*: Stonehenge.
(Courtesy: the artist and Zeitgeist Films)

Figure 2.3 Yvonne Rainer, *Journeys from Berlin/1971*: Berlin Wall.
(Courtesy: the artist and Zeitgeist Films)

Riddles of the Sphinx as a charged cultural signifier of the enigma of woman.[8] But rather than divide one site from another, say nature from culture, the primitive from the contemporary, West from East, these shots track the logic of the trace as but signifiers of enigma itself. Stonehenge itself is shown, as the film gradually brings it into perspective, to be marked by enigmatic traces of graffiti that disturb the privileged status of the site, whether taken as a mystery of history or as a symbol of monolithic power. What Derrida terms 'a track in the text', the trace

> is not only the disappearance of origin – within the discourse that we sustain and according to the path that we follow it means that the origin did not even disappear, that it was never constituted except reciprocally by a nonorigin, the trace, which thus becomes the origin of the origin'.
>
> (1976: 61).

The track of the trace, materialized by Rainer through the camera's ambivalent omniscient perspective, is compounded in *Journeys from Berlin/1971* by an intruding specter that repeatedly disrupts the aerial footage of the Berlin Wall. Protruding in and out of the lower frame of these aerial trackings is the unwelcome pontoon of the helicopter (figure 2.4), a fetish figure not only resembling the filmic apparatus of the sound boom used conventionally to guarantee the entrapping synchrony of female voice and image but also corresponding to the figure disrupting a much earlier portrait of colonial tyranny. This would be the anamorphic skull that so seized the attention of Lacan when he viewed Holbein's *The Ambassadors*.[9] These contrasting tracks combining the traces of labyrinth and phallus may well summon the spectator to speak Rich's slogan somewhat differently. Perhaps it could be claimed that history is what should now call upon itself to acknowledge psychoanalysis, to dwell on the varying ways in which the social body politic always has been modeled on some type of mapping of the human psyche. In terms of the procedures specific to psychoanalysis itself, Jean Laplanche asks

> what type of presence of oneself to oneself is inaugurated or, at least, enticed by psychoanalysis? Does psychoanalysis usher in a new mode of such presence, and in what sense can one also say that such presence of oneself to oneself is mediated, necessarily perhaps, by the other?
>
> (Laplanche 1981: 41)

These mixed fragments from the films of Rainer and the fables of Ida fit particularly well into the female trajectory of psychoanalysis and cinema traced by Kaja Silverman. The case-history of Ida is especially well suited to Silverman's Lacanian approach, by contrast to the

Figure 2.4 Yvonne Rainer, *Journeys from Berlin/1971*: helicopter pontoon. (Courtesy: the artist and Zeitgeist Films)

differing, post-Kleinian strategy of Torok, which I will pick up later. Especially as Ida stands enveloped in the mixed-media framework of the preceding narrative sequence, she matches almost to the letter ('I') Silverman's inscription of femininity in three conditions of the Lacanian account of the subject: castration, subordination to the gaze of the cultural Other, and 'discursive interiority'. The first, castration – that is, the subject split by the signifier of desire for the unrecoverable object of plenitude ('l'objet petit (*a*)') – surfaces throughout Ida's tale, from the obvious phantasm of the detachable penis to Ida's account of the threatened castration of her own silky arm:

> At the convent . . . there were no mirrors at all. I was never able to look at myself in a mirror. . . . At the convent, I wasn't permitted to wash myself all over. I mean you had to do it piece by piece. It was ridiculous. I never looked at myself down there. How odd. When my arm falls from the bed between the wall and the mattress and touches the carpet, it's silky and soft down there, even though I have the impression that someone ventures to cut or bite it.
>
> (Torok 1987: 162)

This displacement of the threat of castration as a contrasting substitute

for the virtually whole mirror-image merely negates the reality of the second condition marked out by Silverman, subordination to the gaze of the cultural Other. The narcissistic lure of the complete, mirrored gaze is evoked by Ida's mournful account of the missing mirror as well as by her admission, in another session with Torok, of her primal exhibitionism: 'When I was a young girl, I wanted everyone to look at me, to fall in love with me. To be seen, to be watched. That is how one becomes an actress' (ibid.: 161). This exhibitionistic drive to be appropriated as image also constitutes what Lacan understands as the subjective reality of being contained in vision, of being unable to escape seizure in the look of the Other, of being 'photo-graphed' by the Other. What Lacan calls the 'screen' collapsing the dual constitution of subjective image as narcissistic and exhibitionistic comprises the paranoid theatre scenes in which Ida joins Rainer's Kristina as a schizo-subject, oscillating between the positions of spectator and spectacle. The third condition of the subject, 'discursive interiority', that is, insertion into a preexisting symbolic order, prevails throughout Ida's accounts, from the imagined, negative legacy of the mother's parents and the prohibitions of the nuns to Ida's frustrating, semiotic entrapment in the theatres of cinema and psychoanalysis. Indeed, in recounting her fear of pleasure itself, she acknowledges that even her somatic sensations are 'already there', always already there, that is, only as the figuration of the psychic play of discursive interiority. As the Girl's Voice in *Journeys from Berlin/1971* sums up this condition:

> Everything I've written has been put down for the benefit of some potential reader. It is a titanic task to be frank with myself. I fear my own censure. Even my thoughts sometimes appear to my consciousness in a certain form for the benefit of an imaginary mind-reader. And strangely enough, *I* am that reader of these pages; *I* am that reader of this mind. I have very strong impressions of my childhood 'acting'. Up to a few years ago, whenever I was alone I would 'perform'. I don't think I did anything unusual or dramatic at these times, but the things I did do I did with the thought in mind that I was being watched. Now this reaction is becoming more and more unconscious, having been transmitted to my actions, speech, writing, and my thoughts.
>
> (Rainer 1989: 161)

I should add that Silverman qualifies her brief summary of these conditions in a way that is crucial for the discussion to follow. These conditions work in the Lacanian system to structure the subjectivity of both male and female, even though, as Silverman adds, their disavowal and projection serve in large part to define masculinity. So what might be understood to pass for femininity, from castration to visual

subordination, is actually constituent of all subjectivity. Or, put other-
wise by Silverman, what is pathological for the male subject represents
the norm for the female subject (1988a: 155).

It is in this context that Silverman adds a fourth dimension to the
phallic model which is crucial to sustaining the femininity inherent in it,
that of the repression of the girl's negative Oedipus complex, the
repression of her desire for the mother. Although such repression is
suffered by the boy as well as the girl, it provides that essential window
for the girl's linguistic sustenance of narcissistic identification and eroti-
cism (it also highlights the different stakes of femininity for the male and
female subjects). In reading against Freud to argue for a stronger pos-
ition of female narcissism, Silverman focuses on that small aperture of
female identification and eroticism potentially open at the stage of the
negative Oedipus complex. This is the period, she writes,

> after the little girl's separation from the mother – after pre-
> Oedipality – but before the onset of the positive Oedipus complex
> during which her identity is formed through the incorporation of
> the mother's imago. This identification would seem to coincide in a
> very exact way with what Freud mistakenly, in my view, describes
> as the phallic phase, and indeed to be responsible for the girl's
> aspiration toward activity.
>
> (Silverman 1988a: 152)

In linking the child's momentary identification with the mother to an
identification with activity as well (an identification said to be shared by
children of both sexes), Silverman emphasizes the mother's early role as
an agent of discourse and as a model for the child's linguistic identifi-
cation (ibid.: 100). This stress on maternal activity also allows her to
question the primacy for the girl of the subsequent third element of the
oedipal relation, that troublesome rival the father. In his place, she
wishes to insert a term more central to the early libidinal economy of the
daughter. This would be the fantasy of 'the child whom she both wishes
to give to the mother and to receive from her' (ibid.: 153). One aspect of
this feminized tertiary, which could be said to be especially promising
for a heterosexual, feminist revision of Freud, is that it projects, in
Silverman's words, 'a three-generational community of women' (with
the provision, I suppose, that one can assume, along the lines of female
narcissism, that the birth gift projected by the infant is necessarily
female). It is partially through this fantasy of female exchange that
Silverman commits herself to what she calls a 'necessary reference to
biological identity' (ibid.: 148).[10]

While such a promising reading may appear to allow for the perma-
nent closure of the gynaeceum doors, it actually provides for only a
partial closure, at best, of the phallocentric space. If anything is clearly

foreclosed by traces of female narcissism, it is the space outside of the gynaeceum. For Silverman is quick to stress that her theoretical paradigm of biological identity 'closes off the pre-Oedipal drama both as an arena for resistance to the symbolic and as an erotic refuge' (ibid.: 123). Running counter to both Irigaray's critique of Lacan and Klein's much earlier psychoanalytic dismissal of phallocentrism, these remarks incorporate the Phallus directly into the discursive field of female narcissism. This is because the subject's relation to her body is lived only through the mediation of heterosexual discourse, thus bringing, so Silverman concludes, 'the homosexual axis of mother and daughter fully within symbolic castration and lack, and so renders it incapable of leading to any full and final satisfaction even if the incest taboo could be mounted' (ibid.: 123). Now we can see how female narcissism surfaces as a shadow figure of the Phallus, of castration, which means, as Jacqueline Rose describes its place in the Lacanian system, that 'the child's desire for the mother does not refer *to* her but *beyond* her, to an object, the phallus, whose status is first imaginary (the object presumed to satisfy her desire) and then symbolic (recognition that desire cannot be satisfied)' (Rose 1986: 62).

MELANCHOLIC VICISSITUDES

Just how much this reference *beyond* the mother highlights the different stakes of the phallus for the girl and the boy (the one who 'is' it and the other who 'has' it) is made especially evident by feminist discussions of another psychological state understood to harbor and dramatize the symptom of the girl's repressed desire for her mother. I am alluding to the condition of melancholia and how it has been said to relate to the constitution of female subjectivity. It was Irigaray's book *Speculum of the Other Woman* (1985a: 66–73) which drew prominent attention in the 1970s to the issue of female melancholia. Irigaray emphasizes the parallel of the condition of the female offspring of the debased mother to that of the melancholic, full of self-reproach, self-abasement, inhibition of activity, and loss of the capacity to love. But Irigaray is quick to qualify this analogy by pointing to the gender imbalance inscribed in the Freudian terrain of melancholia. Since physical castration devalues the mother and deprives the girl of anything primary to lament, Irigaray charges that Freud has left the scarred female subject not even with enough narcissistic reserves to sustain melancholia (actually 'anaclitic' reserves might be a better way of phrasing it, since the problem stems from Freud's positioning of woman as one who can only love narcissistically and not anaclitically, as one deprived of the maturation of secondary narcissism inscribed in object-relations). This cuts the female off from the sublimational benefits of the super-ego, which allow the

subject facing loss to stabilize itself through the replay of the hostility directed against the devaluation of the original erotic object. It is this process of the potential, albeit perilous, dissipation and resolution of the erotic energy concentrated on the lost object that plays, so Freud realizes in *The Ego and the Id*, a frequent role in the formation of the character of the ego (1953–74: XIX, 28–39). This is the role that Freud deems deficient in the development of girls who are left, as Irigaray complains, only with the primary outlet of hysteria.[11]

However, Silverman's scheme rights the scales of gender imbalance so that woman might have her melancholia without her hysteria too. But this is possible only as long as the girl enters the positive Oedipus complex not through Freud's ocular and physical castration but through 'symbolic castration', that is, 'through aphanisis of being and separation from the mother' (Silverman 1988a: 156). This would provide theoretically for the period of the daughter's desire for and infantile identification with the mother, allowing for the initial accumulation of the girl's narcissistic and anaclitic reserves. It is following this convergence of object-choice and narcissism, when the mother undergoes devaluation during the subsequent castration complex (which, I should stress, Silverman positions for the girl, by contrast to Freud, after the oedipal moment), that the girl then displaces her desire on to the father. The object of melancholic incorporation, according to this tempered logic of the positive Oedipus complex, is the daughter's virtual relation to the mother whose devaluation is the source of the hostility which the subject then directs on to itself under the influence of the death drive and the supervision of the super-ego.

In a significant sense, this compelling and persuasive account provides for the female subject's mediated enunciation of pre-individuated *jouissance* signified as unrecoverable by the Phallus. This position seems to provide a mechanism for the kind of entry of *jouissance* into female speech which has recently been argued by Judith Butler to be a critical imperative for the feminist project. In pondering Lacan's nostalgia for the lost fullness of *jouissance*, Butler reflects on how such nostalgia casts its shadow over the phallic system: 'that we cannot know that past from the position of the founded subject', she writes, 'is not to say that that past does not re-emerge within that subject's speech as *fêlure*, discontinuity, metonymic slippage . . . the prejuridical past of *jouissance* is unknowable from within spoken language; that does not mean, however, that this past has no reality' (Butler 1990: 56). In a fascinating 1984 essay, 'La troisième dimension du fantasme', Jean-Michel Ribettes situates such slippage in the gap between what he calls 'the two modalities of *jouissance*: as fantasy in the guise of pleasure, as symptom in the guise of displeasure. . . . This function of *jouissance* attached to the fantasy is what permits Freud to give primordial masochism and the death drive

their place in psychoanalysis' (Ribettes 1984: 187). It is a similar re-emergence of *jouissance* as slippage that seems to underlie Silverman's gestures to the fantasy of a non-essential but 'necessary reference to biological identity' and which, I might add, also surfaces in the procedure of incorporation as a sadomasochistic symptom.

Still, it is the complex and sometimes underdeveloped way in which Silverman qualifies this provision that diminishes her revision of Freud's account of the missing penis. Regarding the rise of melancholia, Silverman writes that 'with the advent of the castration complex, the mother would undergo a devaluation, and the girl would be encouraged to displace her desire onto the father' (Silverman 1988a: 156). She bases the emergence of female melancholia on the following claim: '[The girl] would at the same time feel enormous cultural pressure to continue to identify with the mother, and it is here that melancholia enters the picture' (ibid). Taking the lead from debates over the cinematic gaze and its revision in feminist film, Silverman develops this crucial assertion of *cultural pressure* in view of the hypothetical case of the female melancholic who, much like the beleaguered heroine of classic film, is confronted by 'the rigorous system of internal surveillance with which the female subject so frequently torments herself' (ibid.: 157). (It is not insignificant that Silverman undercuts the credibility of this hypothesis by arriving at it in the wake of an unqualified substitution of female for male pronouns in Freud's account of the melancholic.) To ponder the implications of such internal surveillance, it might be valuable to consider the comparative cultural pressures confronting the female subject on the level of the symbolic, which is to say, *the cultural pressures mediating the female's identification with the mother*. These would be signifiers of the kinds of historical pressures, to use Silverman's terminology, that coerce and mold the subject's relation to her body through the mediation of discourse.[12]

The most pressure-laden, cultural signifiers from within and without the psychoanalytic institution remain to be inscribed in the fascination with the fetish targeted by Maria Torok in my introduction to this chapter. She writes that

> it is the lure of the phallus that opens the way to the institutional relations of the two sexes. The entire problem of missed identifications is camouflaged by means of the fetish behind active and passive fascination. . . . One understands the profound import for man to promote 'penis envy' in the other sex and to transmit it in his institutions.
>
> (Torok 1987: 169–70)

For a cultural corollary of this fetishistic reduction of woman, Torok turns, as Sarah Kofman does almost two decades later, to the Biblical

myth of Eve, the originary Judeo-Christian mother whose intimacy with the serpent reflects the divine decree of penis envy.[13] Being part of the body of Adam, Eve is simultaneously his thing (his servant) and his attribute. If any cultural pressure is inscribed in this originary maternal figure, it must be the legacy of the 'mutilated', 'dependent', and 'envious' condition of the daughter (Torok 1987: 170). Or, put another way by Constance Penley, if the pressure of *culture* is likely to lead to any kind of mediation, it must be through the route of the phallus. For 'the phallus, as a sign that belongs to culture rather than to nature, is itself the sign of the law of sexual division' (Penley 1989: 76).

This is how even female identification remains anchored in the logic of the fetish; how, in Silverman's own words, 'it must be sustained in the face not only of a general cultural disparagement, but of the most relentless self-castigation as well' (Silverman 1988a: 158). Nevertheless, this same insistence on the incorporation of the relentless social pressures wrought on the mother Imago is what leads Silverman away from a constructive account of how female subjectivity, like that of the male, is inscribed in (leans on) the *active* convolutions of the death drive. Citing the extreme result of suicide, Silverman discounts any of the potential benefits of the melancholic devaluation of the mnemonic traces of the mother when symbolized as 'mutilated', 'dependent', and 'envious'. Instead, she insists that melancholia works only unproductively to map on to the body and mind of woman the worst effects of the positive Oedipus complex.[14]

However – and this is where things become difficult – Silverman does not discount altogether the procedures of incorporation. In and of itself, incorporation remains for her a necessary mechanism for the expression of the negative oedipal relation – 'since identity is unthinkable apart from incorporation' (ibid.: 157). Because she denies that the process of devaluation ever reaches a conclusion, it also would appear that even melancholia could play a structural role, since 'the lost object is not so much surrendered as relocated within the subject's own self – which is, of course, precisely where the mother's imago must be situated if the girl is to identify with her' (ibid.: 156–7). This would also be in keeping with Freud's alignment of melancholia and identity formation in *The Ego and the Id*. Still, it is the status attributed to the Imago that distinguishes Silverman's argument from both her Lacanian and her Kleinian counterparts. For in contemplating the source of melancholic sadism – the devaluation causing the female subject's confusion and subsequent self-torment over 'what' has been lost – Silverman shifts her attention away from analyzing the traces of an originary fracture of mother-daughter identification to a foregrounding of the logic of castration:

While I do not mean to suggest that the girl's desire for the mother

is without ambivalence, or untempered by hatred, it does seem to me that the real force of the hostility which she directs against herself after the conclusion of the negative Oedipus complex has more to do with the devaluation of the original erotic object than with anything else. In effect, the female subject is punishing the mother (and consequently herself) for being inferior and insufficient, unworthy of love.

(ibid.: 158)

It is thus a devaluation of the object, not the intrinsic splitting and ambivalence of the virtual relation itself, that *causes* female melancholia. If the patient is to be cured, concludes Silverman, 'it will most certainly be through a revival or reconstruction of the negative Oedipus complex' (ibid.: 159). A cure, then, would open the window to a repressed self-sufficient female identification which apparently would not be disrupted by the split of desire and symptom discussed above as comprising the *jouissance* inscribed in the economy of castration. The negative Oedipus complex must be understood to work affirmatively in this context as a 'regressive fantasy', as 'an after-the-fact construction that permits the subject who has already entered into language and desire to dream of maternal unity and phenomenal plenitude' (ibid.: 124). Even though 'the mother emerges as an erotic object for the daughter only after the latter has been separated from her' (ibid.: 160), this dream of 'a psychic "Philosopher's Stone"' would have the practical effects of transforming normative female subjectivity. It also provides 'the model for a different kind of cinema' (ibid.: 183), one positioning the negative version of the Oedipus complex against the positive one.

An exemplar of such a cinematic model is said to be *Journeys from Berlin/1971*. As Silverman reads this film, it clearly articulates the stakes of the disassociation of female sound and image – 'the freeing up of the female voice from its obsessive and indeed exclusive reference to the female body, a reference which turns woman – in representation and in fact – back upon herself, in a negative and finally self-consuming narcissism' (Silverman 1990: 315). This formula provides the conceptual mechanism for the film's alignment of classical cinema's internalization of the specular and auditory regime with a prescription of female performance (à la Hayworth, Goldman, Wyman) constituting a masochistic glamorization of pain, renunciation, and death. In other words, the rigorous procedures of over-seeing and over-hearing are so severe that they leave the performative female subject with no capacity for struggle, often resulting in suicide. Standing in contrast to these entrapped, celluloid heroines are two other sets of women in *Journeys from Berlin/1971* whose bodies bear marks of the discourse of suicide. But at issue is whether they are more different than analogous. While the failed suicide of the

film's psychiatric patient (Set 1) is certainly analogous to the political deaths of its revolutionaries (Set 2: Meinhof, Zasulich, Figner, Berkman), the latter are also deaths whose potential rationalization as 'suicide' is critiqued by Rainer for representing 'State Psychiatrification.'[15] By so choosing not to distinguish between the film's contrasting layers of public and private discourses on political death and suicide, Silverman turns her reading away from the related infelicities of political and analytical struggle. Instead she puts all of the pressure of her reading on the female psychoanalyst's quotation of the passage from Freud's 'Mourning and Melancholia' that discusses the extreme case of melancholic suicide deriving from a regressive narcissism gone mad.[16] It is in view of this tiresome, melodramatic end that Silverman somewhat surprisingly identifies melancholia as the trait shared by the female voices resonating throughout Rainer's film. This is 'the melancholia', she writes, 'induced in the female subject by the positive Oedipus complex, which holds her to an identification with the mother even as it obliges her to withdraw her libidinal investment from that first and most important of erotic objects' (Silverman 1988a: 178). Silverman then appears to engage in an open disavowal of the mechanism of incorporation when she somewhat surprisingly reads against the contrasting grains of Journeys from Berlin/1971 to praise the film's plurivocal conclusion as constituting an unqualified denunciation of the mechanisms of melancholia:

> In its final moments it involves its female speakers in a collective repudiation of melancholia – of its self-hatred, and of its 'failure to imagine a world' outside. It also broaches, in a tentative and fragmentary manner, the possibility of moving beyond that psychic condition toward externally directed action – the possibility, that is, of political struggle.[17]
>
> (ibid.: 178)

This endorsement of a psychic, that is, filmic, praxis picks up the call to artistic arms already voiced in the preceding chapter of The Acoustic Mirror: 'once we have recognized that unconscious desire is far from monolithic – that it is divided between at least two very different fantasmatic scenes – then it becomes possible to think of all sorts of discursive and relational strategies for activating the fantasmatic scene which corresponds to maternal desire' (Silverman 1988a: 124). Being careful not to opt for presence and immediacy, cinema thus masquerades as the mirror-screen of the undisturbed maternal relation.

LIKE A FILM

Still, it remains unclear just how film can mimic the unconscious relation as unified and plenitudinous. Within the Lacanian trajectory, any 'dream' of a maternal Philosopher's Stone would likely be held in check by what Slavoj Žižek calls the paradoxical intermediate role of fantasy: 'it is a construction enabling us to seek the maternal substitutes, but at the same time a screen shielding us from getting too close to the maternal Thing – keeping us at a distance from it' (Žižek 1989a: 120–1); whereas the model espoused by Silverman for a different kind of cinema appears to require film to be constructed as if the screen could be viewed (by woman) from the other side. It would have to depend on a kind of feminist reversal of Lacanian apparatus theory, in which 'the screen is a mirror' of the negative instead of the positive Oedipus relation with maternal plenitude being the Thing. Such a notion would appear to assent to an equivalence between the feminist image and/or voice and the female spectator allowing the subject to embrace the fantasy as a unified representation of its desire for the (M)other.

That Silverman even appears here to approach the fantasy of such an adequation is somewhat surprising, since she has shown herself more recently to share the view espoused by Joan Copjec that 'film theory' may have missed Lacan's point.[18] Copjec argues that it is imperative to reverse the apparatus relation, 'the screen is a mirror', so that it reads, 'the mirror as screen'. This would properly represent the subject's identification with the gaze as 'the signifier of the lack that causes the image to languish' (Copjec 1989a: 70). The effect of such representation, insists Copjec:

> is not a subject who will harmonize with, or adapt to, its environment (the subject's narcissistic relation to the representation that constructs it does not place it in happy accord with the reality that the apparatus constructs for it). The effect of representation is, instead, the suspicion that some reality is being camouflaged, that we are being deceived as to the exact nature of some thing-in-itself that lies behind representation. In response to such a representation, against such a background of deception, the subject's own being breaks up between its unconscious being and its conscious semblance.
>
> (ibid.: 71)

A fragment from one of Ida's dreams provides a case in point. Consider for a moment the transversality of spectacle and gaze, of cinema and psychoanalysis, experienced by Ida, the spectator/spectacle of this (un)familiar passage:

It was like a film. . . . There was an arena. . . . The lion should

have been inside, but, in fact, he was on the outside. He was running, running around the arena. . . . I was with a friend and I asked him to protect me. I was beside him and we were running as well. The lion was running in the same direction as us. He was like a man. How odd. I turned round and saw that he was doing leaps like a dancer, he was doing splits in the air . . . you know I always thought it was dead in me, quite dead. And then, now, I felt something.

(Torok 1987: 155)

Doubly inscribed here on the somatic and psychic screens is a troubling break between conscious being and unconscious semblance, between subjection and projection. But, as Ida so aptly puts it, this break can only be *like a film*. Or, stated conversely, the filmic screen can only be *like a break* faced by the cinematically habituated viewer, whether Ida herself, Maria Torok, Kaja Silverman, or their readers. This break, inscribed on the line of the shifting analogy, 'like a', is the closest the viewer comes to the dream of a plenitudinous primary and/or secondary relation. Or, put simply by Jean Laplanche, 'this "like a" is no longer like what it is' (Laplanche 1989: 53).

But it is probably less the agency of contemporary feminist filmmaking itself than a foregrounding of the screen device that establishes the cinematic mirror not as a plenitudinous fantasy but as a split trajectory of unsteady reading and analysis. That this mixed scene of reading, one combining the screens of cinema and psychoanalysis with a charged likeness, might always already be endemic to classic as well as experimental film is brought home persuasively by Judith Mayne, who plots out both historical and current trajectories in her book, *The Woman at the at the Keyhole*.[19] For my part, I would like to situate this point within the fantasy frame of this chapter by turning to the film whose scenario corresponds to the likeness of the dream of the lion threatening Ida and her impotent man from within the cinematic arena.

I am thinking of Jacques Tourneur's 1942 horror film *Cat People*, starring the French actress Simone Simon, whose character bears not the name of the patient, Ida, but that of the site of her condition, Irena. In this film, Irena is consumed by the legend of her Serbian village that sexual arousal transforms women into large cats or panthers who then attack the male source of their desire. Irena meets her future husband, Oliver, at the zoo in front a cage containing the creature described by the zookeeper as 'an evil critter ma'am. Read your Bible. . . . Revelations, where the book's talkin' about the worst beast of them all. It says, "and the beast which I saw was like unto a leopard". Like a leopard, but not a leopard' (cited Linderman 1990: 76). Because Irena remains terrified of the fantasy that she too is like a woman, but not a woman, she refuses to

consummate her marriage. Later, when she fails to keep her appointments with Dr Judd, the psychoanalyst found by Oliver, the husband transfers his affection to Alice, the 'girl' at the office. Several episodes result from Irena's jealousy which convince all but Dr Judd that she does metamorphose into a panther. Dr Judd is then killed by Irena-the-panther when he tries to force 'analysis' by kissing his patient in the confines of her home. Injured by the doctor's sword, she then dies from a collision with the leopard which she lets loose at the zoo.

This film has received two very excellent and conflicting readings by Deborah Linderman and by Mary Ann Doane. Doane turns to this movie in *The Desire to Desire* to provide a striking example of the 1940s genre of medical-discourse films which capitalize on the tension between puzzled, male psychoanalyst and hysterical, female patient. Two major points of Doane's reading of this film are significant for understanding the ongoing construction of female subjectivity within the proximate arenas of film and psychoanalysis. The first regards *Cat People*'s commentary on the failure of the male psychoanalyst to sustain the barriers between rationality and irrationality, visibility and invisibility, which function as frequent markers of gender difference in psychoanalytic discourse. The second dwells on the relation of such mixture to the substitutibility of feline and feminine (a substitution also seen in the dream of Ida, in which the man-like lion bears the characteristics of the female-like Germane). Doane calls attention to Freud's essay 'On narcissism: an introduction', where he compares the inaccessibility and self-contentment of women entrapped in excessive narcissism to the charm of children and 'certain animals which seem not to concern themselves about us, such as cats and the large beasts of prey' (Freud 1953–74: XIV, 89). Doane stresses this linkage to foreground the analytic context of the film's comment on the inaccessible knowledge of female sexuality and its devastating effects on psychoanalytic authority. 'Because the implementation of psychoanalysis in the cinema is forcefully linked to a process of revelation, to an exposure of the answer to the text's hermeneutic question, it is', she writes, 'inseparable from issues of narration and the woman's access to language and vision' (Doane 1987: 52). As if providing the conclusion missing from Doane's reading, Linderman interprets this film as a mapping of cinema on to the failed project of psychoanalysis. Following a careful and fascinating analysis of Irene via Kleinian envy and Kristevian abjection, she maintains that the cinema itself carries on Dr Judd's aborted work and appropriates the screen image of Irena only to kill her, to 'abject' her:

> Hence the cinema is an institution which has ritual efficacy; for collective fascination, it calls up the horrors of the indifferentiate, of fusion and engulfment, of the old maternal imago, only to reject

(abject) them with all possible force. The cinematic ritual, in other words, operates to shore up the symbolic by applying to that frail order the greatest pressure.

(Linderman 1990: 83)

What is fascinating about this reading of cinema as the supplement of psychoanalysis is not merely how cinematic ritual is said, once again, to displace on to woman the frailty of the symbolic, but also, and much more significantly, how the symbolic displays itself through cinema as a ritual which always already needs 'shoring up'. So rather than favor one of the above readings over the other, I screen them together to exemplify the frailty of institutionalized ritual itself. For it could be said that having let the beast out of the symbolic bag, *Cat People* concludes with Irena continuing to roam free – like a leopard, but not a leopard.[20]

These same frailties screened as the path of the leopard, as the break-up of the composure of classic film, are exemplary of, but not necessarily new to, the experimental, feminist film strategy recommended by Silverman: 'the path leading away from fixed and hierarchical schematizations to a transversality of spectacle and gaze, diegesis and enunciation, character and viewer, voice "in", "off", and "over"' (Silverman 1988a: 183).[21] Rainer's *Journeys from Berlin/1971* not only experiments with voice but also foregrounds the screen device combining the habits of cinema and psychoanalysis. Throughout the film, variations of the screen mediate the representations of voice, camera, character, and narration. Denoting and disrupting the linearity of the narrative, the film returns sporadically, for example, to tracking shots of an industrial landscape filmed through the closed window of a moving train. But rather than merely gazing out passively at the no-longer-pastoral landscape, the camera and spectator are frequently turned back on themselves through the anamorphic reflection of light from the train's interior on the lower portion of the window, as if a trace of split vision. (figure 2.5). In similar sequences, the camera takes in scenes of the Bowery from behind a closed window whose voyeuristic distance is offset by the sounds of the traffic outside. Moreover, in a different strategy, used by Rainer throughout the sequences between patient and psychoanalyst, characters move about in the back of the loft so as to effect an ongoing split between the frontal movie screen of analysis and the 'rear projection' of dance movement stylized after the performances for which Rainer was known in the past. In these same scenes, the 'rear projections' of Rainer's past performances also are montaged on to the history of 'screen projection' itself when the figure of the psychoanalyst shifts back and forth from male to female to boy. For just as the performers retrace the steps of Rainer's past, the boy psychoanalyst stands out as an especially interesting figure of the screen memory of one influential

Figure 2.5 Yvonne Rainer, *Journeys from Berlin/1971*: train window.
(Courtesy: the artist and Zeitgeist Films)

trajectory of experimental, feminist film. The credits introduce the actor as the very same Chad Wollen who was conspicuously absent from his parents' earlier film, *Riddles of the Sphinx* (1977). Chad's absence is made particularly evident in *Riddles of the Sphinx* by the role of the son played by his conceptual stand-in, Kelly Barrie, son of Mary Kelly. Kelly Barrie was the toddler of the seventies who figured in his mother's feminist art project *Post-Partum Document* (1973–9), as the marker of motherhood, of the onset of the boy-child's Oedipus complex, and, most significantly, of 'maternal femininity'. This last is the condition of femininity which Mary Kelly calls 'the "ideal moment", in that the woman, in relation to her child, is constituted as the actively desiring subject, without transgressing the socially accepted definition of her as "mother"' (Kelly 1990: 56). Incorporated deeply into the lining of Rainer's film, then, are enigmatic traces of the projects of Kelly and Mulvey, still more configurations of the discourse of maternal desire.[22]

Also screened throughout *Journeys from Berlin/1971* is the split between the female and male account of the oedipal complex, the former desiring but suspicious, the latter knowing but anxious. This is made nowhere more apparent than in the middle of the female psychoanalyst's reading of the passage from Freud's *Mourning and Melancholia*, when the camera,

Figure 2.6 Yvonne Rainer, *Journeys from Berlin/1971*: screen door.
(Courtesy: the artist and Zeitgeist Films)

positioned behind her, tracks a woman in the background who walks through a swinging door and into the street. Rainer's spectator is then shown a close-up of the street scene beyond the receding exit; a close-up, that is, perceivable only through the literal *screen* of the swinging door (figure 2.6). It is this prolonged 'screen shot', moreover, that mediates and complicates the analyst's voiced-over recitation of the following fragment from Freud: 'the ego's original reaction to objects in the external world. In the two opposed situations of being most intensely in love and of suicide the ego is overwhelmed by the object, though in totally different ways.' Just such a difference between inside and outside, between narcissistic and anaclitic love, between love and death, even between male and female analyst is what is maintained 'under erasure' by the shot fixed by the tracks of the screen (and which complex montage works, I believe, to challenge Silverman's stress on the unequivocal role of female voice in the recitation of *Mourning and Melancholia*).

It is also the site of such a 'screening' that Rainer herself describes as the unresolved challenge of her filmic reflections on psychoanalysis, which, as she writes of her heroines, I find to be 'deeply skeptical of easy solutions and very self-critical, constantly looking for their own

complicity in patriarchal configurations' (Rainer 1987: 382). In reflecting on her conceptual practice, Rainer foregrounds the ambivalent complicity of her work's attentiveness to these same sorts of configurations. She admits that

> one does not have to probe very far into the psychoanalytic uses of Oedipus to find a phallocentric bias in both myth and theory. . . . The problem is that even as we employ these terms for describing and unveiling the workings of patriarchy, we implicate ourselves deeper into those very operations, as into a well-worn track in the forest. The very notion of lack, as proposed by Jacques Lacan, mirrors the prevailing cultural bias by privileging the symbolic threat of loss of the penis over the actual loss of the mother's body. Yes, I know that language is an all-important mediating factor and that loss of the breast predates the acquisition of language . . . Psychoanalytic hierarchies of sexual synecdoche are mind-boggling and, for psychoanalysis, irrevocable. For women, however, psychoanalysis can only define a site of prolonged struggle.
>
> (Rainer 1990: 195)

But instead of turning her back on the struggle, Rainer develops cinematographic strategies for foregrounding and engaging its complexity and ambivalence:

> What I'm talking about is a disruption of the glossy, unified surface of professional cinematography by means of optically degenerated shots within an otherwise seamlessly edited narrative sequence. Play off different, sometimes conflicting, authorial voices. And here I'm not talking about . . . finding a 'new language' for women. I'm talking about registers of complicity/protest/ acquiescence within a single shot or scene that do not give a message of despair. I'm talking about bad guys making progressive political sense and good girls shooting off their big toe and mouth. I'm talking about uneven development and fit in the departments of consciousness, activism, articulation, and behavior that must be constantly reassessed by the spectator.
>
> (ibid.: 196)

Just such a degenerated shot disrupts a glossy surface in one of the louder exchanges of *Journeys from Berlin/1971*. After shooting off her mouth about a shopping trip to Bloomingdale's following two days of love-making with Samuel Beckett, the Patient adds,

> And I can talk to you until *I'm* blue in the face all about modes of production and exchange, surplus value, commodity fetishism, and object-cathexis. But when the chips are down who do we find

Figure 2.7 Yvonne Rainer, *Journeys from Berlin/1971*: water cuts the frame.
(Courtesy: the artist and Zeitgeist Films)

in Bloomingdale's spending the sperm? . . . Samuel Beckett, god-
dammit, Samuel Beckett! And furthermore, my cunt is *not* a cas-
trated cock. If anything, it's a heartless *asshole!* (Rainer 1989: 153)

As if understanding the registers of complicity/protest/acquiescence to
be underdeveloped in this already overly complex exchange, Rainer then
doubles this discursive field of commodity fetishism, spent sperm, and
heartless assholes with an optically degenerating frame. Following the
patient's shouting declaration, 'it's a heartless *asshole!*' comes a shot of
the contents of a bucket of water being thrown from off-screen across the
frame in slow motion (figure 2.7). This brief sequence is totally out of
synch with the narrative continuity of this film, which systematically
grounds its new dialogue in an uncanny return to familiar tracking shots –
Stonehenge, the Berlin Wall, a mantelpiece full of objects, Apothekes on
Berlin streets . . . etc. By contrast, splashing water here resists figuration
by blending with, by becoming, the surface of viewing. And no matter
how much its imagistic texture may play off the context of the analytical
sequence which it disrupts, say as a watery inflexion of heartless
assholes, in one context, or as a signature of spent sperm in another
(foreshadowing the style of Andres Serrano), Rainer's degenerate

51

montage here demands constant reassessment by the frustrated analytic spectator.

SWALLOWING IT WHOLE

An analogous reassessment of the analytic actions of reading and mapping woman's access to language and vision also concerns the two feminist psychoanalytic readers who frame this chapter, Maria Torok and Kaja Silverman. The same struggle of mapping 'penis envy' brings them together and drives them apart. Sharing with Silverman the position that 'penis envy' is less a symptom of sickness than an index of narcissistic desire, Torok claims wistfully that '"penis envy" will disappear on its own the day the troublesome state of lack sustaining it is brought to an end' (Torok 1987:136). And I believe they would agree, as Torok puts it, that 'even though the idealized penis has no effective (or biological) existence, its counterpart for the subject – depression, the devalorization of self, rage – it does have an existence, and how' (Torok 1987: 138).[23] But while they also share the belief that incorporation provides a mechanism for filling the gap, they differ crucially both about the nature of incorporation itself and the extent of its occluded *jouissance*. For although both reflect on the intersection of narcissism and object-relations at the site of mother-daughter identification, Torok puts more pressure on both the fracture wrought by the tension of these early relations and on the inscription of this fracture within a feminine economy of pleasure and aggressivity. This fracture is inscribed not only in desire but, to as great a degree as is possible, in the 'sex' and pleasure of the daughter, that is, in the somatic symptom through which Freud links biology to the theory of the drives. For Torok joins Irigaray in working away from castration and penis envy *per se* toward the female acknowledgement of a different *case*, that is, the *case* of *jouissance* itself: the vessel, casket, crypt circumscribing the vaginal sensations recast as penis envy. When analyzed prior to the castration complex but, as Silverman would have it, always already on the threshold of the preoedipal – that is always already standing in the shadow of the Phallus – female narcissism is the signifier of multiple subject formations as well as of *jouissance* figured as the death drive in terms both of the daughter's pleasure and of her cultural production. This explains Ida's consternation over her doubled incapacity not merely to be seen as passive, to be looked at – that is, how one becomes an actress – but also, and more importantly, to perform actively as a woman in bed and at work – that is, how one's female actions disrupt the equilibrium of the phallic Eros.

The difference between the approaches of Torok and of Silverman thus has two dimensions. On one side is Torok's insistence that any narcissistic relation between mother and daughter of the sort privileged

by Silverman need account for the primary envy which does not devalue the mother but alienates her daughter owing to her ambivalent response to the mother's authority over anal eroticism. This is consistent, by the way, with Freud's assertion in *Mourning and Melancholia* that one striking feature of melancholia is 'derived from anal eroticism which has been torn out of its context and altered in a regressive sense' (Freud 1953–74: XIV, 252) – or, as we have heard Rainer's patient speak this relation, 'my cunt is *not* a castrated cock. If anything it's a heartless *asshole*!' What is envied and thus devalued, according to this partial Kleinian view, is not the eroticized 'object' but the heartless maternal acts (Imago) sustaining them. Primary identification with the mother, with her sexual and prohibitive powers, is thus marked by a lacuna which is then displaced on to penis envy. 'Penis-envy', writes Torok, 'appears as if a disguised demand – not for the organ and attributes of the other sex – but for her own desires for maturation and auto-elaboration by means of the en-counter of self in the conjunction of orgastic and identificatory experi-ences' (Torok 1987: 141–2). In this way Torok puts both prospective and retrospective pressure on the same intersection of object-relations and identification evoked but avoided by Kaja Silverman's nostalgic inser-tion of them in a virtualized, retrospective envelope. While Silverman contains this nexus in the frame of specularity through which the viewer compares the positive version of the Oedipus complex against the negative one, Torok stresses the psychoanalytic pressure of fantasy itself which cannot be seen so readily from outside of the screen.[24] (I might add that Torok's attempt to theorize the virtual break-up of maternal unity and phenomenal plenitude can be compared to other recent interpretations of the psychic traces of this early split, from André Green's discussion of the special case of 'la mère mort' and Julia Kristeva's broader extension of it into a matricidal drive, to Jean Laplanche's mapping of the death drive on to the 'enigmatic signifier' and Juliet Mitchell's current linkage of hysteria to the death drive and primary identification.)[25]

The other major difference between Torok and Silverman lies in their conflicting accounts of incorporation itself. Regardless of Silverman's gestures to the incorporated mother Imago, she tends to see incorpor-ation as primarily a masochistic business for woman. Thus, *Journeys from Berlin/1971* 'suggests that by taking into herself the power-relations which organize the existing cultural order, the female subject can never be anything but smoothly aligned with it . . . with those discourses which are dominant at any given moment' (Silverman 1990: 325). But while the political struggle of cinema is easily conceived as an action beyond melancholia, does not the foreclosure here of the incorporation of 'dominant discourses' position cinema as little more than a mystic supplement of the female's speaking cure, as only something like a

filmic exploration of the negative Oedipus complex? For is not the relation of female desire precisely what is sustained mentally, if not culturally, primarily via the discarded mechanisms of incorporation?

How incorporation functions for woman on a cultural level is suggested by Torok's mapping out of object-relations and psychoanalytical strategies which have transferential currency on the scene of cinema. I emphasize strategies because the reading of penis envy she provides in 1964 is most beneficial if graphed on to her complex writings in the years to come, which assume a further distance from an applied Kleinian approach (Abraham and Torok 1987).[26] On the least complex level, and the one most indebted to Klein, female penis envy is read by Torok, in 'La signification de l'"envie du pénis" chez la femme', as the displacement of maternal identification by the idealized penis (not 'a natural loss but the effect of a privation or denial') (Torok 1987: 138). The penis is received by the girl as the 'good' sex in contrast to the penile hand of the mother, which excessively cleans the anus or prohibits the masturbatory activity of 'the "touching oneself", the experience of "I-myself"' (ibid.: 144). The subsequent path from penis envy to genital fulfillment passes through an intermediary stage of 'the permitted fantasy, through which the desired child no longer has a sense of what it has ("n'aura plus le sens de ce qu'on a") but of what has been integrated in the becoming of life ("mais de ce qui vient à s'intégrer dans le devenir même de la vie")' (ibid.: 146). Rather than being subject to the torment of melancholia, whose significant feature is identified by Freud as the patient's inability to distinguish *what* has been lost, female penis envy could be said to function more constructively on the substitutional level of mourning. No longer possessing a clear picture of *what* it *has*, it is marked not so much by 'incorporation' as by 'introjection', as these terms are distinguished by Torok and her collaborator, Nicolas Abraham.

They understand introjection to correspond roughly to a procedure of narrative supplementation: words replace loss through which the presence of an object – initially the mother's breast, or in this case her hand – gives way through metaphorization to an auto-apprehension of its absence. An essential feature of Abraham and Torok's notion of introjection, distinguishing it from Lacanian language acquisition as the inscription of the Law of the Father, is the symbolic role of the mother, whose constancy is the necessary guarantor of linguistic signification. Through introjection, words are able to replace the maternal presence and give way to newer introjections.

But while this might explain the route to maturation followed by the boy, it does not seem to account for the girl's world of fragmented reality marked by a 'void', a 'lacuna in the subject in lieu of a vital identification' (ibid.: 143). This lacuna may be accounted for in the stuff of incorporation. It is in Torok's better-known piece of 1968, 'The sickness of

mourning and the fantasy of the exquisite corpse' (Abraham and Torok 1987: 229–51), that she works out, in conjunction with Abraham, the theorization of incorporation as the denial of the denial of loss (of the mother – and consequently, I suggest, of the girl's castration). Otherwise put, incorporation constitutes the refusal of mourning itself to the extent of censoring the inconsolability of loss, of dispensing with the painful procedures of psychic reorganization. 'In lieu of this relief outlet', she writes with Abraham in 'Mourning *or* melancholia', 'there will remain only to counter the fact of the loss with a radical denial – by feigning to never have had anything to lose' (Abraham and Torok 1987: 266). The result would be a 'phantom' installed by the ego in a 'secret crypt' where a camouflaged, hallucinatory world sustains a separate and occult life. 'Alive in this crypt, reconstituted from memories of words, of images, and of effects, lies the objective correlative of the loss as a complete person with its own topical structure, in the same way as the traumatic moments – real or imagined – that had rendered the introjection impracticable' (ibid.). What Torok and Abraham term 'cryptophoria' is the condition of not being able to do otherwise than bury a lost clandestine crime or pleasure by establishing it as a hallucination, a phantom, an 'intrapsychic secret'.

Cryptation is especially difficult to analyze, since the inaccessibility of the phantom constitutes itself in resistance to figural translation. It is marked by both *objectification* (what is undergone is not a wound to the subject but the literal loss [incorporation] of an object) and *demetaphorization* (taking literally what is understood figuratively). Even in her early essay 'La signification de l'"envie du pénis" chez la femme' Torok's conceptualization of the idealized penis bears very similar traits. The female act of masturbation and guilty introjection – she here uses the term, 'incorporation coupable' (Torok 1987: 143) – is abandoned for the sake of an exterior object, the idealized penis, which not only displaces the psychic wound with the literal loss of an object but also reads literally instead of figuratively. In addition, Torok emphasizes the work of camouflage assumed by objective realities which are invoked as 'generally inaccessible' objects of loss and lust. Such camouflage – or perhaps 'masquerade' would be a more appropriate term in the context of film – is so effective as a foil masking 'afferent' (encrypted?) inhibitions that only the machinery of analysis can soften its hold (ibid.: 135). While the link between these external objects and their incorporation had not yet been theorized by Torok in 1964, the theoretical mechanism already appears to have been in place for the smooth transition into the broader terrain of cyptophoria.

It is in terms of this latter work that Torok joins Abraham in stressing how easily the analysis of cryptation can be thwarted by the way incorporation feeds on 'anti-metaphor': 'Incorporation entails the

phantasmatic destruction of the act itself by which metaphor is possible: the act of putting into words the original oral void, the act of introjecting' (ibid.: 268). Here, on the axis of the phantasmatic destruction of the act of introjection itself, not (as concerns Silverman) on the level of the melancholic devaluation of the mnemonic, maternal trace, is where Torok finally situates, in 1968, the incorporation of female penis envy:

> As *language* which can only *signify* introjection (and not effect it), the fantasy of incorporation can enter into the most varied and contrary contexts: sometimes to signify a desire for impossible introjection (i.e. penis envy), sometimes to indicate that an introjection already took place (phallic demonstrations), sometimes to signal a displacement of introjection (denoting, for example, the oral zone when in fact another zone is sought).
>
> (Abraham and Torok 1987: 239)

What is curious about this notion of fantasy which can only signify introjection – whether in the guise of text or of image – is its strong affinity to more recent efforts to rethink the role of the signifier in the space of fantasy. In closing, I will mention only two: one from the realm of feminist film, the other from the scene of French psychoanalysis. As if performing a masquerade of closure, these examples return indirectly to the traces of Rainer's tracking shots of Wall and labyrinth which still haunt the margins of this chapter's work of conceptual montage.

Certainly it is not disruptive to the flow of this chapter that Yvonne Rainer equates her filmmaking more than once with some kind of process of incorporation, one sometimes only signifying introjection, but often marked by demetaphorization as well. In a 1976 interview with the *Camera Obscura* collective, she contests the ideology of her auteurship by stressing the literality of its work:

> I must call my own shots, create my own terms and definitions – I mean artistic terms – as I go along. You may call *this* an ideological choice, but I don't think it is as idealistic as you might wish. It is the result of coming in contact very early with the notion of innovation as a necessary component of work, a notion provided by contemporary art history. I inherited that; I swallowed it whole.
>
> (Rainer 1976: 87)

What she swallows whole is innovation, not supplementation – a distinction, as she seems to put it, between a change of contexts (a different logic) and an oedipal disguising of past losses and lacks (a return to the same). It is very much in this spirit that, more recently, she discusses her use of footage from other films in *The Man Who Envied Woman*. 'I think I've shown another use for images that other people have made, including 1940s movies, Michael Snow, and Hollis Frampton. . . . So I'm

Figure 2.8 Yvonne Rainer, *Journeys from Berlin/1971*: Yvonne Rainer in converted video footage. (Courtesy: the artist and Zeitgeist Films)

interested in a certain kind of documentary that can incorporate pre-vious treatments of the same material that originally had an aesthetically transgressive purpose' (Rainer 1989: 41). Might not this comment prompt, then, an appreciation of how film might only *signify* (aesthetic) innovation but not necessarily effect the same transgression? And might not this prompt the viewer, recalling Ribettes's two modalities of *jouis-sance*, into seeing the recycled bits of footage both as a pictorial fantasy in the guise of pleasure and as a symptom of a disturbing phantom in the guise of displeasure? Something very much like this split occurs in the end of *Journeys from Berlin/1971* (figure 2.8), when a weepy character played by Rainer herself appears on a video screen – an apparatus marking the historical moment – to report to her mother about her sublime experience in watching *Morgen beginnt das Leben*, directed by Werner Hochbaum in Berlin in 1933. She recounts in a melodramatic fashion the gasps she heard as young members of the post-war audience recognized the street signs of neighborhoods that were otherwise unre-cognizable. The film provided the spectators with a living link to pre-war Berlin, a city 'that is no more'. So too will the aerial footage of the Berlin Wall, incorporated into *Journeys from Berlin/1971* in 1979, now

provide a material link to Cold War Berlin, a divided city marked by a Wall 'that is no more'.

Laplanche's notion of 'the enigmatic signifier' comes immediately to mind: 'we have to place considerable stress on the possibility that the signifier may be *designified*, or lose what it signifies, without thereby losing its power to signify *to* (*signifier à*)' (Laplanche 1989: 45). Sustaining the life of fantasy, this enigmatic signifier stands, according to Laplanche, as the (new) figure of 'primal seduction'. 'Primal seduction' is the term used by Laplanche to denote 'a fundamental situation in which an adult profers to a child verbal, non-verbal and even behav-ioural signifiers which are pregnant with unconscious sexual significa-tions' (ibid.: 126). Here the enigma is in and by itself a seduction whose mechanisms are unconscious. Cited by Laplanche are examples which return his readers to the (un)familiar sites of feminist film and theory: a Sphinx outside the gates of Thebes and 'the unforgettably *enigmatic* smile of the Mona Lisa' (ibid.: 128) (why not add to these examples the cryptic smile of the Medusa?). Much like the break of the cinematic screen, this enigma is reciprocal: for just as the language of the child is inadequate to that of the adult, the language of the adult is inadequate to the source-object acting upon her. In Laplanche's words,

> given that the child lives on in the adult, an adult faced with a child is particularly likely to be deviant and inclined to perform bungled or even symbolic actions because he is involved in a relationship with his other self, with the other he once was. The child in front of him brings out the child within him.
>
> (ibid.: 103)

It is along this reciprocal, but uneven axis, that the fantasy of the enigmatic signifier is always already in destabilizing circulation.[27]

I find Laplanche's theory of the enigmatic signifier, especially as the enigma confronts both child and adult, to provide a helpful entry into what is perhaps the most bizarre aspect of Abraham and Torok's theory of the phantom: this being that the undetected phantom, so they be-lieve, can skip generations, thus creating a 'familial' disturbance in the transgenerational sense of the term. This phantom is said to be a formation of the unconscious which is notable, and here's the rub, for serving as a mode of passage from the unconscious of the parent to that of the infant. Such a passage appears possible as well within the realm of cultural transmission. 'The phantom of popular beliefs', suggests Abraham in one of his spookier moods, 'does little more than objectify a metaphor which works in the unconscious: the internment in an object of an undeniable fact' (Abraham and Torok 1987: 427). Although it is bizarre, if not almost incredible, that a subject or a text could be thought capable of carrying an ancestor's phantom, might not something like

this mechanism explain the enigmatic uncanniness of the resemblance of the fantasies of Ida and Marie-Germane, the tracks of Stonehenge and the Berlin Wall, as well as the curious relation of Ida's tiger, Irena's panther, and Freud's feline, not to mention (to appropriate Silverman's words) 'the discursive and relational strategies shared by these textual sequences for activating the phantasmatic scene which corresponds to maternal desire'? These corresponding, but not identical, fantasies work something like a phantom, or perhaps it would simply be more prudent to say, something *like* an enigmatic signifier (which is to say that the signifer is *no longer like what it is*). Now the idealized penis could be said to jump from text to text, from generation to generation, from dream work to film work, as a *petit objet (à)*, one signaling not *what* it signifies (*what it lacks*) but *that* it continues to signify (*that* it continues to trace). Now the concept of the enigmatic signifier might clarify my earlier reformulation of B. Ruby Rich's demand – for history to call upon itself to acknowledge psychoanalysis, to dwell on the varying traumatic ways in which the social body politic always has been modeled on some type of mapping of the human psyche. And also, now, we may have a response to Torok's question with which I opened this dreamlike essay, 'Why does the sentiment of castration and its corollary, "penis envy", constitute the almost universal lot of the feminine condition?' Because the enigma is in itself a seductive history, it conditions the discursive relation of the body politic to the performance of the female psyche. It signifies the vicissitudes of sexual difference, just like (à) film.

NOTES

1 I here cite Florio's translation of Montaigne in accord with Tom Conley's belief (1986: 48) that its sensitivity to 'allegorical violence' makes it 'the *only* translation of Montaigne'. I pursue the relation between Montaigne's text and Florio's translation in Murray (1991). In *Making Sex* (1990: 126–30), Thomas Laqueur discusses Montaigne's gloss of Ambroise Paré's clinical account of Germain Garnier, christened Marie, whose jump across a ditch provided enough 'heat' to allow 'the male rod to be developed in him'.
2 See Juliet Mitchell's discussion of penis envy (J. Mitchell 1982: 7).
3 Mitchell (ibid.) provides an excellent overview of how penis envy functions differently in the systems of Jones-Klein and of Lacan.
4 For the most part, I have chosen not to rely on the translation of this collection (Chasseguet-Smirgel 1970), because of the tendency of the anony-mous translator to graph Kleinian vocabulary and accounts on to the more allusive moments of Torok's allusions to idealization.
5 Montrelay's 'Recherches sur la féminité' (Montrelay 1977: 57–81) was first published as a review in *Critique* 27 (1970), and revised in 1978 for *m/f* as 'Inquiry into femininity'.
6 An excellent account of the economy of the *Fort/Da* game is provided in Weber (1982: 94–9).
7 Rather than compare *Journeys from Berlin/1971* to other films by Rainer, I

prefer to read it in tandem with Helke Sander's *Redupers* (1977), which presents a different kind of feminist reflection on West Berlin and its ambivalent relation to the Wall. Their differing methods of tracking the Wall are particularly interesting. In her analysis of tracking shots in *Redupers*, Judith Mayne (1990: 55) writes that 'the screen emerges as a figure that embodies simultaneously the possibility of separation and connection, of obstacle and threshold. The Berlin Wall functions in these terms in *Redupers*, but as a critical figure of ambivalence. The film articulates that ambivalence in one of its preferred techniques, the tracking shot of the city and in particular of the wall, a tracking shot that embodies both distance and contemplation.'

8 *Riddles of the Sphinx* (Mulvey and Wollen 1977: 77) closes with a memorable sequence of the camera tracing the path of a mercury ball moving to the center of a maze puzzle. In the preceding sequence, Laura listens to a taped segment of her rehearsal of her earlier introduction: 'to the patriarchy, the Sphinx as woman is a riddle and a threat. But women within patriarchy are faced by a never-ending series of threats and riddles – dilemmas which are hard for women to solve, because the culture within which they must think is not theirs. We live in a society ruled by the father, in which the place of the mother is suppressed. Motherhood and how to live it, or not to live it, lies at the root of the dilemma. And meanwhile the voice of the Sphinx is a voice apart, a voice off.'

9 See Lacan's discussion of anamorphosis and *The Ambassadors* (1978: 79–90). In a reading of Perrault's version of *Cinderella* (Murray 1976), I discuss fluid linguistic procedures analogous to anamorphosis which are disruptive of the binarisms of structural anthropology and linguistics. More recently, in a *Discourse* essay (Murray 1987b) on the televised Statue of Liberty spectacle and its contrast with avant-garde performance, I consider briefly how anamorphosis in *The Ambassadors* might be read as a baroque analogue to contemporary performance practice. Acute theoretical discussions of anamorphosis and perspectival analogues can be found in Marin (1977); Lyotard (1971: 355–87); Bryson (1983: 87–131); Damisch (1987: 53–78); Gantheret (1987); and Žižek (1989b).

10 Questioning the feminist promise of such a fantasy of female exchange, Sarah Kofman writes that 'the desire to have a child, if it does stem from the female sexual function, still basically refers us back to a masculine constitution: inasmuch as it corresponds with penis envy, it is classified, in the final analysis, within woman's castration complex' (Kofman 1985a: 195). Lesbian theorists also have focused on the dependency of psychoanalysis on a heterosexual model whose economy of heterosexual exchange occludes lesbian desire and satisfaction. These polemical texts make evident the different stakes and challenges posed by lesbians knocking on the oedipal gates: de Lauretis (1987: 127–48; 1990); Butler (1990); Findlay (1989); Case (1989a; 1989b); Dolan (1990).

11 Butler (1990: 57–72) provides a helpful overview of the gender stakes of melancholia in Freud, especially in terms of the taboo against homosexuality.

12 On this complex relation of discourse to body, see de Lauretis's 'Desire in narrative' (1984: 103–57). Rodowick provides an exceptionally concise and crisp summary of this relation in *The Crisis of Political Modernism*: 'Identity and Identification are not fixed through their analogical coincidence with the body. Rather the division of the subject in language traverses distinctions of interiority or externality, as well as the temporal assignation of origins, in its organization through processes of identification. Furthermore, these pro-

cesses are always incomplete and must seek continually to inscribe or rememorize sexual difference as positionalities through which the subject articulates its (imaginary) relation to its body, its sexuality, and its relation to others' (Rodowick 1988: 255). Still, as I hope to suggest further on, it might not be unhelpful to continue to put pressure on the role of the body itself as the interpellating site of the drives. As Mary Ann Doane depicts the re- duction of the female body in 1940s film, 'in a patriarchal society, to desexual- ize the female body is ultimately to deny its very existence. The woman's film thus functions in a rather complex way to deny the woman the space of a reading' (Doane 1987: 19).

13 Kofman concludes *The Enigma of Woman* by recalling how even in Gérard de Nerval's multi-layered 'Oriental' interpretation of the creation of Adam and Eve, Eve comes out in *Voyage en Orient* as the original source of sin and evil (Kofman 1985a: 224–5).

14 As Silverman sees it, masochism, a trait inherent to melancholia and its more benign traces in Ego formation, is one of the worst effects of the Oedipus complex on women. This is both because of the passive submission associ- ated with masochism and because it provides 'a crucial mechanism for eroticizing lack and subordination' – 'an accepted – indeed a requisite – element of "normal" female subjectivity' (Silverman 1988b: 36). Or, put into the words of Silverman's patent formula: 'what is acceptable for the female subject is pathological for the male' (ibid.). But in a reading critical of Deleuze's division of sadism and masochism, in 'Coldness and cruelty' (Deleuze 1989b), and the attendant separation of female and male sexuality in view of passivity and activity, Linda Williams suggests in *Hard Core* that 'the masquerade is part of the very nature of a sadomasochism that has been too often understood as inalterable passivity and powerless suffering' (Williams 1989: 214). She adds that 'sadomasochistic fantasy offers one important way in which groups and individuals whose desires patriarchy has not recognized as legitimate can explore the mysterious conjunction of power and pleasure in intersubjective sexual relations' (ibid.: 217–18). Below, I will suggest how melancholic incorporation, as conceived by Torok and Abraham, provides another possible form of sadomasochistic masquerade that contributes to the enhancement, rather than the dimunition, of the preservation of the power and pleasure of subject-formations mis-recognized and ill-treated by patriarchy.

15 In his highly complimentary review of the film, Noel Carroll touches on the issue of suicide by focusing on the patient and Meinhof: 'the psychiatric patient represents the most highly privatized mode of existence, while Ulrike Meinhof symbolizes the most politicized. The two suicides are opposites as well as analogs – Meinhof's act was a political gesture, but her politics may have resulted from displaced personal rage' (Carroll 1981–2: 44).

16 Freud writes that 'the analysis of melancholia now shows that the ego can kill itself only if, owing to the return of the object-cathexis, it can treat itself as an object and if it is able to direct against itself the hostility which relates to an object and which represents the ego's original reaction to events in the external world. In the two opposed situations of being most intensely in love and of suicide the ego is overwhelmed by the object, though in totally different ways' (Freud 1953–74: XIV, 252).

17 I mean to suggest that Silverman reads against the grain of what Rainer calls her filmic strategies of difference rather than opposition: 'Raised as I have been with this century's Western notions of adversarial aesthetics, I continue

to have difficulty in accommodating my latest articulation of the narrative 'problem' – i.e., according to Teresa de Lauretis's conflation of narrativity itself with the Oedipus complex, whereby woman's position is constantly reinstated for the consummation or frustration of male desire. The difficulty lies in accommodating this with a conviction that it is of the utmost urgency that women's voices, experience, and consciousness – at whatever stage – be expressed in all their multiplicity and heterogeneity, and in as many formats and styles – narrative or not – from here to queendom come and throughout the kingdom. In relation to the various notions of an avant-garde, this latter view, in its emphasis on voicing what has previously gone unheard, gives priority to unmasking and reassessing social relations, rather than overturning previously validated aesthetic positions. My personal accommodation becomes more feasible when cast in terms of difference rather than opposition and when the question is asked: 'Which strategies bring women together in recognition of their common *and* different economic and sexual oppressions and which strategies do not?' (Rainer 1987: 380)

18 See Silverman's essay of the same year (1989): 'Fassbinder and Lacan: A reconsideration of gaze, look and image'.

19 Mayne opens her book with a chapter, 'Spectacle, narrative, and screen', examining how 'the screen' functions in a group of 'dominant' Hollywood films as 'peculiarly resistant to the hierarchy of male subject and female object' (Mayne 1990: 8). Mayne is careful to note Silverman's more skeptical perspective that 'the displacement of losses suffered by the male subject onto the female subject is by no means a necessary extension of the screening situation. Rather, it is the effect of a specific scopic and narratological regime' (Silverman 1985: 25). Mary Ann Doane adopts a contrasting, but not completely different, approach in *The Desire to Desire*, by suggesting that contemporary filmmaking might in fact build on the resistance to Hollywood narrative's attempt to contain female subjectivity: 'The formal resistances to the elaboration of female subjectivity produce perturbations and contradictions within the narrative economy. The analyses in this study emphasize the symptoms of ideological stress which accompany the concerted effort to engage female subjectivity within conventional narrative forms. These stress points and perturbations can then, hopefully, be activated as a kind of lever to facilitate the production of a desiring subjectivity for the woman – in another cinematic practice' (Doane 1987: 13).

20 In *Power & Paranoia*, Dana Polan situates *Cat People* in the context of the construction during the war years of 'an image of psychology and psychoanalysis as effective and necessary human sciences. The war period becomes discursively a moment of psychical tension – the difficulties of homefront life and a fear of war as a source of irremediable psychological change' (Polan 1986: 180). It is within this specific historical context that Polan emphasizes the complexity of the ambivalence and inconstancy of the image of psychoanalysis within this film, 'where the doctor and his desire are one more cause of Irena's problems: Dr Judd's scientific interest – seemingly legitimated by the film's opening with an authoritative quotation from the doctor – becomes interwoven with a desire that exceeds the bounds of scientific propriety. Judd, not Irena, is the figure of an energy that transgresses limits' (ibid.). As a means of pointing backward to this chapter's opening remarks on the cinematic trace, I might add that Polan argues, in the conclusion of *Power & Paranoia*, that the significance of 'the very fact that so many directors or producers decided to deal with the question of women can suggest a recog-

nition, no matter how recontaining, of women as a force of represent-
ation. . . . And yet this "feminism" doesn't come out as any sort of full,
expressed, intended voice: following Jacques Derrida, for whom the notion
of the voice's full presence is an impossible (if constantly attempted) myth, I
would suggest that the films maintain traces of a female experience that tries
to assert itself in a number of ways but whose presence is frequently con-
tained by narrative development and other structures of the cinematic rep-
resentation' (ibid.: 284–5).

21 Another interesting classic backdrop for Ida's dream would be Ophüls's *Lola
Montès*, a film which moves between Lola's active and passive exhibitionism
as a circus performer. A helpful context for such a discussion is provided by
Silverman's interesting analyses of this film (Silverman 1983: 226–30; 1990:
312–13). Her summary of the vicissitudes of Lola's position points, moreover,
to a more problematic aspect of the cinematic and psychoanalytic association
of the female subject with the jungle beast: 'Both constituents of the surveil-
lance system – visual and auditory – must be in effect in order for it to be
successful. To permit the female subject to be seen without being heard
would be to activate the hermeneutic and cultural codes which define
woman as a "dark continent", inaccessible to definitive male interpretation'
(Silverman 1990: 313). This latter point is developed by Doane in her daring
and important essay 'Dark continents: epistemologies of racial and sexual
difference in psychoanalysis and cinema' (Doane 1991: 209–48), where she
argues convincingly that 'the trope of the dark continent is an early symptom
of the white woman's fundamental and problematic role in the articulation of
race and sexuality'.

22 In *Riddles of the Sphinx*, the ex-husband, Chris, shows his wife (whom he left
because she could not part from her infant daughter) clips of a film about
Mary Kelly and her work, *Post-Partum Document* (Institute of Contemporary
Arts, London 1976; published 1983). Kelly reports in these clips that 'the
diaries in this document are based on recorded conversations between
mother and child (that is, myself and my son) at the crucial moment of his
entry into nursery school. . . . There also occurs at this moment a kind of
"splitting" of the dyadic mother/child unit which is evident in my references,
in the diaries, to the father's presence and in my son's use of pronouns
(significantly "I") in his conversations and of implied diagrams (for example,
concentric markings and circles) in his "drawings". The marking process is
regulated by the nursery routine, so that almost daily finished "works" are
presented by the children to their mothers. Consequently, these markings
become the logical terrain on which to map out the "signification" of the
maternal discourse' (Mulvey and Wollen 1977: 71–2). In an interview with
Hal Foster, 'That obscure subject of desire', Kelly discusses the relation of her
recent project, *Interim*, to *Post-Partum Document* (Kelly 1990: 53–62).

23 In 'Is the rectum a grave?', Bersani makes a similar point: 'Unfortunately, the
dismissal of penis envy as a male fantasy rather than a psychological truth
about women doesn't really do anything to change the assumptions behind
that fantasy. For the idea of penis envy describes how men feel about having
one, and, as long as there are sexual relations between men and women, this
can't help but be an important fact *for women*' (Bersani 1988: 216).

24 I make this point in reference to the conclusive statement of Penley's 'Femi-
nism, film theory, and the bachelor machines': 'The formulation of fantasy,
which provides a complex and exhaustive account of *the staging and imaging of
the subject and its desire*, is a model that very closely approximates the primary

aims of the apparatus theory: to describe not only the subject's desire for the filmic image and its reproduction, but also the structure of the fantasmic relation to that image, including the subject's belief in its reality' (Penley 1989: 80).

25 See Green (1983: 222–53); Kristeva (1987: 11–106); Laplanche (1989: 89–151); Rose (1989).

26 See especially Torok's essays in the section of *L'Ecorce et le noyau* entitled 'La crypte au sein du moi: nouvelles perspectives métapsychologiques' (Abraham and Torok 1987: 229–324) and 'Histoire de peur, le symptôme phobique: retour ou refoulé ou retour du fantôme?' (ibid.: 434–46). Also see Abraham and Torok (1976); Abraham (1979; 1988). For analyses of Abraham and Torok, see Derrida (1979); Kamuf (1979); Rashkin (1988); Rand (1989).

27 Since Laplanche understands the primal seduction of the enigmatic signifier to be a fundamental relation, he defines it as the essence of the other two levels of Freudian seduction: pedophilia and precocious seduction by the mother (the site of desire for Silverman, and of penis envy for Torok). Being a feature of both the primary and the secondary processes, the engimatic signifier calls into question Freud's 'experience of satisfaction', since the enigmatic signifier is inscribed before any attempt is made to translate it (Laplanche 1989: 131). What is significant about this mapping, especially in view of the reopened case of the missing penis, is that it situates both castration and the oedipal scenario on a secondary topographical level in corollation to the secondary logical pattern inherent in verbal communication – secondary, of course, to the enigmatic fantasy of primal seduction. Also operating on both levels of this topography are the two theories of the drives retained by Laplanche. The first being the sexual drives, marked by *Anlehnung* (leaning on; propping) in which the sexual function is supported by the self-preservative function, both said to be *simultaneously psychical and somatic* (ibid.: 144). The second being the life and death drives with the '"life" sexual drive' corresponding to a whole and *totalizing object*, and the death drive corresponding to a *part object* 'which is scarcely an object at all . . . unstable, shapeless and fragmented' (ibid.: 146–7).

3

PHOTO-MEDUSA
Roland Barthes Incorporated

The writer is someone who plays with his mother's body . . . in order to glorify it, to embellish it, or in order to dismember it, to take it to the limit of what can be known about the body: I would go so far as to take bliss in a *disfiguration* of the language, and opinion will strenuously object, since it opposes 'disfiguring nature'.

(Barthes, *The Pleasure of the Text*)

'Of all the structures of information', Roland Barthes writes in his 1961 essay, 'The photographic message', 'the photograph is the only one to be exclusively constituted and occupied by a "denoted" message, which completely exhausts its being' (Barthes 1985: 7). This statement frames one of Barthes's most succinct claims about the fine arts: that photography is an image without a code. A remarkable assertion, it is one to which Barthes returns frequently in his essays on art. Perhaps the 1964 'Rhetoric of the image' is where he most blatantly reveals the critical stakes of this minimalist claim:

> In the photograph, in effect – at least on the level of the literal message – the relation between signifieds and signifiers is not one of 'transformation' but of 'registration', and the absence of a code obviously reinforces the myth of photographic 'naturalness': the scene is *there*, registered mechanically, but not humanly.
>
> (Barthes 1985: 33)

The mythical scene, the natural register, the inhuman 'thereness' of the photographic image, these are the artistic topoi which Barthes wants to be capable of resisting the tarnish, the corrosive effect of representation. In his view, returning to the 'Rhetoric of the image', 'it is understandable that in an aesthetic perspective the denoted message can appear as a kind of Adamic state of the image; utopianly rid of its connotations, the image would become radically objective, i.e., ultimately innocent' (ibid: 31).

Barthes's texts on photographic innocence have become a cornerstone of reference in theoretical essays on photography. Theoreticians turn to

65

them, however, less to reap the benefits of his philosopher's stone than to cast it aside forever. Especially Victor Burgin (1986), Alan Sekula (1982), and John Tagg (1988) have written substantial essays reinscribing Barthes's mythology of natural realism in the gritty social realities of photography. Sekula reminds Barthes's readers that every Adamic state is marked by the differing slashes of mechanical reproduction, that 'every photographic image is a sign, above all, of someone's investment in the sending of a message' (Sekula 1982: 87). Whether the invested subject is producer or receiver, denotation cannot be separated from connotation, unless falsely by the whims of desire.[1]

Still, in briefly rehearsing this ideological split in photographic theory, we must not forget that Barthes's own writings permanently rip asunder the seams of any Adamic canopy of representation. He readily admits that photography is marked by a paradox, what he calls in his early essays on imagery 'the photographic paradox'. This is the coexistence of two messages: one without and another with – a code. When codified, the paradoxical message 'would be the "art", or the treatment, or the "writing", or the rhetoric of the photograph' (ibid. 8). Although Barthes is reluctant to give up his codeless message, he is continually drawn to the relay of language and the rhetoric of photography. This is most notably the case with two of his illustrated texts, *Roland Barthes by Roland Barthes* (1977) and *Camera Lucida: Reflections on Photography* (1981). Not content to bring together a collection of photographs to speak forcefully for themselves in imagistic silence, Barthes packages his 'codeless' images in the fabric of the essay, in the paradoxical relay of the second code, 'writing'.

In *Roland Barthes by Roland Barthes*, this relay enfolds the 'photographic' in the multilayered tissues of autobiography. The writer opens *Roland Barthes* with a forty-page childhood photo-essay which begins with reflections on the break between photo-image and writing-texture, the 'visible' and the 'readable'. The images of childhood provide the writer with a field for meditation ('la méditation (la sidération)'), a counter-production of reflexivity, a sort of mixed memory-trace of the mirror stage:

> Embracing the entire parental field, such imagery acts as a medium and puts me in a relation with my body's *id* (*le ça*); it provokes in me a kind of obtuse dream, whose units are teeth, hair, a nose, skinniness, long legs in knee-length socks which don't belong to me, though to no one else: here I am henceforth in a state of disturbing familiarity: I *see* the fissure of the subject.
>
> (Barthes 1977: 5)

The familial visions of *Roland Barthes* ground the split subject in an alien fetishistic whole. The text's photographic imagery enacts the figuration

of the 'pre-history of the body'. Yet these im-personal images of *obvie/ obtus* remain isolated in the first part of *Roland Barthes* to clear the way for the project of writing, the terrain of 'un autre imaginaire' leading the writer's body elsewhere, 'far from my imaginary person, toward a kind of memoryless speech' (ibid.: 6). It is the text's frame alone, apart from the ground of memory, that effaces the image of the subject in the *fading* of enunciation, in the splits, fissures, and breaks of circulating references. Here the subject is rendered partially indistinct by the shadows of its textual fabric, by the partial traces of its productivity. 'This shadow is *a bit* of ideology, *a bit* of representation, *a bit* of subject: ghosts, pockets, traces, necessary clouds: subversion must produce its own chiaroscuro' (Barthes 1975: 32). In transferring the author from mirror-image to shadow-boxer, writing thus inscribes the subject in the fecund vapors of agonistic generation. Whether such agonism distinguishes affirmation from negation (*Bejahung* from *Verneinung*), art from history, or utopia from practicality – the flip-sides of cultural economy – the shadowy frictions of text designate in *Roland Barthes* the composition of the partial, lacking components of the language of self.[2]

Even when Barthes's description of writing appears to mimic the reproductive structures of imagery, it does so in reverse, turning the seeing self of photography into the desired Other of text. Take, for example, his references to both text and image as fetishistic. Not only is the writer of *Roland Barthes* aroused by the fetishistic fragments of family photographs, but the author of *The Pleasure of the Text* is solicited by the fetish of writing:

> The text is a fetish object, and *this fetish desires me*. The text chooses me, by a whole disposition of invisible screens, selective baffles: vocabulary, references, readability, etc.; and, lost in the midst of a text (not *behind* it, like a *deus ex machina*) there is always the other, the author. As institution, the author is dead.
>
> (Barthes 1975: 27)

Still, while there may be some fetishistic similarities between image and text, they are said here to generate only the scarred figures of their difference through repetition. This is the difference embodied by the separate sections of *Roland Barthes*, photo-essay and textual autobiography, in which the more substantial scripted part announces the continual representation of otherness and the death of authorship rather than nostalgia for the primal sameness of rebirth. If Barthes's theory of textuality, one encompassing both art and literature, provides any hope of reconstituting the fragmented subject, it remains inscribed only on the terrain of supplemental difference. As Barthes writes in relation to Cy Twombly's art, the split 'subject' of the canvas (painter/picture) 'summons, attracts the spectator: he wants to join the canvas, not in

order to consume it aesthetically, but in order to produce it in his turn (to "re-produce" it), to try his hand at a making whose nakedness and clumsiness afford him an incredible (and quite misleading) illusion of facility' (Barthes 1985: 191).

But what about *Camera Lucida*? Where should it be placed in relation to this seemingly clear-cut divide of reproduction? On the photographic site of the primal, familial image, or on the fractured surface of writing? Which scene stands out, that from Bayonne or that from Paris? And who 'produces' the text fielding this choice? Should *Camera Lucida* be understood as a production of image, or text, or author, or reader, or all of the above? Or, should it be analyzed in terms of broader epistemological and necessarily more ideological referents, those of visibility, readability, consciousness, or re-presentation? Finally, might it not be misleading even to seek to identify or locate a single site for this text? Perhaps it would be more helpful to think of *Camera Lucida* as a series of sites, citations, meditations, and scriptations that reposition the separate subjects of writing and reading in relation to the chains of discourse structuring the very notions of subjectivity, family, and death.

PHOTOGRAPHIC PRIVATION

Sub-titled in French *Note sur la photographie*, *Camera Lucida* inscribes, etches, and gouges the surfaces of photography with the awkward and violating marks of writing. These marks extend their violence to the terrain of photographic theory and analysis as well, none of which, complains Barthes, 'discussed precisely the photographs which interest me, which give me pleasure or emotion. What did I care about the rules of composition of the photographic landscape, or, at the other end, about the Photograph as family rite?' (Barthes 1981: 7). By contrast to formalist or sociological readings of photographs, the twisted, contorted, and baroque project of *Camera Lucida* confronts the reader with the fecundity of fissure. This is what Barthes describes, in 'The third meaning', as the obtuse 'accent', 'fold', and 'gash' from which meaning is expunged and along which reading wants to skid beyond culture, knowledge, and information.[3] As a tenuous weave of slipping discourses, *Camera Lucida* reads neither as a mere theory of photography nor simply as a nostalgic meditation on the recent death of Barthes's mother. At stake is what Barthes calls elsewhere the *hyphologie* of text. Being the fabric and web of a spider, *hyphos* is the imagistic trope of writing through which the subject undoes itself in trying to go beyond culture, just as a spider dissolves itself in the still binding secretions of its web (Barthes 1975: 64). 'Still binding secretions', the suturing stuff of both the silvery emulsion of photography and the inky texture of writing, are what constitute the *hyphos*, the amoebic fiber that holds

together the writer, Barthes, in the suffocating net of his own representation, *Camera Lucida*.

Although Barthes dedicates the book to Sartre's phenomenological study, *L'imaginaire*, he promises to surpass the limits of phenomenology by analysing the desire and mourning of the viewing experience. From the outset, Barthes's book dwells on the death drive of photography, 'that rather terrible thing which is there in every photograph: the return of the dead' (Barthes 1981: 9). Ultimately, according to Barthes's reading, photography links up with an older representational form, theatre, to share the universal relay, death. Photography is said to be a 'denatured theatre', a scene from which 'death cannot "be contemplated", reflected and interiorized'; or, as he states it in a way that recalls not only theatre but its aesthetics and writing-effects, 'the dead theatre of Death, the foreclosure of the Tragic, excludes all purification, all *catharsis*' (Barthes 1981: 90). Photography, in this sense, promises the foreclosure of Aristotelian aesthetics, that is, the denial of the reconstitution of Self, of the wholeness of Subject, of the self-sufficiency of representation.

Barthes makes this especially clear in dwelling on photography's role as a medium of autobiography. Discussing his own photographic portraiture, he reflects on his discomfort with the artistic medium to which he is compellingly drawn. Faced with a malaise bordering on the abyss of terror, Barthes sees:

> that I have become Total-Image, which is to say, Death in person; others – the Other – do not possess me of myself, they turn me, ferociously, into an object Ultimately, what I am seeking in the photograph taken of me (the 'intention' according to which I look at it) is Death: Death is the *eidos* of that Photograph.
>
> (Barthes 1981: 14–15)

This seeking of *eidos*, the intention of autoportraiture, confronts Barthes with the death drive, the condition of representation compounding self and object as well as the 'I' of enunciation and the 'you' of interlocution.

This act of death has been discussed by Lacan as the fact of representation, the subject's traumatic enclosure in differing phantasms such as dream, photo, and play – all of which Symbolize through concealment the Real psychic loss of linguistic presence, on one side, and object-cathexis, on the other. 'Photo-graphed', to be 'photo-graphed', is Lacan's term for Barthes's becoming 'Total-Image' (Lacan 1978: 106). Here the self is framed and enveloped in the scopic field of natural light (*lumière*): 'this is something', writes Lacan, 'that introduces what was elided in the geometral relation – the depth of field, with all its ambiguity and variability, which is in no way mastered by me. It is rather it that grasps me, solicits me at every moment, and makes of the landscape something other than a perspective' (ibid.: 96). It may be more the

aperture of Lacan than the lens of Sartre that reveals the scope of Barthes's photographic death-drive, the representational screen on which he finds himself imprinted – *photo-graphié* – by the (missing) gaze of the scopic field. The agent of death, in this instance, is not so much photography itself as the mechanical, that is, repetitive, performance of psychic gazing.

Barthes makes this connection explicit in an essay on the gaze and the photography of Richard Avedon, 'Right in the eyes'. To do so, he suspends his own perspective in citing generous portions of Lacan's treatment of the subject of visual privation in *The Four Fundamental Concepts of Psychoanalysis*: '"The relation of the gaze to what one wants to see is a relation of deception. The subject presents himself as other than he is, and what he is allowed to see is not what he wants to see. Thereby the eye can function as an object, i.e., on the level of privation" (Lacan, *Seminar XI)*' (Barthes 1985: 239). In terms of *Camera Lucida*, this eye – functioning as an object on the level of photographic privation – stands in for the Subject, the I (Iye) imprinted on the apparatus of photography.

If so, where does this leave phenomenology? What can be made of Barthes's backward gaze at Sartre's book, which foregrounds the *Imaginaire* as a tool to be used by the reasoning Subject, an *Imaginaire* very different from the Lacanian field of the same name that fore-grounds subjective privation?[4] Barthes begins to answer this question by etching out a 'cynical phenomenology'. Reminding me of Merleau-Ponty's later work (1964), with which Lacan (1978: 93) dialogued so productively, this cynical project is marked by an 'affective intentiona-lity', by a view of the object motivated by pleasure, steeped in the by-products of 'desire, repulsion, nostalgia, euphoria' (Barthes 1981: 21). One result in *Camera Lucida* is Barthes's discussion of only those photos which please him, a discussion framed by observations about the 'co-presence' of two structural elements of photography: the *studium* and the *punctum*.

The *studium* portrays the *unary* element of a photo. It 'emphatically transforms "reality" without doubling it, without making it vacillate . . . no duality, no indirection, no disturbance' (ibid.: 41). Shaping the realistic surface of photographic portraits, historical tableaux, and jour-nalistic photos, the *studium* is always situated culturally as receivable and viewable much in the way that Barthes earlier denied for photogra-phy. Since the *studium* always stands coded, it is thus an ideal agent of phenomenological intention. Resembling Sartre's notion of 'certainty' in *L'imaginaire* (Sartre 1986: 15–40), the *studium* 'allows me to discover the *Operator*, to experience the intentions which establish and animate his practices, but to experience them "in reverse", according to my will as a *Spectator*' (Barthes 1981: 28).

The other, co-present element arises from photography's pure

contigency. This is the *punctum*, the vehicle of neither 'Art' nor 'Communication' but 'Reference', 'the founding order of photography'. Being the primal element of photography, it reveals intensity, Time, what Barthes terms 'the lacerating emphasis of the *noeme* ("that-has-been", *ça-a-été*), its pure representation' (ibid.: 96). And because the *punctum* is uncoded, it confronts the viewer with the photo's unnameable, untouchable elements that not only wound, pierce, and prick Roland Barthes but also 'bruise' him, in the sense of being 'poignant' to him. Resembling Lacan's scopic 'light' which is both solicitous and disarming, the *punctum* clouds the unicity of reading with disturbing indirection and phantasmatic duality. Very often the *punctum* is a 'partial object', a photographic detail, such as a hand, ankle-strap, collar, or even a pinch, whose lack of immediate significance demands attention and arrests the comforts of reading. 'By the mark of *something*, the photograph is no longer "anything whatever". This *something* has triggered me, has provoked a tiny hock, a *satori*, the passage of a void . . . what cannot be transformed but also repeated under the instances of the insistence (of the insistent gaze)' (ibid.: 49). The 'partial object' lends itself as well to being understood as the figure of the arrested gaze. It functions, to stress Barthes's pun, as the 'part-object' (*objet partiel*) of psychoanalysis, one of those symbolic substitutes of self and body whose partiality makes visible the fissure of subjectivity.[5]

By now it is quite apparent that the field of 'Reference' sustaining *Camera Lucida* is much broader, yet, more indistinct, than the flat terrain of pictoriality which Barthes earlier argued to be a 'message without a code'. While the message of the *punctum* may remain uncoded in so far as it is unwritten (that is, unspoken; that is, non-represented; that is, not really a 'message'), *Camera Lucida*'s discursive account of the *punctum* inscribes the photographic message in the meta-condition of epistemological and psychoanalytical performance. For the *punctum*'s 'silent cry' results in the *C'est ça!*, the temporal designation of the *punctum*'s definitive time-essence, *Ça-a-été* (ibid.: 109). Precisely this machinery or relay of designation, not the object of designation itself, is what foregrounds the fine overlays of epistemological and psychoanalytical matter framing Barthes's message or *punctum*. Such a mixed framework of designation sustains his vow to go beyond phenomenology which he cannot remember to have spoken of either desire or mourning.

Barthes explicitly reveals his machinery at the commencement of *Camera Lucida*. To emphasize photography's infinite repetition of what only takes place once, he makes a less than oblique reference to Lacan's discussion of the *Fort/Da* mechanism:

> [The photograph] is the absolute Particular, the sovereign Contingency, matte and somehow stupid, the *This* (*Tel*) (this

71

photograph, and not Photography), in short, what Lacan calls the *Tuché*, the Occasion, the Encounter, the Real, in its indefatigable expression. In order to designate reality, Buddhism says *sunya*, the void; but better still, *tathata*, as Alan Watts has it, the fact of being this, of being thus, of being so; *tat* means *that* in Sanskrit and suggests the gesture of the child pointing his finger at something and saying: *that, there it is, lo!* (*Ta, Da, Ça!*) but says nothing else.

(Barthes 1981: 5)

Barthes here situates the designation of photography in the ludic scene of childhood, in the deictic game, analyzed by Freud, through which the infant compensates for the trauma of the mother's departure by repeatedly throwing and recovering a bobbin. In the process, the child utters the designation, *Fort/Da*. Through the repetition of the representational act, the infant performs the fragmentation of his/her self caused by the sudden separation from the mother. In discussing this point, moreover, Lacan is very insistent that the bobbin being thrown back and forth not be understood as symbolizing merely the mother. Rather, it should be understood as

a small part of the subject that detaches itself from him while still remaining his, still retained. . . . If it is true that the signifier is the first mark of the subject, how can we fail to recognize here . . . that it is in the object to which the opposition is applied in act, the [bobbin], that we must designate the subject. To this object we will later give the name it bears in the Lacanian geometry – the *petit a*.

(Lacan 1978: 62)

The bobbin thus becomes the agent of the split self. Its game is abreaction, a phantasmatic figuration of the drive to repeat through playful mastery the originary lack, fissure, and fragmentation of subjectivity in the field of desire.

A similar doubling of desire and death through attraction and repulsion characterizes *Camera Lucida*'s writing about photographic primality. Barthes's places the weight of photographic reference on the fine thread, *hyphos* (or perhaps *suture* would be even a better term) separating/joining desire and mourning. While *hyphos* is Barthes's term for the fiber of writing, *suture* is the post-Lacanian concept for the fading relation of the subject to the chain of its discourse.[6] Being separated from the discourse of the Other – the unconscious which Lacan claims to be structured like a language – the subject is born divided in the guise of a signifier. Its presence in language, the Symbolic, marks its division, its structure as lack-in-being, its constitution as *'less-than-one'*.[7] Suture figures the way that the signifier stands in for the absent subject whose lack is always signified. And as Kaja Silverman describes the term

initially coined by Jacques-Alain Miller, suture resembles the subject's inauguration into language through the fissure of the *Fort/Da* game (Silverman 1983: 200). Suture, then, is a comprehensive term for the entire representational field initially introduced to the subject by the childhood bobbin. It designates the lacking subject who plays out the relay of desire and mourning.

This concept has proved particularly beneficial to the theory of pictorial narration. Especially in the analysis of film, theoreticians have turned to suture to describe how the position of the viewer, especially when male, can be constructed by a combination of narrative and visual conditions. Suture is understood to operate in certain films as a means of effacing the absence of the cinematic image from its spectators by providing them with visual and narrative stand-ins. Such a suturing covers over the wounds of fragmentation with structures of seeming closure. Although suture's hegemonic efficiency is open to debate, it clearly facilitates the construction of a certain point of view, character, or overall discourse to stand in for the viewer in defining what he sees. The cut, the tracking shot, and, especially, the shot-reverse-shot are characteristic agents of suture's coherence through which, writes Silverman, 'each positive cinematic assertion represents an imaginary conversion of a whole series of negative ones' (Silverman 1983: 205). Nor should the significance of such a system be relegated merely to its psychoanalytic benefits. As Stephen Heath argues, suture can also mark the materialist constitution-construction of the subject in so far as it joins the subject in structures of meaning whose status and affect excede the privatized death-drive of any nostalgic return to primal cohesiveness (Heath 1981: 106).

WELCOME HOME

Suture plays a particularly playful role in *Camera Lucida*'s display of the 'photographic paradox' of Barthes's writing about photography. As suggested above, his structural analyses of the *studium* and *punctum* stand in primarily as the methodological supplements of phenomenology's lack, the discourse of desire and mourning. This methodological stand-in not only flavors Barthes's commentary on his favorite photographs but also fills in and effaces the gap between the two separate parts of *Camera Lucida*, even when they insist most explicitly on division. I refer here to what he names his ode and palinode, the two parts of the book whose later personal remarks regarding the death of his mother reputedly contradict the earlier phenomenological analysis stemming from structuralism and semiotics. Implied by the palinode is a dismissal of the ideological claims of formalist method for the sake of a more personal, melancholic retreat into the privatized terrain of the family.

Yet it can be argued that the two parts of the book have the same ideological terrain. Consider a passage in Part One when Barthes elaborates on the *punctum* of Charles Clifford's urban landscape *Alhambra*. Extending his remarks to successful landscapes in general, Barthes claims that they emit a feeling

> as if *I were certain* of having been there or of going there. Now Freud says of the maternal body that 'there is no other place of which one can say with so much certainty that one has already been there.' Such then would be the essence of the landscape (chosen by desire): *heimlich*, awakening in me the Mother (and never the disturbing Mother).
>
> (Barthes 1981: 40)

The awakened figure of the never-disturbing Mother is certainly prevalent in *Camera Lucida*, which dwells at length on the irreplaceable merits of the recently departed Madame Barthes. This reference and numerous passages in the text foreground the sentiment previously cited from *Roland Barthes* that photo-essence evokes a state of disturbing familiarity (*un état d'inquiétante familiarité*). Yet, this stress on the familiar or embracing nature of the primal photo-scene, that which is *heimlich*, forcefully frames nostalgic comfort in the language of blockage. The writer continually wants to negate the lesson of Freud, who left any hope for an undisturbed source, *heimlich*, afloat in the repetitious stuff of the *unheimlich* (*inquiétante étrangeté*). Freud's text 'The uncanny' demonstrates how *heimlich* signifies two different but interrelated sets of ideas: 'on the one hand it means what is familiar and agreeable, and on the other, what is concealed and kept out of sight' (Freud 1953–74: XVII, 224). This second sense leads to Freud's realization that the essence of *unheimlich* finds itself inscribed in *heimlich*: everything disturbing or dangerous which ought to have remained secret has come home, has come to light. What returns, or perhaps what has always been there but never with enough light, is not so much the primal scene itself as the differing relays of repression, negation, or foreclosure: the machinery that blocks out disturbance from the complex sight of the Mother. These relays surface frequently in Barthes's later texts when he desires his return to essence to be cushioned in the fabric of *jouissance*. As he reveals in *A Lover's Discourse*, Barthes embraces the *heimlich* as a field of innocence, as *Bejahung* cleansed of the discomforts of *Verneinung*:

> one and the same word (*Bejahung*) for two affirmations: one seized upon by psychoanalysis, is doomed to disparagement (the child's first affirmation must be denied so that there may be access to the unconcconscious); the other, posited by Nietzsche, is a mode of the will-to-power (nothing psychological, and even less of the social in

it), the production of difference, the *yes* of this affirmation becomes innocent (it contains the reaction-formation): this is the *amen*.

(Barthes 1978: 181–2)

Barthes's manipulation of this Nietzschean 'yes' enacts a turn-away from Freud's *Bejahung*, which inscribes negation in the fetishistic split of the subject's acknowledgement of lack in denying it, the 'Yes, but nevertheless' of *Verneinung*. It might even be said that this swerve situates Barthes's desire on the plane of Lacan's *Verwerfung*, foreclosure, the constitution of what lies outside of symbolization. Marked by the absence of the sign, this site not only denies representational fracture but also disavows the significational bar, whether that designating sense (*signifiant/signifié*) or that marking possession, *Fort/Da*.[8]

Such a move toward the idealistic terrain of pure desire could be said to be highly evident in *Camera Lucida*'s retreat from social as well as psychoanalytical photo criticism. Yet the conclusion of Part One reveals a weighty ambivalence about such a turn aside from the Symbolic. In calling for a palinode, a refutation of what came before, it refutes desire's ability to cast out fracture and death from the *eidos* of the photograph. Summarizing the results of Part One, Barthes admits: 'I had perhaps learned how my desire worked, but I had not discovered the nature (the *eidos*) of Photography. I had to grant that my pleasure was an imperfect mediator, and that a subjectivity reduced to its hedonist project could not recognize the universal' (Barthes 1981: 60). Barthes's solution is to turn 'even deeper into himself' to find the evidence of photography. This dive into the abyss of mourning and melancholy leads away from the conventional time-frame of fiction opening the book, 'One day, quite some time ago', to the ever-present moment of grief introducing Part Two, 'Now, one November evening shortly after my mother's death'. Now is the transferential moment when the past will always be inscribed in the future, punctuated by the designation of the *punctum*'s immediate time-frame, *Ça-a-été*. Now, Barthes's writing rejoins the realm *Ça* where the flow of desire meets the River Styx to produce intimate reflections on the dissolution of the maternal body and its irreversible impact on the scene of writing:

> Once she was dead I no longer had any reason to attune myself to the progress of the superior Life Force (the race, the species). My particularity could never again universalize itself (unless, utopically, by writing, whose project henceforth would become the unique goal of my life). From now on I could do no more than await my total, undialectical death.
>
> (Barthes 1981: 72)

Writing here becomes the declared machinery of the death drive. Its

utopic fulfillment equals the author's own undialectical death. Or put another way, the authorial text gives way to the disembodied, self-contained slash that once designated division, that once hinged *Fort/Da*, that once barred *signifiant/signifié*.

But it is also now, during this moment of palinode, of de-composition, that Barthes prolongs a familiar methodological game to fill in the gap of awaiting the arrival/return of death. He replaces the bobbin with the family photo album in a process of casting out images until he discovers the essential one, the *punctum*, of his departed mother. This he eventually locates in a photo of 'sovereign innocence' showing her at 5 years old standing with her slightly older brother in the confines of a Winter Garden. In this picture, Barthes locates the temporary solution both to his own ontological waiting and to the methodological dilemma frustrating his earlier, phenomenological study of photography:

> I therefore decided to 'derive' all Photography (its 'nature') from the only photograph which assuredly existed for me, and to take it somehow as a guide for my last investigation. All the world's photographs formed a Labyrinth. I knew that at the center of this Labyrinth I would find nothing but this sole picture.
>
> (Barthes 1981: 73)

But it is also now, during this moment of the re-discovery of labyrinthine innocence and undialectical death, that one baffling rhetorical gesture lays bare the violence of *Camera Lucida*'s sutures. Barthes makes it in an off-handed manner, in the guise of a parenthetical afterthought explaining to his readers why the book includes no reproduction of the essential Winter Garden photo:

> (I cannot reproduce the Winter Garden Photograph. It exists only for me. For you, it would be nothing but an indifferent picture, one of the thousand manifestations of the 'ordinary'; it cannot in any way constitute the visible object of a science; it cannot establish an objectivity, in the positive sense of the term; at most it would interest your *studium*: that period, clothes, photogeny; but in it, for you, no wound.)
>
> (Barthes 1981: 73)

Just having been persuaded by Barthes to open themselves to the potential wound of any photograph, to the partial detail which might be different for each viewer, the readers of *Camera Lucida* find themselves confronted by Barthes's aggressive giving and taking-away of the Winter Garden's *punctum*, not to mention his compulsion to make them conscious of this censorship. As Barthes himself describes this imbalance, 'to reading's *Dearth-of-Image* corresponds the Photograph's *Totality-of-Image*' (ibid: 89). In lieu of sharing Barthes's sight of the image

of totality, the readers must reinforce their blind trust in the substitutional efficacy of his *phylos*, his suture.

One of Barthes's subtlest readers sees no incongruity here. Instead of taking Barthes's censorship as a performative aggression of the reader, Ned Lukacher understands it to affirm Barthes's critical acceptance of the fading of the subject and the disintegration of presence. In Lukacher's opinion:

> no reproduction could reproduce what is important to Barthes about the image of his mother. . . . It is the peculiar rhythm of the image and the peculiar rhythm of the voice that create the 'tonal instability', the 'fading', of presence. In *La Chambre claire*, he calls this destabilizing focal detail the 'punctum,' the point in the image where presence seems to leak out.
>
> (Lukacher 1986: 77–8)

Lukacher proposes this compelling interpretation in the context of a subtle discussion of Barthes's stress on the slippage and instability of presence. Yet, it might be the reinscription of just such presence that is at stake here. For Barthes's censorship openly denies the reader access to the photographic *punctum*, thus reestablishing privilege as the fortune of authorship.

Only the author here can glean the 'infra-knowledge' of the Winter Garden photograph. This is acquired, so Barthes maintains, from the piercing sight that supplies the viewer with a fetishistic collection of partial objects. By so depriving the reader of the *punctum*'s fetishism, Barthes forecloses the photographic gaze which would permit 'the [imagined male] reader to manipulate the woman's body phantasmally, to do with it what he will, to imagine it in the future tense, caught up in a scene adapted to his desire and to his benefit' (Barthes 1985: 106–7). But this is not to say that Barthes demystifies the gaze itself by combatting fetishism with the eradication of its easy access. I would argue instead that Barthes here doubles to his own benefit the logic of fetishistic disavowal. For he frames his discussion of the motherly *punctum* with a denial of the significance of his broken promise of access. '*I know very well*', he might have written, 'that the *punctum*'s not there for you . . . *but nevertheless* you can imagine it to be phantasmally present.' In smoothing over the vicissitudes of access, the textual *phylos* makes the logic of the fetish all the more operable; it fetishizes the fetish.[9]

Photo-Medusa

While veiling the essential lack of the body of Barthes's mother in the *phylos* of writing, *Camera Lucida* also enhances specular titillation by teasing the reader with the phantasm of what remains concealed.

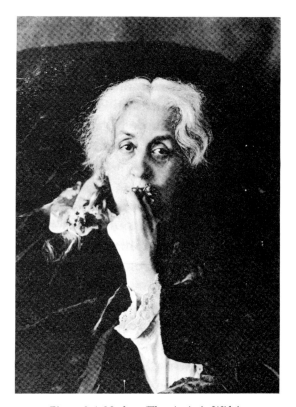

Figure 3.1 Nadar, 'The Artist's Wife'

Readers of this book may find themselves surprised, if not captivated, by a substitute image which is positioned in the exact place one would expect to view the Winter Garden photo. Appearing immediately after this phrase, 'I could not define [the Winter Garden photo] better than by this feature', is a reproduction of Nadar's photograph of his 'mother', or, as Barthes quips, of 'his wife – no one knows for certain' (figure 3.1).[10] This textual oedipalization is doubled by the details of Nadar's photograph, which Barthes praises for containing 'more than what the technical being of photography can reasonably offer' (Barthes 1981: 70). In one stunning shift from writing to image, textual *hyphologie* thus gives way to the *punctum* of an unrestrained display of the bodily fabric of woman. Especially striking is how this photograph's bright foreground lighting (Lacan's *lumière*?) works to withdraw the female figure from the photo's dark recesses, where the subject's black costume blends

indistinguishably with the background. The sharp contrast of the lighting interacts with the body and its lacey garments to double in difference the small V-shaped fold of the sleeve's finely laced border, the flow and excess of the mother–wife's hair, bright as silver, not to mention the wispy braid which floats free to the left on a plane of darkness. Here is a photo replete with the fetishistic details of female body parts and the mysterious folds of womanly costume – those unqualifiable traits which might easily submit the viewer to a good pictorial wounding.

But just how much can be claimed for the V-shaped folds and wispy hairs of this substitute photograph? Could the fetishistic catalogue provided by one photo's illumination possibly be sufficient to emblematize the suture in operation throughout *Camera Lucida*? This may well be the case, especially if Nadar's mother–wife is read in the context of Barthes's analyses of comparable motifs. If placed adjacent to Barthes's analysis of the fetish, in 'Erté, or À la lettre', Nadar's photo may help to illuminate the web sustaining Barthes's substitution of a photo of a mother–wife for that of an innocent little girl:

> Anthropologically, by a very old metonymy appearing out of the mists of time – since religion obliges Women to hide it (to desexualize it) upon entering a place of worship – her head of hair is Woman herself, in her instituting difference. Poetically, hair is a total substance, close to the great vital milieu, marine or vegetal, ocean or forest, the fetish-object par excellence in which man immerses himself (Baudelaire). Functionally, it is that part of the body which can immediately become a garment, not so much because it can cover the body, but because it performs without preparation the neurotic task of any garment, which must, like the blush which reddens a shamed face, at once conceal and parade the body. Symbolically, finally, the head of hair is 'what can be braided' (like the hair of the pubis): a fetish which Freud places at the origin of weaving (institutionally devolving upon women): the braid is a substitute for the missing penis (this is the very definition of the fetish), so that 'to cut off the braids' . . . is a castrating act.
>
> (Barthes 1985: 108–9)

The institutional difference of woman is said here to be constituted by her fibrous threat to the subjectivity of man. Hair is the fetish-object in which man loses himself. Although Barthes shifts his focus from hair to the fetishistic letter in analyzing Erté's alphabet series,[11] *Camera Lucida*'s opening pages on the photographic imaginary isolate two Renaissance artists whose pictures enshrine the female head of hair as artistic come-on: 'If only I could "come out" on paper as on a classical canvas, endowed with a noble expression – thoughtful, intelligent, etc! In short, if I could be "painted" (by Titian) or drawn (by Clouet)!' (Barthes 1980:

79

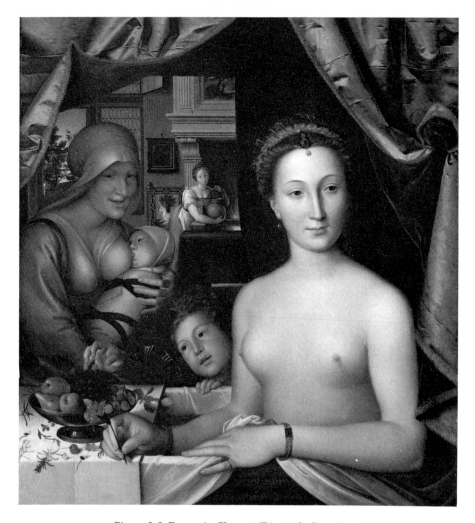

Figure 3.2 François Clouet, 'Diane de Poitiers'.
(Courtesy: National Gallery of Art, Washington, DC)

11). What 'come out' of the picture plane, when both Clouet and Titian portray women, are less the abstract elements of noble expression than the physical endowments of female sexuality. To begin with Clouet's memorable painting *Diane de Poitiers* (figure 3.2), I note how Clouet exaggerates the pictorial convention of Diane's beauty by contrasting her fine features and delicately shaped breasts with the coarser traits of a wet-nurse giving suck in the background. It could also be argued that Clouet revolutionized the fetishism of female portraiture by infusing the fine lines of drawing with the precious detail of the fetish.

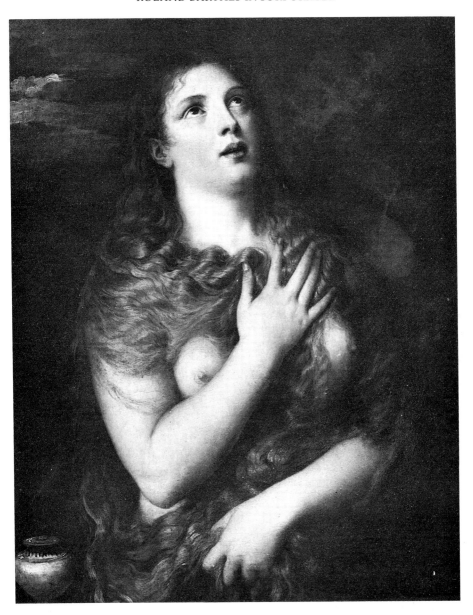

Figure 3.3 Titian, 'Mary Magdalen', Palatine Gallery, Pitti Palace.
(Courtesy: Alinari/Art Resource, New York)

This is particularly true in the way his drawings displace and condense the painterly convention of erotic, frontal depictions of Diane de Poitiers. Even his own painting of Diane displays his focus on individual strands, knots, and curls of female hair. His drawn portraits, moreover, abandon the tired theme of bare-breasted beauty to dwell on the finely crafted headdresses of female subjects. It would hardly be an exaggeration to suggest that hair functions poetically in Clouet's precisely turned drawings to symbolize the total substance of female beauty. By sharp contrast, Titian's more memorable depictions of female hair openly exhibit the Christian motif of woman's concealing parade of shameful sexuality. This is particularly true in his unforgettable painting of Mary Magdalen, hanging in the Pitti Palace (figure 3.3). In this moderately sized painting, Titian enshrouds Mary Magdalen's sexualized, female body in overabundant, flowing tresses which the repentant woman grasps poignantly in a knot, just above her groin. In a performative gesture thick with paint, the artist depicts the excessive hair of the tainted woman as both concealing and parading her castrating body.

But even though Barthes alludes to the work of Titian and Clouet and dwells on the hairs of Erté, he shuns similar hirsute elements in discussing his favorite photos. In describing the *punctum* of Mapplethorpe's portrait of Robert Wilson and Philip Glass (figure 3.4), he concentrates on the unlocatable attraction of Bob Wilson rather than mention Philip's unkempt locks. Similarly, in treating Mapplethorpe's self-portrait, *Young Man with Arm Extended* (figure 3.5), Barthes locates the picture's 'kairos of desire' in the open hand, not also in the untamed ringlets hanging aimlessly from the V of Robert's nude armpit (ringlets which also frame the penetrating handle of the whip featured in Mapplethorpe's stunning self-portrait in leather of 1978 – indeed, Mapplethorpe easily wrought through photography the erotic detail of hair that Clouet rendered in drawing). Nor does Barthes mention his mother's hair in his initial description of her face, hands, and expression in the Winter Garden photo; not, that is, until a parenthetical comment much later in his text makes a condensed reference to 'her hair, her skin, her dress, her gaze' (Barthes 1981: 82).[12] So it goes, then, that the picture of Nadar's mother–wife, to return to the reason for taking this hairy detour, stands forth as the silent supplement of what is neither shown nor openly spoken about the essential photo, the Winter Garden. Only indirectly, then, as if by mistake, does the untamed body of hair, especially the mother–wife's hair, appear within the field of *Camera Lucida*'s gaze to depict the threat posed to phallocratic discourse by the nuanced presence of the Other.

Nowhere is this more ironically evident than in Barthes's initial description of the Winter Garden photograph. The little girl is said to stand

Figure 3.4 Robert Mapplethorpe, 'Philip Glass and Robert Wilson', 1976.
(Copyright © 1976 The Estate of Robert Mapplethorpe)

with her brother in the hemplike aperture of a Winter Garden: 'dans la trouée des feuillages et des palmes de la serre' (Barthes 1980: 106). Here, the enunciational frame, the device presenting the absent photo to the reader, is itself a doubled figuration of the leafy, even vaginal, enclosure of nature and its architectural re-construction, 'the gap of the conservatory's foliage and the ornamental palm'. Much like the bobbin and the Winter Garden photo itself, the linguistic ornament, the relay of language, here inscribes the suture of representation in the gap it seeks to censor through supplementation.[13]

What's more, this *mise-en-abîme* continues to generate more scenarios of representational negation in Richard Howard's translation, *Camera Lucida*. As if it were necessary to restage Barthes's aversion to the pubescent weave, Howard acts on behalf of Barthes by reenacting the

83

Figure 3.5 Robert Mapplethorpe, 'Self-Portrait', 1975.
(Copyright © 1975 The Estate of Robert Mapplethorpe)

author's failed censorship. Howard neutralizes the leafy aperture, 'dans la trouée des feuillages et des palmes de la serre', by transforming it into a naturalistic, metaphysical canopy: 'under the palms of the Winter Garden'. This time the suture of translation attempts to cover over what remains evident in 'le corps de sa mère' (Barthes's term in *The Pleasure of the Text* for 'mother language'). Wanting to deny the reader any future manipulation of the mother's phantasmatic image, suture operates once again as the mystifying supplement of authorial fetish.

The circuitous nature of the preceding commentary, which departed from the supplementary photo of Nadar's mother–wife, attests to the abysmal complexity of Barthes's writing in the face of photography. A complexity which is not only psychological but also ideological. Whether as writing's defiguration of the mother tongue or as translation's

reenactment of maternal death, the *phylos* of Barthes's textuality is embedded in the source of its dis-pleasure: the disturbing sight of Woman, her instituting difference, her castrating V. In *Roland Barthes*, the writer even explicitly connects his spidery *phylos* with what it fills in for: 'Medusa, or the Spider: castration. She stuns me. (*Elle me sidère*)' (Barthes 1977: 126). This concrete linkage is also echoed by Barthes's response to the Winter Garden photo: 'I suffer, motionless. Cruel, sterile deficiency' (Barthes 1981: 90). Here Barthes returns passively to the primal photo scene lending itself, to recall the language of *Roland Barthes*, to meditation, to 'la sidération'. Thus frozen in the sight of the Medusa figure, Barthes's writing seems univocal about its designation. '*I* see *the fissure of the subject*' (Barthes 1977: 5).

This clearly affirms the thesis voiced by Naomi Schor that Barthes's aesthetics is an icon of castration, one figured emblematically by the gap, slash, opening: by the V. Schor's reading benefits from the pressure she places on Barthes's aesthetic detail, that part-object which becomes 'the privileged point of contact between reader and text: the discursive punctum is the hook onto which the reader may hitch her own fantasies, fasten his own individual myths' (Schor 1987: 96). While this thesis fits the fabric of the preceding discussion, it too provides only a partial explanation of the dilemma posed by Part Two of *Camera Lucida*: the 'why' of the censorship of the Winter Garden photo. After baiting the viewer's phantasmatic hook, Barthes wistfully withdraws the photographic lure of the Winter Garden connecting reader and text.

His method of doing so, moreover, cryptically casts on to the reader the aspersions of the Medusa herself. I make this suggestion while recalling that Medusa stands forth in *Roland Barthes* as the threatening (female) figure of Doxa, opinion. It is Doxa who excludes and oppresses the Roland Barthes self-described as a 'Man of paradox'. In *Camera Lucida*, Barthes preserves his own territory by doubling the gestures of photographic paradox and phenomenological certainty. Consider, for example, the significance of his departure from the mainstream of theoretical opinion (Doxa) in downplaying photography's technical debt to painting's *camera obscura* and photographic voyeurism. Rather than identify the photographic process with the operator's '"little hole" (*stenotope*) through which he looks, limits, frames, and perspectivizes' (Barthes 1981: 9–10), Barthes emphasizes the contrasting relay of *camera lucida*, 'the name of that apparatus, anterior to Photography, which permitted drawing an object through a prism, one eye on the model, the other on the paper' (ibid.: 106). In so privileging the apparatus of composition – one eye on the model, the other on the paper – *Camera Lucida* positions the photo-text in the relay of authorship as distinguished from the free-floating terrain of 'the writer' as well as from the empirical inconstancy of reception, Doxa. Thus safeguarded by this

machinery of composition is the phenomonological *certainty* of the image, returning to Barthes's debt to Sartre, one located in an '*arrest* of interpretation' (ibid.: 107). Guided by the sureness of his light, Barthes's compositions on photography stand apart from the flux of darkness on the transcendental terrain he calls 'Ur-Doxa'.

MELANCHOLIC MADNESS

Let us not forget, still in dialogue with Naomi Schor, that Part Two of *Camera Lucida* also abandons desire, the hook of readerly fantasy, for the sake of mourning. To some degree, Barthes's concealment of the Winter Garden photo mimics the privatization of mourning analyzed by Freud, in which the bereaved retreats from the world which death has made poor and empty. Mourning's turn from reality is thus marked less by the loss of the object itself than by a compulsion to cling to it through hallucinatory wishful psychosis, in this case Barthes's own prismatic fetishization of the dead mother in the image of childhood. Barthes himself makes a similar point in alluding to the Winter Garden photo as his 'Ariadne, not because it would help me discover a secret thing (monster or treasure), but because it would tell me what constituted that thread which drew me toward Photography . . . what we romantically call love and death' (Barthes 1981: 73). And yet this is no romantic Ariadne that guides Barthes's hand. Speaking elsewhere of photography's essential futurelessness, he situates its *eidos* as lying beyond mourning in the land of melancholy. 'It is said that mourning, by its gradual labor, slowly erases the pain; I could not, I cannot believe this' (ibid.: 75). Alone with the Winter Garden photo, Barthes laments that 'nothing in it can transform grief into mourning' (ibid.: 90). Photography in this sense not only fails to function as a wishful memory device but it also 'actually blocks memory, quickly becomes a counter-memory' (ibid.: 91). Through such a melancholy-like apparatus, the specificity of object-loss is henceforth withdrawn from consciousness. The relay or Ariadne, in this instance, is not the Winter Garden photograph itself but, here anew, the complex mechanism of its censorship, this time making it difficult for reader and author alike to clarify exactly *what* has been lost.

Two related trajectories can be traced to grasp the extent to which *Camera Lucida* reads as a map of melancholy. One is mechanical, the other narrational. One reflects the transfer of photography, the other the counter-transfer of writing. Both revolve around the Winter Garden photograph, whose image encloses death in the trajectory of method. The first duplicates the melancholic's regression from object-loss to narcissistic identification. Photography is said by Barthes to enact a monstrous immobilization of time, one in which 'Time is engorged'. Personified by such a mechanical devouring of time is the melancholic's

regression into the narcissistic oral phase through which s/he 'incorpor-
ates the object into itself by devouring it' (Freud 1953–74: XIV, 249).
Called to mind by this condition is Barthes's methodological descent
'into himself' as well as his literal incorporation of the Winter Garden
photo. Not only does he 'engender' his mother in her illness (Barthes
1981: 72), but he also reverses the tides of regression by claiming the
Winter Garden child as 'my little girl', 'my feminine child'.[14]

In this sense, Barthes's text resembles the endoscopic machinery of
the reliquaries constructed by one of his favorite artists, Réquichot. This
is the machinery which Barthes equates with primary narcissism in his
text on the artist: 'Is not the body's internal magma which is placed here,
at the limit of our gaze, as a deep field? Does not a baroque and funeral
concept govern the exhibition of the anterior body, *the body before the
mirror-stage?*' (Barthes 1985: 208) Incorporated by melancholy's endo-
scopic machinery is not merely the Medusa-gaze discussed above but
the gaze itself. Foreclosed is the *mise-en-scène* of the mirror stage, that
which permits the viewing subject cognitive, although mediated, access
to the mother. As Barthes describes a similar moment in Proust, 'the
Mother is not forbidden, she is foreclosed, and I go mad' (Barthes 1978:
178).

The second trajectory of melancholic madness surfaces less in
Barthes's concepts than in his language. One poignant detail suggests
how his prose also sets in motion the endoscopic machinery of melan-
choly. *Camera Lucida* consistently describes the *punctum* of his mother's
youthful portrait as *flou*, *pâli*. The economical depth of this written
portraiture goes far beyond the sense of 'vague, faded' as Howard
translates the terms. *Flou*, for instance, also appears in photographic
glossaries, in the technical sense of a *photo floue*: that is, as an unfocused,
irresolute image, one embodying materially the alternate definition of
flou as uncertainty and doubt. This play on Barthes's language illustrates
the frailty of narrational suture. For the written supplementation of the
certain image of the mother's death is precisely what evokes the inevi-
table erasure of interpretational certainty. It ruptures the hermeneutical
circle guaranteeing the results of any efforts to read closely, or as the
French might put it, *pâlir sur les livres*. The derailment of hermeneutics
suggested by *flou* thus works metonymically to broaden the connotation
of *pâli*. While *pâli* denotes the faded surface of an old photograph, it also
connotes the fading of subjectivity in the face of death, the emptying of
ego catalyzed by photographic melancholia.

In *A Lover's Discourse*, Barthes voices the extremes of mourning and
melancholy this way: 'the silent Mother does not tell me what I am: I am
no longer established, I drift painfully, without existence' (Barthes 1978:
200). If death in *Camera Lucida* bears any relation to the mutism of *A
Lover's Discourse*, the wound of the photographic *punctum* corresponds

sharply to Freud's description of the complex of melancholia. To Freud, melancholia 'behaves like an open wound, drawing to itself cathectic energies . . . from all directions, and emptying the ego until it is totally impoverished' (Freud 1953–74: XIV, 249). Barthes himself seems to pick up this thread in the section of *A Lover's Discourse* entitled 'Fading': 'the fading of the love object is the terrifying return of the Wicked Mother, the inexplicable retreat of love I am not destroyed, but dropped here, as refuse' (Barthes 1978: 130).

From destroyed subject to subjective waste, *Camera Lucida* envelops itself in the material of melancholy. And even though this text need not be relegated to an exact identification with melancholy, the pervasive madness shaping the narration of the Winter Garden photo stands forth as a poignant remnant of the twisted threads of love and death – 'to that crazy point', in Barthes's words, 'where affect (love, compassions, grief, enthusiasm, desire) is a guarantee of Being. It then approaches, to all intents, madness; it joins what Kristeva calls "la vérité folle"' (Barthes 1981: 113). This reference to Kristeva, although brief and allusive, is a fundamental thread of Barthes's *phylos* which remains underdeveloped in critical analyses of *Camera Lucida*.[15] In her text, 'The True-Real', included in the collection, *Folle vérité: vérité et vraisemblance du texte psychotique* (Kristeva and Ribettes 1979: 216–37), she discusses how 'truth' is grounded in the split subject of enunciation, 'the permanent fluctuation in speech between a subject *I*, and an I-object/I-refuse, an *I* referring to objects' (Kristeva 1986: 234). This oscillation of the subject, the kind exemplified by Barthes in *Camera Lucida*, turns less around the question of 'truth' (essence or noeme) than around the tensions of reality, prohibition, drive, as well as their conflicts resolved by denial. Resolution occurs through 'a process of *subtle suture* between different orders' (ibid.: 219) in which the subject comes to fruition as the complement of its suturing discourse. Kristeva's broader discussion of the subject's relation to language via narcissism implies even more about the ideological complexity of suture in *Camera Lucida*. Readers of Kristeva will recall that the symbolic suture enacts the censorship of affect and the rejection of the maternal flesh. In a way not unfamiliar to the strategy of *Camera Lucida*, the production of subjectivity – or the *mise-en-scène* of authorship – depends, in Kristeva's terms, on the abjection of the mother, on the linguistic transformation of vaginal flesh.

Abjection is not difficult to locate in *Camera Lucida*, since Barthes spurns all adult photos of his mother. Particularly interesting is his admission of 'engulfing himself (*je m'abîmais*)' in one of them. This photo, published as the frontispiece of *Roland Barthes*, provides an out-of-focus glimpse of his mother as a young, vibrant woman walking directly toward the camera on the beach at Les Landes. Her figure, like that of the little girl in the Winter Garden, is *flou, pâli*. Among the details

more in focus than others are her shadow, her belt, the V-neck of her dress, and her hair, which frames a grotesquely distorted face. Although this image conceals what is said to typify the mother's many photos, 'the brightness of her eyes', it does capture a certain exhibitionism, maybe even flirtation with the camera. As Barthes says of his mother, she 'let' herself be photographed, she 'gave herself' to photography.

Barthes's rejection of the photographic truth of this picture, the one which had previously grabbed him, exemplifies the paradoxical fate of all special photographs:

> The only way I can transform the Photograph is into refuse: either the drawer or the wastebasket. Not only does it commonly have the fate of paper (perishable), but even if it is attached to more lasting supports, it is still mortal: like a living organism, it is born on the level of the sprouting silver grains, it flourishes a moment, then ages . . . Attacked by light, by humidity, it fades, weakens, vanishes; there is nothing left to do but throw it away.
>
> (Barthes 1981: 93)

What is fascinating about this passage is how abjection represents much more than an act of violation against a particular picture and its own enactment of 'Death'. Abjection is inscribed in the photograph itself through the structural component of silver, which functions both as the *punctum*'s unique support and as its agent of mortality. Favoring photography's debt to chemistry over its traditional link to the *camera obscura*, Barthes understands photography's noeme, *Ça-a-été*, to be possible only through the chemical wonder of silver halogens capable of recovering and printing directly the luminous rays of a photo's variously lit subject. 'The loved body is immortalized by the mediation of a precious metal, silver' (ibid.: 81). Silver is the agent of photographic arrest, 'flat Death', that projects while paralyzing figures of love such as Barthes's mother or the silver-haired body of Nadar's mother–wife. The chemical machinery of photography thus functions in a way similar to the famous bronzed shield of Perseus. Like its mythical analogue, photographic silver transfers the primal wound of Medusa on to the deadly mirror of representation: *Ça-a-été*.[16] While photographic representations of the Medusa and her cousins may continue to petrify their beholders, their hallucinatory *punctum* depends on the image's impossible resistance to the entropic erosions of its chemical support. Silver, then, is the privileged agent of photography's essence as well as its engine of eventual abjection.

ROLAND BARTHES INCORPORATED

In *Camera Lucida*, however, the 'abjective' agency of silver acquires an ambivalent hallucinatory value of its own. As an apparatus of the author

who is wounded by the sight of the Winter Garden image, narrative abjection aggressively transforms Barthes's birth-source into his infant-mother, 'my little girl', 'my feminine child'. In holding the narrative key to the mother-abjected, the father-son makes way for narrative rebirth. Through this process of abjective supplementation, narrative thus fulfills the 'being' of photography, at least as Barthes defines it in *A Lover's Discourse*: 'The image is perfectly adapted to this temporal deception: distinct, abrupt, framed, it is already (again, always) a memory (the nature of the photograph is not to represent but to memorialize [*de remémorer*])' (Barthes 1978: 194). By standing in for the Winter Garden photo, the text of *Camera Lucida* functions as a textual epitaph foregrounding the *punctum* as always already a memory of abjection, a trace of the putrefaction of reference.

This adherence of decayed reference to photographic memorialization also catches Derrida's eye when he reflects on the 'adhering referent' in *Camera Lucida*:

> Although [the referent] is no longer *there* (present, living, real, etc.), its *avoir-été-là* now being a part of the referential or intentional structure of my relation to the *photogramme*, the return of the referent assumes the form of an obsession. It's a 'death drive' whose spectral arrival in the space itself of the *photogramme* truly resembles that of an emission or an emanation. Already a sort of hallucinating metonymy: it's something, a fragment come from the other (the referent) which finds itself in me, before me but also in me as a part of me.
>
> (Derrida 1987a: 292)

Memory itself, as a sort of hallucinating metonymy, thus always already stands before the reader's encounter with *Camera Lucida* as a part of the putrefying core of self-reference. Still, the promise of Derrida's intuitive reading of *Camera Lucida* is disrupted by Barthes's curiously explicit change of heart when he contradicts his earlier position by refuting the role of *remémoration* in photography: 'The Photograph does not memorialize (*ne remémore pas*) the past (nothing Proustian in a photograph)' (Barthes 1981: 82). Rather than being encapsulated in an emission or emanation of reference, the ultimate essence of photography is finally claimed by Barthes to be structurally contingent on sentiment, that is, on the viewer's immediate empathetic identification: pity.[17]

There remains, however, a structural link in Barthes's text between pity and the kind of hallucinating metonymy singled out by Derrida. This is the trace of the *retour de mort*, the textual specter of the abject matter of melancholic incorporation made poignantly manifest by the vicissitudes of self-pity. Especially if approached from the theoretical

viewpoint of Abraham and Torok, incorporation can be understood as a bridge between pity and *remémoration* in *Camera Lucida*. In their analyses of melancholy (1976, 1987), Abraham and Torok distinguish between two differing means of taking in loss: introjection and incorporation. Introjection corresponds to the procedure of narrative supplementation discussed above: words replace lost maternal presence through which the presence of an object gives way to an auto-apprehension of its absence. Regarding abjection, this figuration of presence can be understood only in the midst (*qu'au sein*) of a 'community of empty mouths' (Abraham and Torok 1987: 262–3). By contrast, incorporation is the denial of the denial of loss – the refusal of mourning itself to the extent of censoring the inconsolability of loss. The lament that cannot be spoken then installs 'a secret crypt' in the subject where a phantasmatic world sustains a separate and occult life. 'Cryptophoria' is the condition of not being able to do otherwise than perpetuate a lost clandestine crime of pleasure by establishing it as an hallucination, an 'intrapsychic secret' (ibid.: 266–7). Abraham and Torok cite the Wolf Man, who 'carried' his sister in such a way, as the exemplary case history of incorporation. And, as they stress through the example of Freud, cryptation produces false leads and weak sutures for the analyst. It feeds on 'anti-metaphor', which defigures interpretation.[18]

Returning to the case of *Camera Lucida*, a sort of cryptophoria might be isolated as the discursive carrier of melancholic phobia. We might consider, for example, how the text has seduced readers into focusing either on its sociological significance as a treatise of photography or on its psychological significance as the author's personal discourse on the death of his mother. Both routes reveal the true madness, *la vérité folle*, that marks this text. In each instance, Barthes writes, photography 'becomes a bizarre *medium*, a new form of hallucination: false on the level of perception, true on the level of time: a temporal hallucination . . . a mad image, chafed by reality' (Barthes 1981: 115). Yet neither the photographic *eidos* nor its designation of loss, *Ça-a-été*, seems to embody the sort of hallucination, the perpetuation of lost clandestine criminal pleasure, typical of cryptophoria. Neither seems to lead beyond the image to what Barthes calls 'a stilled center, an erotic or lacerating value buried in myself' (ibid.: 16).

To isolate a significantly different clandestine trace in the pages of *Camera Lucida*, permit me to return to the well-worn theme of Barthes's foster-parenthood of his mother. I do so, however, not to provide a final psychoanalytical solution to the mystery of *Camera Lucida*, but to flush out an additional sequence of 'lacerating values' which promise to function like the *punctum* in energizing the flow of textual fantasy. Indeed, the anticipated result of any further probing of Barthes's 'stilled center' is that it will serve as a critical catalyst, instead of an hermeneutical

foreclosure, of additional readings of this text and its cherished photographs.

As if itself an hallucination, Barthes's paternalistic adoption of his mother mimics a childhood moment recalled in *Roland Barthes*. Accompanying the pictures of his father, who died in the war during Roland's childhood, an inscription reveals that Barthes's mother assumed the role of speaking on behalf of his lost father: 'By maternal intermediary his memory – never an oppressive one – merely touched the surface of childhood with an almost silent bounty' (Barthes 1977: 19). Much could be made of the fact that *Camera Lucida* utters hardly a peep about Barthes's father. When it does, in commenting on a photograph of 'my father as a child' (Barthes 1981: 105), the text transforms the silent bounty of fatherhood into the 'lineaments' of the species, into the facial surface of childhood. It thus envelops the barely audible and visual pleasure of the father's memory in a childlike nostalgia, in a tomblike/womblike silence. Still, this observation contributes little in itself to an understanding of this text's mechanisms of ideological fantasy. For any subsequent analytical amplification of Barthes's nostalgia of paternal pleasure, while fascinating in itself, will do little more than continue to encrypt the text in a purely privatized frame, one aiming at nothing more ideological than primal cohesiveness, 'a certain persistence of the species' (Barthes 1981: 105).

The pertinent question, it seems to me, is whether Barthes's endoscopic machinery links up at all to the highly ideological past of his textual history, to his effacement of authorship and the attendant death-blow it dealt to metaphysics. Might there not be significantly more hallucinatory matter awaiting regeneration in this photo essay whose boundaries ask to be seen, in Réda Bensmaïa's opinion, 'in a sort of perpetual mobility: no fixed sender, no unified subject or themes, and finally, no definite addressee' (Bensmaïa 1987: 90)?

There may be one particular ideological phantasm which is carried and renewed by 'perpetual mobility', that is, by the same feature denying designation which Bensmaïa isolates as the decentering device of the text. While it cannot be said to represent anything other than an 'indefinite addressee', it camouflages itself among the thematic lures and sutures of Medusa, silver, and lead. And as an appealing phantasm of clandestine pleasure, it underlies the methodological hopes of phenomenology and psychoanalysis. Finally it lends urgency to reconsideration of Barthes's enthusiastic embrace of Kristeva's *folle verité*. This phantasm, one made clandestine by Barthes's own writing, is 'the desired object, the beloved body' of metaphysics itself.

To suggest the extent to which metaphysics rests encrypted in *Camera Lucida*, I would like to cite a passage from Kristeva's text 'Stabat Mater.' Her analysis of the Virgin Mary's avoidance of death could be said to

resituate Barthes's transformation of his mother into his 'feminine child' within the historical allegory of Christian metaphysics:

> [The Virgin Mary's] transition [or Assumption] is more passive in the Eastern Church: it is a Dormition (*Koimesis*) during which, according to a number of iconographic representations, Mary can be seen changed into a little girl in the arms of her son who henceforth becomes her father; she thus reverses her role as Mother into a Daughter's role for the greater pleasure of those who enjoy Freud's 'Theme of the Three Caskets'.
>
> (Kristeva 1986: 168–9)

One bearer of the pleasure of the three caskets common to the texts of Freud, Shakespeare, Barthes, and even Greek Orthodoxy is paternal *logos* or speech. Whether framed by the lead casket of *The Merchant of Venice*, the silent eloquence of *King Lear*, the leaden support of iconographic stained glass, or the *flou*, *pâli* focus of the Winter Garden, the girl-child always seems to reflect the transcendental *logos* of the father. By thus adapting the censored image of the 'girl-child' to the glimmering *logos* of Barthes's pen, *Camera Lucida* preserves the overinflated hallucination of the benevolent goodness of an imaginary father.[19]

This is nowhere more evident than in the text's extensive valorization of the apparatus of silver which supports both camera and abjection, and which links the *pâle* visage of the Winter Garden to the silver-gray hair of Nadar's mother-wife. While the silver imprint of the imaginary father may not be readily apparent in *Camera Lucida*, a brief mention of Paul Claudel's essay 'Silver and silver-plate' should account for the high metaphysical worth of this device: 'Perhaps this pale metal also evokes in my mind a lure of mystical sensibility. In the Bible, silver is the symbol of the speech of God!' (Claudel 1965: 355). Extending from the voice of Barthes to the *logos* of God, silver might be said to provide the hallucinatory lining of *Camera Lucida*. In this vein, it follows that the *punctum*'s maddening 'pity' (*la Pitié*) can be identified in Kristeva, Freud, and Shakespeare as the ecstatic 'piety' of metaphysics.

But rather than enclose the melancholic trajectory of *Camera Lucida* in a full hermeneutic circle, I wish to note in conclusion that even the benevolent father finds himself silenced by the violent machinery of Roland Barthes Incorporated. For the Winter Garden photo should be remembered for reproducing the mournful coming neither of the father nor of the mother but ultimately of the son.

> Always the Photograph *astonishes* me, with an astonishment which endures and renews itself, inexhaustibly. Perhaps this astonishment, this persistence reaches down into the religious substance out of which I am molded [*dont je suis pétri*]; nothing for it:

Photography has something to do with resurrection: might we not say of it what the Byzantines said of the image of Christ which impregnated St Veronica's veil: that it was not made by the hand of man, *acheiropoietos*?

(Barthes 1981: 82)

Might we not say as well that the impregnating crown of thorns, not merely the snakelike image of Medusa, asks to be acknowledged as a secret phantom of *Camera Lucida*'s textual *punctum*? Might we not say also that the blood of Christ, not merely the hair of Mary Magdalen, is what offers to Roland Barthes the stiffening reassurance of his incorporation? And might we not say finally that this, the clandestine delight of son devouring the body/gaze of sacrificed son, stands forth as the writer's lost pleasure of 'photographic ecstasy'? Might not something like this provoke the deictic referent, the final cry of all language, *C'est ça*!?

It goes without saying that such a catalogue of enlivening referents would open *Camera Lucida* to a homoerotic set of hallucinating metonymies very different from those analyzed earlier in this chapter. Phantoms of the bloody image of Christ impregnated on the St Veronica veil emanate from a wide range of homoerotic artistic productions. At the 1989 ACT UP demonstration at New York's St Patrick's Cathedral, for example, the gay video artist Ray Navarro performed as the public's favorite television host, Jesus Christ. Sporting a crown of thorns, 'he showed up at the demo in savior garb, holding a mike wrapped in a beautiful FBN logo – Jesus' own "Fire and Brimstone Network." The only thing he was missing', adds Ellen Spiro in her memorial tribute to Navarro, who since has died of AIDS, 'was a camera but that turned into an asset as he moved around plugging his mike into various people's camcorders, posing for a few precious moments as radical Jesus protesting, as he stated to Testing the Limits, "the church's bastardization of my teachings"' (Spiro 1991: 7).[20] The traditional stage provides yet an earlier example of homoerotic attraction to the figure of Jesus, when Peter Shaffer's young protagonist in *Equus* shocks his father by performing a nightly ritual of masochistic masturbation in front of an exaggerated image of the bleeding Christ. Similar relations are emphasized in the photography of Robert Mapplethorpe. Mapplethorpe's colorful, homoerotic collages of the early 1970s allude in form and theme to his spraypainted *Jesus* (1971), who stands resplendent in a crown of thorns. These allusions are also evident in his later formal experiments with crowning stars and binding crosses – from *Orchid with Palmetto Leaf* and *Self-Portrait (with Gun and Star)* (both 1982) to *Richard* (1978), *Andy Warhol* and *Chest* (both 1987) (Mapplethorpe and Marshall 1988).[21]

On yet a different artistic scene, the figure of Jesus is the prominent

object of homoerotic desire in Derek Jarman's film *The Garden* (1990), his autobiographical reflection on AIDS. So too the homoerotic *punctum* of Caravaggio's many religious paintings provides the point of departure for Jarman's stylized film *Caravaggio*. Bearing in mind the kinship of Barthes's hallucinations of the Veronica veil to this polymorphous homoerotic tradition, I now move on to a broader consideration of analogous 'Dirty Stills' in film and their relation to the homoerotic melancholy of the aesthetics of Derek Jarman.

NOTES

1 This point, of course, is not something unique to photographic theory, but derives from a complex critical tradition. See Benjamin (1969, 1971, 1978); Horkheimer and Adorno (1972); and Kluge (1981–2).

2 Bensmaïa (1987), Ungar (1983), Schor (1987), Lukacher (1986), and Kritzman (1989) theorize in differing ways how Barthes's writing is an 'effect' (to use Bensmaïa's term) of the composition of the partial.

3 I elaborate on my reservations about such a 'skid beyond culture' in the next chapter, 'Dirty stills'.

4 Helpful and elaborate accounts of *Camera Lucida*'s many allusions to Sartre and his philosophical forerunners are provided by Halley (1982), Shapiro (1989), and Wiseman (1989).

5 Burgin (1986: 86) points out that Richard Howard's translation of *objet partiel* as 'partial object' underemphasizes the play on the psychoanalytic term 'part-object'.

6 Willis (1987: 56) also relates Barthes's use of this concept in *Camera Lucida* to the function of 'suture' in film theory. Astute overviews of the theory of suture are available in Heath (1981: 76–112) and Silverman (1983: 194–236).

7 I here adopt Heath's helpful translation (1981: 81).

8 Compagnon (1979: 191–6) provides an invaluable analysis of the differences between *Verneinung* and *Verwerfung*. In a superb account of 'gynotextual activity' in Barthes's writing, Kritzman (1989: 116) goes so far as to suggest that, in *Camera Lucida*, 'Barthes's writing puts forth the desire to preserve the unravished purity of illusion in which the filial subject opts for symbiotic dependency with a singular maternal figure'.

9 The textual economy suggested by such 'fetishizing the fetish' inscribes the text in a doubling supplementation of loss, very similar to that enacted by suture in film. Consider the representational effect of Barthes's narrative supplementation of the Winter Garden photo on the reader for whom the 'discursive *punctum*', in Schor's words (1987: 95), 'draws its force from its indexation on a referent guaranteed by a subject, apprehended in his or her most intimate specificity'. When the text thereby appropriates through deprivation and supplementation the 'intimate specificity' of the subject, it replicates the effects of film's multiple cuts and negations discussed by Silverman: 'each positive cinematic assertion represents an imaginary conversion of whole series of negative ones. This castrating coherence, this definition of a discursive position for the viewing subject which necessitates not only its loss of being, but the repudiation of alternative discourses, is one of the chief aims of the system of suture' (Silverman 1983: 205).

10 It is actually his wife! It should be noted that this correlation of Barthes's text

with the layout of Nadar's photograph holds true only in the original French text, *La chambre claire*. In the translation, the photograph faces the text. While this difference can be attributed to the idiosyncracies of typesize and layout, many features of the printed translation remain indifferent, indeed counterproductive, to the intertextual detail of *La chambre claire*. Aside from the problem of translation, discussed above and below, Richard Howard's most egregious emendation is his elimination of the carefully designed marginalia scattered throughout *La Chambre claire* and the three-page bibliography concluding the French text. While Howard sometimes transforms a marginal source into a direct quotation ('it joins what Kristeva calls *la vérité folle*' (Barthes 1981: 113), he drops the subtler marginalia altogether, thereby silencing Barthes's citation of specific passages in Proust or his pointed references to such interlocutors as Edgar Morin and Philippe Lacoue-Labarthe. The violation motivating the printed translation even extends to the semiotic framing of the cover. As pointed out by Burgin, '*Camera Lucida* itself leaves something out; in a strictly literal sense, in respect of *this* book at least, it is Barthes's last word; I close my copy of *Camera Lucida*. The back cover is, entirely, a photograph of Barthes. I close my copy of *La chambre claire*. There is no photograph. The back cover carries an emblematically enlarged quotation from a work called *Practice of the Tibetan Way*. It seems peculiarly apt to me that the English-language version of this work should conclude with a portrait of the author; whereas the author chose to end it all with a paradoxical text' (Burgin 1986: 91–2). Still, it could be argued that this reemergence of the author is more prescient than regressive. For it points to the return of the author, which, I will ultimately suggest, typifies the disturbing hallucination of this *Camera Lucida*.

11 Kritzman analyzes Barthes's characterization of 'Erté's conception of the female body as a fetishized textual object. . . . Unlike the conventional concept of the fetish as a fragment severed from the larger body, it here takes on new meaning in the form of a cultural artifact submitted to the mortifying gesture of a totalized harmonious figuration' (Kritzman 1989: 103–4).

12 This echoes, by the way, Barthes's catalogue of death's partial fetishistic objects in *A Lover's Discourse*: 'I catch myself scrutinizing the loved body. . . . Certain parts of the body are particularly appropriate to this *observation*: eyelashes, nails, roots of the hair, the incomplete objects' (Barthes 1978: 71).

13 Lydon (1989: 127–8) dwells on the noun *serre* to make a fascinating link between the visual world of the Winter Garden and the apparatus of the *Camera Lucida*.

14 Woodward seeks to identify 'something *in between* mourning and melancholia, that we may point to (and may experience) grief that is interminable but not melancholic in the psychoanalytical sense, a grief that is lived in such a way that one is still *in* mourning but no longer *exclusively* devoted to mourning' (Woodward 1990–1: 96). She reads Barthes's textual bereavement of his mother as such a figure and performance of interminable grief. This process is exemplified, she stresses, by the way Barthes seeks to block the work of mourning by *externalizing* the figure of his mother in the form of a photograph. While acknowledging her interesting linkage of interminable grief and Barthes's phenomenological relation to the photograph, I am more interested in how such a phenomenological externalization is disrupted by Barthes's subsequent symbolic introjection of this same image, through which he engorges time and incorporates the mother *into* himself as 'my little girl'.

15 Burgin (1986: 84) is one of the few readers of *Camera Lucida* to read the text in the light of Kristeva's psychoanalytical theory.

16 This reference is indebted to Louis Marin's complex discussion of Caravaggio's representation of Medusa (Marin 1977: 130–76). In Chapter 5, I discuss Marin's work in relation to 'Medusa's head: male hysteria under political pressure' (Hertz 1985: 161–215), where Neil Hertz discusses the compulsion to freeze the Medusa (and her representational threat) in relation to male hysteria.

17 Barthes's turn-away from *remémoration* toward pity marks one of his sharpest conceptual differences from Lacan. In the *Four Fundamental Concepts of Psychoanalysis*, Lacan argues insistently that *repétition* (*Wiederholen*) and its kin, *remémoration* (*Erinnerung*), are significantly different in Freud from *reproduction* (*Reproduzieren*): 'To reproduce is what one thought one could do in the optimistic days of catharsis. One had the primal scene in reproduction as today one has pictures of the great masters for 9 francs 50' (Lacan 1978: 50). Barthes's nostalgic turn to pity could be said to lead his text back to the 'optimistic days of catharsis'. For a critique of such an 'economy of pity' and its relation to the history of theatrical catharsis, see Derrida's reading of Rousseau's *Essay on the Origin of Languages* (1976: 171–90) and Lukacher's fascinating essay 'Anamorphic stuff: Shakespeare, catharsis, Lacan' (Lukacher 1989).

18 I discuss Abraham and Torok in more detail in Chapter 2.

19 *Camera Lucida*'s censorship of the 'girl-child' photo is doubled by Barthes's motivated censorship – negation – of the metaphysical phantom lurking in his text. He curiously frames his reading of the Winter Garden in language revealing a complex economy of censorship shaping his discourse throughout: 'And no more than I would reduce my family to the Family, would I reduce my mother to the Mother. Reading certain general studies, I saw that they might apply quite convincingly to my situation: commenting on Freud (*Moses and Monotheism*), J. J. Goux explains that Judaism rejected the image in order to protect itself from the risk of worshipping the Mother; and that Christianity, by making possible the representation of the maternal feminine, transcended the rigor of the Law for the sake of the Image-Repertoire. Although growing up in a religion-without-images where the Mother is not worshipped (Protestantism) but doubtless formed culturally by Catholic art, when I confronted the Winter Garden Photograph I gave myself up to the Image, to the Image-Repertoire. Thus I could understand my generality; but having understood it, invincibly I escaped it. In the Mother, there was a radiant, irreducible core: my mother' (Barthes 1981: 74–5).

20 For a description of the AIDS demonstration 'Stop the Church', see Crimp and Rolston (1990: 130–41).

21 Among the many essays written on Mapplethorpe since the censorship controversies, those focusing on *Black Book* by Yingling (1990) and Mercer (1991a) provide acute theoretical analyses of Mapplethorpe's homosexual aesthetics.

Part II

DIRTY STILLS

4

DIRTY STILLS
Arcadian retrospection, cinematic hieroglyphs, and blackness run riot in Olivier's *Othello*

The ontological conditions of the motion picture reveal it as inherently porno-graphic The million times in which a shot ended the instant the zipper completed the course down the back of a dress, or in which the lady stepped behind a shower door *exactly* as her robe fell, or in which a piece of clothing fell into the view of a paralyzed camera – these were not sudden enticements or pornographic asides; they were satisfactions, however partial, of an inescapable demand.

(Stanley Cavell, *The World Viewed*)

Just how inescapable is this cinematic demand rendered partial by the vicissitudes of desire? Is the motion of film inextricably linked to the undoing of a zipper or the disrobing of a lady? Does the demand, the need, for pornography really constitute the ontological condition of the moving picture? If so, what does it mean that the ontology of cinema is inscribed in the activation of sexual demand, that is, in the dependence of a cinematic need and the construction of a scopic (sexual) difference? And why is it that the analysis of the ontology of film dwells so readily on the paralysis of the dirty still?

For a partial response to such a complex set of questions, I will turn to a point made by Linda Williams that theorists of realist cinema, like Cavell and his predecessor, André Bazin, are drawn inescapably to 'the perversion of the cinema'. Williams uses this emphatic term to describe how the realist theory of cinema understands perversion as a problem both inherent and disturbing to cinematic form, to its man-ner of representing things outside of their conventional time and space (Williams 1989: 189). Consider, for example, not only how film might dwell excessively on the 'partial' satisfaction of heterosexual undressing (rarely an activity portrayed as reciprocal between the sexes) but also how it might portray – as if conventional – sexual conditions such as sadomasochism or homosexuality or how it could depict – as if domi-nant – social positions normally relegated to subservience by the

hierarchical classification of marks of gender, color, or class. These and similar possibilities fuel the realist anxiety over the contagious 'perversion' of the cinema. To make this point, Williams cites not only Bazin's concern over the pornographic misuse of the 'natural realism' of the medium but also Cavell's more sophisticated line on the ontologically pornographic. Cavell's writings on the character of cinematic filth are particularly important to any consideration of the 'aesthetics' of film since they rely on the assumption, outlined in the preceding epigraph, that the demand as well as the satisfaction of cinematic perversion derives not so much from the stasis of the dirty picture itself as, ironically, from the 'clean movement' constituting the ontological relation between cinema and its 'invisible' spectator. In other words, the ontological conditions of cinema are revealed less by dirty shots of open zippers than by antiseptic movements of cinematic sutures.

This section will discuss the aesthetic disjunctions of dirty stills and clean moves in relation to two films with conflicting methodologies of inescapable demand: Derek Jarman's *Caravaggio* (1983) and Stuart Burge's adaptation of John Dexter's stage production of *Othello*, the film commonly known as 'Olivier's *Othello*' (1965). The next chapter's detailed reading of Jarman's film, which produces an aesthetics of homosexuality, will be introduced here by a much briefer consideration of the pricklish issue of racial identity addressed by the Burge/Dexter adaptation of *Othello*. Both films provide cogent examples of how formal, aesthetic disjunction surfaces with differing ideological specificity in the theory and practice of artistic films addressing the complex matters of gay and racial representation. It is significant, moreover, that the charged reception of the sexual and racial politics of these films is fueled by their status as adaptations of highly valorized Renaissance literary/artistic precedents. At issue in the critical evaluation of both films, then, is also the relation of cinematic realism to the fantasy of Renaissance precedent, a relation marked by the intersections of nostalgia and melancholia on the one hand, and of humanistic criticism and literary politics on the other. As a means of pinpointing these complex mixtures in both films, *Othello* and *Caravaggio*, and their intertwined critical legacies, 'the Renaissance' and 'realism', I plan to put pressure on charged 'nodal points' – pictorial and theoretical 'dirty stills' taken from the films and the critical discourse enveloping them.[1] I might note, from the outset, that my selective focus on 'dirty stills' may well leave my analysis open to the charge of 'foul play'. For my attention will be focused on pictures and notions that might not only obscure many received notions of Renaissance culture but might also run counter to strict realist assumptions about the technology of moving pictures, especially when this movement is compared to the stasis of the two cultural enterprises here discussed as having been adapted to film: theatre and art.

MOVING PICTURES

I wish to spend a few moments of this initial chapter on 'dirty stills' in mapping out the conceptual terrain of cleanliness valued by a realist approach to the combination of literature and film. This is a topography marked more for orderly travels than for wasteful rests. In the view of Stanley Cavell, who holds a somewhat conventional opinion, it is motion that constitutes 'the material basis of the media of movies' – 'a succession of automatic world projections' (Cavell 1979: 167). The fact of 'moving pictures' is significant to Cavell in light of the ontological reflections provoked by the magic of cinematic projection. The motion of being-there is what film makes available to Cavell, the viewer.[2] In *The World Viewed*, he maintains that framed movement expands the ability of art to represent 'a phenomenological frame that is indefinitely extendible and contractible' (ibid.: 25), one that makes film the ideal medium for representing 'the implied presence of the rest of the world, and its explicit rejection' (ibid.: 24).

In this regard, film's ideality is said by Cavell to stand apart from the alienating distance of theatre and the legacy of theatricality inherited by the novel and photography. His sense is that 'setting pictures to motion mechanically overcame . . . the inherent theatricality of the (still) photograph. The development of fast film allowed the subjects of photography to be caught unawares, beyond our or their control' (ibid.: 119). In view of such a doubled epistemology of subject and subjection, Cavell maintains that celluloid entrapment is the essence of film's philosophical beauty – one that captures artistically the experience of human beings taking part in the drama of film.

But what happens to this essence when an essay proposes to toy theoretically with cinematic motion, to suspend it in writing, to transform it, so to speak, in the manner of a serial photograph, of a hieroglyphic inscription, of a filmic image-band? It could be said that such a proposal might not do too much philosophically to tarnish the cinematic beauty described in *The World Viewed*. For the fusion of motion and picture as 'spatial form' is precisely what constitutes the epistemology of presence that Cavell so admires as the ontology of film. Traditionally, this fusion has been associated with the artistic and literary absorption of action in a single energetic moment or trope. Known rhetorically as *ekphrasis*, such fusion is common to figural painting and poetry. In the realm of film, *ekphrasis* might serve as an appropriate figure for that other 'region of theatricality' which Cavell claims to arise when the photographic image is set in motion. This is the region in which 'the presenting of the past world becomes a presentation of it' (ibid.: 119). Here cinematic movement frames a specific theatricalization of action in a single, retrospective moment of energy. The realist advantage of such

103

framing can be understood to derive from the condensed, descriptive effect of *ekphrasis*, what Roland Barthes has called the 'effect of the real': 'the foundation of the unavowed verisimilitude which constitutes the aesthetic of all of the current works of modernity' (Barthes 1968: 88). It is through the garb of unacknowledged verisimilitude, or fictional suture, that realist notions of cinema benefit from the rhetorical hope of *ekphrasis*. How else to understand a critical position like Cavell's that, in cinema, 'nothing revealed by the world in its presence is lost' (ibid.: 119)?[3]

Such a lack of loss clearly needs to be understood as more rhetorical than real, as merely an 'effect of the real'. For the analysis of cinematic construction leads to the inevitable conclusion that figures of filmic presence reveal little more than the occlusion of loss. Whether such occlusion is understood methodologically (the work of frames, splices, sound tracks, etc.), psychoanalytically (the activities of condensation, displacement, and secondary revision) or sociopolitically (the project of ethnocentric presence), it depends on complex procedures of exclusion and foreclosure common to influential strains of film and literature. These strategies involve the geometrical ordering of space and territory as well as the narrative production of patriarchal and ethnocentric narratives, references, hints, riddles, and puns.[4] The dual productions of image and text can be mobilized not only to valorize the phallocratic mode of cultural production but also to effect this sameness, say, by victimizing the body, figure, and notion of woman as well as peoples of racial, social, and sexual difference. Such are the procedures of Occidental representation which, since the Greeks, have attempted to reshape the figures of difference, deviancy, cunning, and strategy – imagine a composite portrait of the Sphinx and the Medusa[5] – in the narrative resolution of dissonance, not to mention in the patriarchal dissemination of the aesthetic standards of goodness in taste, value, and judgement.

PICTURES FROM ARCADIA

We need not limit ourselves to realist film theory to assess the social implications of such an orderly structuring of retrospection for the study of cinematic adaptations of theatre. While not explicitly named as such, retrospection also abounds in Shakespeare's plays as the guarantor of subject and subjection. In *The Tempest*, to cite only one instance, retrospection is the patriarchal and colonial procedure manipulated by Prospero for the common definition of his and his daughter's heterogeneous beings, for the figuration of their combined past and present. In the opening scene, following the storm, Prospero tempers Miranda's theatrical pathos with a partial account of their history. He bolsters his order to Miranda that she 'Be collected, No more amazement' with a

reminder of her ontological dependence on the secret matter of his self-fashioning: 'who / Art ignorant of what thou art, nought knowing / Of whence I am, nor that I am more better / Than Prospero' (I.ii.17–20).[6] Prospero's strategy is to offer his daughter the gift of retrospection as a means of refiguring their temporal and ontological diversity in his patriarchal image. The histories of Prospero and Miranda may be multiple, but their refiguration through his 'art' unifies them in an economical return to the teleological movement toward undifferentiated, phallologocentric Being.

In speaking of the emphasis on retrospection in his filmic adaptation of *The Tempest*, Derek Jarman attributes the drive to look backward directly to Shakespeare, that is, to England: 'our culture is backward-looking and always has been. Shakespeare is backward-looking. What interested me is that Elizabethan England is our cultural Arcadia, as Shakespeare is the essential pivot of our culture' (Field and O'Pray 1985: 49). While such a vision of Shakespeare as the source text of social retrospection might seem curiously nostalgic, if not ethnocentrically perverse,[7] Shakespeare scholars can cite its precedent in the textual and critical legacy left by Heming and Condell. They were the editors of the First Folio collection of Shakespeare's works, published in 1623. In gathering together Shakespeare's many texts as a monument to be looked back on, they tamed the temporal and generic disorderliness of the plays, printed texts, and performances. Not only did they produce their version of a definitive text, but they also subjected the plays to the clean generic division of 'Comedies', 'Histories', and 'Tragedies'.[8] These editorial practices of textual formation and generic classification set a dramatic precedent of privileging literary and bookish codes over the multiple and often contradictory conditions of the plays' collaborative constructions and performances. Indeed, the editorial enterprise of Heming and Condell froze Shakespearean textuality and theatricality into something like an *ekphrastic* monument of unified representation.[9] The editors themselves positioned this corpus as 'the essential pivot' of British culture:

> It is not our province, who onely gather his works, and give them you, to praise him. It is yours that reade him. And there we hope, to your divers capacities, you will finde enough, both to draw, and hold you: for his wit can no more lie hid, then it could be lost. Reade him, therefore; and againe, againe: And if then you doe not like, surely you are in some manifest danger, not to understand him.
>
> (Heming and Condell 1623: A2v)

The constancy of retrospection, 'Reade him, therefore; and againe, againe', is presented by Heming and Condell as if the reality factor of a

cultural arcadia which 'can no more lie hid, then it could be lost'. Only one path, that returning to Shakespeare, is said to provide a confident litmus test of the differences separating the 'manifest danger' of the daftness of mind from its saving opposite, deftness of mind. Or, as Jarman might reformulate this distinction, between the soundness of 'British' mind and the daftness of cultural deprivation, since

> nearly everyone [British] who works in the arts at some point actually pays attention to Shakespeare. The whole myth of Camelot, Blake, Tennyson – you can go through all the English artists – there's the dream of Arcadia. We seem to be the only European culture which really has that dream background.
>
> (Jarman 1985: 49)

Without the Shakespearean corpus, so Heming and Condell might add, the British subject is open to the manifest danger of being Other, of being European or, even worse, of being without that dream background. It is in this context that the unifying retrospection of Shakespeare's multiple texts suggests, as Cavell says of film, both 'the implied presence of the rest of the world, and its explicit rejection' (Cavell 1979: 24). It is the promise of a confident cultural subject that here purports, like the philosopher's stone, to contain or stand in for the danger of its lack or diverse excess.

But what is the lesson to be learned from these digressive remarks on Shakespeare's Folio? As a precedent of filmic retrospection, the Folio may suggest less about issues of historical convention and literary adaptation – the transference of primal memories from canonical literature to media text – than about the habits and strategies of textual construction and reconstruction, the matters of writing and reading. In essence, the epistemology of retrospection structures any project of review, reassessment, or editing whose aim is an economical return to the same. This is the sort of narrative strategy that Heath identifies as the misleading law of 'a film memory': 'the re-imaging of the individual as subject, the very representation of identity as the coherence of a past safely negotiated and reappropriated' (Heath 1981: 125).

In his short 1973 essay 'Acinéma', Jean-François Lyotard outlines the formal and ideological traces of this negotiation in classic film. By contrast to the celebratory tone of Cavell's remarks, Lyotard laments classic film's method of privileging 'elements in motion' in order to exclude aberrance and to channel primal drives into the image of a recognizable organic and social body. To Lyotard, such film enacts a complex machinery of ordering (*ordre*), whose principle economic function is to excise, cut out, and expunge any psychoaesthetic waste or excess (*ordures*). Without these strategic procedures of the selection and exclusion of movement, film would have to accept, writes Lyotard,

106

what is fortuitous, dirty, confused, unsteady, unclear, poorly
framed, overexposed For example, suppose you are working
on a shot in video, a shot, say, of a gorgeous head of hair à la
Renoir; upon viewing it you find that something has come undone:
all of a sudden swamps, outlines of incongruous islands, and cliff
edges appear, lurching forth before your startled eyes. A scene
from elsewhere, representing nothing identifiable, has been
added, a scene not related to the logic of your shot, an undecidable
scene, worthless even as an insertion because it will not be re-
peated, and taken up again later. So you cut it out.

(Lyotard 1986: 350)

This description bases the logic of classic cinema on the quantitative
principles of decidable worth, familiarity, and visibility which stand
threatened by the filmic lurching-forth of swampy outlines, incongruous
cliff edges and visions – the sort of threatening phantoms that always
seem to lurk behind fiction's heads of gorgeous hair, that always seem to
have to be startling to the eyes. Whether miming procedures of steriliz-
ation or castration, the filmwork aims to contain the sort of dirt associ-
ated historically with the cultural strategies and aesthetic personae of
the Medusa and the Sphinx. So it goes that the dominant, classical
strains of film, much like those of literature, work incessantly to contain
the Medusa and her cousins by developing subtle procedures that
generate divisions, exclusions, and repressions – procedures shared,
although differently, by the fiction-producing apparati of text and
psyche.

It is in this multiple context of apparatus, fiction, and psyche that the
work of conventional cinema can be said to be invested in the repetition
and propagation of a return to the same. 'The affective charges, carried
by every type of cinematographic and filmic "signifier" (lens, framing,
cuts, lighting, shooting, etc.) are submitted', Lyotard argues, 'to the
same rule absorbing diversity into unity, the same law of a return of the
same after a semblance of difference' (Lyotard 1986: 353). Such an
investment in the psychoaesthetic entrapment of 'the return' fore-
grounds a broad scopic phenomenon important to the cinematic dis-
course of both literature and film. I am referring not merely to the visual
machinery of orderly perspective, framing, and mirroring, but also, and
more importantly, to the reinscription of perception itself in the symbol-
ic envelope of 'the return', in the tenuous procedures of retro-spection
common to both the critical and the psychoanalytical scenes. This is
where 'perverse overflow', 'vain simulacra', and 'blissful intensities' are
gathered together as the 'productive/consumable objects' of diegesis, on
the one hand, and as 'the camouflaged stuff of perspectivist represent-
ation', on the other; the former locks together the synthesis of

movements in the temporal order while the latter synthesizes movements in the spatial order (Lyotard 1986: 352).[10]

Had Lyotard's 1973 essay been able to reflect on more recent developments in the theory of film and the psychoanalysis of the image, it probably would have given less attention to the 'effect of the real' than to the 'effect of the screen'. This would entail more emphasis on how 'the camouflaged stuff of perspectivist representation' functions to offset cinematic synthesis, classic or not. As Joan Copjec describes the 'effect of the screen', it does not shape

> a subject who will harmonize with, or adapt to, its environment (the subject's narcissistic relation to the representation that constructs it does not place it in happy accord with the reality that the apparatus constructs for it). The effect of representation is, instead, the suspicion that some reality is being camouflaged.
>
> (Copjec 1989a: 71)

The screen effect foregrounds the break or lack constituting the mechanism of cinematic camouflage and its spectatorial recuperation. While the tendency in 'realist' film theory is to respond to camouflage with the fetishistic logic of suture, 'yes, but nevertheless . . .', the reality of the screen demystifies this logic. This is because it both foregrounds camouflage itself as the sole return of suture and inscribes camouflage in the disturbing temporal relay of fantasy. In this instance, retrospection is less a methodological gathering-together than a psychological rending-asunder.[11]

An even broader context for thinking this trajectory is provided by Guy Rosolato's notion of the 'perspectival object', *l'objet de perspective*. Signified by this term is the way the subject concretizes the perception of the unknown through visual and linguistic perspectives that aim to make visible or plastic what is not. In dialogue with Merleau-Ponty's work on the invisible, Rosolato privileges perspective as the figure of the uncanny horizon framing the near and the far, the familiar and the (un)familiar:

> the extremely remote distance, measured by the effect of gazing on the 'disappearing point' of the sea, marks the horizon as the interface, the perspectival object, between our familiar territory and an elsewhere for imagined wanderings, either unwanted or elating by their call [*leur appel*] to adventure.
>
> (Rosolato 1987: 151)

At stake in the 'perspectival object', then, is the way the resolution of perspectival distance is transgressed by interpellation, by the sensation of the unknown, by the perspectival 'seizure' of the imaginary lack covered over by the object. When mapped on to the theory of classic

film, the 'perspectival object' can thus be understood as the constitutive stuff of structural camouflage that disturbs orderly pictorial space and narrative resolution.[12]

An example from the archives of Shakespeare on film provides a fitting illustration of the wide extent to which classic notions of cinema rely on the complicated dynamics of perspectival camouflage. I am thinking of a concluding moment from the adaptation by Stuart Burge of John Dexter's stage production of *Othello*, the film commonly known as 'Olivier's *Othello*'. This is when Othello embraces the limp Desdemona in Act V. The description of the image by the theatre critic John Simon is almost as unforgettable as is the ekphrastic film image itself:

> Othello, having jumped into the bed with the dead Desdemona, passionately rocks back and forth with her body, and erotic over-tones coupled with the frenetic emphasis on blackness embracing blonde whiteness run riot – or should I say race riot? It is an awesome sight, but unmoving.
>
> (Simon 1972: 155)

Set in motion by this description is not so much the pathos of sight as a realization of the unsettling figure of the image and its narrative recuper-ation by Simon. Unmentioned by Simon's racist description of what he feels to be blackness run riot is the extent of this erotic moment's visual overtones. Aside from the dis-ease of allusions to necrophilia, the viewer is struck by the realization that Olivier's black make-up has rubbed off on the white face of Maggie Smith (Desdemona) and that the director chose, for whatever practical or conceptual reasons, not to edit this dirty still out of the film. As a frozen frame that reflects the complexity of Olivier's performance, this picture is indeed awesome (figure 4.1).

But how should it be analyzed? Of course, it could suggest the technical difficulty of working with sooty materials. Olivier, after all, is not the only modern film worker to spread the filth of Othello's black-ness. Derek Jarman, for instance, recounts the story told by Suso Cecchi D'Amico, the collaborator of Visconti and Rossellini, about 'the uneasy relationship between Visconti and Zeffirelli and the disastrous *Othello* with Gielgud. "The moment he appear he try to leave. He put his hands on set of Franco and the black came off all over it. Lucino he smile like thees", and she puts her hands to her high cheek bones, pushing her face into a wicked Florentine grin' (Jarman 1984: 31). It is hardly coinci-dental that both *Othello*s, by Olivier and by Gielgud, attest to the stains of blackness tainting the performance as well as the text of Shakespeare's tragedy. For *Othello*'s darkened stains read as material traces of nothing less than the Eurocentric horror of miscegenation, a

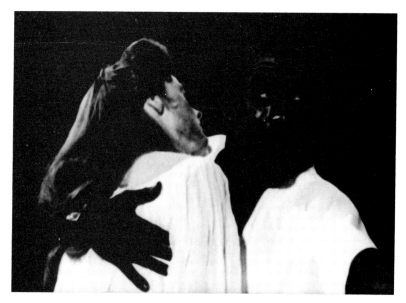

Figure 4.1 Othello (Laurence Olivier) holding the dead Desdemona (Maggie Smith) from Stuart Burge/John Dexter, *Othello*

horror often glossed by critical overinvestment in the humanist theme of the enigma of moral darkness.

Most recently, a group of my well-intentioned freshmen – spurred on, no doubt, by the clean textual outlines of *Cliff Notes* – proved themselves capable of writing papers on the theme of darkness in *Othello* without even mentioning race or ethnicity. To do so, they had to overlook, among so many other passages, Brabantio's displaced fear of miscegenation that frames his unforgettable description of Desdemona's passion:

> she, in spite of nature,
> Of years, of country, credit, everything.
> To fall in love with what she feared to look on!
>
> (I.iii.96–8)

In my students' defense, I should note the critical precedent for their decision to reflect on the darkness of desire at the expense of any commentary on Desdemona's desire for darkness. At the conclusion of the play, Lodovico hastily orders the curtains drawn on the deathbed bearing Desdemona and Othello. He then ends the drama by repositioning the horrors of this dark and deadly loading of the bed on the comforting screen of retrospection. He supplements his prescription, 'The object poisons sight, / Let it be hid', with the promise of a narrative gloss or flashback: 'Myself will straight aboard, and to the state / This

heavy act with heavy heart relate' (V.ii.364–5, 370–1).[13] 'This heavy act', the charged perspectival object of miscegenation and its repression, of poisoned sight and its occlusion, is doubled by the narrative supplementation of textual affect, 'with heavy heart relate'. What will count in the official version of events, so Lodovico would like to believe, is less the poisoned dramatic image of excessive exchange in desire and death than the mournful darkness of its perspectival ordering. A return to the order of the same at the conclusion of *Othello*, 'Myself will straight aboard, and to the state', thus depends on a reinstatement of the conventional narrative conditions that frame representation, that put things into sovereign perspective. This perspectival object, the unfulfilling promise of a narrative frame, is what shapes as well as disrupts subsequent analytic efforts to read, to understand, to interpret broader textual structures and strata in *Othello*.[14]

While we need not imagine how Lodovico might have fashioned his story, we can find something of a model of retrospective narration in Simon's review, which also follows the lead of Lodovico in blocking out the poisoned sight. Failing to mention Desdemona's smudged face, Simon glosses over the sloppy shot in a manner suggestive of his attempt to white out the racial implications of Shakespeare's text. Rather than focus on cinematic detail, Simon criticizes the film for trying

> to capitalize rather meretriciously on contemporary racial problems, to make this Moor *plus catholique que le pape*, which is to say blacker than black, almost blue, so as to milk (if I may be allowed to mix my colors) Othello's *negritude* for all it is worth – or, rather, for all that it isn't.
>
> (Simon 1972: 155)

Grounded in the punning analogy of the metaphysical disappearing point (*plus catholique que le pape*), Simon's review belies the hues of the cinematic horizon to fashion a critical subjectivity free of the specificities of color.

But Olivier's method of portraying Othello's blackness is hardly any better. My claim is that Olivier does more to maintain the cultural ideology of negritude, which inscribes resistance in the web of colonial fantasy, than to expose it to any sustained performance of retrospective critique.[15] This statement may appear somewhat rash given Olivier's desire 'to look from a black man's world. Not one of repression, for Othello would have felt superior to the white man I was to be beautiful. Quite beautiful' (Olivier 1986: 153). Yet, Olivier's discussion of the methods of his performance reveals the now familiar epistemology of presence underlying the humanistic drama of domination and subjection, one aiming to transform the complexity of race relations into the

beautiful wholeness of the ultimate performance, the picture of 'our cultural arcadia'.

For Olivier, characterization involves not only the mental conversion of dramatic motion into a picture of presence but also the literal creation of character that will double as the lasting image of the actor. There is certainly much in the cinematic performance of *Othello* that speaks more to the prowess of Olivier than to the dramatization of the Moor. Jack Jorgens is not alone in suggesting that the Burge/Dexter adaptation succeeds primarily owing to 'the sheer *range* of Olivier's performance [which] is unmatched on film' (Jorgens 1977: 204). Indeed it is Olivier's intense commitment to getting the most out of his performance that represents the range of his identification with the character, or rather, the character's identification with Olivier. In his autobiography, *On Acting*, Olivier speaks blatantly of his cunning transformation through 'oil', in

> creating the image which now looked back at me from the mirror. Black all over my body, Max Factor 2880, then a lighter brown, then Negro No. 2, a stronger brown. Brown on black to give a rich mahogany. Then the great trick: that glorious half-yard of chiffon with which I polished myself all over until I shone I am . . . I am . . . Othello . . . but Olivier is in charge. The actor is in control. The actor breathes into the nostrils of the character and the character comes to life. For this moment in my time, Othello is my character – he's mine. He belongs to no one else; he belongs to me.
>
> (Olivier 1986: 158–9)

Much could be said about this passage regarding the question of retrospection: it suggests the fetishism of the acting tradition's representation of color ('Negro No. 2') as well as the actor's mastery of virtuality ('creating the image') that dominates cinema and its 'realist' assumptions. But most of all, this passage sums up the dominant discourse of Occidental aesthetics which I rehearsed earlier through the voice of Prospero. In this aesthetic, the cultural diversity of individual characters is camouflaged by the representation of a composite subjectivity to be safely communicated and appropriated through art. Put simply by Olivier, 'He belongs to no one else; he belongs to me'. Not truly wishing Othello to portray the historical differend of racial identities, Olivier acts out the cultural desire to efface difference through identity. In this sense, it can be suggested that Olivier's acting participates powerfully and effectively, much like the cinema described by Teresa de Lauretis, 'in the social production of subjectivity: both the disinvestment of fantasy in work-related imaging [the realist effect of Olivier's make-up] and the investment of fantasy in film's imaging (the movies as the great escape) are modes of subjective production effected by cinema

through the articulation of human action, cinema's imaging' (De Lauretis 1984: 53). And this very imaging takes place, of course, on the broader screen of fantasy marked temporally, so Laplanche and Pontalis would say, by its traumatic resemblance to familial events and cultural tropes once thought only to be innocent in their benign simplicity.

LIKE A STILL

In view of this paradoxical role of fantasy, I just cannot shake the appeal of that one dirty picture in the Burge/Dexter film – in which Olivier's glistening oils smudge the blonde whiteness of Maggie Smith's face. It is as if filmic reality resists the totalizing ideology of presence underlying Olivier's performance. It is as if the representations of fantasy exceed the 'innocent' unifications of race, gender, and identity traditionally sought by humanist aesthetics. It is as if this shot suffices in itself to suggest the riot of Otherness that surpasses, that violates the idealization of possession, identity, and even patriarchy sustaining the composite picture of Shakespearean drama. Finally, on the broader level of theatre on film, it is as if Roland Barthes were on to something in claiming that 'the filmic, quite paradoxically, cannot be grasped in the projected film, the film "in movement", *au naturel*, but only, as yet, in that major artifact which is the still' (Barthes 1985: 61). For, as I have wanted to be able to maintain from the outset, something like the still, being a perspectival object at once parodic and disseminative, is what undercuts the unifying imperatives of cinematic motion. Dissolving the limits of filmic time, the still quotation stands alongside the film in a palimpsest relation, like that of the *punctum* to the *studium*, to foreground the constraints of logico-temporal order and the decaying baggage of subjection (Barthes 1985: 61). In sum, something like the still might be said to parody filmic retrospection.[16]

But why this irresolute, phantasmatic emphasis on 'something like a still'? I wish to suggest that we need not necessarily privilege the still shot itself as the sole means of liberating what Barthes calls the obtuse or 'third' dimension of film. By this he means the signifying 'skid' or 'excess' of film, something which resembles Rosolato's 'perspectival object' on the one hand, and a combination of Lyotard's intense field of acinematic aberrations and Kristeva's semiotic heterogeneity on the other. This is the disorderly field which Barthes says has

> something ridiculous about it; because it opens onto the infinity of language, it can seem limited in the eyes of analytic reason. It belongs to the family of puns, jokes, useless exertions; indifferent to moral or aesthetic categories (the trivial, the futile, the artificial,

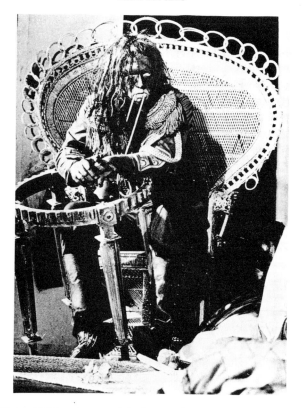

Figure 4.2 Ulrich Wildgrüber as Othello, in the adaptation of *Othello* by Peter Zadek, Deutsches Schauspielhaus in Hamburg

the parodic), it sides with the carnival aspect of things' (Barthes 1985: 44).

It returns us to 'something like' the punning strategies and playful artifices of the sisters of cunning: the Sphinx and the Medusa. And within the tradition of Shakespearean performance, I might cite the example of the German director, Peter Zadek, whose radical staging of *Othello* in the late 1970s disrupted nostalgia for 'our cultural arcadia'. Zadek's disorderly portrayal of Othello, performed in 1976 by Ulrich Wildgrüber of his company, Deutsches Schauspielhaus, in Hamburg, displaced Olivier's glistening oils with the visible face of a white actor dirtied, much like Maggie Smith's, by sloppy smudges of black paint (figure 4.2). And instead of Olivier's gorgeous head of Afro hair, Zadek's Othello sported a moplike wig of dishevelled locks that lurched forth before startled spectators as the 'acinematic' portrait of a carnivalesque social construction.

By thus endorsing 'something like' a filmic 'skid', I also wish to stand aside from Barthes's concomitant desire to purge 'culture, knowledge [and] information' from the field of obtuse meaning. As illustrated by the mere juxtaposition of stills from productions of *Othello* by Olivier and Zadek, a certain repressed and traumatic terrain of culture is precisely what is at stake in any valorization of the obtuse, the semiotic, or the carnivalesque. And what brings this terrain to the forefront, as John Simon's review so aptly demonstrates, is less the still shot itself than the ambiguous procedures of quotation, perspective, and retrospection it exemplifies.

I make this suggestion in clear opposition to Raymond Bellour's claim in 'The unattainable text' (1975) that both the still shot and the critical quotation are what distinguish the photograph and the literary text from film. Bellour insists, in this important essay on filmic *écriture*, that the motion of film prescribes the impossibility of citation as well as the necessary detour taken around film's 'uncitable text' by any critical or filmic metalanguage. The analytical citation and critical disfiguration of the filmtext cannot, according to this position, respect the 'property or propriety' of the figural unit of film which Bellour, following Metz, argues to be essentially different from the work of literature, music, and theatre.[17] Yet, as Marie-Claire Ropars-Wuilleumier insistently responds to Bellour, the study of *écriture* in the sense of Derrida reveals the 'uncitable' or the 'unfindable' as the constitutive material not only of literary textuality (Ropars-Wuilleumier 1982: 92–3) but also of the complex procedures of cinematic writing itself, what she calls 'cinema's hieroglyphic dimension' (ibid.: 158).[18]

On the surface, Ropars-Wuilleumier's concept of the cinematic hieroglyph seems to echo Barthes's desire for a culturally unspecific heterogeneity. In her essay on *Breathless*, 'The graphic in film writing', she wishes to align herself with Derrida by embracing 'the complex metaphor of the hieroglyph, in which the figure's thrust causes signification to shatter into heterogeneous networks' (Ropars-Wuilleumier 1982: 147). In her book, *Le Texte divisé*, moreover, she situates such a *cinématexte* specifically outside of the sociocultural confines of naturalist film history: the term 'text' not only limits itself to 'books or films which precipitate a rupture with forms naturalized by a period' but also 'finds itself excluded from all reference to the mechanisms of production which engage in a cultural practice of merely marginal socio-economical uniformity' (i.e. the totalizing visual apparatus of Baudry and Comolli, which would include such individual elements as Olivier's makeup job) (Ropars-Wuilleumier 1981: 121–3). These critical distinctions may leave her reader with the impression that Ropars-Wuilleumier prefers the rhetorical or figural *force* of the moving image to the psychopolitical or ideological *power* of the social object. However, insistence on such an

inflexible binary distinction between the rhetorical and the ideological, between force and power, could diminish the subtlety of Ropars-Wuilleumier's argument.

A better way of approaching Ropars-Wuilleumier might be to insist on the delicate, ideological fabric of cinematic force at stake in her work. There are many ways in which her concept of the cinematic hieroglyph repositions Barthes's desire for filmic heterogeneity in direct relation to the public sphere of knowledge, that is, to the cultural arena of ideological fantasy.[19] Of particular significance to this chapter is how she defines the hieroglyph in negative proportion to two properties frequently assumed to be shared by literature and film: (1) she refuses the 'proper' or 'clean' (*propre*) and the essentialist interpretation implied by such perspectivism; (2) she rejects the assumption that language (*la langue*) has propriety (*propriété*) over writing, as well as any belief in the exclusive propriety of writing over language or even language over image (ibid.: 19). The image of the filmtext sketched by Ropars-Wuilleumier is dirtied not merely by this rejection of the hierarchical order of Occidental aesthetics but also, and most poignantly, by her productive conflation of Eisensteinean montage and Derridean writing, the double vocation of the hieroglyph both as 'materially figurative' and as 'signifying by destination' (ibid.: 38). Through its inscription in montage, film folds the naturalized diegesis of narrative and sociocultural 'fact' into the shifting envelopes of designation and enunciational discourse. Her attentiveness to procedures of enunciation also positions montage in Eisenstein and Derrida on the oscillating site of the double structure of signification theorized by Benveniste: (1) the *semiotic*, a succession of signs to be recognized separately; (2) the *semantic*, the overall field of reference and discourse shaping culture and its ideological manifestations. The conceptual impact of this hieroglyphic meeting of Derrida, Eisenstein, and Benveniste is what Dana Polan praises as *Le texte divisé*'s most important contribution to film theory: 'Ropars's readings of figures often pull them out of historically dominant representations to give their discourse new force and potential' (Polan 1984: 76).[20]

Yet the potential force of this critical blend is precisely what D. N. Rodowick criticizes as the weak link in Ropars-Wuilleumier's hieroglyphics. In his view, 'the theories supposed by enunciation, on the one hand, and *écriture* on the other, might be incompatible' (Rodowick 1985: 48). Rodowick argues that this incompatibility derives from the distinction between the pressure of a deconstructive reading and the artistic development of 'a formal system' governing enunciation: 'the complexity supposed by the concept of enunciation paradoxically restores to the text the self-identity of a system; it circumscribes the text, establishes its limits, and designates it as an object presupposing determinant subject relations' (Rodowick 1985: 48). Such an emphasis on the self-

116

identity of enunciation stems most likely from Benveniste's discussion of the semiotics of artistic production through which the artist 'creates his own semiotic' in selecting and arranging materials. If limited to this semiotic context, Ropars-Wuilleumier's turn to Benveniste would only reinforce the kind of authorial assumptions that fuel Olivier's investment in the portrayal of his character: 'he belongs to no one else; he belongs to me'.

However, Benveniste's description of such a 'closed system' serves, in 'The semiology of language', merely as the foil for his more complicated discussion of the distinction between the semiotic and the semantic. To emphasize the complex role of the semiotic in the realm of the figurative arts, Benveniste introduces the possibility of the closure of authorial intentionality only to muddy its colors with a turn to the openings of artistic semiology:

> As for the figurative arts, they already depend on another level, that of representation where line, color, and movement combine and enter into a whole governed by particular needs. These are distinct systems, of great complexity, in which the definition of the sign will only become specific with the development of an equally imprecise semiology.
>
> (Benveniste 1974: II, 59)

This notion of artistic imprecision leads Benveniste to suggest somewhat naively that art, unlike language, does not derive from conventions identifiable to all viewers. 'Each time one must discern in them the terms which are innumerable, in brief, inapt for learning. The sense of language, in contrast, is sense itself, founding the possibility of all exchange and communication, and by that, of all culture' (ibid.: 59–60). Important to Ropars-Wuilleumier, however, is less Benveniste's unhelpful claim about the cultural independence of imagery than his subsequent provision, important to the theory of film, that the semiology of a non-linguistic system relies on the enunciational mechanisms of language, that is, on the interpretant of all other systems, linguistic and non-linguistic.

While this claim for the institutional significance of language might actually be the source of Rodowick's worry about the self-identity of an enunciational system, its apparent presupposition of determinant subject-relations ('the possibility of all exchange and communication') is disturbed by Benveniste's crucial emphasis on how the subject is split not only by the tripartite folds of the *énoncé* (*je/tu/il*) but also, and most crucially, by the dual inscription of *énonciation* in the semiotic and the semantic. While the semiotic marks the recognition of an identity between the anterieur and the actual (*histoire*), the semantic disrupts this relation by opening understanding to the perception of evolving

enunciations (*discours*) dependent on the indecisive operators of reception.[21] As Ropars–Wuilleumier suggests in stressing the correlation of enunciation and *écriture*, a filmic culture might be understood, in this context, as the site, screen, or enunciational construct through which the shifting of image and text designates a break in epistemological closure, a rupture in the aesthetics of identification that equates person and name, name and thing.[22] It is in this sense that the critical figure of the hieroglyph juxtaposes enunciation with the deconstructive deferral of the metaphysics of presence. The hieroglyph forcefully positions reference in relation to its non-identical other – whether text as image, text as discourse, or self-as-other. The recognition of this relation-in-rupture is made possible, moreover, by the rhetorical connotation of shifting sociolinguistic relations and appropriations, as well as by the hermeneutical denotation of a semiotic system whose self-identity is, therefore, always already under erasure.[23]

When translated into Derrida's terms, such an enunciational hieroglyphics foregrounds the monstrous trace of *Arché-écriture*:

> Arche-writing as spacing cannot occur *as such* within the phenomenological experience of a *presence*. It marks the *dead time* within the living present, within the general form of all presence. The dead time is at work. That is why, once again, in spite of all the discursive resources that the former may borrow from the latter, the concept of the trace will never be merged with a phenomenology of writing.
>
> (Derrida 1976: 68)

This failure to merge speaks not only to the 'dead time' of *écriture*, but also to the phenomenological and enunciational aporia of cinematic suture. By so revealing the ontological condition of the motion picture to be monstrous rather than, as Stanley Cavell would have it, phenomenologically pornographic, the cinematic hieroglyph stands out as the cultural mark of the critical fold demystifying 'retro/spection'. It is only in this operative sense of the tracing of 'dead time' that the hope of *ekphrasis* can be said to be arcadian. That is, to turn Cavell's words back on themselves, 'nothing revealed by the world in its presence is lost'.

I wish to conclude by noting how Raymond Bellour makes a similar point in his recent essay, 'The film stilled' (1990), which analyzes how cinematic form can internally immobilize movements in film. In somewhat of a departure from his earlier opposition to the analysis of filmic stills, he here reflects on the way the freeze-frame so marks post-war cinema that 'movement is not guaranteed any more than is speech, subject to a paralysis that can at any moment condemn them to a standstill' (Bellour 1990: 113). Calling to mind the conclusion of *Othello*, as well as the inescapable demand of Cavell, Bellour emphasizes the

way Jean-Luc Godard thematizes the decomposition of movement in his films through the combined interrupted instants of sexual pleasure and death. The partial satisfactions of interruption result in 'a divided time . . . as points of transcendence, known, repeated in the ellipses, decompositions and immobilizations that run through it' (ibid.: 121). Yet, what is exhibited by the freeze-frame of the cinematic hieroglyph, by 'the film stilled', is not, as Cavell would have it, the camera paralyzed by its shot of a zipper. Rather it is the suture of phallologocentrism itself which is stilled and ripped asunder by what Bellour suggestively terms the cinematic 'mix of desperate utopia and regression' (ibid.: 121).

NOTES

1 'Nodal point' is the term coined by Laclau and Mouffe for the discursive figure of the impossible object, the partial fixation, around which the social positions itself 'to dominate the field of discursivity, to arrest the flow of differences, to construct a centre' (Laclau and Mouffe 1985: 112). They insist, moreover, that 'every nodal point is constituted with an intertextuality that overflows it. The practice of articulation, therefore, consists in the construction of nodal points which partially fix meaning; and the partial character of this fixation proceeds from the openness of the social, a result, in its turn, of the constant overflowing of every discourse by the infinitude of the field of discursivity' (ibid.: 113).

2 Cavell develops this point in 'Film in the university', the Appendix to *Pursuits of Happiness* (Cavell 1981: 265–74). By contrast, Doane emphasizes that the movement of cinema 'allows for the possibility of thinking vision through structures which exceed but nevertheless corroborate individual subjectivity' (Doane 1991: 193).

3 Such a hopeful investment in the powers of *ekphrasis* is spelled out even more explicitly by Cavell, when he praises 'the declaration of simultaneity' made by the artistic 'framing' of Louis, Noland, Olitski, and Stella which creates 'a way of acknowledging finality as a specific spiritual step' (Cavell 1979: 112). But any such metaphysical tendency to link the frame with spirituality can be sustained only in disregard of the widespread poststructural demystification of the ideology of framing, from Barthes's 'Diderot, Brecht, Eisenstein' (Barthes 1985: 89–97) and Derrida's *Truth in Painting* (1978b) to Heath's *Questions of Cinema* (1981), Trinh's *Woman, Native, Other* (1989), and Mayne's *The Woman at the Keyhole* (1990). Heath's argument, for example, departs from a simple observation pertinent to the status of movement in Cavell: 'If life enters cinema as movement, that movement brings with it nevertheless its problems of composition in frame . . . what enters cinema is a logic of movement and it is this logic that centers the frame' (Cavell 1981: 36). This logic constructs frame space as the terrain of narrative space, the space of 'total thereness'. Accordingly, the desire to narrate the world viewed enacts the phenomenological conversion of 'seen into scene, the holding of signifier on signified: the frame, composed, centered, narrated, is the point of that conversion' (ibid.: 37). What thus allows the world to be viewed in the realm of the moving picture is the narrative desire to relocate or rearticulate that view, that frame, that world. In brief, it is the conversion of filmic motion into the picture of presence. But it might also be understood in

psychoanalytic terms as the narrative infelicity enacted by the figurations of transference. The possibility of this figuration depends on conditions standing aside from the precise differences between motion and picture. For their common articulation relies upon a third party, an agent of conversion: the spectator as stand-in for the unified and unifying subject of the vision of film. 'What moves in film, finally', in Heath's words, 'is the spectator, immobile in front of the screen. Film is the regulation of that movement, the individual as subject held in a shifting and placing of desire, energy, contradiction, in a perpetual retotalization of the imaginary' (Heath 1981: 53). So it goes that especially in the more conventional projects of film, like those of critical writing, the ultimate subject is neither motion nor picture but narrative representation as regulation. In other words, this is the agent of retrospection: the locus of 'the action of looking back or referring to something' (*OED*). The indeterminateness, excess, and, I might even say, overflow signified by this figure of 'something' is important to the conditions of narration. For the significational openness of 'something' not only suggests the formal violence always inflicted on reference by the process of retrospection, but also the ideological implications of cinema's engagement in questions of reference.

4 This second point is developed with particular care by Teresa de Lauretis in *Alice Doesn't*, when she reflects on Pasolini's representation of social practice as '*trans*linguistic: it exceeds the moment of the inscription, the technical apparatus, to become a "dynamics of feelings, affects, passions, ideas" in the moment of reception' (de Lauretis 1984: 51). It need be emphasized, however, that de Lauretis makes no gesture here to the sort of personal or idiosyncratic response that Cavell wants to locate in film, what he describes in *Pursuits of Happiness* as his attempt to describe his 'experience' of film (Cavell 1981: 278). On the contrary, de Lauretis stresses that emphasis on the subjective leads the critic in a different direction: 'It points to the current notion of spectatorship as a site of productive relations, of the engagement of subjectivity in meaning, values, and imaging. It therefore suggests that the subjective processes which cinema instigates are "culturally conscious", that cinema's binding of fantasy to images institutes, *for* the spectator, forms of subjectivity which are themselves, unequivocally, social' (de Lauretis: 51).

5 The resemblance of the Sphinx and Medusa within and outside of the oedipal scenario is developed by de Lauretis in 'Desire in narrative' (ibid.: 103–57).

6 All citations of Shakespeare are from *The Riverside Shakespeare* (1974).

7 Regardless of Jarman's occasional tendency to long for some of the more utopian features of high cultures of the past, his adaptation of *The Tempest* is neither nostalgic nor ethnocentric. This point is made convincingly in John Collick's analysis of the film's relation to punk and homosexual culture (Collick 1989: 98–106) as well as by Jarman's own claim in his chapter on the film in *Dancing Ledge* (Jarman 1984: 182–206). More recently, writing about his film on the 'Sonnets', *The Angelic Conversation*, Jarman provides a succinct account of his relation to the past: 'I have a deep hatred of the Elizabethan past used to castrate our vibrant present' (Jarman 1991: 112).

8 The most provocative discussion of the theoretical stakes of genre in the plays of Shakespeare is Orgel's 'Shakespeare and the kinds of drama' (Orgel 1979).

9 I analyze the relationship between early modern notions of authorship and collections of printed plays in my book *Theatrical Legitimation: Allegories of Genius in Seventeenth-Century England and France* (Murray 1987). While the book focuses on the epistemological–ideological implications of the first

English folio collection of plays, the *Workes* of Ben Jonson (1616), it also touches on the 1623 Folio of Shakespeare and the ideological implications of the eighteenth-century revision of the Shakespeare Folio.

10 I provide a more detailed reading of Lyotard's aesthetics in Chapter 6. Maureen Turim provides attentive discussions of the usefulness of Lyotard's 'subliminal economy' for the study of film in her introductory essay to a special section of *Camera Obscura* on Lyotard (Turim 1984) and in her book, *Abstraction in Avant-Garde Films* (Turim 1985).

11 In 'Fantasy and the origins of sexuality', Laplanche and Pontalis focus on 'retrospection' as the means by which the subject comes to know originary trauma through the evocation of the 'second' post-puberty scene of trauma which evokes, retroactively, the initial event of the 'pre-sexually sexual' (Laplanche and Pontalis 1986: 9). Two features of their understanding of fantasy are particularly important to any theory of the screen effect. First is the fact that the 'screen' is a fantasy effect inscribed in the structure of the original fantasy: 'the original fantasy is first and foremost fantasy – it lies beyond the history of the subject but nevertheless in history – a kind of language and a symbolic sequence, but loaded with elements of imagination; a structure, but activated with contingent elements' (ibid.: 18). Second is the positioning of the subject within, rather than outside, of fantasy: 'Fantasy . . . is not the object of desire, but its setting. In fantasy the subject does not pursue the object or its sign: he appears caught up himself in the sequence of images. He forms no representation of the desired object, but is himself represented as participating in the scene although, in the earliest forms of fantasy, he cannot be assigned any fixed place in it' (ibid.: 26).

12 In his fascinating book on the graphic in film, *Film Hieroglyphs*, Tom Conley provides a helpful account of the many ways 'the perspectival object' (his translation) might operate in classic film: 'the *objet de perspective* may be akin to a vanishing point in classical painting, where the lure of a resolution of pictural and narrative tensions appears to offer an escape from physical constraints but actually does not; or it may be an appeal to an imaginary space of resolution that is the 'happy ending' of a film – such as the rays of dawn that crown the unsettling conclusion to *Mildred Pierce* – that promises none. It figures a concentrated point of attention that captures what a subject chooses to see, simply because in it resides what cannot, because of its paradoxical evidence and accessibility, be seen The *objet de perspective* complicates, however, when conventions of cinema use classical perspective to locate bodies or objects in filmic space. Studio traditions depend on vanishing points for the purpose of having spectators see a visual exit or *deus ex machina* where the characters in the film do not. The triangular relation scaffolded among the viewer, the figures on the screen, and the spatial depth effectively shows where narrative and visual solutions, each displaced in the same space of a given shot, produce the literal ambiguities of a classical film' (Conley 1991: xxii–xxiii).

13 For a rich resource in the theory and history of cinematic retrospection, see Turim's *Flashbacks in Film* (1989).

14 I discuss this scene in the context of the narrative transference enacted by other Shakespearean endings, in 'Drama trauma: psychoanalysis and the epistemology of tragedy', a chapter in my forthcoming book *Performance Reading: Theatre in a Multi-Cultural Age* (Routledge). For a broader analysis of narrative conditions in *Othello*, see my contribution to *Shakespeare and Deconstruction* (1988), Green (1979: 88–136); Fineman (1991: 143–64); Parker

(1985); Snow (1980); and Newman (1987).

15 My understanding of the representational ruse of negritudism and its literary manifestations is deeply indebted to the work of three of my Cornell associates: Biodun Jeyifo's *The Truthful Life* (1985); Jonathan Ngate's *Francophone African Fiction* (1988); and Tejumola Olaniyan's dissertation 'The poetics and politics of 'othering' (1991).

16 Peter Brunette and David Wills suggest that the 'still image' is 'a contradiction in terms, for its multiple lines of force always put it into movement It might even be argued that it was a shift in perspective, occurring within "stills", that enabled cinema much more than the invention of the movie camera and projector' (Brunette and Wills 1989: 108–9). See also Victor Burgin's fascinating discussion of Barthes's *Camera Lucida*, fantasy, and the filmic still in 'Diderot, Barthes, *Vertigo*' (Burgin 1986b), and Annette Michelson's 'The kinetic icon in the work of mourning' (Michelson 1990).

17 Bellour's development of this line of reasoning in his short essay, 'Analysis in flames' (Bellour 1985), is almost a spoof of this chapter's attentiveness to the 'dirty still'. Bellour suggests that film analysis has been made illusory as an object by four analytic gestures requiring the 'stopping' of film: (1) fixation on the image, the freeze frame which moves the film closer to the book; (2) 'good criticism' exemplified by the writing of Serge Daney whose 'stops in his sentences correspond with freeze frames that are projected into the reader's mind; (3) cinematic theory which banks on 'a practically complete inventory of the range of possibilities that allow for playing on the lack or the excess of the absent image'; (4) the dissolution of film analysis in cinema and video – the possibility of citing the 'unattainable text' on television in a way providing 'an answer of the image to the image'. I might mention that Bellour himself seems to fall prey to the analytical stoppage of film when he reflects more positively on 'The film stilled' (1990), the essay with which I conclude this chapter.

18 In the 1985 issue of *Diacritics* which includes 'Analysis in flames', Crawford and Rodowick provide similar critiques of Bellour's position.

19 By relating the public sphere to the cultural arena of ideological fantasy, I allude to the possible results of intermixing Negt and Kluge's early analysis of fantasy in the public sphere (1988) with the more recent and more sophisticated work of Žižek on popular culture and ideological fantasy (Žižek 1989a; 1991). Such an experimental mixture would be more in line, by the way, with Adorno and Kracauer's materialist adaptations of Eisenstein's earlier work on the hieroglyph as intellectual montage. A careful elaboration of German appropriations of the cinematic hieroglyph is provided by Miriam Hansen in 'The hieroglyphics of mass culture: Adorno on film and television', a manuscript which she delivered at Cornell University, September, 1991.

20 Although Ropars-Wuilleumier has not received the kind of attention from Anglo-American critics given to many of her French colleagues, say Bellour and Kuntzel, helpful discussions of her work are provided in Bensmaïa (1988); and Brunette and Wills (1989: 128–34).

21 Laclau and Mouffe make a similar point in arguing that 'the hegemonic subject, as the subject of any articulatory practice, must be partially exterior to what it articulates – otherwise, there would not be any articulation at all. On the other hand, however, such exteriority cannot be conceived as that existing between two different ontological levels. Consequently, it would seem that the solution is to reintroduce our distinction between discourse

and the general field of discursivity: in that case, both the hegemonic force and the ensemble of hegemonized elements would constitute themselves on the same plane – the general field of discursivity – while the exteriority would be that corresponding to different discursive formations It must therefore be the exteriority existing between subject positions located within certain discursive formations and 'elements' which have no precise discursive articulation. It is this ambiguity which makes possible articulation as a practice instituting nodal points which partially fix the meaning of the social in an organized system of differences' (Laclau and Mouffe 1985: 135).

22 To appreciate the extensive fruits of Benveniste's semiological distinctions, especially when they are woven into the discourse of psychoanalysis, see the amazingly productive and provocative analyses of Louis Marin in *Etudes semiologique: écritures, peintures* (1971) and *Détruire la peinture* (1977).

23 A close reading of how pronominal shifters enact the 'falsification of memory in its very staging' is provided by Sharon Willis in her subtle analysis of *Hiroshima mon amour* (Willis 1986: 42–5).

5

DIRTIER STILL?
Wistul gazing and homographic hieroglyphs in Jarman's *Caravaggio*

The boys emerging from the shadows reminded me of ghosts come to haunt me, all my dead friends. As always life was far more 'advanced' than art.

(Derek Jarman, *Queer Edward II*)

Embalmed in film, the paintings look desperately lonely. Michele Caravaggio, you've gone the way of those old statues you despised so much. To save you, we'll have to adopt your methods.

(Derek Jarman, *Derek Jarman's 'Caravaggio'*)

Arche-writing as spacing cannot occur *as such* within the phenomenological experience of a *presence*. It marks the *dead time* within the living present, within the general form of all presence. The dead time is at work.

(Jacques Derrida, *Of Grammatology*)

'Dead time' might be an appropriate epitaph for the still concluding Derek Jarman's film, *Caravaggio* (figure 5.1). Emblematizing the death of the artist, a close-up shot of the face of Michele Caravaggio shows his eyes to be covered by two gold coins. This deadly ending is preceded in the film by the specter of Michele's delayed death, which is marked diegetically on at least two occasions by polyvalent close-ups falsely suggesting the premature passing of the protagonist. This final, frozen moment also stands out in stillness from Michele's multiple death-bed flashbacks which constitute the film's energetic and disruptive narrative of artistic and sexual exchange. This concluding image screens not only the fixity of Caravaggio's stilled presence but also the fluid *economy of death* in which the cinematic hieroglyph intersects with the wistfulness of the gay protagonist and the decentering of subjectivity and autobiography shared by painter and filmmaker. According to Jarman's account, he actively manipulated various combinations of stasis and fluidity, as well as mixtures of cinematic subject and artistic subjectivity, to enliven the film's doubled actions of painting and filmmaking.

I have followed the pattern of Michele's life in the film. Moments of violent action, which are recorded by his biographers with all the

124

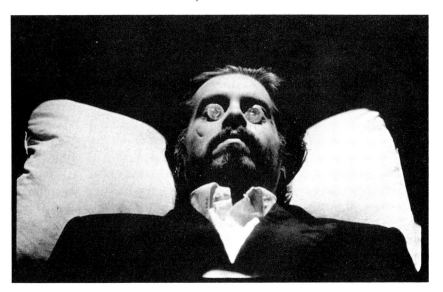

Figure 5.1 Derek Jarman, *Caravaggio*: dead still. (Courtesy: the artist)

gusto of the yellow Press, contrasted with the calm of the studio, where even the most rowdy models are reduced to silence as they pose before the brush – or the camera. With sharp concentration, the smallest gestures are fixed on the canvas – like the flicker of the waiter's eyes in the scene with Giustiniani and Del Monte, or the tear on the Magdalen's cheek. As I grew to know Michele I felt I was able to pare away many of the mannerisms of my early films without sacrificing spontaneity. Life was breathed into the characters, who were no longer ciphers like the characters in *Jubilee* based on the personification in medieval dream allegory. Michele is a strange mixture of vanity and humility, with a confidence born of extreme doubt; a much quieter man than his biographers have allowed, secretive and withdrawn. The sudden aimless outbursts in a bright undifferentiated world are balanced by the darkened studio, where a controlled light shines that tells the story. This story, as it grew, allowed me to create many details of my life and, bridging the gap of centuries and cultures, to exchange a camera with a brush.

<div align="right">(Jarman 1986: 132)</div>

Although *Caravaggio* builds on details of its director's life, it is a film shaped primarily by Jarman's fascination with the signs of death. It attests not only to his personal interest in the hieroglyphic mysticism of Giordano Bruno and John Dee but also, and perhaps most significantly,

to his development of a hieroglyphic film practice in order to mark dead time, or, as he puts it, 'to present the present past' (ibid.: 44).[1] In this film, the disjunctive play between image/sound and movement/stillness resounds in the bleak discourse of death and the dirty wounds of mourning, if not also in the incorporations of melancholy. Although I soon will elaborate on this latter point, I wish to stress from the outset that *Caravaggio*'s sensitive allusion to the artistic tradition of melancholia will alter this chapter's analytical course from the kind of 'return to the same' cherished by classical cinema. It soon should be evident how *Caravaggio*'s polysemic play on death and gay wistfulness differs from my previous treatment of incorporation in *Journeys from Berlin/1971* and *Camera Lucida*. For the sometimes unacknowledged 'frozen moment' – the still, cinematic sign of death – doubles in *Caravaggio* as 'the eroticization of the moment.'[2] This is the ekphrastic indicator of the passive, homosexual aesthetics constantly at work in Jarman's cinema, one combining the energetic tensions of poetic art and sexuality.

DEAD TIME

Typifying this combination is the moment in sequence 14 when Michele extinguishes the candle illuminating his work-in-progress and transfers his voyeuristic gaze to his lover, Davide, whose naked sleep is embellished by the soft aura of the moonlight. The tranquillity of this cinematic moment is disquieted by Michele's voice-over comment:

> A cold blue doubt, an infinity of uncertainty, the black tide ripples against arsenic highlights. The dark is invading. Esse in anima, to be of violet soul. Your master eats with sinners. The healthy don't need a doctor, only the jaundiced sick. And the Gods? The Gods have become diseases, Thought without image lost in the pigment trapped in the formless umber wastes.
>
> (Jarman 1986: 40)

Just such an artistic, sexual, and ontological ambiguity of invading darkness and 'dead time' inscribes *Caravaggio* in an energetic, yet sometimes cryptic, relay between clean movements and dirty stills, between a quiet poetics of *ekphrasis* and a frenetic cinematics of *hieroglyphics*.[3]

This contrast between the presence of *ekphrasis* and the fracture of hieroglyphics becomes readily apparent in considering *Caravaggio*'s creative blend of style and content. Jarman's strategy downplays the faithful, historical portrayal of biographical documents for the sake of a pastiche of phantoms designating the proper name, Michele Caravaggio, and the artistic method of his paintings. So it goes that 'the narrative of the film is constructed from the paintings. If it is fiction, it is the fiction of the paintings' (ibid.: 75). To achieve this painterly-

Figure 5.2 Derek Jarman, *Caravaggio*: Marat's tub. (Courtesy: the artist)

fiction-effect, Jarman patterned shots and citations after selective images from Caravaggio's *oeuvre*; he juxtaposed still cinematic shot with the still-life of painting; and he matched untrained actor to artistic image in his casting for the film:

> All the major characters, became a Caravaggio painting: Del Monte – *St Jerome*; Caravaggio – the *Boy with a Basket of Fruit* and Christ in *The Entombment*; Lena – the *Magdalen*; and Ranuccio – King Hirtacus in *The Martyrdom of St Matthew* Several years ago I had decided that Nigel Terry would be the perfect Caravaggio. He had the eyes, the warmth, and the ability to be absent as if thinking of more important matters. He also bore an uncanny resemblance to the only portrait we have of Caravaggio.
>
> (Jarman 1986: 15)

The same characters evoke dead time within the living present by conforming to the film's uncanny focus on the fissures of historical resemblance.[4] As if to emphasize the split inherent in the *Un/heimlich*, the film is charged with familiar, yet incongruous historical details such as a pocket calculator used by the Renaissance collector Vincenzo Giustiniani, or, a motorbike used by Caravaggio's male model Ranuccio. On an even grander semiotic scale, a 'Royal' typewriter is the writing tool of the pernicious art critic Baglioni, who types his diatribes in the bathtub of Marat (figure 5.2), a doubled, cross-cultural citation of the playwright Peter Weiss and the painter David (whom Jarman [1986: 45]

accuses of turning painting into a deadened '"scientific", archeological method').

The arbitrariness of *Caravaggio's* narrative retrospection is also brought home by Jarman's irreverence for the temporal specificity of historical moments. A notable example is his chronological repositioning of two important events in Caravaggio's life: Baglione's libel suit and the charge that Michele threw artichokes in a waiter's face. Although these two civil suits occurred relatively early in the professional life of the painter, Jarman situates them toward the end of his biographical narrative. Adding to these confusions of chronology is the soundtrack's fluctuation between dialogue, voice-off, and voice-over, which only infrequently matches picture to voice. Constantly moving in and out of the cinematic frame, the soundtrack allows the fragmented retrospections of the unconscious Michele to lay bare the inevitable jumble and confusion of everyday life which biographical film often seeks to gloss. While this picture's disorienting mixture of history and fiction reveals for Jarman 'the old myths as living reality' (Jarman 1986: 92), it also functions to stress the psyche's irreverence for the marked time of legal documentation, not to mention the film's affection for the dirty details of memory which indiscriminately cast their subliminal shadows on the conventional orderliness of historical narration.[5]

To heighten the rhetoric of designerly resemblance, Jarman's costume designer, Sandy Powell, dressed his lawmen 'in the trilbys and leather coats of a 40s B-movie, which gave them a cinematic authority which they would not have possessed with pikes and hallberds' (ibid.: 82). The ultimate *coup de théâtre* was the verisimilar costume effect conceived by the production designer, Christopher Hobbs. His decision to cover the costumes with fuller's earth, a fine powdered clay used in the nineteenth century for dry-cleaning, resulted in the crew's obsession with 'acinematic' dirt:

> The exact amount became a matter of serious debate. We shut our eyes during the dust bath of fuller's earth. Christopher, looking imperturbable, announced that he was being far too cautious. Everyone in Visconti's film of *The Leopard*, he said, looked as if they had rolled through a China claypit. We sneezed and coughed in the dust clouds. When there was a lull in the shooting the cry would go up – 'fuller's earth!'
>
> (Jarman 1986: 82)

This rather filthy anecdote isolates the theatrical gesture best denoting the film's dead time within the living present. At stake in the film's production was less a clean and unremarkable match of costume to historical analogue than the designer's rhetorical conceit of – 'dirtier still'.

ECONOMIES OF VISION

This is not to say, however, that the shining coins finally covering Caravaggio's dead eyes fail to signify the orderly, metaphysical economy of the supplement which reinscribes the mess of anamnesis in the framework of analytic certitude. For Michele's metallic eyes are emblematic of Alfred Sohn-Rethel's discussion of how coins function socially as 'an immutable substance, a substance over which time has no power, and which stands in antithetic contrast to any matter found in nature' (Sohn-Rethel 1978: 59). Taking the Sohn-Rethel thesis one step further, Slavoj Žižek foregrounds the *material* character of money which was undervalued by Marx:

> not of the empirical, material stuff money is made of, but of the *sublime* material, of that other 'indestructible and immutable' body which persists beyond the corruption of the body physical – this other body of money is like the corpse of the Sadean victim which endures all torments and survives with its beauty immaculate.
>
> (Žižek 1989a: 18)

Surely the immaculate still of Caravaggio's dead, shining eyes epitomizes the 'sublime object' signified by 'this immaterial corporality of the "body within the body"' (ibid.). Jarman's filmic testimony to Caravaggio is in itself an account of the lasting beauty of the painter's life tormented by the vicissitudes of sadomasochism, a point to which I will soon return.

But first it might help to develop the broader implications of the 'hallucinating metonymy' of coin and corpse.[6] In making his Sadean claim, Žižek refers to Sohn-Rethel's hypothesis that the sublime object depends on the symbolic authority of the social function sustaining it. In the words of Sohn-Rethel:

> A coin has it stamped upon its body that it is to serve as a means of exchange and not as an object of use. Its weight and metallic purity are guaranteed by the issuing authority so that, if by the wear and tear of circulation it has lost in weight, full replacement is provided. Its physical matter has visibly become a mere carrier of its social function.
>
> (Sohn-Rethel 1978: 59)

The authority of a coin's social function is said here to rest on a critical distinction between 'a means of exchange' and 'an object of use'. In the case of a coin, its stamp signifies the 'means of representation', not the object of circulation. Yet, might not this same distinction break down when the wear and tear of use is serious enough to obliterate the signs of a coin's issuing authority? The shining coins in *Caravaggio* remind me of

the results of one of my favorite childhood rituals when trains still ran regularly through the middle of small American towns. My young friends and I used to enjoy placing coins on train tracks in order to delight in the obliteration of the object by the weighty 'stamp' of the engine. It is not difficult to claim that, in this case, the playful and sometimes parodic 'use of the object' effected 'an exchange of means' so that the 'issuing authority' of the coin and its social function were of much less significance to the youthful recipients of the smashed object than was the coin's new imprint from the powerful train (itself a 'carrier' with a social function). There is no question, regardless of the banality of the example, that one community's 'use of the object' can effect 'an exchange of means' rather than 'a means of exchange'. Might not the dead Caravaggio's ocular coins also pose the retrospectively critical question of the film's 'exchange of means', of its 'issuing authority'? Exactly whose social functions find themselves authorized by the reflecting polish of Caravaggio's golden metal?

A challenging aspect of *Caravaggio* is the polysemous nature of the film's issuing authority which is inscribed in the coining of competing social registers. The range of these registers in *Caravaggio* is extensive and extremely difficult to chart: from differing ocular economies of the filmic apparatus to a challenge of the heterosexual rationality of what Derrida calls 'the white mythology' through which 'the white man takes his own mythology, Indo-European [heterosexual] mythology, his own *logos*, that is, the *mythos* of his idiom, for the universal form of that he must still wish to call Reason' (Derrida 1982: 213). Particularly helpful to my reading of the filmic still closing *Caravaggio* is Derrida's analysis of coining in 'White mythology'. This is where he plays off a fragment from Anatole France's *Garden of Epicurus* to read the surface of the polished coin as a historical performative of a 'White' metaphysical economy:

> Polyphilos: It was just a reverie. I was thinking how the Metaphysicians, when they make a language for themselves, are like (image, comparison, a figure in order to signify figuration) knife-grinders, who instead of knives and scissors, should put medals and coins to the grindstone to efface the exergue, the value and the head. When they have worked away till nothing is visible in their crown-pieces, neither King Edward, the Emperor William, nor the Republic, they say: 'These pieces have nothing either English, German or French about them; we have freed them from all limits of time and space; they are not worth five shillings any more; they are of an inestimable value, and their exchange value is extended indefinitely'. They are right in speaking thus. By this needy knife-grinder's activity words are changed from a physical to a metaphysical acceptation.
>
> (Derrida 1982: 210)

Commenting similarly on the metallic shift from the physical to the metaphysical register, Derrida argues, in *Of Grammatology*, that the symbolic authority of coins derives from the social stamp of economic rationality, that is, from the metaphysical imprint of signs that replaces the natural metal of materials:

> This movement of analytic abstraction in the circulation of arbitrary signs is quite parallel to that within which money is constituted. Money replaces things by their signs, not only within a society but from one culture to another, or from one economic organization to another. That is why the alphabet is commercial, a trader. It must be understood within the monetary moment of economic rationality . . . money gives the 'common measure' to incommensurable objects in order to constitute them into merchandise.
>
> (Derrida 1976: 300)

While *Caravaggio* foregrounds precisely such a fetishistic economy, it does so, I want to suggest, in a way that places the polish of Caravaggio's coins under erasure. For rather than merely reflecting the sublime, 'common measure' of incommensurable objects, the shining surface covering Caravaggio's lifeless eyes can be understood to designate the film's poignant commentary on the infelicities of incommensurability itself. For the gold that constitutes the common measure of 'merchandise' across one broad economic/scopic register gives way in the film to a differend psychopolitical resonance on a competing, specifically homosexual, register.[7] 'Gold to translate into light has been a constant topic of conversation', admits Jarman,

> in the seven years it has taken to raise the money for the film: gold to buy the scarlets and blues and even the humble earth colours; gold for the rent and the toothpaste. I have a gold leaf from a Greek funerary crown on my mantelpiece, shaped like Moses' fiery horn, a tiny incandescent flame. There's a gold papier mâché hat, the interior scarlet, with silk tassels and silver thread, the gold a dusky burnished yellow, the hat shaped like a bowler with a deep crown, a hat from the golden gardens of the Incas. For Caravaggio I gilded my teeth and spent an evening out watching the reaction of the boys in the pub. Caravaggio hands Ranuccio a golden ducat; gold is the prize. He poses him for *The Martyrdom*. High above Jerusaleme lights him with a gold reflector, with the light from a two-kilowatt source. As the coins were thrown to pay Ranuccio for the pose, his mouth filled until it was contorted into a golden scream. Everything conspired to mirror the painting.
>
> (Jarman 1986: 52)

Precisely what is mirrored in the sheen of gold varies in *Caravaggio*

according to the exchange of the means of reflection on contrasting levels of economy and desire. What buys rent and toothpaste in one economy is the source of gilded teeth and golden screams in another.

Further consideration of the uncommon measure of such mirroring should clarify the disruptive impact of the differend on any virtualized reading of *Caravaggio*. Along the axis of the 'white mythology' imprinted in the film, Michele's shining eyes of death can be understood not only to allude to the sublime supplement of economic rationality but also to signify their affinity to the specifically *ocular* economy of sexual difference imprinted in Western letters since Oedipus. I am thinking of what might be called the 'mirrorical' economy of retrospecularity – that fetishistic 'look back' which blinds the male to the fissure of his lack while binding the female to the lack of her speculation.[8]

Two contiguous sequences foreground *Caravaggio*'s demystification of the specular structure in which the filmic apparatus operates. First, in sequence 31, Baglione, the scornful critic of Caravaggio's art, thumbs through a glossy art magazine, *MFR*, which includes photos of Michele's work. After throwing it down in disgust, thus casting out the images of the other, Baglione looks directly into the camera to admire himself narcissistically as if in a mirror. The camera is thereby identified as the mirrorical stand-in of symbolic virtuality.[9] The film then cuts to sequence 32, which presents the female on the other side of the mirror, so to speak. This is Lena, the girl friend of Michele's model, Ranuccio. By contrast to Baglione's narcissistic relation to the camera as a mirror, Lena stands in profile admiring herself in a hand mirror, thus establishing the tripartite relation of camera–female–mirror, a specular convention of art history's many toilet scenes.[10] Then, letting her hair down (figure 5.3), she disrupts her passive position in this voyeuristic relation by facing the camera with, as Jarman writes, 'a look of triumph and determination' (Jarman 1986: 84). It is almost as if this parodic moment disrupts, in acknowledgement of the perspectival object, Lena's entrapment in the ocular triangle of desire that structures her female identity throughout the film.[11]

Lena's gaze usually works in *Caravaggio* to enhance the homosexual passion of Ranuccio and Michele. This is especially true when she attends the painting sessions in which Ranuccio maintains manly erotic poses for Michele's epic canvases. Her presence frequently seems to inflame the sadomasochistic intensity of the men's growing desire. Ironically, their passion for each other becomes more intense when they are in friendly competition for Lena's look and pleasures.[12] Nor is this mediation of homosexual desire by the competitive presence of a woman limited to scenes in the film between Lena, Ranuccio, and Michele. The fantasy of a similar bisexual triangulation surfaces with

Figure 5.3 Derek Jarman, *Caravaggio*: Lena with mirror. (Courtesy: the artist)

erotic fury in one of Michele's final voice-overs, spoken as Jerusaleme kneels adoringly at his bedside:

> Pasqualone yawns. Time stops for no man, he says caressing himself. I watch the ripples in his trousers. 'Can I put my hand in?' The words fall over themselves with embarrassment. Pasqualone sighs and removes his hand slowly without looking at me. I kneel beside him and timidly reach into the dark. There are holes in his pockets, my hand slides in. His cock grows under my fingers. Pasqualone says his girl Cecelia holds it harder, harder, the air hisses through the gap in his golden teeth. Touch mine! Touch mine! But my mouth is dry and the words refuse to come. An ice-cold bead of sweat forms and trickles down my back. The seed is warm in my hand. His body tightens, he swallows, 'Harder, Michele, harder.'
>
> <div align="right">(Jarman 1986: 97)</div>

This phantasmatic voice-over doubles the film's more realistic depictions of scenes with Lena in a way that literalizes two competing but complementary theories of the triangularity of desire. The least complex of the two is René Girard's notion (1965; 1977) that desire is always triangular, always mediated by the presence of the desiring rival. For evidence from *Caravaggio*, Girard would likely refer to how Lena's jealousy of Michele's expressions of passion for her lover catalyzes the two scenes in which she is shown making love to Ranuccio.

But, from a feminist point of view, there is a potentially darker side to the fragile satisfactions received by Lena from such a triangular love. This can be summarized by Luce Irigaray's well-known thesis that chivalric mediation functions to veil the triangular trading of women on which Occidental culture is based:

> In this new matrix of History, in which man begets man as his own likeness, wives, daughters, and sisters have value only in that they serve as the possibility of, and potential benefit [from], relations among men. The use of and traffic in women subtend and uphold the reign of masculine hom(m)o-sexuality even while they maintain that hom(m)o-sexuality in speculations, mirror games, identifications, and more or less rivalrous appropriations, which defer its real practice. Reigning everywhere, although prohibited in practice, hom(m)o-sexuality is played out through the bodies of women, matter, or sign, and heterosexuality has been up to now just an alibi for the smooth workings of man's relations with himself, of relations among men.
>
> (Irigaray 1985b: 170–1)[13]

If read as a commentary on 'hom(m)o-sexual' relations, Jarman's film certainly confirms the gist of Irigaray's theory that the place of women in a patriarchal economy can be confined only to that of 'the abject' since her role is to function as a well-oiled hinge of 'hom(m)o-sexual' desire. And when her agency becomes more viscous than fluid, she is cast out for fresher, purer matter. So it seems to work in *Caravaggio*. Ranuccio kills Lena after she announces her pregnancy and her desire to mother the baby in the household of a richer man, Scipione Borghese, the nephew of the Pope. Ranuccio's justification for the murder is that he drowned her to purify his 'hom(m)o-sexual' love for Caravaggio.

HOMOGRAPHESIS

Of course, what is tricky about Irigaray's thesis and its relation to *Caravaggio* is how its terminology indirectly equates female bondage with homosexuality. In *Between Men* (1985), Eve Kosofsky Sedgwick chooses the term 'homosocial' over 'hom(m)o-sexual' as a means of avoiding any traces of homophobia that might remain latent in Irigaray's punning use of the term. Yet, Jarman's film challenges its reader to reflect on, rather than avoid, this fluid slide between the homosocial and the homosexual. That is, *Caravaggio* displays how easily alternative (homosexual) modes of socialization find themselves fused with homophobic and misogynistic (homosocial) traditions. The film's sometimes contradictory slide between homosocial and homosexual relations illustrates the instability of any 'gay male political identity', especially when

positioned within the pervasive apparatus of heterosexual 'economy'. My understanding of the subtle facets of such oscillation is indebted to Leo Bersani's text 'Is the rectum a grave?' (1988). In this challenging essay on public responses to AIDS, Bersani suggests that gay male identity is frequently inscribed in a paradoxical identification with both poles. On the one hand, an 'authentic' homosexual political identity implies a struggle 'against definitions of maleness and of homosexuality as they are reiterated and imposed in a heterosexual [homosocial] social discourse' (Bersani 1988: 209). On the other hand, the same identity is often shaped, he insists, by the ambivalent sadomasochistic incorporation of homosocial ideals:

> The dead seriousness of the gay commitment to machismo . . . means that gay men run the risk of idealizing and feeling inferior to certain representations of masculinity on the basis of which they are in fact judged and condemned. The logic of homosexual desire includes the potential for a loving identification with the gay man's enemies. (ibid.: 208)

This potential is met head-on by the enigmatic diegesis of Jarman's *Caravaggio*.

Consider the dangerous stress placed by Lena's murder on the homosexual bonds joining Ranuccio and Caravaggio. No doubt to Ranuccio's amazement, Caravaggio responds to his admission of the murder of Lena by slitting his throat. One reading of this surprising act might understand it as Michele's punishment of Ranuccio for his violence against women. As Lynne Tillman suggests, 'it says, for one thing, that Caravaggio will not love over this dead woman's body' (Tillman 1987: 23).[14] Yet, a less generous view might suggest that the murder attests to Michele's inability to love Ranuccio outside of the sadomasochistic bond produced by mediated, bisexual desire. This explanation could be supported by Freud's suspect linkage of jealousy, paranoia, and latent homosexuality, as summarized by Kenneth Lewes in *The Psychoanalytic Theory of Male Homosexuality*:

> Quite interestingly, the process of converting rivals into love objects is the mirror image of the process by which passive homosexual love is transformed into persecutory or delusional paranoia. In the latter case, the intolerable homosexual impulse, 'I love him', is transformed by negation into 'I hate him', and then rationalized through projection into 'He hates me', so that paranoia keeps the subject from becoming homosexual.
>
> (Lewes 1988: 42)[15]

In keeping with this conceptual scenario, Ranuccio's death at the hands of Michele fulfill's that former's projection, 'He hates me'. But this

works only in view of a filmic narrative built on the theme of a paranoid fear of homosexuality which is precisely what is disputed by Jarman's celebration of male-to-male lovemaking in *Caravaggio*. By contrast, Girard might counter that the triangular role of Lena is more likely to support his qualification that

> nothing is gained from reducing triangular desire to a homosexuality which is necessarily opaque to the heterosexual. If one turned the explanation around, the results would be much more interesting. An attempt should be made to *understand* at least some forms of homosexuality from the standpoint of triangular desire.

> (Girard 1965: 47)

Lending credibility to this hypothesis is a striking filmic memory evoked by Jarman's portrayal of this scene. After Michele slashes Ranuccio's throat, the limp Ranuccio falls into his lover's arms and smears the blood from his wound back on to the face of Michele (figure 5.4). This gesture mirrors a moment from an earlier scene, in which the two men first express their affection for each other. In scene 23, Michele and Ranuccio engage in an inexplicable knife fight (watched by their respective rivals, Lena and Davide). When Ranuccio gains the upper hand, he withdraws his knife and prompts a smile from his weakened opponent.

Figure 5.4 Derek Jarman, *Caravaggio*: blood brothers (final death).
(Courtesy: the artist)

Figure 5.5 Derek Jarman, *Caravaggio*: blood brothers (initial bloody kiss).
(Courtesy: the artist)

In that same moment, however, Ranuccio suddenly stabs his rival in the ribs. Michele then returns the surprise by putting his hand to the wound and wiping it on Ranuccio's face. In response to Michele's comment, 'Blood brothers', Ranuccio laughs and kisses him on the mouth (figure 5.5). This act frames the next scene, in which Lena confronts Ranuccio with the jealous outburst that leads to their intercourse.

But should it not matter that in constructing this mirror-image, Jarman also reveals that it does not quite match? Since Lena is no longer in the picture the second time around, might this bloody exchange between the two men denote the vicissitudes of homosexual passion, rather than the rigid grid of heterosexual or even bisexual triangulation? Could one not stress the enigma of Michele's stabbing of Ranuccio, especially as it refers to the complex web of homosexual relations and economic exchange extending throughout the film? Might not such an 'enigmatic signifier' confirm, rather than challenge, the opacity of a reading of these relations in heterosexual terms?

Consider, for example, how Ranuccio's 'exchange of means' leading up to this scene occludes the 'issuing authority' of both the diegesis and its interpretation. Ranuccio's criminal subterfuge inverts his psychopolitical subservience to Michele, his patron, by causing the painter to be further indebted to his religious superiors. Following the incarceration of Ranuccio, whom Michele presumes to be innocent, the artist wistfully prostitutes himself by offering to paint a portrait of the Pope in

exchange for the Pope's release of the condemned. The ideological implications of this trade are emphasized by the Cardinal Scipione Borghese: 'The Holy Father and I will turn a blind eye to Sodom as long as you make it worth it by bringing the riff-raff back to the Church, placing them in awe of the power of the Holy Father' (Jarman 1986: 118). Viewers of this scene will note, moreover, its mnemonic relation to earlier scenes of male-to-male exchange. First is Michele's teenage subterfuge of pretending to sell paintings rather than sex, a homosexual exchange in which Michele maintains the upper hand.[16] Second is his deal in the next scene with the Cardinal del Monte to trade his cherished knife for *Luteplayer*, the painting on which he wrote: 'You know that I love you' (ibid.: 27). This trade is followed by a close-up of Michele, who masochistically slits his mouth with his shiny appendage. These earlier moments of homosexual trading, which are all marked by tilts of sado-masochistic power balances, so pervade the film that they attach themselves metonymically to Michele's tradings with the Pope. The psychosexual traces of his exchange of the Pope's portrait for his model's life stand out in Caravaggio's dealings with the Pope when, in Tillman's words, 'the Pope whispers to Caravaggio about the painter's naughtiness as if the two were in sacrilegious cahoots' (Tillman 1987: 21). While the naughty hallucinations of the many scenes of homosexual exchange lend an explicitly homoerotic cast to Michele's murder of Ranuccio, their differing blends of male-to-male exchange inscribe homosexuality in a performative scene of shifting signification.

For what makes these differing series of exchange opaque to a 'common measure' is the fact that their 'issuing authority' remains contingent on differing and shifting 'exchanges of means' rather than on any commonly inscribed objects of use, like a coin, a woman, a painting, a knife, or a cock. And even though sadomasochistic exchange might fuel passion in all of these instances, its personal and institutional means of power, pleasure, and pain oscillate to such a substantial degree that any 'common measure' of sociality and sexuality is dispersed among differing forms of male-to-male inter(dis)course.

Even within the homosexual community of theorists, this 'common measure' is disputed in ways that continually mark the circulating tension between the homosocial and the homosexual. In *Sodomy and Interpretation: Marlowe to Milton*, Gregory Bredbeck argues that 'throughout the Renaissance homoeroticism is figured and refigured as a slippery category that is at once both a type of sexual meaning and an effacement of sexual meaning . . . the entrance of sodomy into idealized languages of social order somehow also invokes the broader arenas of dissent trying to be controlled' (Bredbeck 1991: 21). Writing more specifically about the wide arena of contemporary homoeroticism, Simon Watney invokes a 'new gay identity . . . constructed through

multiple encounters, shifts of sexual identification, actings out, cultural reinforcements, and a plurality of opportunity (at least in large urban areas) for desublimating the inherited sexual guilt of a grotesquely homophobic society' (Watney 1989: 18). For Bersani, by contrast, these calls for 'sexual pluralism' stand forth as the tainted traces of homosocial sublimation itself, since 'it is perhaps primarily the degeneration of the sexual into a relationship that condemns sexuality to becoming a struggle for power' (Bersani 1988: 218). What is homo-*sexual* for one is hom(m)o-*social* for the other.

The point of focusing on these conflicting theoretical and cinematic scenes is not, however, to insist on the inevitable homosocial fiber of homosexual aesthetics but, rather, to emphasize the ambivalent and polymorphous role played by homosexual relations in and out of the film. Especially complex and difficult to read is the frequent disjunction between the *sexual* and the *artistic* in Jarman's choice of subject-matter and its portrayal. Although sexual scenes of graphic sadomasochism dominate many of his earlier films, from *Sebastiane*'s highly erotic depiction of the martyrdom of St Sebastian to the brutal 'snuff' scenes of *Jubilee*, Jarman has since spoken emphatically 'of the need to expunge the strong sadomasochistic trait in homosexual art – a fault he finds in Pasolini's work' (O'Pray 1985: 12). But just as Jarman remains vague in his writings and interviews about precisely what is at fault with sadomasochism – which Foucault claims to enhance the pleasure of homosex (Foucault 1988b: 298–9) – he builds *Caravaggio* around literal wounds or faults which attest to the depths of sexual passion. In fact, sadomasochism and its hallucinating variants are the very traits that attracted Jarman to Caravaggio's paintings and which shaped his account of the painter's life and work:

> [Caravaggio] bolsters up his insecurity with hostility and he numbs the hurt with wine. He paints his lovers as Saint John, the wild one in the wilderness who will be destroyed by a capricious woman. When he's not gazing at these heroes he paints himself as Saint Francis, contemplating death. He paints with a knife: painting is a revenge; on the knife is written, 'No hope, no fear.' He hacks his way through altar pieces, Isaac and Holofernes, crucifixion, wounds, flagellations. It culminates one morning in the real murder of Ranuccio.
>
> (Jarman 1984: 23–4)

If *Caravaggio* is meant to expunge sadomasochism it does so only indirectly by displacing precedents of sadomasochistic homosex in Jarman's earlier films with the 'sadomasochistic traits' evident in the painter's 'homosexual art'. One crucial question raised by this shift is whether or not Jarman's homosexual interest in art remains sufficiently

sexual. As Bersani would ask, does it 'turn our attention away from the body – from the acts in which it engages, from the pain it inflicts and begs for – and direct our attention to the romances of memory (Bersani 1988: 219–20)?

The critical import of this distinction becomes especially evident, as well as problematic, in Jarman's fanciful adaptation of still a different homosexual economy in the paintings of Caravaggio. The film contrasts the sadomasochistic coupling of Michele and Ranuccio with Jerusaleme's expressions of passionate loyalty to Michele, his pedophiliac master who freed him from poverty as a young boy.[18] Demonstrating a critical aporia blind to the sexual economy of pedophilia, Tillman suggests that the bond between Jerusaleme and Caravaggio counters 'the conventional view of the painter as a violent man, and perhaps challenges a view of homosexuals that would not allow them to be good paternal or maternal figures' (Tillman 1987: 21–2). But rather than attest to the normality of homosexual paternalism – the reinscription of homosexuality in the family drama – this controversial conceit of pedophiliac relations is actually a by-product of a certain pathology, that is, of the homosocial perversion of cinematic practice. For it stems from hostile, heterosexual reactions to homo-*sexual* representation, to Jarman's realist desires to cast a young, male model for Caravaggio's most erotic painting:

> Most of the paintings were easy to reconstruct with actors – only *Profane Love* was impossible to reproduce in the present moral climate: the homo-erotic pin-up painted for the Marchese Giustiniani of a naked twelve-year-old boy as Cupid trampling over Culture and Architecture and the Martial Arts with a wicked grin. Nearly all the agents that we rang to cast the film asked if the actors they represented would have to appear in the buff. The permissive sixties are over. . . . Naked twelve-year-old boys are not a speciality of the theatre schools The solution in the end was to cast Dawn Archibald and ask her to keep all her clothes on, rather than have a half-naked compromise; and to restore the paedophilia in the soundtrack with Caravaggio's relation to the fictional character of Pasqualone, his first love, turning the painter himself into the *putto* who trampled over Art and Culture.
>
> (Jarman 1986: 75).

Jarman's response, then, to the sexual anxiety of his period was to provide a paranoid culture with the exaggerated narrative of its own inhibitions. And this is where the sexual, at the least the diegesis of sexuality, can be seen to desublimate, to return to Watney's point, 'the inherited sexual guilt of a grotesquely homophobic society'. And in so doing, this cinematic case history clearly positions the pathology of

paranoia on the site of 'normal' homosocial exchange, not on the level of homosexual identity.[19]

Especially striking about these and other paradoxes in *Caravaggio* is the stress they put on the fracture integral to any project of aesthetic retrospection aiming to circumscribe sexual identity as sex, as something prior to or beyond the infelicities of (cinematic) discourse. Similarly, and even more significantly, it attests to the difficulty of mapping homosexual praxis, whether textual, sexual or visual, from the omniscient standpoint of an essential identity and totalizable projection. Critical attempts to fix such a homosexual identity are said by Lee Edelman to depend on the misleading assumptions of 'homographesis'. This is the subtle term coined by Edelman to account for the drive to put 'homosexual difference' into writing:

> the process whereby homosexuality becomes a subject of discourse, and therefore a subject on which one may write [which] coincides with the process whereby the homosexual as subject is conceived of as being, even more than as inhabiting, a body on which his sexuality is written So it produces the *need* to construe an emblem of homosexual difference that will securely situate that difference within the register of visibility.
>
> (Edelman 1989: 194)

Edelman goes on to suggest, however, that still another discursive production, the 'homograph' – a word of the same written form as another but of a different meaning or origin – stands out as the visible element making homographesis an unstable, differential relation rather than a determinate entity:

> The homographic nature of homographesis would thus point to the potential for misreading inherent in the graphesis of homosexuality to the extent that such a graphesis exposes the non-coincidence of what appears to be identical or what passes for identity. Recalling in this context metaphor's appeal to the idea of essence or totalizable identity, we can say that the homographic element in the notion of homographesis reinterprets what seems to be a mirroring or a (re)production of identity . . . as a relation of contiguity, of items so close in the graphic register that they share a single signifier though they may be radically different in meaning or derivation.
>
> (ibid.: 196)

We need but turn to a brief *Artforum* review of *Caravaggio* to appreciate how the film's contiguity of mirror-images and triangular bonds might confuse its reader. In response to Jarman's blending of fact and fiction in scripting the homosexuality of his subject, Wolfram Schutte emphasizes

the personal nature of Jarman's concern 'with his own ideas and fanta-
sies of Caravaggio . . . his bi- or homosexuality' (Schutte 1986: 13). Of
note here is not so much Schutte's ambivalent attentiveness to Jarman's
fantasy of Caravaggio as the critic's elision of sexual orientations. In
sliding somewhat casually over the difference between bi- and homo-
sexuality, Schutte responds to the mixed signals of Caravaggio's ex-
pression of bisexual fondness for both Lena and Pipo (the 'male' model
portrayed by a clearly female, howeover boyish, Dawn Archibald).[20]

Although the mixed signals of passion in *Caravaggio* do position bi-
and homosexuality in a metonymical position on the film's graphic
register, they represent to Jarman the gap, rather than the bond, separ-
ating the contiguous signifiers of sexual practice on the film's graphic
register. In remarks published two years prior to Schutte's review of his
celluloid fantasy, Jarman distinguishes sharply between these two sex-
ual orientations:

> Caravaggio breathed his life, himself, into old ideals. Bacchus was
> the androgyne god and this was a reflexion of the painter's sexual-
> ity. At first Caravaggio was probably bisexual, at eighteen or
> nineteen growing up with the conventions that surrounded him.
> Later you hack them away, but the strictures of Church and society
> leave a cancer, a lingering doubt, which leads to the dis-ease in this
> painter, and to the extraordinary force of his work as he attempted
> to overcome it. He brought the lofty ideals down to earth, and
> became the most homosexual of painters, in the way that Pasolini
> is the most homosexual of film-makers.
>
> (Jarman 1984: 22)

Thus suggested by the inconstant mirror-images of sexuality in
Caravaggio is less the fantasy of the facile slide between 'bi-' and 'homo-'
than the homographic slippage of sexual construction at issue in the
paintings of Caravaggio and the films of Jarman.[21] It is in the duplicitous
texture of such slippage, moreover, that Edelman locates the homo-
graphic inscription in 'homographesis':

> the literature in which homosexuality enters the Western field of
> vision characteristically arrives at what passes for a moment of
> sexual revelation or recognition; that moment, on closer inspec-
> tion, can be seen as the point at which what is 'recognized' is also
> constituted and produced, the point at which a crisis of retroactive
> interpretation finds expression as a crisis of representation.
>
> (Edelman 1989: 196).

HAIL, MEDUSA!

The difficulty of reading *Caravaggio* is that the crisis of retrospective interpretation varies according to the subject-position interpellated by the filmtext. This could certainly account for my interest, as a heterosexual male reader, in Jarman's discursive (some might say 'relational' rather than 'sexual') blends of homosexual art and sex on one hand, or for a feminist reading of Lena's murder on the other. Either of these critical sensibilities could suggest, to return to the latter theme, that the transfigurations wrought by the homosocial murder of Lena can easily serve as the fulcrum point of such a crisis of representation. But to limit a reading of the scenes surrounding Lena's enigmatic death to one recognizable strain of interpretation, say a critique of hom(m)o-sexual victimage, would be tantamount, in Edelman's words, to asserting a metaphoric 'dominance over the metonymic contingency that it seizes upon and vivifies with meaning' (Edelman 1989: 198). By contrast, further discussion of a narrative thread supplementing these scenes, the discourse and vision of wistfulness, will clarify the complex way in which *Caravaggio* interweaves, however ambivalently, the phallocentric dramas of homosociality and the homographic hieroglyphs of homosexuality. For the cinematic contingencies surrounding Lena's murder demystify the tri(str)angulation of woman in the homosocial economy as well as distinguishing sharply between the tradition of univocal, homosocial relations which are negative for women and the representation of heterogeneous, homosexual practices which are positive for men. And what remains consistent throughout the film is how the operations of one economy are contingent on its ambivalent appeal (interpellation/desire/negation) to the other.

Many homographic details blur the mourning of Lena in *Caravaggio*. While the resonant voice-offs and the cuts in and out of the hospital room at Porte Ecole confirm the script to be an autobiographical flashback awash with melancholic self-reproach, the film's image-traces align it with a wider tradition of aesthetics, one encrypting the loss of woman in the continually sutured space of homosocial exchange. In one significant sense, the filmic scenes of mourning could be read to engage only in a pitiful return of phallocratic sameness. Take sequence 42, following Lena's death, when her muddied corpse lies horizontally across Michele's studio table (figure 5.6). While Michele gently combs her hair at one end, his companion, Jerusaleme, washes her feet at the other. It's almost as if they are made to compete for the fetishistic supplements of her life. What's more, Ranuccio is centered behind the bier, mirroring the spectator's position through the centered camera, weeping and wringing his dirty hands, which accomplished her death. In this scene, Lena thus lies framed by the two competing planes of

Figure 5.6 Derek Jarman, *Caravaggio*: Lena dead on table. (Courtesy: the artist)

touch and sight, which double the homosocial bonding of painting and film to which she is returned, even in death.

A shot appears in the preceding scene which complicates this relatively clearcut reading of triangular relations (figure 5.7). It stands out, in my mind, as the most significant and parodic retrospective shot in the film, the kind described by Pasolini as best relating cinematic language and image, the kind which is *in* and *before* the film, found, he writes, in 'a complex nexus of *significant images* which *pre-figures* cinematic communication and acts *as its instrumental foundation*' (cited by de Lauretis 1984: 50). Jarman describes the shot this way: 'Lena's body floats in the golden waters. Like Ophelia, she is dressed in a scarlet gown which streams out from her, turning, turning, an image of peace and beauty at rest' (Jarman 1986: 102). Jarman thus aligns this shot with the convention of artistic depictions of Ophelia which reaches its height with John Everett Millais's Pre-Raphaelite *Ophelia* – a convention later ghosted in *Vertigo*, when Madeleine floats in the waters of San Francisco Bay.[22] Living up to Jarman's charge that the Pre-Raphaelites achieve the 'ideologist' crescendo of Western art (Jarman 1985: 55), this picture stands out as an emblem of Occidental art's aestheticization of female death. For it romanticizes Ophelia's inferred hysterical suicide as a consequence of her doubled loss of father and lover (a continuance to her death of homosocial tri[str]angulation).

Still, Jarman's cinematography works directly against this phantasm of what it might mean for him to cite Ophelia. In his shot of Lena's death

Figure 5.7 Derek Jarman, *Caravaggio*: Lena floating dead in the water.
(Courtesy: the artist)

in the water, he depicts no return to the same, but rather a darkly indistinct image, one in which the so-called scarlet gown is no more recognizable than are the features of the victim. This shot only parodies Jarman's scripted desire to cast Lena in the aura of Ophelia. Encoded is not 'an image of peace and beauty at rest' but a visual reminder of the cast-off 'snuff' victim in Jarman's *Jubilee*, whose indistinguishable figure lies crumbled in a heap of clothes at the foot of the Thames. Especially as it bears such an uncanny resemblance to Jarman's earlier victim of cinematic sex, the image plays off the Shakespearean tradition by repositioning Ophelia as a victim not of her own hysteria, but of viola-tion and murder, of a phallologocentrism which defines her and casts her aside. Indeed, Michele's voice-off accompanying the death image suggests that this picture is beautiful only in so far as it elicits the even deeper history of its own pictorial repression. 'Your hair streams out', announces the voice-off, 'dark as the Medusa weed.'

By citing Jarman's reference to the Medusa, the Gorgon who lives after death through literary and artistic representation, I wish to stress the homographic heterogeneity of the film's representational strategy instead of its repetition of a tiresome narrative of female victimage. This contrast is nowhere more apparent than in Jarman's polymorphous representation of the Medusa figure itself. In speaking of his fanciful reconstruction of Caravaggio's biography, Jarman alludes to the Gorgon as a means of describing the camp which he imagines to have seduced

145

the young Caravaggio in Rome: 'the boys are beautiful, healthy and young; the worst they can do is play at being Medusa and frighten nobody' (Jarman 1984: 22). (Followers of recent work in homosexual video will recognize the contemporary corollary of the playful snap queen, 'Medusa Snap', featured by Marlon Riggs in *Tongues Untied* (1989).) This specter of a parodic performance of the Medusa laughing along with her peers plays a significant role in Jarman's film. It produces a doubled phantom. First, a psychoanalytical one, a kind of incorporated phantom that rekindles the specters of Medusa cited in the preceding chapters by preserving the fantasy of a Gorgon attractive in guile as well as beauty. Jarman's analogy of Medusa and the deadly transfiguration of Lena leaves open the possibility that the film carries with it the mechanism of incorporation in which a forgotten phantom stands aside from the supplemental economy of death. It thus recalls Abraham and Torok's description of a refusal of mourning, the condition of not being able do otherwise than perpetuate a lost clandestine pleasure/crime – the patriarchal murder of Medusa–Ophelia–Lena – by establishing it as an encrypted hallucination, an 'intrapsychic secret' disruptive of narrative blockage. So what makes woman's death significant in *Caravaggio* is its cryptation throughout the film, before and after death, in a heterogeneous discourse of aesthetic mourning which always already stands out in contrast to her dependable, diagetic disappearance in the epic fiction that kills her.[23] In addition, the film nurtures a second, filmic phantom, the kind proposed by Teresa De Lauretis with regard to avant-garde film practice through which contradictory or 'phantom percepts' might be produced not to negate illusion and destroy visual pleasure, but to problematize their terms in cinema.[24] One strategy might be to counter the deathly images of Lena and Ophelia with the visual and methodological phantom of a 'gay' figure like Medusa, one similar to that described by Hélène Cixous: 'you only have to look at the Medusa straight on to see her. And she's not deadly. She's beautiful and she's laughing' (Cixous 1981: 255).

Jarman features just such a sensuous relation of the look beautified by the laugh to serve as a polymorphous performative of homosexual exchange. Early in the film, the young Caravaggio smiles parodically to seduce the older Englishman who camouflages his purchase of Michele's sex with an interest in his paintings. At the conclusion of this scene, which leaves the customer defenseless under the mixed influences of sex and wine, Michele laughs with glee at his success in frightening the British John into leaving behind his wallet. The next shot of Michele crowning himself with a vine propped next to a basket of fruit is doubled metonymically by a cut to Caravaggio's self-portrait, *Boy with a Basket of Fruit*. This boy's bare shoulder and wistful gaze are cited

Figure 5.8 Derek Jarman, *Caravaggio*: Jerusaleme removing the Medusa shield.
(Courtesy: the artist)

frequently by Caravaggio scholars as exemplary of 'the homoerotic character of the figures' (Gregori 1985: 214).

Another citation of what I call 'the looking laugh' occurs a bit later. In Scene 13, when an older Caravaggio harshly reprimands his lover Davide and other models for breaking pose for *The Martyrdom of St Matthew*, he shares a private wink and snicker with Jerusaleme attending off to the side. These two characters again revel in a similar, intimate moment, when Jerusaleme awakens to laugh affectionately at Michele, who returns home dressed in masquerade for the arts ball. The viewer of *Caravaggio* learns, moreover, to read homoerotic glee as a performative which denotes more than the private asides between Michele and his assistant. For both times Caravaggio and Ranuccio are wounded one by the other's knife, the act of penetration is preceded by the victim's tendering of an appreciative smile to the other holding the upper hand. Similar exchanges of performative gesture and homoerotic passion can be said to imprint *Caravaggio* with the mark of 'the looking laugh'.[25]

This is made explicit in an early sequence, when Jarman dramatizes Caravaggio's painting on a shield, *Head of Medusa*. Upon entering Caravaggio's studio for the first time as a young boy, Jerusaleme stops and sticks out his tongue at an object off-camera which is subsequently revealed to be the Medusa shield. He then removes the shield from its easel (figure 5.8), runs with it around the room, and thrusts it toward his master's face. In response to the apotropaic image, Caravaggio first

147

exhibits and/or feigns a startled response and then joins Jerusaleme in mocking the mythological power of the image by also sticking his tongue out in return. These cinematic performances through movement and gesture exemplify the 'libidinal economy of the cinema' which Lyotard suggests 'should theoretically construct the operators which exclude abberations from the social and organic bodies and channel the drives into this apparatus' (Lyotard 1986: 356). Caravaggio feigns his being caught off-guard by the libidinal thrust of one of the Occident's most forceful devices of aberrational exclusion, the representational shield of Perseus. The painter's playful, yet ambiguous, response to this dirty still from another age and another medium – classicism's literary depiction of the disfigured Medusa – suggests the lingering potency of the phantom operators of stilled historical action. In Jarman's words, 'the sudden aimless outbursts in a bright, undifferentiated world are balanced by the darkened studio, where a controlled light shines that tells the story' (Jarman 1986: 132). Functioning like the figure of *ekphrasis* which the phallocratic tradition thought to have controlled as its own, this phantom absorbs the oppressive re-action to aimless outburst in a single moment of apotropaic energy. In doing so, moreover, it (re)turns the evil mechanism of phallologocentrism against itself.

The circuitous and multi-layered return of the Medusa is made possible in *Caravaggio* through a sophisticated weave of psychopolitical interpellations – the kinds of call to performance which unite in one phantasmatic object (the Medusa) the many drives spread across the polymorphous body of celluloid. In Jarman's script, the significance of the Medusa scene lies more in the *performance* of the artifact than in its observer's *response* – for which, interestingly enough, the script fails to account:

> Jerusaleme discovers the serpent-wreathed painting *Medusa*, as Michele opens the shutters and floods the room with the first light of dawn. He slips the painting from the easel and runs round the room holding it as a shield. Michele scoops him up and puts him on his knee. Exhausted by their journey, they fall asleep. In the silence a serpent glides out of the basket, the serpent of memory, bringing with it the sounds of the country: the cicadas, and shepherd's bells. Jerusaleme's whistle wakes Michele with a start. Time has passed, the child has grown into a young man who gesticulates and signals to him in sign language.
>
> (Jarman 1986: 13)

Jarman wished to script this scene so that the Medusa would stand forth as the figure of anamnesis intertwined in the phallic signifiers of the Medusa, the snake of memory, Jerusaleme's whistle, and his gesticulating sign language. But what is signified by such a polymorphous group

of images and signals? Could it be that exactly *what* they are meant to memorialize might be less significant than the fact that they *do* so?

My answer is an unequivocal 'yes', provided that these elements can be understood to be composite features of three performative functions of interpellation which have been said to (de)constitute the ideological subject:

1) Althusser's formulation that 'all ideology hails or interpellates concrete individuals as concrete subjects' (Althusser 1971: 173)
2) Žižek's hypothesis concerning the 'strange look' of 'an interpellation without identification/subjectivation':

> the Kafkaesque subject is the subject desperately seeking a trait with which to identify, he does not understand the meaning of the call of the Other. This is the dimension overlooked in the Althusserian account of interpellation: before being caught in the identification, in the symbolic recognition/misrecognition, the subject (\cancel{S}) is trapped by the Other through a paradoxical object–cause of desire in the midst of it (a), through this secret supposed to be hidden in the Other: $S\lozenge a$ – the Lacanian formula of fantasy. . . . It is exactly the same with ideology. Ideology is not a dreamlike illusion that we build to escape insupportable reality; in its basic dimension it is a fantasy-construction which serves as support for our 'reality' itself: an 'illusion' which structures our effective, real social relations and thereby masks some insupportable, real, impossible kernel (conceptualized by Ernesto Laclau and Chantal Mouffe as 'antagonism': a traumatic social division which cannot be symbolized).
>
> (Žižek 1989a: 44–5)

3) Laplanche's corellative notion of the *enigmatic signifier*:

> that aspect of the signifier which signifies to someone, which interpellates someone, in the sense that we can speak of an official signifying a court decision, or issuing a distraint order or prefectoral decree. This foregrounding of 'signifying to' is extremely important, as a signifier can signify *to* without its addressee necessarily knowing *what* it signifies. We know *that* it signifies, but not *what* it signifies we have to place considerable stress on the possibility that the signifier may be *designified*, or lose what it signifies, without thereby losing its power to signify *to*.
>
> (Laplanche 1989: 44–5)

It would not be difficult to argue, especially in light of examples from the preceding chapters, that the Medusa has served historically as a

'fantasy-construction' supporting phallocentric reality as well as, and more interestingly, a memorable 'enigmatic signifier' whose interpellative force lies in the uncertainty of its signification. This latter enigmatic force was described ironically by Timothy Billings during my seminar's discussion of the role of the Medusa in Jarman's film: 'it works as a perfect mnemonic device, but I'm not quite sure what I'm remembering'. It is such a gap, or fault, between the hailing snakelike image and its doubled psychopolitical significance as memory (anamnesis) and forgetfulness (*apotropaion*) that problematizes the terms of the Medusa in *Caravaggio*.

A conventional strategy of approaching the film's Medusa scene can be gleaned by juxtaposing the two most dominant interpretations of the image, the one from mythology, the other from psychoanalysis. As put succinctly by Louis Marin, in his analysis of Caravaggio's *Head of Medusa* (Marin 1977: 134), mythology (as well as early philosophy) holds that the Medusa symbolizes reason's apotropaic victory over the passions. Being the 'natural' enemy of virtue, the passions are petrified when they see the head of Medusa, as are the physical, political enemies in the myth of origin. This mythological formula is then provided structural ballast by Freud's emphasis on the phallic reversal enacted by apotropaion. While the terror of the Medusa is related by Freud to the terror of castration, its inscription in sight also carries a counterphobic effect:

> The sight of Medusa's head makes the spectator stiff with terror, turns him into stone. Observe that we have here once again the same origin from the castration complex and the same transformation of affect! For becoming stiff means an erection. Thus in the original situation it offers consolation to the spectator: he is still in possession of a penis, and the stiffening reassures him of the fact.
>
> (Freud 1953–74: XVIII, 273)

Little reason is provided by *Caravaggio*'s Medusa episode not to perceive the snake issuing from it as symbolic of the fetishistic memory of male reassurance in the face of loss. Yet it might prove fruitful to delve further into the cinematic mechanism sustaining such phallic reassurance. For such an account of consolation softens, as does Jarman's penning of the scene, the unsettling effects produced by cultural encounters with the Medusa.

When cultural practice combines the mythological and psychoanalytical accounts so that the Medusa effect occludes the Gorgon's sense, it mirrors aesthetically what Neil Hertz identifies as 'a still more explicit linking of what is politically dangerous to feelings of sexual horror and fascination [associated with the Medusa head]' (Hertz 1985: 168). In Renaissance culture, for instance, the Medusa image stood as a substitute figure not only for female and social difference but for sexual

preference as well. This is a point on which Alan Bray touches in *Homosexuality in Renaissance England*. Discussing 'the other-wordly context in which references to homosexuality are likely to occur', Bray stresses how 'the poet Walter Kennedy shows no hesitation in speaking in the same breath of a sodomite, a werewolf and a basilisk' (Bray 1982: 19). This reference provides a striking example of what Hertz understands as the discomfort produced by sociosexual positions deemed 'unnatural' by dominant cultural discourse. Foregrounded is the vulnerability of the homophobic speaker who is driven by fantasies of fatal sodomites. Hertz sees the figures of difference to be

> threatening to the extent that they raise doubts about one's own more natural ways of looking at things; and it is that threat that prompts these powerfully rendered Medusa fantasies when they are offered as substitutes for a more patient, inclusive account of political conflict.
>
> (Hertz 1985: 179)

MISSED ENCOUNTERS

Representative of such a patient, inclusive account is the cinematic method of Derek Jarman. As Mark Nash acutely views it:

> Jarman's sexual politics are uncompromising. The subculture and sexuality his films participate in are not simply 'gay' or 'camp'. The films take on broad issues of sexual politics, particularly notions of masculinity, prefiguring, anticipating a change in social order and social mores which his films so passionately demand.
>
> (Nash 1985: 35)

Nash's emphasis on the homographic differential in Jarman's scripts of gay identity speaks directly to the fascinating effects of the Medusa fantasy in *Caravaggio*. Spectators of this film may be struck by the curious way in which the cinematic results of Jarman's Medusa citations shift the image from its association with the bounds of castration, deadly vision, and apotropaion (whose warding-off of evil inscribes the apotropaic gesture in the logic of the fetish) to its pleasurable inscription in a certain wistfulness of the gaze.

An episode late in the film provides a telling example of this shift. Sequence 49 cuts between shots of Michele holding Lena's corpse in his arms and his brush strokes on the work-in-progress, *Death of the Virgin*. While evoking the final scenes of *Othello* and *King Lear*, not to mention *Oedipus Rex*, in which shattered heroes embrace lifeless female doubles, this image of cradled death is enveloped in Michele's melancholic voice-over foretelling his own watery demise:

Look! Look! Alone again. Down into the back of the skull.
Imagining and dreaming, and beyond the edge of the frame –
darkness. The black night invading. The soot from the candles
darkening the varnish, creeping round the empty studio, wreath-
ing the wounded paintings, smudging out in the twilight – sharp
knife-wounds that stab you in the groin, so you gasp and gulp the
air, tearing your last breath from the stars as the seed runs into
parched sheets and you fall into the night. I float on the glassy
surface of the still dark lake, lamp-black in the night, silent as an
echo; a mote in your eyes, you blink and send me spinning,
swallowed in the vortex.

<div align="right">(Jarman 1986: 113)</div>

These disempowering words relate melancholy and doom to the dis-
junction of sight in painting and desire. Recalling the biblical reference
of Matthew vii.3 to a slight blemish noted in another person by one who
fails to see a greater fault in himself, 'a mote in your eyes' signifies the
irrevocable shift between the fault/wound of Lena (corpse, model, and
portrait) and the vulnerable voice-over of a silent Michele. It is the imago
of Caravaggio, moreover, which is here rendered split, or partial, by the
whirling vortex of the differend. This phobic moment, so recollective of
Shakepeare's tragic conclusions, sets the stage in *Caravaggio* for a violent
apotropaic retort (figure 5.9). 'Michele picks up his paintbrush and starts
to paint feverishly. He spins and gives the sign of the evil eye straight

Figure 5.9 Derek Jarman, *Caravaggio*: evil eye. (Courtesy: the artist)

into the camera' (Jarman 1986: 113). With the sign of the basilisk aimed directly at the lens, the filmmaker's apparatus of homographic art becomes the ambiguous site of sado-masochistic self-reference: 'God curse You! You!' (ibid.: 113).

But if the cinematic spectator, also the recipient of the evil eye, is at all taken aback by this gesture, the response can only be momentary, if not merely parodic – much like Caravaggio's reaction to Jerusaleme's earlier thrust of the Medusa shield. For in this gesture too lies a fault. In the heat of the take, Nigel Terry fails to direct the evil sign straight into the camera. Pointing instead to the dead space at the camera's left, Terry's Caravaggio highlights more his own wistful gaze than anything resembling a cinematic eclipse.

This irony is emblematic of the gesture of apotropaion which typifies the two art projects at hand: Caravaggio's and Jarman's. Consider, first, Jarman's model for apotropaion – Caravaggio's painting *Head of Medusa*. This is a painted shield given in 1608 by the Cardinal del Monte as a wedding gift to Cosimo de Medici, the future Grand Duke of Tuscany (Marin 1977: 134). Such a wedding-present bore the symbolic value of a talisman able to ward off Cosimo's enemies, as well as bearing, one might expect after Freud, the surplus sexual value of its stiffening counterphobic effect. But this latter value of the counterphobia of the gaze is what Louis Marin disputes in his analysis of oscillation in the look of this Medusa. Marin notes that Caravaggio's Medusa fails to look directly at the viewer. Instead she casts her glance somewhat to the side in a gesture of missed vision – a gesture comparable to Nigel Terry's failure to point the sign of the evil eye directly into the lens of the camera. If this painting represents anything like a psychoanalytical/ mythological fight to the death, Marin suggests that it would be one without any definitive resolution, without any victim or victor (Marin 1977: 143). Otherwise put, both the seer and the seen are caught here in a display of the gap of representation between '*représenté*' and '*représentant*'. If any paralysis results from the spectatorial reception of Caravaggio's *Head of Medusa*, it would be a traumatic fantasy effect of the hallucination or the expectation of the missed encounter rather than any lasting fetishistic supplementation of lost potency. The uncharted fault thus hailed by Jarman's *Caravaggio* lies not so much in the castration anxiety generated by the Medusa shield itself than in the retrospective hallucination, the enigmatic signifier, figured by Caravaggio's bemused and enigmatic 'looking back' at it. That is, to describe the scene more precisely, Caravaggio's look is aimed not only back at the Medusa shield but also over its 'back' (figure 5.10). He leans over the shield to direct his parodic look, it seems, at the small boy propping it up from 'behind'. The import of this reading for Jarman's film, which frames Caravaggio's Medusa shield as an operator of homosexual desire, would signal a

Figure 5.10 Derek Jarman, *Caravaggio*: Michele looking back at Medusa.
(Courtesy: the artist)

homographic shift away from the destabilizing primal/maternal scene of castration said by Freud to be symbolized by Medusa's head. By looking 'behind' the Medusa to the hallucination of the homoerotic encounter, Michele leads his viewers into the enigmatic scene of male-to-male desire not so diligently charted as positive by the Medusa's legacy, the science of psychoanalysis.

How consistently Jarman's method engages in designations of homoerotic play can be appreciated by charting two interrelated elements of his cinematic style. The early sequence of Jerusaleme's carnivalesque manipulation of the Medusa shield introduces the operators of *blinding light* and *circular movement* that take on significant performative weight as the film progresses. At key erotic moments of *Caravaggio*, Jarman choreographs a blend of both elements to involve the camera, characters, and spectators in a dirtier still homographic relay of sensuous provocation and wistful delay. Also important is how Jarman's emphasis on light and movement positions his cinematography in relation to the commentary made by avant-garde film on sexual coding, politics, and preference.

A couple of asides regarding films and theories of the 1970s may provide a helpful context for understanding Jarman's experimentation with the apparatus. In 'The unconscious as mise-en-scène', Jean-François Lyotard (1977b: 96–8) discusses the conceptual implications of Michael Snow's pivoting apparatus in *La région centrale* (1970–1), which

154

gives 'the camera an equal role in the film to what is being photographed' (Snow in Center for Inter-American Relations 1972: 35). Responding to the disorienting and demystifying movement of Snow's camera apparatus, which rotates in and out of all possible planes, Lyotard equates its pivotal action with 'the dischronisms of Freud's primary processes' (Lyotard 1977b: 97). In a way foreshadowing his theory of postmodern narrative (on which I touch in the following chapter), Lyotard associates this apparatus with 'a paradoxical logic related to that of the sophists and Nietzsche: there is nothing but perspectives; one can invent new ones' (ibid.: 96). Such perspectival shifting is also said to move between cinema and language (which scripts film and comments on it):

> both are inexhaustible means for experimenting with new effects, never seen, never heard before. They create their own reference, therefore their object is not identifiable; they create their own addressee, a disconcerted body, invited to stretch its sensory capacities beyond measure.
>
> (Lyotard 1977a: 96)[26]

To Laura Mulvey and Peter Wollen, however, this disconcerted body carries the traits of gender whose capacities are frequently bound to the sensory measure of film. In their film *Riddles of the Sphinx*, Mulvey and Wollen manipulate a recurrent 360° pan of the camera to free the narrative and its spectators from the scopophiliac gaze of the traditional camera, a gaze encoded specifically as male by its fetishistic focus on the (lacking) female body. In Mary Ann Doane's terms, the circular camera movement 'effects a continual displacement of the gaze which "catches" the woman's body only accidentally, momentarily, refusing to hold or fix her in a frame' (Doane 1987: 34). In turning the camera around on itself, *Riddles of the Sphinx* opens up an additional, forgotten space of cinematic discourse between women empowered politically by their sociopolitical sensitivity and their newly discovered lesbian awareness.

It is this broader emphasis on the sexual politics of the apparatus that gives special meaning to Jarman's teasing play with light, movement, and camera action. This play first occurs in *Caravaggio* during the Medusa sequence. This is when Jerusaleme transfers the oval Medusa painting into cinematic image-action as he twice runs around the room holding it as a shield. The movement is registered by two dialogical camera positions, one from the foreground and the other from the background, whose alternations violate the perspectival suture of the 180° rule. In three of the five shots constituting this sequence, the foreground camera tracks the boy's semi-circular movement toward Michele, who is positioned on a windowsill in the background. By contrast, the second camera initially stands in for Michele to receive the first look at/of the Medusa and then returns two shots later to track

Michele's look-back at Jerusaleme's second circling of the room. The alternating camera positions establish and then distinguish the difference between the spectator and Michele on the one hand, and the spinning motion of Jerusaleme and the Medusa on the other. What could be read here as a merely parodic scenario, being almost insignificant enough to evade critical reflection, becomes retrospectively traumatic in the wake of its echoed images and utterances as the film progresses. This early hint that Michele and his spectatorial stand-in might be taken by the 'moving look' of the boy behind the Medusa, perhaps more than he is by the frontal view of the Gorgon herself, is borne out not merely by the way their bodies are soon intertwined in sleep but also by the film's other matches of erotic action with rotating movement and blinding light: 'a mote in your eyes, you blink and send me spinning, swallowed in the vortex' (Jarman 1986: 113).

In a later retrospective scene from an earlier period of Caravaggio's life, the adolescent Michele's drunken English John is affected by a similar turning-round, when homoerotic desire provokes him to chase the taunting boy in circles around the youth's room. The actors dance around a pivoting hand-held camera, whose unstable angles and varying depth of focus (from medium-close to close-up) are embellished in the film by a spinning series of quick shot-reverse-shots between the two figures, who bob and weave in a mixture of glee and desperation. Here the 360° camera stands in as the libidinal operator of male-to-male desire whose displacing rotatation favors the unstability of hallucination over the fixity of the gaze. The characters' energetic twirling ceases abruptly when Michele falls on his mattress and threatens the old man with his menacing knife: 'I'm an art object and very very expensive – you've had your money's worth' (Jarman 1986: 21). The earlier reaction of Caravaggio to the apotropaic Medusa is doubled by Jarman's stage direction for the Englishman's 'fuddled and bemused' look in response to the phallic thrusts of this homoerotic Bacchus-become-Medusa. The look-back in befuddlement and bemusement, rather than the certainty of the counterphobic gaze, stands out as the libidinal operator of this hallucinatory scene. At either end of this blend of dizzying vortex and bacchanal still-shot, the viewer is left confronted by a murky, hallucinating mixture 'of desperate utopia and regression' (Bellour 1990: 121).

Even Caravaggio's art bares traces of such wounded rotation. It is marked, as Jarman insists, by Michele's penchant for marring his paintings with the circular strokes of his knife. As they are matched in the film by Jarman's insistence on the homoerotic ambiguity of circular movement, none of these traces of design and desire seems to return to the full control of its erotic and artistic source. A haunting example of such dispossession is provided by the force of twirling motion in the film's bizarre pageant that ushers in the New Year, 1600. While a

drunken Davide sits unsteadily on a horse being led round the studio by an old man, Jerusaleme pivots around the center of the room waving a red flag in a circular motion. By contrast to the previous seduction scene, the twirling and whirling seem gradually to seduce the detached camera instead of being staged by it. At first movement and motion eclipse the edges of the frame in the guise of the circular, sweeping motions of the large flag (figure 5.11). Then a sequence of close-ups, alternating between long, establishing shots, shifts between metonymical cuts of Davide's unsteady arm swinging a large sword, and Jersuleme's circular motions of body and flag. Midway through this carnivalesque sequence of some twenty-four shots, spinning close-ups of the wall begin tracing the camera's own circular efforts to follow the dance of the players (figure 5.12). As in the scene discussed above, these rotations become increasingly frenetic in a disorienting way which is alluring yet frustrating to the viewer. Also similar to how the earlier scene ends with the ambiguous shot of Michele's bacchanal pose, the movement here comes to a halt when Davide 'slips from the horse and lies drunken on the floor, convulsed with laughter [and] Michele comes out of the shadows, removes his cowl and kisses him' (Jarman 1986: 42). The scene then closes with a cryptic close-up of Michele lighting a candle, framed by the screaming reflection of a golden wall-plate.

The ambivalent position here shared by viewer, camera, and, ultimately, Michele – all caught in the hallucinatory space between actively

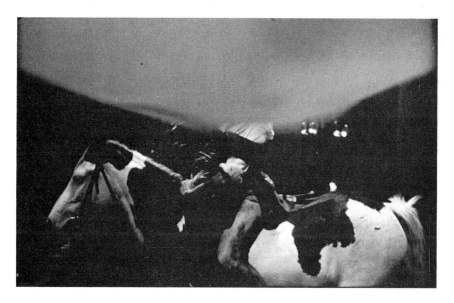

Figure 5.11 Derek Jarman, *Caravaggio*: New Year: flag and sword.
(Courtesy: the artist)

157

Figure 5.12 Derek Jarman, *Caravaggio*: close up of wall. (Courtesy: the artist)

reeling participants and not altogether passive voyeurs of arrested bacchanal pleasure – takes on a different and more striking turn at the end of the masked ball, where Michele unveils *Profane Love*. This is the fête staged in honor of the painting frequently said to be Caravaggio's most homoerotic. Following a night of drink, revelry, and unrequited passion, Michele watches, again from off to the side, the circling dance of the painting's model, Pipo, who is twirled aloft from the waist by a hardbodied Adonis, dressed only in provocative gold shorts. Oblivious to Michele's presence, the other two leave together laughing. Next (figure 5.13), 'Michele blows them an unseen kiss. He smiles and then his face goes blank with loneliness' (ibid.: 91).

Wistfulness and its hallucinatory echoes of the missed encounter: ultimately this combination – and not the fetishistic satisfactions of suture or counterphobia – is what rotating movement leaves with its unpossessing voyeur, whether it be the anonymous viewer of Jarman's film or the cinematic character distanced by his remove from homoerotic spectacle. The wistfulness of remove is what is crucial here and, perhaps, most distanced from the heterosexual conventions of cinematic voyeurism, which, no doubt, would provide the viewer with solacing shots of the bedroom scene to follow. By depriving the camera/ protagonist/viewer of the gaze of satisfaction, the film commits itself to the most enigmatic scene of fantasy. Otherwise put, the diegesis here sustains a fantasy-within-a-fantasy, since it beckons the spectator to hallucinate Michele's imaginations of the missed (wished) encounter.

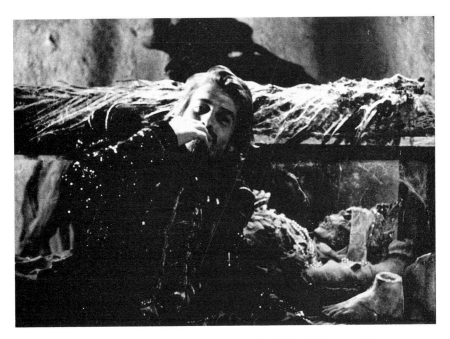

Figure 5.13 Derek Jarman, *Caravaggio*: Michele blowing kiss.
(Courtesy: the artist)

A very similar cinematic relation has been praised by Teresa de Lauretis as the significant lesbian achievement of Sheila McLaughlin's *She Must Be Seeing Things* (1987). Although I do not mean to elide the fantasy content of lesbian and male homosexual film, I find de Lauretis's text 'Film and the visible' (1991) to provide a stunning psychoanalytical articulation of the homographic relations I had been attempting to describe in earlier drafts of this chapter. For the sake of stressing what can only be a tenuous analogy between the filmtexts of McLaughlin and Jarman, I here substitute 'homosexual' for 'lesbian' in my citation of 'Film and the visible', a text that grounds its reading in Laplanche and Pontalis's work on fantasy:

> By positioning the spectator in the place of the subject – the subject looking on or the desubjectivized subject – of the fantasy it represents, the film does not merely represent a [homosexual] fantasy but makes it accessible to the spectator; renders it representable for [him] as self-representation. In other words, in acting as the relay of our spectatorial positions(s) in desire, [Michele provides] a *visualization* of the subject and the figure, mise en abîme, of the very process of spectatorship, namely, identification with the

159

image(s) (of the primal fantasy), production of reference and meaning in the narrative construction (selective [re]arrangement of the images into a secondarized, narrativized scenario), and affective participation at a distance: the spatial and the symbolic, representational distance of the spectator from the screen and of the voyeur from the scene looked on, and the psychotemporal distance of the subject from that 'other scene', the original fantasy.

(de Lauretis 1991: 237)

The challenge of capturing such a visualization of homosexual fantasy in Caravaggio's work also provides Jarman with something of a moral imperative to experiment with the effects of lighting. For he saw himself following the lead of 'the painter who had "invented" cinematic light' (Jarman 1986: 6). To Jarman this means working with a 'spiritual' light marking the progress in Caravaggio's work 'away from reality' (ibid.: 22). The world imagined by Jarman to be Caravaggio's is one in which, to return to a now-familiar passage, 'the sudden aimless outbursts in a bright undifferentiated world are balanced by the darkened studio, where a controlled light shines that tells the story' (ibid.: 132). To achieve the appropriate filmic balance between light and dark, Jarman worked alongside Gabriel Beristain, director of photography, to structure the film around contrasting values of the spectrum: the dark chiaroscuro of Caravaggio's paintings on one end, and the bright lights and star filters of Hollywood on the other.

Although the difficulty of creating the illusion of darkness with bright lights and Hollywood filters would be daunting to most filmmakers, it was not so new to Jarman. Throughout his career, Jarman has experimented with the effects of reflected light on the lens of the camera. Tony Rayns notes Jarman's discovery in shooting his Super-8 films

that the effect of shining bright light into the lens of a camera set for automatic exposure was to cause the camera to over-compensate by drastically reducing its own aperture, thereby darkening the image to near-blackness. Once the refracted light was taken away the camera would gradually readjust itself to its previous aperture setting, and the exposure would gradually return to 'normal'.

(Rayns 1985: 62)

Most significant is Jarman's way of capitalizing on this cinematic illusion of blindness to align the apparatus with the psychosexual politics of homoeroticism. This relation is so striking in *The Angelic Conversation*, Jarman's meditation on Shakespeare's *Sonnets*, that Mark Nash singles it out as a crowning achievement of the film:

The Angelic Conversation . . . is a meditation on light, cinema,

160

desire, death. The writer's beloved shines in the reflection of his gaze. Cinema reflects the gaze, doubling as light, reflected off the water and body of the young man as he bathes, paralleling the projector beam as another youth, holding a mirror, reflects the sun into the camera.

(Nash 1985: 34–5)

But while Nash understands these lighting effects to increase 'the sense of mastery over the image', their momentary darkening effect may have the opposite result. It may well function, much like Caravaggio's misdirected sign of the evil eye, to foreground the viewer's hallucination of a missed (wished) encounter instead of providing any fetishistic sustenance of lost presence. Indeed, it may well be that the dream of sexual mastery associated by psychoanalysis with the heterosexual male runs counter to the disrupting violence of Jarman's light.

Just such a fracture of the heterosexual dream is figured in scene 29, when Lena sits still at a window dreaming of her fairytale encounter at the upcoming masked ball. This still is disrupted when

Pipo breaks her dream by focusing the last rays of sunshine onto her with a mirror. It's beginning to rain. She looks up angrily. In the corner Ranuccio is sullenly cleaning his motorbike. An atmosphere of tension which even Pipo's gentle mocking cannot dispel.

(Jarman 1986: 78)

If anything is signaled here by mirrored light, it is the parodic dispossession of psychosexual certainty, especially as it shines on bisexual affairs. In this case, the beckoning light disrupts the transcendental dream in order to illuminate a scene of lost certainty and domestic irresolution. Later, in Lena's drowning scene, a similar shining points even to the erosion of bisexual love (figure 5.7). Here bright golden lights bounce off Lena's watery crypt partially to disfigure her tranquil image as well as the aperture passively receiving it. While these examples suggest that Jarman's use of light disrupts the unity of the homosocial norm, it also establishes something like a disjunctive metonymic link between the passing of Lena's homosocial fancy and the coming-out of Ranuccio's homosexual passion.

One of the film's more performative assaults of bright light on passive camera and character comes somewhat early in the film. I am thinking of the scene, mentioned by Jarman in a passage quoted earlier, when Ranuccio poses as the model for Caravaggio's *The Martyrdom*. Throughout the slow course of a long evening's sitting, Ranuccio seductively stuffs his mouth with glimmering gold coins tossed to him by the painter in reward for his erotic stillness. At dawn, Michele places the last piece of gold in his own mouth in order to give it to the passive Ranuccio

161

Figure 5.14 Derek Jarman, *Caravaggio*: golden reflector. (Courtesy: the artist)

in the fashion of a very deliberate kiss. But the exchange of gold in this captivating scene excedes the homoerotic interaction of the two principals. For a few brief and significant moments (two of which frame this sequence), the camera itself becomes the object of spectacle, when the montage shifts its glance back and forth from the scene of the 'golden scream' to a bright golden reflector of light held by Jerusaleme, who stands off to the side (figure 5.14). Given Jarman's penchant for creating dazzling camera effects, the viewer familiar with his cinema will recognize this designerly trope of the reflector shield which seems to arrest, if only for the briefest of moments, the camera's ability to focus actively either on it or on the exchange between Ranuccio and Michele. In this sequence, the camera again seems to be anthropomorphized by Jarman in becoming the stilled, passive recipient of Jerusaleme's blinding rays. But, much like Michele's evil eye, the reflector actually suggests more apotropaion than it delivers. For Jerusaleme aims his bright light at the canvas just off to the side of the vulnerable cinematic aperture. Once again Jarman's cinematography presents to the viewer of *Caravaggio* a spectacle of the illusion of optical stasis, the kind of virtual arrest said by Lacan to be imposed on the gaze by the blinding look of the light ('la lumière'). In Lacanian terms, the hallucination of blindness, perhaps even more than any realistic darkening of the camera lens, conjoins the separate but interrelated operations of look and gaze on the plane of the 'screen', which dis-plays and breaks-up the imagistic virtuality of mastery on which identity so feebly relies. In this context the hallucinatory

look of the camera itself 'is photographed'. It is through the momentary arrestation of the subject in the destabilizing envelope of hallucination, so I wish to suggest, that this complex scene from *Caravaggio* condenses the narrative actions of painting, seeing, blinding, and kissing to function as a 'screen memory' of the 'frozen moment' of the enigmatic signifier.

CINEMATIC PERVERSIONS

Yet one should not forget to dwell on the particular imprint marking the 'screen' of *Caravaggio* as the machinery specific to homosexual desire, as the visual support of the eroticization of the 'frozen moment'. I stress this point in response to Kaja Silverman's suggestion, made in a reading of Fassbinder,

> that we insist upon the social and historical status of the [Lacanian] screen by describing it as that culturally generated image or repertoire of images through which subjects are not only constituted, but differentiated in relation to class, race, sexuality, age and nationality.
>
> (Silverman 1989: 75–6)

But what makes Silverman's suggestion particularly inappropriate for an analysis of homosexual cinematography is the particularly heterosexual repertoire of images she singles out as exemplary of Fassbinder's 'screening':

> Fassbinder not only refuses to give us male characters who might in any way be eligible for 'exemplariness', focusing always upon figures who are erotically, economically, and/or racially marginal, but he obsessively de-phallicizes and at times radically de-idealizes the male body, a project which . . . leads to a corresponding psychic disintegration expressive of the absolute annihilation of masculinity.
>
> (Silverman 1989: 65)

By contrast to this questionable reading of the body in Fassbinder, Jarman's homographic screen of culturally generated imagery foregrounds the differential gap in representations of masculinity, not its absolute annihilation (unless understood, perhaps, only in the strictest of heterosexual terms).[27] While it is true that Jarman's film problematizes the masculine aggression and self-assurance typical of conventional film, it can also be said that its filmic environment of homoeroticism depends on an unresolved tension between the 'look' and the 'gaze'. Sustaining this tension, moreover, is less the 'de-idealization' of the male body than its erotic 'de-realization' by the cinematic apparatus.

In an analysis of Jarman's cinema, 'Submitting to sodomy', Tony Rayns lauds Jarman for his cinema's production of:

> a specifically homosexual passivity, the passivity of a gay voyeur who points his camera rather than his cock at the objects of his desire. The most interesting aspect of this passivity is the way that it imposes an exactly matching passivity on the viewer. The films are not emotionally manipulative in the way that narrative cinema is, but neither are they 'democratic' in the way that, say, Straub/Huillet's cinema is. For one thing, they are primarily addressed to male viewers. For another, they are too tautologous in their endlessly arbitrary rhythms and clusters of light to allow the mind any real freedom of movement. For viewer and film-maker alike, they represent a perpetual state of arousal without the attendant climax.

> (Rayns 1985: 61)

As Rayns implies, the stasis of such a rigid condition of de-realized satisfaction is matched in Jarman's cinema through a screening of the camera's own de-realization. Every now and again the machinery of point of view shifts its focus away from the narrative arousal at hand to register, instead, its subliminal fascination with the look of the light virtually arresting it.

Caravaggio thus responds to the call of the enigmatic signifier with an alluring series of de-realizations, or what I would rather call 'missed cinematic encounters'. I might add, in tying together the loose ends of this two-chapter section on 'dirty stills', that *Caravaggio*'s apotropoaic illusion of perpetual arousal also de-realizes the supporting props of realistic cinema: camera and motion / body and spirit. It is only in this sense – now 'looking back' at Stanley Cavell's epigraph opening the first chapter of this section – that one might claim that the 'ontological conditions of the motion picture reveal it as inherently pornographic', that the million shots ending with 'the view of a paralyzed camera – these were not sudden enticements or pornographic asides; they were satisfactions, however partial, of an inescapable demand'. It is only in this context of the inescapable demand of partial satisfaction that one might adequately appreciate Jarman's 'cinematic perversions'.

POSTSCRIPT: MOURNING AND MILITANCY

It's not much use warning that each cigarette knocks three minutes off your life when a fuck can stop you dead in your tracks.

(Jarman 1991: 30)

It would be difficult to conclude such a lengthy analysis of *Caravaggio*

without acknowledging the fact that the homographic hieroglyphs endorsed by the film have themselves been the subject of lively debate within the gay theoretical community. The film's stress on wistfulness and unfulfilled passivity will strike a negative chord on the part of viewers desiring a more uplifting and gratifying representation of homosexual passion. The general tone of *Caravaggio* aligns it with a particular cinematic image of homosexuality which Richard Dyer elegantly critiques for its negative, cumulative effect: 'this delighting in the autumnal twilight melancholy of lesbian and gay culture' (remarks made in Clare Beavan's video *White Flannel* [1990], produced for 'Out on Tuesday'). In still another context, the film certainly seems to live up to Bersani's complaint that 'the phallocentrism of gay cruising becomes diversity and pluralism; representation is displaced from the concrete practice of fellatio and sodomy to the melancholy charms of erotic moments and the cerebral tensions of courtship' (Bersani 1988: 220). Such displacement in *Caravaggio* can be traced all the way back to Jarman's attraction to the 'passionate detachment' of Caravaggio's religious paintings that beckoned him to shoot the film. Jarman's description of this detachment endorses precisely the kinds of homographic phantoms and wistful looks on which Bersani would likely focus:

> Michele gazes wistfully at the hero slaying the saint. It is a look no one can understand unless he has stood till 5 a.m. in a gay bar hoping to be fucked by the hero. The gaze of the passive homosexual at the object of his desire, he waits to be chosen, he cannot make the choice.
>
> (Jarman 1984: 22)

Stilled wistfulness. This is, no doubt, the fantasy of 'dead time' constituting *Caravaggio*'s interpellation of homoerotic desire. Or, to pun on Žižek's emphasis on the aporia of the 'strange look' of the ideological appeal (the one whose subject does not understand the meaning of the call of the Other), wistfulness is here a cinematic waiting to receive the strange look of the Other, to hear the cry 'dirtier still'.

But even though *Caravaggio* might disappoint some for *not* being even dirtier still, others will find something darkly prescient about Jarman's cinematic turn away from the hot cocks of *Sebastiane* to the melancholic fantasies of *Caravaggio*: 'And now all the boys are covering up their cocks again, not at all like the good old days of "Sebastiane"' (Jarman 1991: 16). On one level, the narrative of *Caravaggio* is organized around the fantasy of 'hoping to be fucked'. This is the very same legitimizing fantasy as Dyer laments as having been absent from post-Stonewall gay male porn: 'although at the level of public representation gay men may be thought of as deviant and disruptive of masculine norms because we assert the pleasures of being fucked and the eroticism of the anus, in our

pornography this takes a back seat' (Dyer 1985: 28). On another, contiguous level, the wistful hallucinations of *Caravaggio* seem almost to presage the traumatic realization of Jarman's latest films, *The Garden* (1990) and *Edward II* (1991), that 'the boys emerging from the shadows reminded me of ghosts come to haunt me, all my dead friends. As always life was far more "advanced" than art' (Jarman 1991: 52). AIDS has taken not only Jarman's friends from the wings of art (and, soon, Jarman himself), but also the sexual culture of Jarman's Super-8s.

As Douglas Crimp describes the new reality of homosex in the age of AIDS:

> Alongside the dismal toll of death, what many of us have lost is a culture of sexual possibility: back rooms, tea rooms, bookstores, movie houses, and baths; the trucks, the pier, the ramble, the dunes. Sex as water sports, cocksucking and rimming, fucking and fist fucking. Now our untamed impulses are either proscribed once again or shielded from us by latex Our pleasures were never tolerated anyway; we took them. And now we must mourn them too.
>
> (Crimp 1989: 11)

In a strange way, *Caravaggio* confronts the spectator with the militant possibilities of just such a wistfulness. Reminding me of Montaigne's slogan, 'To philosophize is to learn how to die', Jarman's film teaches neither untamed impulses nor 'homophiliac' abstinence[28] but, rather, the militant agenda proposed by Crimp, to situate sexuality in the script of reflective mourning. This means acknowledging that both militancy and misery stem from psychic as well as social struggles – that the death drive gives interior rythmn to the public impulses of sublimation. 'In this perspective', adds Slavoj Žižek,

> the 'death drive', this dimension of radical negativity, cannot be reduced to an expression of alienated social conditions, it defines *la condition humaine* as such; there is no solution, no escape from it; the thing to do is not to 'overcome', to 'abolish' it, but to come to terms with it, to learn to recognize it in its terrifying dimension and then, on the basis of this fundamental recognition, to try to articulate a *modus vivendi* with it.
>
> (Žižek 1989a: 5)[29]

So it goes that *Caravaggio*'s many contradictory details of desire, ambivalence, melancholia, and wistfulness provide a thoughtful screen of historical fiction through which to calculate the many conflicting realities of today's mourning and militancy. Perhaps a fitting way to come to terms with the death drive of this chapter would be to conclude on a note of additional articulation. Why not end by adding a

retrospective prologue to *Caravaggio*, one with Michele in voice-off reading a text something like Douglas Crimp's on militancy and the ambivalence of mourning?

> When, in mourning our ideal, we meet with the same opprobrium as when mourning our dead, we incur a different order of psychic distress, since the memories of our pleasures are already fraught with ambivalence. The abject repudiation of their sexual pasts by many gay men testifies to that ambivalence, even as the widespread adoption of safe sex practices vouches for our ability to work through it. Perhaps we may even think of safe sex as the substitute libido-position that beckoned to us as we mourned our lost sexual ideal. But here, I think, the difference between generations of gay men makes itself felt most sharply. For men now in their twenties, our sexual ideal is mostly just that – an ideal, the cum never swallowed. Embracing safe sex is for them as act of defiance, and its promotion is perhaps the AIDS activist movement's least inhibited stance. But, for many men of the Stonewall generation, who have also been the gay population thus far hardest hit by AIDS, safe sex may seem less like defiance than resignation, less like accomplished mourning than melancholia
>
> Frustration, anger, rage, and outrage, anxiety, fear, and terror, shame and guilt, sadness and despair – it is not surprising that we feel these things; what is surprising is that we often don't. For those who feel only a deadening numbness or constant depression, militant rage may well be unimaginable, as again it might be for those who are paralyzed with fear, filled with remorse, or overcome with guilt. To decry these responses – our own form of moralism – is to deny the extent of the violence we have all endured; even more importantly, it is to deny a fundamental fact of psychic life: violence is also self-inflicted.
>
> (Crimp 1989: 11–16)

NOTES

1 Jarman calls film 'the wedding of light and matter – an alchemical conjunction' (Jarman 1984: 188). His interests in Neoplatonic philosophy and science are most pronounced in *Jubilee*, which is framed around Dee's writings, and *The Tempest*, which he says was conjured by his 'readings in the Renaissance magi – Dee, Bruno, Paracelsus, Fludd and Cornelius Agrippa' (ibid.: 188). For informative discussions of this traditon, see Yates (1964) and French (1972).
2 This is the phrase coined by Michael O'Pray in his interview question to Jarman: 'Francis Bacon said recently that some of his paintings he saw as frozen moments. This eroticization of the moment seems to be a strong element in your films' (Field and O'Pray 1985: 55).

3 I develop the distinction between a poetics of *ekphrasis* and a cinematics of hieroglyphics in the preceding chapter.

4 In speaking of 'resemblance', I mean to play doubly off Barthes's 'effect of the real', discussed in the previous chapter, and off what Borch-Jacobsen terms Freud's 'logic of similitude', one inscribing the ego in the slippery verisimilitude of 'identification' (as) 'resemblance': 'For though the *ego* is everywhere in the dream, though it can even diffract itself into several "part-egos", we still have to recognize that it is nowhere properly itself, given that it never avoids yielding to an identification and always confuses itself in some way with another (an alter ego – but one that is neither other nor self). This egoism can thus in no case be reduced to the frank and brutal affirmation of an ego that would refuse to give in where its own pleasure is concerned. To achieve its own pleasure, the ego has to take a detour, one that causes its own pleasure to pass through that of another. And this detour is identification (*mimesis*), resemblance (*homoïosis*). One only enjoys, in fantasy, as another: tell me whom you are miming and I'll tell you who you are, what you desire, and how you enjoy' (Borch-Jacobsen 1988: 21).

5 Of the many critiques of the conventions of historical cinematic narration in docudrama and documentary, Trinh T. Minh-ha's *When the Moon Waxes Red* (1991) is particularly sensitive to the specific relation of cinematic method to the ideologies of historiography.

6 'Hallucinating metonymy' is Derrida's term, which I discuss in Chapter 3, for 'something, a fragment come from the other (the referent) which finds itself in me, before me but also in me as a part of me' (Derrida 1987: 292).

7 Regarding the incommensurability of political discourses, Lyotard chooses the word 'differend' to signify 'the unstable state and instant of language wherein something which must be able to be put into phrases cannot yet be' (Lyotard 1988: 13). The potential benefit of the differend, he adds, 'is to institute new addressees, new addressors, new significations, and new referents in order for the wrong to find an expression and for the plaintiff to cease being a victim. This requires new rules for the formation and linking of phrases.'

8 I give further attention to the 'mirrorical', a concept coined by Duchamp, in the following chapter on Lyotard. For further discussion of the iconography of coins, also see Marin (1981: 147–205), Mitchell (1986: 190–6), and Deleuze (1985: 103–5).

9 It might also be argued that the use of the mirror by the artist–critic, Baglione, aligns him with the axis of mirror–narcissism–homosexuality which Richard Dyer traces in the work of Jean Cocteau (Dyer 1990: 66–7).

10 I am thinking, of course, of the conventions of female toiletry portrayed in a wide range of paintings, from Clouet to Balthus. It is what Laura Mulvey would call the 'to-be-looked-at-ness' of these pictures that is transferred to film: 'In their traditional exhibitionist role women are simultaneously looked at and displayed, with their appearance coded for strong visual and erotic impact so that they can be said to connote *to-be-looked-at-ness*. Woman displayed as sex object is the *leitmotif* of erotic spectacle' (Mulvey 1989: 19). In her film *The House of Science* (1991), Lynne Sachs subtly reflects on the 'to-be-looked-at-ness' specific to the artistic portrayal of nude women and their mirrors.

11 I discuss Guy Rosolato's term 'the perspectival object' in the previous chapter (pp. 108–9).

12 In her astute *Art in America* essay on *Caravaggio*, Lynne Tillman, stresses the

reciprocity of the gaze as it circulates in this triangle: 'The male characters are as much fixed by Lena's gaze as they are by each other's and she is by theirs. When Caravaggio kisses Ranuccio on the mouth, Lena is present and watching. When Caravaggio presents Lena with a beautiful ball gown to wear to an art opening (called an unveiling), Lena's kiss of delight for Caravaggio turns into one of passion, as Ranuccio watches in the background, somewhat out of focus but in the frame. After they break their embrace, both turn to look at him, which is followed by a shot of his looking at them. In fact when Caravaggio first approaches Ranuccio, Lena is there, and what could have been a close-up of Ranuccio alone as looked at by Caravaggio is a medium shot of Ranuccio and Lena as looked at by him. This structure of complicated looks is repeated over and over again' (Tillman 1987: 22). I might add, in terms of Tillman's closing remarks, that Caravaggio first spots Ranuccio when he is alone without Lena in the Bar del Moro. Michele's notice of the good-looker is met with derision by his companion, the waiter Davide: 'You won't get anywhere with him' (Jarman 1986: 36).

13 See also Gayle Rubin's 'The traffic in women' (1975). Discussions of Irigaray's thesis by Sedgwick (1985: 21–7) and Silverman (1988a: 141–86) are especially germane to my discussion of Jarman's film.

14 By contrast to such an apology, Colin MacCabe's recent review of Jarman's *Edward II* alludes to the ambiguity of the misogyny in Jarman's earlier work, 'in that gay male dialectic where identification with the position of the woman is set against rejection of the woman's body' (MacCabe 1991: 13).

15 Sabrina Barton's '"Criss-cross": paranoia and projection in *Strangers on a Train*' provides an excellent reading of Hitchcock's linkage of paranoia and latent homosexuality (Barton 1991). Critical references to the relation of latent homosexuality to paranoia reflects Freud's later, and more advanced, position on homosexuality, the one far exceeding his earlier and much more demeaning emphasis on the pathology of the homosexual's underdeveloped positive Oedipus complex – when the homosubject is unable to develop beyond his 'feminization' (a demeaning position similar to that of female castration, which I discuss in Chapter 2). Although this relation remains problematic, since it continues to link homosexuality to pathology, it opens the way for Mikkel Borch-Jacobsen's reading of homosexuality as the doubled site in Freud of both the 'social' and the 'normal': 'Does the passage from homosexual archisociality to sociality proper introduce any sort of break in this story of the self-Same, of (my)self?. . . . Lacking any precise indication about the process of sublimation of homosexuality, we are obliged to describe things as follows: just as narcissism was already a homosexual relation to oneself and as homosexuality was still a narcissistic relation to the other (myself) and sociality is still a homosexual relation to (another) myself Thus by projecting homosexuality – but we now know what that means – at the basis of the opening toward the other, Freud in no way accounts for the social bond, *if by that is meant the principle of a pacific sociality*. On the contrary, by inferring what is normal (archisociality) from what is pathological (rivalrous, paranoid sociality), he inscribes the pathological within the normal in spite of himself, as it were; he inscribes excess within the norm' (Borch-Jacobsen 1988: 87–8). Also see Edelman's fascinating account of the 'sodomitical spectacle' as the fantasy component of the primal scene which 'presupposes the imaginative priority of a sort of proto-homosexuality, and it designates male heterosexuality, by contrast, as a later narcissistic compromise' (Edelman 1991: 101).

16 Absent from the film is Michele's scripted voice-over which foregrounds the sexual stakes of the Englishman's love of art: 'Another boring English punter – eyes clouded with fog thick as Venetian oilpaint. If they wander though you know you're onto a winner. The best way for a boy to get on in life is to sell his arse along with his art, pad out his crotch, split his trousers in the right places. I bet this one's loaded as he's ugly' (Jarman 1986: 18).

17 As Sedgwick points out, Girard 'treats erotic triangles under the Platonic light that perceives no discontinuity in the homosocial continuum' (Sedgwick 1985: 24) – thus failing to account for the power and pleasure differences introduced by, among other things, a change in the heterosexual gender balance of the participants.

18 In 'Sexual morality and the law' (Foucault 1988a), Michel Foucault, Guy Hocquenghem, and Jean Danet discuss the history of legal sanctions against pedophilia and challenge the legal assumption that pedophilia is always a violent and perverse attack against children.

19 See also Borch-Jacobsen's discussion of the pathological normal, cited above in note 15. Various ways in which paranoia has been propped on to the spectacle of film to represent the pathological (primarily as woman) have been discussed in Rose (1988), Polan (1986), Doane (1987), and Silverman (1988a).

20 The cautious, indeed respectful, tone of Schutte's remarks becomes especially apparent in comparison to Thomas Hoving's homophobic review of the film in *Connoisseur*: 'No one knows whether Caravaggio was homosexual. Nevertheless, the director has seized upon this speculation as if it were the absolute truth, and the film *slithers on* from there' (quoted by Tillman 1987: 23).

21 Vito Russo points out, in *The Celluloid Closet*, that 'from *Cabaret* to *Hair*, bisexuality has been used to disguise or legitimize homosexuality. The emphasis is usually placed on the heterosexual, as though the homosexual were the "quirk" . . . and "real" sexuality was something that neurotics took excursions from occasionally' (Russo 1987: 230–1). Similarly in 'Film and the visible', de Lauretis (1991) reads the bisexuality in Sheila McLaughlin's *She Must Be Seeing Things* as cutting against the grain of lesbian desire. The bisexual moments of *Caravaggio* call to mind similar psychopolitical tensions between fields of desire.

22 In 'Diderot, Barthes, *Vertigo*', Burgin associates Madeleine with the dead Ophelia by noting the fantasy effects of a catalog of watery images of women (Burgin 1986b: 101–3). On the iconography of Ophelia, see Showalter (1985).

23 For more detailed discussions of Abraham and Torok, see Chapters 2 and 3 above. I analyze a similar example of female cryptation in 'Translating Montaigne's crypts' (1991).

24 'Phantom percepts' is the painterly notion, developed by Gombrich, which de Lauretis wishes to transfer to film: 'with regard to avant-garde practices which foreground frame, surface, montage, and other cinematic codes or materials, including sound, flicker, and special effects; could contradictory or phantom percepts be produced not to negate illusion and destroy visual pleasure, but to problematize their terms in the cinema? Not to deny all coherence to representation, or to prevent all perception of all meaning formation; but to displace its orientation, to redirect "purposeful attending" toward another object of vision, and to construct other ways of seeing?' (de Lauretis 1984: 62).

25 My coining of the term 'looking laugh' puns on the Lacanian distinction between the look and the gaze in which the look is the return of 'la lumière' destabilizing the subject's gaze. For a helpful presentation of this distinction, see Rose (1986: 167–97).

26 In *Abstraction of Avant-Garde Films*, Maureen Turim complicates Lyotard's reading of *La Région centrale* by emphasizing the complex role of 'the visual material of landscape' in the film (Turim 1985: 128–9). Also see Turim's discussions (1984; 1985) of the applicability of Lyotard's 'subliminal economy' to the study of film.

27 While I am not persuaded by Sue-Ellen Case's view that considerations of the Lacanian constructs of 'look-screen-gaze' cannot allow 'for an imaginary of the queer' (Case 1991: 11–13), I do recommend her attentive reading of the homoerotic, masculinized body in Fassbinder – made in response to Silverman and in collaboration with Gregory Bredbeck and George Haggerty.

28 Ironically, Jarman's emphasis on the spirituality of Caravaggio's paintings could be said to align his project partially with the tradition of homophilia which downplays homosexuality. In his discussion of Jean Cocteau, Richard Dyer cites André Baudry's description of the term in *Arcadie*: 'The word "homosexual" describes sexual relations between partners of the same sex, while "homophile" describes people who can only find erotic fulfillment (understood in the widest sense of the term: physical, psychological, emotional and mental) with someone of their own sex' (Dyer 1990: 74–5). In elaborating on this definition, Dyer points out that 'as with earlier third sex notions, the idea of homophilia was that it was natural and constitutive of personality. The problem with it, though, as Jacques Girard points out, was that it seemed to concede that sexuality is essentially sinful. Despite its recognition of church hostility, its tone savoured of the religious, as if it sought to cleanse gayness of sexuality, to stress instead the spiritual fulfillment of those people (homophiles) drawn to members of the same sex as themselves.'

29 Also see Jeff Nunokawa's insightful essay, '"All the sad young men": AIDS and the work of mourning' (1991).

30 Laplanche reminds his readers of 'the famous philosophical critique of the idea of nothingness, as it has renewed itself in a contemporary way from Freud to Bergson: I cannot think nothingness, I can always think of *something else*. The thought of nothingness is always the thought of a positive something else, since the idea of an absolute negation is irrepresentable' (Laplanche 1981: 240). I allude to the positive, disruptive forces of the death drive in public performance in 'Subliminal libraries' (Murray 1987b). In 'Where does the misery come from? Psychoanalysis, feminism, and the event', Rose similarly turns her attention to the place of the death drive within a feminist politics under attack: 'And finally, now, the issue of the death drive, of a violence whose outrageous character belongs so resolutely with its refusal to be located, to be simply identified and then, by implication, removed (possibly the only meaning of the persistence, or immutability, of the death drive of which it has so often been politically accused). Perhaps one reason why this issue is now so pressing is that, faced with the hideous phenomenon of right-wing apocalyptic and sexual fantasy, the language of interpellation through which we thought to understand something about collective identification is no longer adequate. At the point where fantasy generalizes itself in the form of the horrific, that implied ease of self-recognition gives way to something that belongs in the order of impossibility or shock' (Rose 1989: 37–8).

Part III

LINES OF DEMAND

6

WHAT'S HAPPENING?
Lyotard writes art

Whatever the transformations of painting, whatever its substance or its context, the same question is always asked: *What is happening here*?

(Roland Barthes)

Art is posed in alterity as plasticity and desire, curved extension, facing invariability and reason, diacritical space.

(Jean-François Lyotard)

Jean-François Lyotard's active collaboration with visual artists evokes his concern for the 'genres of discourse' comprising textuality. The mixture of academic genres and styles in his many catalogue essays raises fundamental questions about critical strategies and their relations to the fields of discourse they address. Specifically in terms of the practical difference between the disciplines of art and philosophy, Lyotard's essays on contemporary art provoke reflections on the stakes of writing about, of representing art. They ask what lies behind the desire to speak for images, to search for the silent graphic figures in art. Does writing on art, about art, lead the critic into the familiar realm of academic research and judgement? Do the figural and textual collaborations of artist and writer function to make distinct and knowable (*re-connaissables*) the unities of art? Or does any generic concern with the unities – whether those of formal aesthetics or, on a different plane, those of semiotics – bring the diacritical text too close to a certain realm of philosophy? Too close to what Lyotard has critiqued, in *Discours, figure*, as 'morality, the vis-à-vis of the visage because the visage is the presence of the absolute Other' (Lyotard 1971: 10–11)? Does philosophy work to refigure art in its own talking head, in what Lyotard has called 'the presence of speech' (ibid.)?

Lyotard poses this dilemma in asking the philosopher of art to entertain a distinction between the graphic and plastic values of the figural:

> When a trace gets its value because it appeals to [the] capacity of corporeal resonance, it inscribes itself in a plastic space; when the

175

trace's function is exclusively to render distinct, thus knowable [*reconnaissables*], unities which receive their relations in a system completely independent from the corporeal synergy, I say that the space is graphic where that trace inscribes itself.

<div align="right">(ibid.: 212)</div>

When philosophy demands to be seen as the essential ingredient of the figural, as the generic essence of form, it inscribes itself in the discourse of the graphic. Thus turning aside from the critical choices left open by the fluid discourses of the plastic, such graphic confidence allows the 'text to produce the visage' of philosophy, the form in which the text brashly addresses itself to its interlocutor as a particular genre of discourse in lieu of facing the ellipticality of the plastic image.

In this chapter, I trace the discourse of figural alterity in three of Lyotard's essays on the artists Valerio Adami, Ruth Francken, and Arakawa: 'On dirait qu'une ligne . . .', in Valerio Adami, *Peintures récentes* (1983); *L'Histoire de Ruth* in Ruth Francken's catalogue of the same title (Francken 1983; Lyotard 1989a), and 'Longitude 180° W or E', in Arakawa, *Padiglione d'arte contemporanea* (1984). I will conclude this discussion by situating the composite argument of these texts in relation to the contrasting political positions of two later publications by Lyotard: *Que peindre? Adami, Arakawa, Buren* (1987) – which includes the two earlier essays on Adami and Arakawa – and the 1990 translation, *Duchamp's TRANS/formers*. This concluding section reflects on the way earlier work by Lyotard reads anew when republished in different contexts and covers. It not only emphasizes the significant political retreat of Lyotard's more recent reflections on art, but also maintains a dialogue with the preceding chapters regarding the critical and political stakes of acinematic readings of cultural production.

GRAPHIC IMPERATIVES

A quick review of Lyotard's collaborations with Arakawa, Adami, and Francken might suggest that graphic 'genres of discourse' are endemic to all narratives on art, even to Lyotard's untraditional essays which speak alongside images rather than about them. His texts do sometimes ask us to recognize the visage of an author, the speaking subject of text whose activity is to produce meaning, to systematize artistic structures or sources, and to textualize the figural. 'On dirait qu'une ligne . . .' covers some of the traditional 'graphic' territory that the history of art has trained us to expect from catalogue essays. It includes the philosopher's detailed descriptions of the chronology of Adami's work, suggestions concerning the importance of literary texts on Adami's subject-matter, even reflections on the philosophical tradition evoked by

<div align="center">176</div>

the work – Hogarth, Burke, Diderot – as well as comments on those portrayed in the work – Lenin, Benjamin, and Freud (Sigmund, not Lucien).[1] Although these familiar moves and sources appear only sporadically throughout Adami/Lyotard, they provide us with the dependable traces of a critical discourse on art which aligns itself with source study and the aesthetic tradition.

Similarly, 'Longitude 180° W or E' is as much Lyotard's auto-reference, with introductory reminders of his writing of *Le mur du pacifique*, as it is a mediated evocation of his philosophical predecessors, Heidegger and Merleau-Ponty. On a related level, the keepers of art history will find themselves on familiar turf when discovering Lyotard's association of Arakawa with Raphael and Veronese, Leonardo and Duchamp. In so revealing the philosophical origins of artistic figures by inscribing them partially in the language of connoisseurship and the history of technique, the philosopher transfers his authoritative visage to the realm of artistic description and recuperation. As Lyotard describes this graphic imperative in *Discours, figure*, the text produces the visage, the philosophical mimics the figural, the author speaks for the artist, the writing Subject (*je*) displaces the subject of art (*jeu*).

So it goes that the readers of *L'histoire de Ruth* learn about aspects of Francken's training and her debt to the male masters of her influence. Of particular interest is Lyotard's citation of Herbert Read's incredible prescription in *A Letter to a Young Painter* that Francken should strive to achieve the sensual in art, which 'is everything virile', to which she responds in the margins of her copy: 'Male?' (Lyotard 1989a: 256). Lyotard notes ironically that the portrait series 'Mirrorical return' limits its portraiture to the double images of successful (male) art and philosophy: Butor, Beuys, Tinguely, Sartre, Cage, Beckett, and, yes, even Lyotard. Although these faces look broken and re-figured, as if deconstructions of the graphic tradition of patriarchal art, they may well provoke the viewer to return Francken to her own question: 'One asks her: but why only men, and the elite?' (Lyotard 1989a: 261). Sustaining the foundation of 'Mirrorical return' are the figures of an *esprit de corps* whose serialization suggests the return to art of a fascination with authorship, systematization, and source.

Rather like that omniscient Cheshire Cat who comes and goes throughout *Alice in Wonderland*, the visage of the philosopher hovers over the terrain of Lyotard's essays on art. There is one especially surprising and bemusing moment in *L'histoire de Ruth* when this becomes especially apparent. This occurs when the reader turns from page 35 to page 36 to see the ironically smiling portraits of Jean-François Lyotard (figure 6.1) in lieu of the concluding lines of an extremely pointed sentence: 'Photography and design are the heirs of that which is the most male in art . . .' (Francken and Lyotard 1983: 35). Whether a

Figure 6.1 Ruth Francken, detail, 'Jean-François Lyotard triptych,' *Mirrorical Return* series, Musée d'Art Moderne, Strasbourg. (Photo: A Rzepka. Courtesy: the artist)

coincidence or a book designer's pun, the appearance of Lyotard's portrait as that which 'is the most male in art' positions itself as a masquerading figure of the heritage of the philosophical reflection on aesthetics. It recalls a similarly striking and curious moment in 'Longitude 180° W or E' when the text cites itself as the visage of tradition. 'That is why a philosopher can discuss it, perhaps, maybe better than a writer', claims Lyotard in a lengthy parenthetical comparison of his selective description of Arakawa to Diderot's *Salons* (Lyotard 1984c: 8). When it comes to the language of art, the philosopher often seems to descend from on high, cloaked in the authority of his discourse.

This is suggested again by Lyotard's choice of a particular genre of discourse – philosophical dialogue – to discuss Adami and Arakawa, and by his variation of it in *L'histoire de Ruth*, when he frames his text with a series of subtitled sites – Prague, Oxford, New York, Berlin, Paris, etc. – resembling the speakers Est and Ouest in *Longitude 180°*. In the wake of *Au juste*, the discourse of dialogue appears to be an especially performative and philosophical choice on Lyotard's part: 'the regulation of dialogical discourse, or even dialectical in the Platonic sense, seemed to me to be associated with power, since it finally aimed to control the effects of the *énoncés* exchanged by the partners in dialogue' (Lyotard and Thébaud 1979: 13). Even when the dialogical partners in these essays do not seem to vie actively for power, they do appear to strive at least for consensus and accord. Such discourse, then, might be said to lend itself to a generic criterion of agreement concerning the interpretation of images of art. Traces of such desire for consensus are nowhere more evident than in the conclusion of *On dirait qu'une ligne* when the

dialogue of Elle, Lui, and L'autre concludes with the previously unheard voice of the philosophical mediator, Moi.

IDENTITY IN EXILE

It is precisely the position of the authoritative *je*, the status of the philosophical self, that the texts of Adami/Lyotard, Arakawa/Lyotard, and Francken/Lyotard display as the central operative of graphic discourse and judgement. Still, in so unveiling the figure of philosophical authority, in showing it as an inevitable aspect of graphesis, the texts of Jean-François Lyotard also work to ironize the mastery of critical judgement. Lyotard's collaborations with Adami, Francken, and Arawaka tend to focus more on the texts' status as figures or apparati (*dispositif*) of academic consensus than on the worth or value of artistic commentary itself. Put into question by Lyotard's ironic narrations of self and other are the figures of aesthetic judgement as such and the academic models of research and analysis constitutive of the language of judgement.[2] While calling to mind the regulatory features of dialogical discourse, Lyotard's playful exchanges could be said to generate the slippage of dialogue which Philippe Lacoue-Labarthe argues to be constitutive of the deconstructive character of Platonic writing: 'the mixture of genres, an inclination for comedy, the indifference to philosophical demonstration' (Lacoue-Labarthe 1979a: 103).[3]

However, indifference to strict, philosophical demonstration is often no more readily apparent in Lyotard than it is in Plato. In *Longitude 180° W or E*, for example, the authority and role of the Subject present themselves as crucial factors of artistic commentary:

> The slightest commentary, mine here, organizes in a similar way a space for language in three parts: you want to appropriate to yourself the work of Arakawa, you are expropriated from it, I am supposed to master it, to be the proprietor of its sense, and the work itself becomes the stake for our commerce or our war.
>
> (Lyotard 1984c: 2)

Here the space of artistic dialogue and criticism is inscribed according to the position(ing) of the subject in the act of presentation (appropriation) and re-presentation (commerce/struggle). Lyotard suggests earlier, in *Discours, figure*, that this strategy of the critic's (self-)presentation depends on his translation of the visible into the readable. To do so, the critic encloses the visual object in the familiar, graphic field of discursive signification. Concurrently, the marketing of the self turns around the performance of the critic's codes and their re-presentation as assimilable models and structures. The voice of what Lyotard specifies as Occidental criticism thus transforms the aesthetic object into a

Figure 6.2 Arakawa, detail, 'Forming Blank Remembered'. (Courtesy: the artist)

commodity of the history of academic research and discourse, whether philosophical or artistic.

Such commodification tends to rely, moreover, on the simultaneous advance and retreat of the Subject by conflating the representation of academic genres of discourse with the presentation of self, by displacing Subject for institutionalized subject-matter. In a painting entitled *Forming Blank Remembered* (figure 6.2), Arakawa confronts the beholder with an oblique figure evoking such critical fusion. Pulsating from the background of this painting's broken images of plastic play, a poignant graphic remembers the pathos of the critical space: 'What occurs within a site of activation when the subject comes to perceive itself as having: blank?' Indeed, what *does* occur when authorial appropriation ('as having') turns up blank? Does the position of the Subject, say the concluding Moi of Lyotard/Adami, relocate itself as the site of blank, as the figure of the missing dialogical pronoun in Arakawa/Lyotard? Might the dialogue of Est and Ouest in Arakawa/Lyotard also reposition the Il/Elle of Adami/Lyotard, not to mention the peripheral Autre and Moi, in the space of cultural differentiation and thus ethnographic specification? Does not Lyotard's choice of even more precise sites – Berlin, Paris, New York, etc. – as the dialogical figures of *L'histoire de Ruth* suggest that the history and politics of place re-figure and re-present the authority or influence of self and Subject? Does not the blank of the Subject thus

accentuate the ambiguous activation of site, site not only as commodity but also, and perhaps more importantly, as the cultural arena of philosophical expression?

The perception of such a blank might provoke the reader's recollection of the *blanc* of Arakawa/Lyotard's pre-text, *Le mur de pacifique*. Here the narrative reveals sitation to be an Occidental apparatus of critical control:

> Localizations mark out a dominated space, with each part having its proper destination, like the body of an animal for the butcher's shop, like the body of a girl for the erotic war of the Chinese. This effort to contain central mobility is also that of the administrations of counties and states when they sketch out routes and adductions on the blank/white [*blanc*] body, localizing the places which must be inhabited, attributing names that should be countries All of the circulatory network, in fact centralizing, attributing a head to the great blank.
>
> (Lyotard 1979: 48–9)

Such colonial figuration of undifferentiated space, what we might even wish to call the authoritative personification of *le corps blanc*, surfaces in Arakawa/Lyotard as the essence of the Western tradition of art and commentary. The dominating force of line fits the aims and spirit of Occidental image-making dedicated to representation as *construzione legittima*, scenic space, and focalization. Within the teleological space of geometric line, the visage of the speaking philosopher functions as but a metonymic link to the larger structure of metaphysics, to the transcendent but still immanent visage of – the smiling Cheshire Cat.

Similarly, the space of Occidental representation inscribes itself in the time frame of narration.

> Italian painting depicts situations, acts, moments, places, feelings. It opens a narrative space-time. A box without a base, *bottomless*, represented by Arakawa's studies (1963–64) bearing this title. But the distance in which Italian space-time opens presupposes blank. Blank unites and separates. Continuity and discontinuity are differentiated in it. So that narration may exist, the moments have to be linked according to some ethical, political, religious finality.
>
> (Lyotard 1984c: 21)

The space-time of narration effects the collapse of blank, the blockage of the textual and temporal lapses of teleology. If viewed from the critical field of political and religious finality, Arakawa's blank becomes indistinguishable from the *blanc* of *Le mur de Pacifique* and *Economie libidinale*, where Occidental philosophy is said, universally and therefore extremely, to manifest itself in the figure of *la terreur blanche de la vérité*, 'the weapon of paranoia and power, the signature of the unity-totality in the

space of words, the reversion and the terror' (Lyotard 1974: 287). This unforgettable figure of *la terreur blanche* personifies for Lyotard the kinship of the research projects of history and philosophy. It also recalls the *terreur blanche* of both 1795 and 1815, whose figural force is accentuated by the terror of diachronic collapse, by the effacement of twenty years of blank. Of special interest to cultural critics, moreover, is the fact that the collapse is performed by a terror of a different visage, that of the critical 'megamachine of reproduction', whose discourse works toward the reconciliation and totalization of space and time. 'It understands alterity only as an opposition, and it offers its services for reabsorbing it dialectically' (Lyotard 1990: 112). Dialectically, Lyotard writes, philosophical text and artistic image operate as calculated apparati of the political, patriarchal economies of Western graphesis. The genres of graphic, dialectical discourse underlie and sometimes even generate other forms of Occidental cultural appropriation: capitalism, colonialism, and ethnocentrism.[4]

Were the audiences of Arakawa, Adami, and Francken to respond to the lure of historical classification and semiological delineation, a seduction always dis-played in Lyotard's aesthetic texts, they might identify the common bonds bridging the pictures of these extremely different artists. The images of Arakawa, Adami, and Francken show figures of what Lyotard terms the alien, the other, the victim, and the differend marked by the representations and judgements of graphic space and culture. Francken and Arakawa's status as artists in exile – driven from their home spaces and languages by the terror of war and the babble of hostility – can be said to translate into the discontinuities of material, genre, and tone in their work, discontinuities also present in Adami's mixtures of style and source, art and philosophy. But these common elements of theme, technique, and even influence tend to underline neither the unity of subject-matter, the harmony of artistic difference, nor the ingenious subject of the creative artist. They depict instead an image of exile most threatening to the Occidental institutions of univocal sense and historical certainty: the exile of mimesis, the plastic dissolution of fullness, the slippage of structural support.

Lyotard writes that Francken's huge photometallic montages put in place 'the anguish of what has no identity by means of forms and materials which are the "coldest", the most clearly defined, the most calculable of Occidental intelligence' (Lyotard 1989a: 257). Identity in exile performs as both artistic structure and analytical tool in *L'histoire de Ruth*, where the story of truth finds itself without a home in the space of aesthetic commentary. Similarly, Lyotard's analysis of Arakawa's stylistic manipulation of line and form, of the sculptural ideals of contemporary architecture and space, leads to their narration as mere 'empty urbanisms', as little more than written signatures of living silhouettes,

whose forms and shapes 'only aggravate the desertion of the civic places' (Lyotard 1984c: 15). In like fashion, Adami's 'perverse architectures' – *Great Northern Hotel, Latrine in Times Square, Bedroom Scene, La Vetrina* – are said to traverse the mental catalogue of articles available from 'the society of consumption'. The artist's acrylic commodification of postmodernism's desired space, the theatre of cruelty, results in a textual refiguration as dead as it is alive: 'Cold monsters who burn with the passion to be consumed ensue from this analysis and catalysis. Space suffers an absolute confinement, time stops, the possible is annihilated' (Lyotard 1983: 17). According to Lyotard's formulation of the particularly plastic nature of Adami's work, representation as graphic time and space melts away in its unused passion. Indeed, graphic dissimilations in the images of Adami function only too well as energetic figures of the signatures behind their critical accounts. 'It is invariable in his drawings of handwriting', Lyotard writes self-consciously, 'the line is the life of the letter, its rhythm, and at the same time its death, its effacement, as in a signature' (ibid.: 10). Art here exiled or re-cited in the text of Lyotard embodies the slow death of graphic mimesis through criticism's barter of Subject for commodity, *je* for *jeu*. At issue here is not only the death of the Subject, but more especially the status of the genre, 'the line' of art, and the death drive of the critical institution.[5]

It is actually to frame the uncertainty of the philosophical tradition and its line that the visage of Moi surfaces to have the final words in Adami/Lyotard:

> I would very much like to put order in their [Il, Elle, L'autre] disorder and succeed at saying what is the line. But, one witnesses that the line precedes the commentary and escapes it If the design conceals something which exceeds all explication, all formal, iconographical, iconological, structural analysis, and second, all commentary, it is because in the apparatus (*dispositif*) of its traits, as hidden as one wants by the composition, even erased in the goings and comings of regret, the sign of life which made the pencil pose itself persists.
>
> (ibid.: 38).

These closing words efface the Subject of philosophy – its certainty of aesthetic commentary and critical consensus – by sketching the question of the line in the figure of the essay's opening ellipses: 'On dirait qu'une ligne . . .' The writer's words here displace the certain assumptions of formalist aesthetics and art history with traces of an art of elliptical discourse leaving open the question of the line. Lyotard suggests as early as 1970 that

in spite of my interest in politics, the best, the most radical critical activity bears on the formal, the most directly plastic aspect of painting, photography or the film, and not so much on the *signified*, be it social or anything else, of the object it is concerned with This deconstructing activity is a truly radical critical activity for it does not deal with the *signifieds* of things, but with their plastic organization, their signifying organization. It shows that the problem is not so much that of knowing what a given discourse says, but rather how it is disposed ... and that the deconstruction of its disposition is going to reveal all of its mystifying content.

(Lyotard 1984d: 28–30)

This idealistic line about the deconstructive project's political ability to reveal 'all' mystifying content takes on a much more subtle tone some fifteen years later in Adami/Lyotard. 'It is a thing that can appear strange', says Elle, 'that the certainty of a god in the line would be accompanied by a weak prayer addressed to the mortals: look at me, understand me, love me, speak of me, speak [to] me' (Lyotard 1983: 4). This feeble demand of the line then generates a set of critical *demandes* with a difference: 'Who then speaks? The painter, the subject, the painting?' (ibid.).

DOUBLING *DEMANDES*

Such a doubling of *demande* resounds throughout the joint authorships of Adami/Lyotard, Arakawa/Lyotard, and Francken/Lyotard. The dialogue on Adami begins by posing the challenge of the *demande*:

One would say that a line is a phrase pursued by other means. A phrase is a demand/desire/need/question (*demande*). As there were other other lines before it outside of picture and in picture, in culture, in imagination, and on paper, which would demand (*demanderaient*) to be pursued, a line is also a sort of response, a way of following up the need/desire (*demande*) produced by the anterior lines.

(Lyotard 1983: 3)

The figures of Francken's work also turn around the traditional responsibility of response, the anterior imperatives of artistic criticism and purpose:

Ruth asks herself and always will ask herself (*se demande et se demandera toujours*) not only who she is, but what she does and how to put it. The *Portraits*, as well as many other works before the

Portraits, originate from this blind spot on her retina, from a paralysis of language, from a Babeling.

<div align="right">(Lyotard 1989a: 251)</div>

But the response to this double *demande* of graphic and plastic may be the generation of more energetic activity ('what it demands of this capacity of corporeal resonance') than reasoned production. In the opening words of *Longitude 180° W or E*, 'You try to understand Arakawa. He is not asking (*demande*) to be understood. He asks (*demande*) not to be understood. He asks (*demande*) nothing. He is asking (*demande*) to be that in which the asking [desiring: *demande*] takes place: blank' (Lyotard 1984c: 1). When the critical imperative to understand, to translate, to systematize is dis-placed by the force of the figural, the most familiar remaining product of philosophy is the empty gesture of the *demande* undercut by its own plastic obliqueness. Or put another way, when the critical imperative is *re-placed* by the masquerade of the figural, the gesture of *demande* enlivens critical receptivity. This formulation is consistent with Lyotard's earlier psychoanalytic privileging of image and the primary process when he refutes, in *Discours, figure*, Lacan's theory of the unconscious signifier:

> the order of discourse remains open to its other, the order of the unconscious. The latter reveals itself as figure. The presence of figures in discourse (on all levels) is not only a deconstruction of discourse: it is also the critique of discourse as censorship, repression of desire: but it also must be the *non-fulfillment* of the phantasmatic from which these figures proceed.

<div align="right">(Lyotard 1971: 323–24)</div>

By contrast to Lacan, Lyotard understands the primary process to consist of a vibrant field of energy preceding and disfiguring the linguistic. In his view, the disfigurative 'positive' and 'affirmative' force of the primary process and the death drive imprints its mark, its line, on language through the performative operations of designation and the deictic.[6]

In a curious way, this same critical emphasis on the deconstruction of *demande* is what constitutes a nexus, however minimal it may be, linking Lyotard and Lacan.[7] For, regardless of whether the idealized field 'beyond representation' is understood as the positive primary process or as the unrecuperable, lost fullness of *jouissance*, the *demande* functions for both Lyotard and Lacan as the horizon *of* representation.[8] Lacan clearly outlines the grounds for generating such a linkage in 'The signification of the phallus' (1958). It is in the *demande* that Lacan situates the elusiveness of desire in the figure of the letter:

> demand in itself bears on something other than the satisfactions it calls for. It is a demand of a presence or an absence – which is what

<div align="center">185</div>

is manifested in the primordial relation to the mother, pregnant with that Other to be situated *within* the needs that it can satisfy. Demand constitutes the Other as already possessing the 'privilege' of satisfying needs It is necessary, then, that the particularity thus abolished should reappear *beyond* demand.

(Lacan 1977: 286)

Here is where Lacan's analysis of the *demande* calls to mind Lyotard's writings on art. For both of these otherwise incompatible writers, the *demande* is the horizon, the plane, eliciting figuration (whether through image or language). And for both, figuration in 'site' of, on the 'screen' of, the *demande* need remain unsatisfactory to the representing subject.[9] If looking to the *demande* of either Lacan or Lyotard for blueprints of the megamachine of reproduction, the critic will find only the interpretative structure of 'a construction *en abyme*, an abyss of signs each effacing itself before the next' (Lyotard 1990: 65). But it is this same seemingly nihilistic, semiotic abyss, I would suggest, that sustains the *demande* of 'the enigmatic signifier' which, to recall the argument of Jean Laplanche, continues to signify *to* without its addressee knowing necessarily *what* is signified.

This distinction between signification, signifying *what*, and designation, signifying *to*, also should be remembered in critiquing the crucial reproductive devices which continue to sustain Lyotard's own critical discourse. His compulsion to speak of the postmodern, for which he is almost unique among his French peers, has been argued to leave traces of a discourse of periodicity in his texts. But Lyotard's emphasis on the postmodern distinguishes between the false confidence of empirical data and the narrative systems dis-playing it:

work and text have the characters of an *event*; hence also, they always come too late for their author, or, what amounts to the same thing, their being put into work, their realization (*mise en oeuvre*) always begin too soon. *Post modern* would have to be understood according to the paradox of the future (*post*) anterior (*modo*).

(Lyotard 1984b: 81)

Similarly, in *The Differend* Lyotard dwells on the situation of the unstable state of the Now and the instant of language in which 'something which must be able to be put into phrases cannot yet be' (Lyotard 1988a: 13).

Lyotard ascribes this 'cannot' to the uncertain situation of the Now. Now, Lyotard writes of Adami's 1970s figures:

the 'for sale' sign attached to the post-industrial monsters is taken down. Now the images are to be quickly perused – dreamily – to be associated. The portrait itself is composed of associations of signs

captured in the illustrated, written, and printed doxography of the hero who serves as its model. The remnants of his immediate life are piously collected, as by an archivist, who collects not curiosities but unsatisfied demands (*des demandes insatisfaites*).

(Lyotard 1983: 18–20)

The *demande* of the Now rests much like the visage of the philosopher hovering above the text, present, but disquieted by its questionable line *in* the text. 'The painting as a world of lines', taunts Elle in Lyotard/ Adami,

that is to say an arrangement of phrases, suggests: undo me in order to know me and remake me in words. The severe response of the classical painter to the question (to the demand) (*à la question (à la demande)*) of lines poses a question in turn, and demands our offerings. The god exhibits the fruit of his decisions to our feelings and our understanding. Chained up himself. Otherwise, how would we know him?

(ibid.: 4)

Perhaps the *demande* is the only pose left to the critic Now faced with the loss of the certainty of critical authority. Maybe this is why *L'histoire de Ruth* (*The Story of [T] Ruth*) reveals itself appropriately as the graphic sign of the enigmatic moment: 'when the past and future no longer consist of certainties and plans, but of questions, the present is contained in the question-mark (*dans le point d'interrogation*), and history is the storm of what occurs' (Lyotard 1989a: 251).

Adami's somewhat neoclassical figures of directionless rowers and empty, abandoned boats embody for Lyotard the pathos of the uncertain figure of the moment caught in the storm:

The small boat of memory awaits the piteous and the melancholic. Rowing is like drawing, one vigorously makes one's mark in any waters, and the trace fades away. One will unload nothing on the shore of the following generation, except the effort of having traced. One will strip oneself, the visage of sense will remain covered.

(Lyotard 1983: 21)

To a certain degree, Lyotard's response to Adami's free-floating boats takes us far afield from the terrain of artistic criticism. Rather than describing the image, much less revealing its referential function in the context of Adami's *oeuvre*, the philosopher relegates pictures to the broader field of *designation*: to the figures' relation to the enterprise of commentary, to the compromise forced on the artistic object by the catalogue's joint authorship of artist and philosopher, or maybe even

187

conversely, to the impact of design on interpretation's traditional power over the revelation of content. Also designated by the more wistful moments of the philosopher's writings is a sort of displacement of graphic sense by plastic *sensibilité*, a move away from the familiar discourse of history and commentary to the enigmatic emotions evoked by a visage of philosophy, a front not made present by the discourse of periodization but enveloped by the question-filled period of the Now.

Yet, Lyotard's fascination with the sensations of the Now, 'the line inhabited by desire' (ibid.: 3), raises the question of his attraction to a dialectical formalism well known to both philosophy and aesthetics. For Lyotard, one of the crucial aesthetic dilemmas of the second half of the twentieth century poses itself as the pathos of tragedy. *L'histoire de Ruth* ponders the implications of our nostalgia for 'fear and pity, tragic purgation', those emotions which Lyotard describes as comprising the legacy of European history: 'the debt of a monumental disfiguration' (Lyotard 1989a: 254–6). Lyotard's source study of the emotions of melancholy and exile evoked by Francken's *Köpfe* leads him directly to the scene of tragic conflict whose dialectical tensions designate stylistic and methodological differences, veiled in the guises of the masculine and feminine. The philosopher cites Ponge's remarks concerning Fautrier's disfigured *Otages*:

> 'the abused innocents who are left without defense (and first almost without conscience), without complaints, without possible struggle, the weak'. Ponge says that contrary to Picasso 'masculine, leonine, solar, virile member, erection' etc., Fautrier 'represents the feminine and feline side of painting, lunar, mewing', etc.
>
> (ibid.: 255)

In an earlier essay, 'One of the things at stake in women's struggles', Lyotard again comments on the representation of gender difference as an influential operative of Occidental criticism. He reflects on how 'men teach women of death, the impossible, the presence of absence. Tragedy is a noble genre because one does not laugh: in fact, it shows that there is nothing to laugh about' (Lyotard 1989b: 112).

Curiously, in summarizing the gender stakes of the noble genre, Lyotard's analysis turns once more to the figure of the rower, this time as the personage of tragedy in Sun-Tse's *Thirteen Articles on the Art of War*: 'Sun-Tse defines a rite of passage: the feminine is on the side of the child, youth, and nature; death is the ferryman; he shows the way to language, to order, to the consideration of lack, to meaning, to culture' (ibid.: 113). Were the commentators of art to join the ferryman's embrace of tragedy (what Hegel praised as the highest form of Occidental aesthetics), they would reinscribe the artistic in the male realm of signification and order. Adami sets this scene outright: 'La tragedia è la forma più

perfetta' (Lyotard 1983: 7). Their representation of the literal and figural exiles of Arakawa and Francken would hope to do little more than ease the pain of pity; this would effect, in turn, the mimetic replication of the source of exile, the fear of death at the hands of patriarchal culture.

But Lyotard's opening of the question of the Now works toward the derailment of such mimesis. 'The twentieth century was perhaps male in painting. The twentieth century-and-a-half has decided, finally, not to leave space-time in the hands of men. I hope' (Lyotard 1989a: 256). His evocation of the relation of gender and genre leaves open the possibility of a non-male genre of discourse. This is not to say, however, that such a possibility leads to the sort of 'female' genres of discourse espoused by Lyotard's French feminist peers. While the exact nature of this genre and its form is what momentarily aligns Lyotard with the likes of Irigaray, to whom he makes a significant gesture of support in 'One of the things at stake in women's struggles' (Lyotard 1989b: 119–20), it also permanently separates his sense of the stake in women's struggles from the strategies employed by a growing number of feminist artists.

One significant artistic alternative to a male genre of discourse has been the feminist exprimentation with something resembling a female space-time. Such work aims to reformulate the earlier (masculine)

Figure 6.3 Nancy Spero, 'Untitled, 1987'. (Courtesy: the artist)

189

romantic interest in the natural, the organic, and what Lyotard calls the corporeal resonance of the figural. Instead of a *mise-en-abîme* turning around the fearful representation of death and its apparati of the past, memory, and recognition, such art is commited to the presentation of such figures as birth, fecundity, performance, and politicized space ('in-sites') whose desire-filled, female organs, gestures, and appellations function as apparati of the unpresentable future, the possible, and the unfamiliar. In neutralizing the romantic machineries of war, conquest, and vision, many feminist artists hope to transform them into inquisitive instruments of progressive, feminist action (consider, for instance, the contrasting examples of the mixed-media projects of Nancy Spero (figure 6.3), the 'Birthworks' series of Renate Ferro (figure 6.4), and the postcolonial installations of Renée Green (figure 6.5)).

At first view, this seems to resemble the effect of Adami's paintings on the interlocutor, Lui. When posed with his feminine double before *The Spring* (figure 6.6) – Adami's depiction of an androgynous pair coupled next to the flowing aperture of a spring (1982), Lui asks, 'would sanctity consist of a sword trace, of a slight wound from which arise the two covers of the white lymph, from one side and the other? In short a division. Each part is taken up and separated there, but each touches the other and partakes of the other' (Lyotard 1983: 10). Here the trace of a sword is said to efface itself in the sanctified lips of the female body-sex. Division is thus transformed into 'touching upon', the figure of female linguistic contiguity, of labial identity-in-exile promoted by Irigaray in *Speculum of the Other Woman* (1985a) and *This Sex Which Is Not One* (1985). And if the lines of division can be said to be retraced in this drawing, they indicate that separation takes place not so much in the oval lip of the spring itself as in the broken flow of its abundance and in the combined forms of its two beholders. If Adami's lines hint that sanctity is the fruit of a wound, the line of a sword, the relation of sanctity to the feminine remains to be only that of a marginal by-product of the spring – brought to fruition by the sight of the flow, by the turning of the oval into the eye.

This observation is echoed in Francken's letter to Lyotard which asks him to 'talk about this fissure/wound that makes men, in my eyes, so pathetic by what they *have seen*' (Lyotard 1989a: 263). Francken sees the fissure of representation, albeit even a fecund wound, to lie in the site of the eye.[10] In this context, any invested hopes in the female figure and/or body as the sole panacea of male mimesis are contingent on the deconstruction of the patriarchal confidence in dialectical representation, what makes visible the invisible. Suggesting that desires for non-male representation rest unfulfilled if focused solely on the promise of renewing the visual figure of the feminine, these many examples relating feminine

190

Figure 6.4 Renate Ferro, 'Macaroni Mama'. *Birthworks* series.
(Photo: Andrew Gillis. Courtesy: the artist)

figures to the complex terrain of feminist discourse recapitulate the acknowledged irresolution of Lyotard's qualification 'I hope'.

Any sort of localized hope in simple gender shifts of genre is exactly what is disfigured in Lyotard's writings on the art of Adami, Arakawa, and Francken, all of which eschews, to some degree, complacent refuge in dialectical thought. In stressing the critical activity designated by Il's romantic vision of *The Spring*, Adami/Lyotard's Elle throws back to her male interlocutor any nostalgic hope in an illicit rejuvenation of dialectics through the agency of the female:

> That is what men say, they make themselves masters of the line, in making it a form. But first they discovered it, and here is how: they crawled on our shores (*plages*), our pale velours, our fabrics, myopic eyes trained on textures of linens or intimate skins, lost in our deserts, overwhelmed by the indefinite, and they fell upon the pure trace, the commissure, the channel, the infant sex, the joint of the dune and the dune. He drew *The Spring* on September 12, 1982. The magnificence of our secret, discovered or dreamed in the banality of forbidden games, should it not provide the key to the sanctity of the line?
>
> (Lyotard 1983: 10)

For the dialectical critic, *The Spring* operates as an apparatus of signification

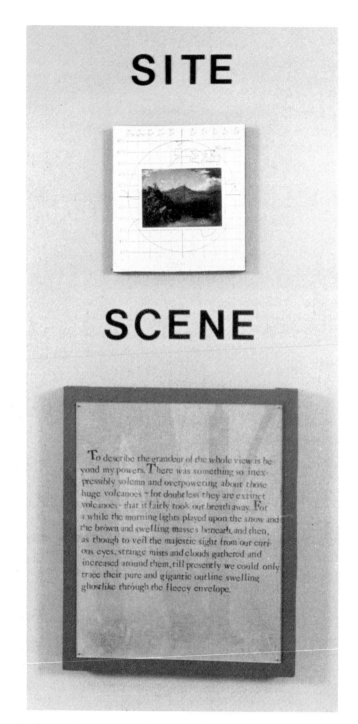

Figure 6.5 Renée Green, detail, 'Site/Scene' Installation. (Courtesy: the artist and Herbert F. Johnson Museum of Art, Cornell University)

Figure 6.6 Valerio Adami, 'La Source' 1982. (Courtesy: Galerie Lelong, Paris)

to be recovered as the pleasurable substitute of the tragic death of the
Subject. Embodying the hopes of critical practice, *The Spring* trades
delight in the unattainability of the corporal *je ne sais quoi* for the
adventurous search for a secret, for the continued graphic represent-
ation of absence as presence in the form of the wet lip, for the necessary
disfiguration of the Other through its sullied diacritical appropriation.
Whether dream or discovery, designs of and on the *je ne sais quoi*

193

generate the banal repetition of critical games (*JEux*) which we might have thought to have been outlawed as the terrorized products of tragedy. Here again, through the attempted figuration of the feminine, through the transformation of the oval into the eye, the critic finds himself at home in the Occidental epic of academic research whose dialectical operations contribute to the *terreur blanche* of 'the poles of power, narrative, war, and envy . . . determined by a mad torsion and a senseless focalization' (Lyotard 1984c: 1). No matter what its shape, the fetishistic key to the sanctity of the line remains inscribed within the banal field of masculine interlocution.

WHAT'S HAPPENING?

Tragically, or, rather, appropriately, this analysis has gone full circle, doubling back on itself to the earlier *demande* of the Now. If Lyotard's focus on the traditional genre of tragedy as gender difference leads us only to the *je ne sais quoi* of acknowledgement of this difference, where do his hopes for a non-male art lead? How does he read in view of the unrepresentable, in view of the differend (these sometimes irreconcilable phrases between genres of discourse), in view of a strategy which might counter the *terreur blanche*? In sum, the readers of Lyotard's collaborations with Adami, Francken, and Arakawa may find themselves desiring to know exactly what occupational stance he finally claims in the wake of so many paradoxical positions on the anatomy of the line.[11] Lyotard would probably respond to these *demandes* by telling an elliptical anecdote, maybe one concerning similarities between Arakawa and Lyotard's favored dada, Duchamp:

> Arawaka comes to New York having gone through a lot of war and a little Dada, as Duchamp comes to New York to free his thought from the terror reigning in Europe. They both see that it won't do to respond to terror with ironic counter-terror. 'Ironicism' is no irony, rather humor. They do not set up a war machine against the war machine, but peacefully take the war machine apart and then put it together again with its pieces deranged but in working order. They don't work by producing effects in things, enchaining and controlling reality, by imposing mastery on mind as if that were its primary goal. They work by inspiring the mind with the question: What's happening there?
>
> (Lyotard 1984c: 3)

The strategy of storytelling in the face of terror asks us to step aside from dialectical confrontation in order to reopen the question of the force of criticism. In response to the masterful *demande* 'What's my line?', Lyotard joins Arakawa and Duchamp in writing his artistic commentaries

around deictic variations of the parodic question 'What's happening?' . . . 'here?' . . . 'there?'.

More than once, readers trained in the finer lines of philosophy and art history might find themselves pausing midstream in Lyotard's writings on art to echo the *demande* of his texts: 'What's happening here?', they might wonder, when Lyotard lapses into anecdotes about his own writing instead of reading paintings. And 'what's happening?' when the dada Duchamp appears so frequently in spirit if not in name throughout Lyotard's texts? Do the images of Francken, Adami, and Arakawa perform merely as dada's happenings, as 'les TRANSformateurs Duchamp'? And, perhaps most significantly in light of the style of Lyotard's philosophical dialogues, 'what's happening?' during the moments in *On dirait qu'une ligne . . .* and *Longitude 180° W or E* when the dialogue pauses to allow characters to respond to themselves, when the speech of Est responds to the preceding speech of Est, or when Lui echoes Lui echoing Lui. During these moments, the critical echo functions as a sort of visual bleep or critical diversion in the development of dialogue, leading the readers to shift their attention from philosophical line to something resembling Arakawa's plastic happenings.[12] 'Often the things written are made barely readable', Lyotard writes of Arakawa's painted messages,

> the shape of the letters is too faint, or their outline is blurred by the re-inscription of their form as it is echoed Or else letters or words are missing, making blanks or gaps in the textual thread. We might say that language is buried and hidden in the depths of the painting, or that it flees as it advances towards us from this depth. We might say that this double envelope, this reversible hem of silence and of language murmurs like a resounding horizon far off. We might say that blank is one name of this horizon.
>
> (Lyotard 1984c: 20)

We might also say that 'style' itself in another name of this resounding horizon in which language nuzzles up to art. 'Style' at least, that is, in the extremely fluid sense which Lyotard gleans from Benveniste's 1956 essay, 'Remarks on the function of language in Freudian theory': 'It is style rather than language (*langue*) that we would take as a term of comparison with the properties that Freud has disclosed as indicative of oneiric "language"' (Benveniste 1971: 75). The oneiric force of such signaling or designation – 'What's happening there?' – stands for Lyotard as the acinematic field of style which transgresses the order of narrative control. In parodic response to the *terreur blanche*, Lyotard's own style asks its readers to concentrate on the oneiric blanks, the critical intervals and asides, the libidinal bleeps and bloops which occur in the midst of what he calls his textual *ludi scoenici*. The humorous play

of bleeps and bloops disfigures the order of the graphic, whether the graphic order is predictably tragic or romantic. In place of the Occidental *mise-en-abîme*, Lyotard calls forth a pagan play, a *mise à côté*: 'This is the paradox of parataxis: to focus beside *focus* (*focaliser à côté du focus*). To make yourself sensitive to what is placed in the margin when we focus. Parataxis is a stylistic feature: you juxtapose instead of putting in order (subordinating, coordinating)' (Lyotard 1984c: 13). Lyotard's critical juxtapositions highlight the relations of the figural whose differend gestures evade the harmony of focus.

In standing beside Arakawa's work, Lyotard notices the varying arcs and lines of texture and text, not to mention traces of the playful confusions of language and image which Arakawa developed earlier with Madeline Gins in *The Mechanism of Meaning* (Arakawa and Gins 1979). He lures his readers to be attentive to how Adami's classic lines differ from the curves of his figures and the subtle variations of his bold acrylic colors. The androgyny of his figures, moroever, is said to invite us to a Dionysian world in which playful sexual pose and voyeurism (*the happy land / Idyll*, 1982; and *Archeologia*, 1982) celebrate their own libidinal feats without localization in the figure of the I, without investment in the fixity of meaning, production, or moral order (although it is highly doubtful that voyeurism can ever escape the figure of the 'Iye'). Similarly, the juxtaposed portraits of Francken's *Mirrorical Return* interfaced with Lyotard's texts perform a contorted dance of irregular rhythm and mood that returns the viewer to the mirror image of the performance of the *construction* of collage. Through the cutting, pasting, drawing, interlocking, and overlapping of photographs, pencil, ink, and found objects, Francken playfully solicits us to notice the new presentations of the portrait as mimetic mixture and fragment. Sharply magnified images of the unpresentable structures of skin and personality pun on their own relation to the flat featureless surface of the silhouette. Like the juxtaposed plastic forms to which Lyotard is drawn, his strategy of critical happenings places the spectator next to figures of textual art whose performances provide the infinite expression of differend positions. At least this is how Elle explains what's happening in Adami/ Lyotard,

> Pagina signified trellis. Writing drew on the page the branchings of a trellis. Bacchic proliferation and profusion. Very content that these words – peace (*paix*), pagan (*païen*), propagate (*propager*), pages (*pages*) – should be the propagations of the branch pag-. And 'pagus', the confines, far from the 'vicus' where men dwell at home.

> (Lyotard 1983: 10)

Whether confined in Arakawa's epistemological unfamiliarity of every-

day objects, whether haunted by the ghostly apparitions of Francken's porous and scarred faces, or surrounded by the proliferation of the grotesquely twisted limbs of Adami's bacchic lovers, the unsuspecting victim of the happening may well feel nude and impotent without his tools of appropriation. Remaining aside from the familiar lines of research and order, the pagan spectator stands shakily between worlds. The *terreur blanche* provides little solace and pleasure on this curved line, which sways and trembles with the rhythmic murmurs of Arakawa/ Lyotard's echoes of Ouest now Est, Adami/Lyotard's contoured lines of Il and Elle, sometimes L'autre and maybe even Moi, and Francken/ Lyotard's concluding mirrorical return to *Ios* (a literal *entre-monde*) where 'the screams and the summons-responses would resound together in a brouhaha' (Lyotard 1989a: 264).

In view of his emphasis on the Now in contrast to the present, Lyotard specifies the *entre-monde* as something different from the space-time demarcating dialectical succession. He speaks of it as the acknowledgement of the duration, the coming and going, evoked by Francken's series of portraits luring the spectator to begin anywhere and traverse the two horizontal directions in whatever manner desirable. To Lyotard, the Now lies beyond our notion of the present, the figure of historical and apocalyptical progression:

> One cannot say now *now*, it's too early (before) or too late (after). What was future is now past, the time of a phrase. The limit is not punctual or linear, the posterior incessantly encroaches upon the anterior. The Now (*Le maintenant*) is precisely what is not maintained (*ce qui ne se maintient pas*).
>
> (Lyotard 1988a: 74)

The Now of Francken/Lyotard, Adami/Lyotard, and Arakawa/Lyotard performs the plastic cacophony of postures, stories, and jokes 'making the juice of alterity flow without end' (Lyotard 1989a: 264).

In the pagan time-space, the plastic lines of art stand 'beyond' as libidinal apparati that demand/desire the attention of the eye and the body. Functioning in consort with the fundamental structures of psychic juxtaposition – the subliminal energies of condensation, displacement, figuration, and elaboration – these apparati figure the figural. As such, they operate as phantasms of the desire of criticism and theory, and they are especially difficult to pinpoint, to maintain, because they remain aside from, *à côté*, the stable reference points of academic criticism. They barely resemble the politico-economical calculations of agreement and consensus that work to affirm the strength of the patriarchal center. Neither judgemental consensus nor genres of unified discourse perform on the main stage of the pagan arena where plasticity overshadows any graphic drive 'to render distinct, thus knowable, unities which receive

their relations in a system completely independent from corporeal synergy' (Lyotard 1971: 212).[13] Much like the writings of Jean-François Lyotard on art, these apparati are invested in neither the imitation of specific critical models nor the needs of specific interlocutors – little concern for past or future ties.

Without denying the continual presence of the negative political force of the *terreur blanche*, the aesthetic writings of Lyotard want to let loose an affirmative activity of pagan ironicism. Pagan praxis displaces the criticism and commerce of the Subject for the humorous free-plays of rhythm and *de-signation* occurring when the *JEux* of criticism stand amidst the brouhaha of incommensurable singularities and differences. The import of the play of plastic discourse is not to represent exactly 'what's happening' in relation to the past and the future – whether tragic catharsis or vaginal projection, whether negation or libidinal displacement. Rather, the textual juxtaposition of such figures as tragedy and romance produces the dizzying structure of 180° on which uncertain, critical praxis happens Now. This is the plastic space of the *charnière* (hinge; joint, articulation), the libidinal apparatus of the erotic, artistic, and political happening. In Arakawa/Lyotard, the *charnière* of 180° doubles with that of *Le mur de Pacifique*, the *peau blanche* with the blank skin:

> not that of a sex (Helen's femininity), or of a race (a world of whites), or of a territory (white civilization), or of a richness (all the colors of energy, white light). White skin (*la peau blanche*) is space-time, undetermined, neutral (*neutre*) Even as you will (*voulez*) blank skin, it is twisting itself into these [contradictions, undulations or diffractions of white] and escaping you.
>
> (Lyotard 1984c: 12)

As absolute surface or structure, the *peau blanche* lies blank beyond representation, beyond substitution, beyond appropriation in the Occidental world of nomination and commercialization.[14]

BEYOND HOPE

But if so necessarily inscribed in the beyond, the *peau blanche* hardly sounds like a political articulation, not to mention a figure lying outside of the fractures of racial difference or the motions of dialectical transcendence. In fact, both a philosophical and an ideological analysis of such structuration could critique it for being unnecessarily idealistic, if not fundamentally dialectical. As Lacoue-Labarthe puts it, such a 'beyond' depends on 'the possibility of presentation, of presence, and of plenitude as something whole, virginal, unadulterated, and uncorruptible' (Lacoue-Labarthe 1977: 125). Might this not also be suggested by the

apocalyptical tone of Lyotard's concluding remarks on Francken, in which the portrait of a particular philosopher is mirrorically returned in the guise of the future?

> The *Portraits* of 1983 conserve their contingency, but immortality swells their pores. This is not that of glory, in the mundane sense at least. It is that of a 'people' or of a 'family', she writes, which is an elite today only because it announces the republic tomorrow. The mirrorical return is not specular reflection. The society of immortals is not doomed to the repetition of the same, but to the infinite expression of the other.
>
> (Lyotard 1989a: 264)

Can what is happening here be described as the expression of anything other than the emission of faint echoes of the speaking visage of teleological philosophy? Once Lyotard wishes to think beyond the critical sites of style, figure, and *demande*, what can he see in the 'infinite expression of the other' that distinguishes it from 'the representation of the same'? As the NAACP recently felt compelled to remind Ross Perot, the make-up of 'a people' does vary according to the power historically accorded to the position of the other – 'your people' simply may not correspond to 'my people'. Could it be that such a mirrorical return announcing the republic of tomorrow is far too indifferent to the demands of the elite today? Might not such a mirrorical return amount, as Lacoue-Labarthe charges, to nothing more than a nostalgia for 'the obsolescent arsenal of the metaphysical police-force' (Lacoue-Labarthe 1977: 125)?

Lacoue-Labarthe's charge is borne out unequivocally by many of Lyotard's writings in *Que peindre?*, the 1987 collection of his essays on Daniel Buren, Adami, and Arakawa (including *On dirait qu'une ligne . . .* and *Longitude 180° W or E*). In the prefatory essay written for this collection, Lyotard announces his desire to rewrite aesthetics, to turn critical attention away from the empirical and ethical transformations of art to the reflection, the 'taking place' of painting. In keeping with his announced (but unfulfilled) wish to leave aside consideration of artistic conventions, he here reflects not merely on the designations of pagan, libidinal styles, but also, and more adamantly, on the 'pre-intelligible organization' of sentiment, on the elementary intrigue of aesthetics which he understands, Now following Kant, to underlie all idioms of the individual and cultural past.

As a poignant, parataxical way of concluding this chapter, I would like to reflect for a moment on the paradoxical relation of the explicit, Kantian pronouncements in *Que peindre?* to the more promising critical strategies also dis-played in Lyotard's writings on art. My hope is to conclude by laying bare, or forcing open, the gap, *charnière*, between Lyotard's recent return to a more formal, philosophical reflection on the

199

prehistoricity of sentiment and his acinematic resistance to a return to the same which remains in evidence throughout his writings on artistic style, spatiality, and specularity.

Que peindre? might account for such a differend of critical practice and philosophical sentiment in distinguishing between an ontological and sociological practice in Buren's work. Lyotard argues that Buren's site-specific installations are ontological because they evoke a visual space-time linked to non-subjective and non-objective experience distinct from that of a subject situated outside of the space-time of vision, who thus would be capable of reading from outside of the object. In so positioning the subject and object (*la vue et le voyant*) as complementary, Buren's work shifts its focus, so Lyotard argues, from the subject's production of signification to the artifact's field of reference, to the sensibilities evoked by an experimental project of making visible what is not. To a certain extent, such reference calls to mind the critical distinction between signification and designation, between signifying *of* and signifying *to*. But in the specific context of an ontological practice, Lyotard presents Buren's art as the exploration of 'a common sentimentality', something fundamentally different from the retrospective enigmatic signifier to which I allude above.

The scope and implications of such ontological art are laid out in the challenging introductory essay of *Que peindre?*, which reflects on the commonalities of Lyotard's site-specific writings on Arakawa, Adami, and Buren. Somewhat cryptically entitled 'Presence', this essay provides Lyotard's readers with his most succinct account of the philosophical stakes of his writings on painting. Lyotard seizes the occasion of this introduction to summarize his take on the 'presence' of painting, which should be understood more in terms of positionality than of temporality.

Being there-now, painting is said, like the differend, to evoke the interval between the 'not already' and the 'not yet'; or as *Que peindre?* puts it another way, presence is too early and too late for language. Although this temporal collapse might prompt readers familiar with *Discours, figure* to consider the corollary of psychoanalytical transference, the reshaping of past desires into an altered reality of present narration which has bearing on the future, it figures here instead as the diferend of the aesthetic reflection of presence. Now maintaining that the 'presence' of painting is unrelated to transference or to any other temporal mechanism invested in the accomplishment of desire or will, Lyotard links it to meditation, to the effect of reflection on the unpresentable.

A practical artistic imperative accompanies this position. Art can be experimental only by abandoning its propaedeutical service to cognitive identification. The recommended alternative is the exploration through practice (of art and criticism) of reflection itself, that is, the enactment of

judgement 'before having discovered the conceptual rule and for the purpose of finding it' (Lyotard 1987: 25). This leaves the artist and spectator open to the expectation, awaiting (*attente*) of universal sentiment in which the 'I' of painting is not subjective but the 'we' of another community in retreat from desire and its causal business. In a crucial chapter on Adami, 'L'anamnèse', Lyotard explains this awaiting in the terms of Kant's *Third Critique*. For Kant, and Now for Lyotard, the aesthetic is a field, *Un Champ*, an 'Idea', immediately present to the universal subject, *le nous sentimental*.

This position is articulated in 'L'anamnèse' specifically in relation to Lyotard's doubts about the very moments in *Discours, figure* which I find most promising for a joint approach to artistic practice and critique. In the closing chapters of *Discours, figure*, Lyotard brings together the almost irreconcilable categories of graphic and plastic in formulating one of contemporary criticism's most provocative accounts of the artistic phantasm. In critiquing Merleau-Ponty's phenomenologization of the unconscious, which locates the symptom of art in an ontology of the invisibility of the visible, *Discours, figure* proposes to 'dramatize' the visual work by taking up its investigation of an 'unpresentable event', one as invisible as the primal scene. But rather than stress the work of art's 'nous sentimentale', Lyotard's earlier reading focuses on the scene of the phantasm, in which primal energy can figure itself 'as an inscription on the body' (Lyotard 1977: 88) only after, or beyond, the fact:

> The fantasy is figurality, difference, challenging every set system of oppositions. We have seen the extent to which it is, consequently, the Waterloo of discourse (*le lieu du défaut du discours*), and even of recognizable representation. But we also know that in some sense it is a 'writing': a repetitive configuration, a sieve in which to catch and 'clarify' all the material, rendered by chance encounters, the day's residues and the episodes of daily life, that bombards the subject.
>
> (Lyotard 1983: 353)

In dialogue with Laplanche and Pontalis's account of retrospective fantasy, this reading links the visual to the montage of desire evident in Freud's account of a 'A child is being beaten'. It thus functions, although not entirely willingly, to inscribe art in the complex fantasy of sexual difference. As Lyotard develops this point in 'The unconscious as mise-en-scène', 'it is indeed the unconscious that stages the discourse of the young girl's desire, and this mise-en-scène, far from being a translation, would be the transcription of a pictorial text of virtual bodies, with effect on the real body of the spectator (masturbation)' (Lyotard 1977b: 92). Lyotard here sets the stage for Jacqueline Rose's feminist retort that what counts over and above the 'unpresentable event' is the phantasmatic

transcription itself, which always bears the marks of sexual identity constantly bombarding the subject:

> [Freud's essay] demonstrates that male and female cannot be assimilated to active and passive and that there is always a potential split between the sexual object and the sexual aim, between subject and object of desire. What it could be said to reveal is the splitting of subjectivity in the process of being held to a sexual representation (male *or* female), a representation without which it has no place (behind each fantasy lies another which simply commutes a restricted number of terms).
>
> (Rose 1986: 210)

But 'L'anamnèse' totally refutes a situation in which art might dramatize the phantasm of the differend of the sexes. Now Lyotard insists that any account of virtual sexuality attests not to the field of artistic presence but to the imposition of language and its law on the enigmatic clinamen of universal sentiment. The differend of 'presence' positions the disinterest of aesthetic pleasure on one side and desire and want on the other. Put another way by Lyotard, 'don't confuse the rules and stakes of cognitive, speculative, or even only logical truth, or those of the empirical, utilitarian or ethical good, with the rules and the stakes of the beautiful' (Lyotard 1987: 62). Universal sentiment, then, requires a mutation of the necessarily fracturing present of community in order to retreat to a community of presence, 'before the drama' (Lyotard 1987: 51).

It is notable that 'L'anamnèse', written in Lyotard's familiar style of philosophical dialogue between Lui and Vous, concludes with a curious exchange in which these two characters are forced to confront the irreverent and distracting challenges of a third interlocutor, Elle. Lyotard has *her* pose the questions which just won't go away in a critique of *his* hopes for presence:

> Do you think you can terminate the ruses of desire at such a small cost? Doesn't your art itself bear the traces of its trappings of a history? Of this Occidental history which does little more than repeat the oracle, the lie, and their fulfillment as well? Is the desert of space-time able not to repopulate itself with characters and conspiracies; is the scenography able not to hatch 'scenes'?
>
> (Lyotard 1987: 66)

While Vous requests that she not make an ideology out of his anamnesis, the echo of this agonistic exchange persists throughout Lyotard's writings on art. If the incommensurability of sexual difference is always already inscribed in the phantasms of desire and will, that is, in the field of representation, how can this differend be thought to evaporate when

folded into its refiguration as a hopeful field of a higher order, *ein Feld* 'beyond sex'? What does it mean, moreover, for Lyotard to label the breach between the phantasm and *le champ* of sentiment not only as an irremissible differend, but also as one hinged with this notable qualification: 'even if reciprocal encroachments are possible, and even desirable' (ibid.: 62)?

A practical response to this question is suggested by the recent translation *Duchamp's TRANS/formers* (1990), which sets the scene for such a desirable/possible reciprocity. This text comments on the redistribution of artistic and critical energies enacted by Duchamp's shifts of movement and perception from the ascetic *Large Glass* to the more popular, pagan formula of *Given*. Lyotard's analysis of the question of Duchamp's artistic application and critical practice provides, moreover, a brief sketch of the pagan politics of incommensurability developed more fully in *Economie libidinale* (1974) and *Rudiments païens* (1977). Released Now in the 1990s in the face of a new, uncertain European topology, *Duchamp's TRANS/formers* seems to envelop *Que peindre?*, a text of the 1980s, in its consideration of matters extending beyond the presence of aesthetics. Although both texts reflect on the incommensurability of art, *Duchamp's TRANS/formers* focuses, first in 1977, and Now again (and thus very differently) in the 1990s, on the relation of topological politics to artistic practice and interpretation. Through his reading of Duchamp, which is renewed by its translation, Lyotard warns against the terrorism of a topological politics which superimposes incongruent spaces, classes, genders, and races. Leaving aside consideration of aspects of Lyotard's theorization made problematic by his unqualified endorsement of Duchamp's bachelor machine (a 'popular, pornographic, pagan' apparatus),[15] I would like to conclude by forcing an incongruous alignment, one made in the spirit of the *Large Glass*, between the sentimental aims of *Que peindre?* and Lyotard's fascinating account of his desire to transform Duchamp into a model of political thought:

the discovery of incongruences and incommensurabilities, if one brings it back from the space of the geometrist to that of the citizen, obliges us to reconsider the most unconscious axioms of political thought and practice. If the citizens are not indiscernible, if they are, for instance, both symmetrical in relation to a point (the center, which is the law) and nevertheless non-superimposable on one another (as we know is the case for the owners or bureaucrats of capital and the sellers of labor power, as we know is the case for men and women, for whites and 'colored people', for urbanites and provincials, for young people and adults), then your representation of political space is very embarrassed. And if you haven't

despaired of your life on the pretext that all justice was lost when incommensurability was lost, if you haven't gone running to hide your ignoble distress beneath the authority of a great signifier capable of restoring this geometry, if on the contrary you think, like YOURS TRULY, that it's the right moment to render this geometry totally invalid, to hasten its decay and to invent a topological justice, well then, you've already understood what a Philistine could be doing searching among the little notes and improvisations of Duchamp: materials, tools, and weapons for a politics of incommensurables.

(Lyotard 1990: 27–8)

This cry of the *ludi scoenici* for a topological justice in the face of hegemonic and patriarchal *JEux critiques* tells me that critical aspiration is the acknowledgement of struggle and politics, not hope in their pastoral Other. What I learn from the uncertainty of Lyotard's writings on art is to be doubly cautious in attempting to write beyond, whether beyond struggle *per se* or beyond what is happening, Now. What is happening, Now, is Lyotard's ambivalent sensitivity to the continual performance of the critical tragedy of judgement whose universal line wants to silence the humor of pagan praxis. Most crucially, what is also happening, Now, are the rhythmical movements of the question-mark disquieting the certainty and stasis of universal sentiment. Yet in re-siting resistance to the terror of Occidental politics, the pagan critic may be seduced to strive too fervently to quicken the unpresentable ends of parataxis and politics. The immediate end would be the loss of rhythm in the wake of sentiment, rather than any unlikely permanent celebration of the bleeps and bloops of the figural. So today's fragmenter of critical discourse might learn from Lyotard's irresolute texts to respect the precariousness of the fine lines of their motion through discourse. For their promising dance always moves perilously close to the fizzled performance of their parataxical ancestor – the unfulfilling (male) visage of Dada.

NOTES

1 Many philosophers and literary theorists might be most familiar with Adami's drawings and lithographs of Derrida's *Glas*, even though this work was not featured in the Galerie Maeght show of Adami's paintings (1981–3) upon which Lyotard bases *On dirait qu'une ligne* Nor does it figure in Lyotard's other essays, 'La franchise', and 'L'anamnèse' (written for the catalogue of the Adami show at the Centre Pompidou), included along with 'La ligne' in *Que peindre?* (Lyotard 1987: 37–68).

2 I wish to stress, at this point, that Lyotard more recently has softened his 'critique of judgement' to incorporate Kant's *Third Critique* into his reflections on the 'pre-intelligible organization' of sentiment. In my concluding remarks, I discuss the weight this complex shift bears on my reading of his earlier

catalogue essays.

3 See also Daniel Brewer's discussion, in 'Philosophical dialogue and the forcing of truth' (1983), of the rhetorical function of philosophical dialogue in philosophy and fiction.

4 In *Mélancolie de l'art*, Sarah Kofman relates Occidental 'philosophical speculation' and 'infinite specularization' to 'the ends of mastery' which seek to contain and control the threat and fascination of 'Otherness' (Kofman 1985b: 19–20).

5 Lyotard's reference to the death-drive of the line appears to be a condensed version of his account of the 'figure-matrix' in *Discours, figure*. Lyotard's complex argument is summarized with acute precision by Geoffrey Bennington: 'Lyotard here finds the way of specifying the problem of the figure-matrix as form and transgression, on "the razor's edge" between constancy and Nirvana, in the state of tension between tension and discharge, life and death, life-death. The figural is not simply the death of discourse, but discourse never quite successfully binds the figural either: desire is never quite literalised, the death-drive is what is never quite brought back to presence, the force that repeats the *Fort* in the *Fort/Da* game. There is indeed binding in the unconscious, but never the formalisation of the signifier: the unconscious can only be "recognized" in the failure of recognition produced by the "unbinding" of the death-drive; it is only "itself" in what constantly separates it from itself: and it is the death-drive which is to be found as the principle of figurality' (Bennington 1988: 99).

6 Bennington (ibid.: 56–77) also provides an exceptionally clear and insightful analysis of Lyotard's emphasis on deixis and designation.

7 Helpful accounts of the sharp disagreements between Lyotard and Lacan are provided by Dews (1984) and Bennington (1988: 80–91).

8 Although Lacoue-Labarthe insists that what lies 'beyond' in Lyotard is 'far from being what Bataille called and Lacan calls the impossible, is that which can present itself actually and as such' (Lacome-Labarthe 1977: 125), I see Lacan as sharing with Lyotard a certain nostalgia for the lost fullness of *jouissance*, one which casts the shadow of the death-drive over the symbolic system. In this regard, I cite Judith Butler's account of *jouissance* in Lacan as a means of foregrounding the prominent role of *demande* in both Lacan and Lyotard: 'that we cannot know that past from the position of the founded subject is not to say that that past does not reemerge within that subject's speech as *fêlure*, discontinuity, metonymic slippage. As the truer noumenal reality existed for Kant, the prejuridical past of *jouissance* is unknowable from within spoken language; that does not mean, however, that this past has no reality' (Butler 1990: 56).

9 That figuration need remain unsatisfactory to the representing subject is a point made especially clear by Lyotard in *Discours, figure*, the text in which he critiques Lacan. In discussing Lyotard's notion of the matrix-figure underlying the other categories of figures as their radical alterity, David Carroll adds to this reading by insisting that 'no figure or form is equivalent to the matrix, but, at the same time, no indication of the matrix is possible outside of the approximations and distortions offered by figures and forms. The alterity of the matrix is never contained *in* either figure or form but lies as a potentiality *beyond* them' (Carroll 1987: 40).

10 For recent, promising accounts of the psychoanalysis of the visual which are sensitive to the wounded eye as the site of representation, see Pontalis (1988) and Rosolato (1987).

11 In my view, the most noteworthy critiques of Lyotard are those of Lacoue-Labarthe (1977; 1984), which challenge Lyotard's trust in a primary process lying 'Beyond representation' (Lyotard 1989c), and of Morris (1984), who offers a serious challenge to the political efficacy of Lyotard's theory of the postmodern sublime (Lyotard 1988b: 69–118, 147–56; 1989c; 1989d; 1989e).

12 This may not be so baffling in view of Lacoue-Labarthe's fascinating essay, 'L'echo du sujet', which reads the 'echo' as the trope of the deconstituted, philosophical subject, in which 'the figure is never one' (Lacoue-Labarthe 1979a: 219–303).

13 The potential detriments of judgemental consensus, especially when cast in the language of 'pluralism', are discussed in the different contexts of literary and art criticism by Murray (1984a) and Foster (1985: 13–32).

14 See Van Den Abbeele (1984) for an insightful reading of Le mur de Pacifique.

15 See Kraus's short account, 'Bachelors' (1990), Penley (1989: 57–80), and Iversen (1991).

7

ALLEGORIZING 'CONTENT'
Metaphysical contradictions in the Harrisons' *Lagoon Cycle*

A work of art can become an *element* of the *ideological*, i.e. it can be inserted into the system of relations which constitute the ideological, which reflects in an imaginary relationship the relations that 'men' (i.e. the members of social classes, in our class societies) maintain with the structural relations which constitute their 'conditions of existence'. Perhaps one might even suggest the following proposition, that as the specific function of the work of art is to make *visible* (*donner à voir*), by establishing a distance from it, the reality of the existing ideology (of any one of its forms), the work of art *cannot fail to exercise* a directly ideological effect, that it therefore maintains far closer relations with ideology than any other *object*, and that it is impossible to think the work of art, in its specifically aesthetic existence, without taking into account the privileged relation between it and ideology, i.e. *its direct and inevitable ideological effect*.

(Louis Althusser)

What I believe to be extremely important is not so much the way the artist has reacted to his social position, but the manner in which he has reacted to the situation capitalism has created as far as his activity goes: instead of continuing to produce unifying, reconciling forms, his activity has become a deconstructing one which is necessarily critical. And I would be tempted to say, in spite of my interest in politics, that the best, the most radical critical activity bears on the formal, the most directly plastic aspect of painting, photography or the film, and not so much on the *signified*, be it social or anything else, of the object it is concerned with And this deconstructing activity is a truly radical critical activity for it does not deal with the *signifieds* of things, but with their plastic organization, their signifying organization. It shows that the problem is not so much that of knowing what a given discourse says, but rather how it is disposed.

(Jean-François Lyotard)

To Louis Althusser and Jean-François Lyotard, art plays an implicit role in the exploration and representation of ideology and its signifying effects. The art object helps to make visible the formal structures and relations regulating the ideological fantasies shaping the social conditions of existence. Especially crucial is the contribution of artistic

representation to personal and social incorporations of the visual struc-
tures of the cultural mechanisms of force and power that shape every-
day experiences and institutional forms. These agents of force rely, of
course, on simple representational and rhetorical codes and systems for
their functioning, control, and profit. In displaying such 'conditions of
existence', the art object reflects our dependence on them while describ-
ing and prescribing its own privileged relation to the world of aesthetics
and pleasure on the one hand, commodification, appropriation, and
capitalization on the other.[1] It shows that the political thrust of art may
be 'not so much that of knowing what a given discourse says, but rather
how it is disposed'.

Critics of contemporary art might be struck by the potential usefulness
of these composite remarks by Althusser and Lyotard on the intrinsic
ideological nature of the art object. They could serve, for example, as a
helpful foil for demystifying the critical stress on the 'content' of contem-
porary American art. Imagine, for example, the ideological effect of
juxtaposing these statements with the conceptual 'Introduction' to the
Hirshhorn Museum and Sculpture Garden's tenth anniversary show
Content: A Contemporary Focus 1974–1984:

> The decade 1974–1984 has also witnessed a critical juncture in
> twentieth-century art, identified with a climate of new ideas about
> art and its place in human culture. The central artistic concerns
> have shifted from issues of form – how an object is made and
> perceived, or what defines its style – to those of content – consider-
> ations of why art is made and experienced, and what a work of art
> means or signifies beyond the experience of its formal and stylistic
> ingredients. Metaphysical ideas, social commentary, and use of
> allusion and metaphor – elements that many artists and critics had
> considered inappropriate to art only ten years ago – are now
> essential to the creation and understanding of much contemporary
> art. Content, in a word, has emerged as a central issue of the
> international avant-garde.
>
> (Fox, McClintoc, and Rosenzweig 1984: Introduction)

If positioned alongside this praise of the international avant-garde for
returning art to the praxis of social life, the epigraphs by Lyotard and
Althusser on ideological form might complement the focus on content
evident in the art and criticism of the past (two) decades. For these
epigraphs caution against any tendency to dismiss formalist and struc-
turalist concerns for having little or no ideological effect. They compel
theoreticians of contemporary art to remember what Merleau-Ponty
calls 'the reciprocal action' of form and content underlying not merely
art but also existence (Merleau-Ponty 1964: 148). If reread in this dialogi-
cal context, the composite message of these epigraphs would be a

warning to contemporary critics not to remain too self-confident in their appropriation of 'content' as the panacea, the *pharmakon*, of an earlier art movement stalemated by the formalist residues of modernism.[2] Finally, and most importantly, it would point to recent texts investigating the ideology of avant-gardism itself in terms of both its form *and* its content: an ideology lending itself to the forward drive of progress and teleology, the narcissistic subjectivity of modernism and phallologocentrism, the exploration and exploitation of capitalism, and the elitism of an *esprit de corps* having found a new fountain of youth.[3] To cite the perils of such fast-moving elitism, one need only mention Hirshhorn's uncritical praise of the return of a mixture of social commentary, metaphor, and metaphysics.

By no means do I wish to suggest, however, that such a mixture failed to surface in the Hirshhorn show. For it was almost inevitable that some of the show's most socially concerned artists undercut ideologically sensitive work with self-conscious references to the humanist notions of metaphysics and metaphor that have given shape to the form and content of the phallologocentric tradition. This paradox is especially prominent in the work of two artists included in the Hirshhorn survey of *Content*: Helen Mayer Harrison and Newton Harrison. This artist couple has been collaborating for two decades in the construction of mixed-media commentaries on the natural and urban environment. In undertaking an analysis of their most impressive project, *The Lagoon Cycle*, I hope to foreground the ideological paradox of their reliance on the formal and referential codes of the metaphysical tradition for avant-gardist purposes. Or put in the terms of 'ideological fantasy', I wish to discuss how they allow the more metaphysical aspects of avant-garde form to act on behalf of their critique of commodity culture.

The Lagoon Cycle, which opened at the Herbert F. Johnson Museum of Art, Cornell University, in 1985, and was subsequently exhibited at the Los Angeles County Museum of Art, 1986, documents, represents, critiques, and moves beyond the artists' twelve-year-long socio-ecological experimentation with a Sri Lankan crab, *Scylla serrata*. The artists initially became interested in this crab as a potential international food source capable of being nourished and observed under museum conditions. *The Lagoon Cycle* plots through picture and narrative, form and content, the Harrisons' lengthy, artistic journey. The exhibition of eighty wall-sized, mixed-media panels moves chronologically through the artists' encounters with crab life and its many natural and human parasites. The narrative begins with the artists' trip to Sri Lanka in quest of the crab symbolic of its native culture. The next sequence documents their subsequent scientific experimentation with the somewhat unpredictable crab which they raised in tanks located in their San Diego studio. The narrative then depicts their technocratic experience with the

award of a Sea Grant (the Harrisons are the only artists to receive this funding reserved for established scientists). An elegant photomontage of their simulated lagoon in a capitalist's backyard vividly contrasts adjacent, comic reports in text and image of the Harrisons' difficult exchanges with experts who sought scientific information from the artists. The Harrisons reflect on the surprise, seduction, disappointment, and humor evoked by their rather unexpected acquisition of expertise. The viewer is then presented with a sequence of serious, yet arrogant, proposals, from plans for massive installations of estuarial lagoons on the shores of the poisoned Salton Sea of California to a proposal to flush clean the Salton Sea with salt water transported in canals from the Pacific Ocean. The artistic document concludes with troubling reflections on ecological and ideological responsibility. Its final panels present an apocalyptic dream of the result of mankind's continual displacement of fragile aqua-systems from one poisoned environment to another: great ocean floods catalyzed by the acidic meltdown of the Arctic zone.

This massive installation, hung in seven different spaces especially designed to stimulate 'lagoons', asks its viewer through description and prescription to acknowledge how art and politics always share the site of cultural and representational struggle. As expressed on a panel from the First Lagoon:

> A culture is a cooperative adventure a complex system of shared interrelated beliefs about the nature of reality and causation of values codes of conduct and ethics by which people define themselves collectively and niche themselves individually It is a fragile form not having the duration of oceans or lands with which it is in discourse and upon which it depends for its survival Its constancy is reproduction and change Its stability is always at risk.
>
> (Harrisons 1985: 37)[4]

The Lagoon Cycle plays out the perils of culture by displaying fragile ecological and ethical systems through artistic forms that constantly shift in style, format, aim, and reception. It is the cooperative adventure of the artists, artifacts, and spectators in presenting, performing, and acknowledging the impact of formalist codes on cultural content that lends to *The Lagoon Cycle* an amoebic life of its own. As such, this aesthetic production reinscribes the activities of creation and perception into the ideological dynamics of art, its structure and content: 'We cannot represent this system without representing ourselves' (ibid.: 44). Even when acknowledging its own occasional formalism and frequent narcissism, this unusual exhibition nurtures the viewers' experience of the artistic surrounds of ideological fantasy. The Harrisons' experimental installation marks, italicizes, frames, and presents with

particular rhetorical force the system of art as a psychopolitical, signifying organization.

POLITICIZED FORMS

For us it was a moment
We didn't know it had begun until we
were already in the middle
Then we looked forward and knew how it
should end
but we didn't know how to get there
You could as well say that knowing the ending
we worked backward to what we must have been
to begin it
as forward to what we must become to end it.

(Harrisons 1985: 26)

A postmodern artist or writer is in the position of a philosopher: the text he writes, the work he produces are not in principle governed by preestablished rules . . . Those rules and categories are what the work of art itself is looking for. The artist and the writer, then, are working without rules in order to formulate the rules of what *will have been done.*

(Lyotard 1984: 81)

The Lagoon Cycle opens with a large, handcolored map of the world, framed by the introductory discourse of the Lagoon Maker (Newton Harrison) and the Witness (Helen Mayer Harrison). The viewers *know* themselves to be at the beginning of an artistic cycle designed to mirror the world, of a series of lagoons through which they will move in forward progression. Yet, from the outset, they also find themselves in the unfamiliar time-space of a wonderland, where forward may be backward, where the science of invention lies as much in the realm of dream ('You have entered the space of my dreaming') as it does in the world of art and science. They find themselves, say, much like the reader of *Alice in Wonderland*, in the world of an illustrated book where the pictures are framed by handwritten words or sometimes the words are framed by pictures. Finally, or rather, initially, they *see* the figure of a special, recentered world whose utopic center is San Diego – the home of the artists. This map thus invites the onlookers to traverse the threshold of the First Lagoon at Upouveli, where they join the artist-tourists in grasping for the familiar in the topsy-turvy East/West world of contemporary Sri Lanka.

Representational strategies of appropriating and re-presenting (un)-familiar cultural forms and discourse establish the First Lagoon as a mental and stylistic forerunner of the three to follow – the lagoons documenting the

Harrisons' actual experimentation with the crab, the experiments' evolving relation to their artform, and the artform's attentiveness to a greedy public willing to follow the leads of the cycle in hopes of satisfying its befuddled curiosity. After being grounded by the realistic panels of the map and flag of Sri Lanka (Ceylon), the spectators of the First Lagoon confront a dizzying series of contrasting artistic experimentations. At the far end of the Lagoon (figure 7.1), one of the few remnants of natural beauty in the exhibition, a giant, beautifully handcolored photograph of mangroves resplendent in soft hues of green and brown, follows in artistic triumph the many alienating panels preceding it (figure 7.2). These contain collaged groupings of text which are framed by small, black-and-white tourist photos. These collages hang on the wall beneath panels of text that frame two enlarged and contiguous handcolored photographs of a lagoon. The grace and beauty of these colorful testimonies of natural peace and tranquillity hang in sharp contrast to the tiny 'amateur' photos of adjacent collage that seek desperately to differentiate between the culturally familiar and the exotic.

Highlighting the political impact of photography as a form of colonial expropriation and documentation,[5] the assembled, miniaturized photos border long and fragmented written accounts of the artists' experiences and conversations in Sri Lanka. The narrative depicts the artists as voracious, yet guilty, visitors in a land blessed and besieged by its ambivalent expansion of the tourist industry.[6] These fragments also document the colonial and capitalistic incursions that have weakened the fragile Sri Lankan lagoon system. Standing out is a segment of a military text from the library of the Sri Lanka National Heritage Trust. Composed by the artists in uncharacteristic roman lettering, the early nineteenth-century decree from the colonial Commander-in-Chief and Governor of Ceylon orders the military to breach the lagoon system and eliminate its human caretakers:

GENERAL ORDERS:

Commander-in-Chief & Governor of Ceylon
To Major D. MacDonald Com'ding Officer
Kandyan Provinces 1817–1820

BROWNRIGG ORDERED MAJOR MACDONALD THAT ALL MEN ABOVE 18 SHOULD BE KILLED. ALL HOUSES PULLED-DOWN AND BURNT. AND ALL TREES BEARING FRUITS OF USE TO HUMAN BEINGS, FELLED. ALL GRAIN SHOULD EITHER BE DESTROYED OR CONFISCATED. IRRIGATION TANKS AND CANALS SHOULD BE BREACHED: ALL CATTLE BELONGING TO THE PEOPLE WHICH WERE IN EXCESS OF THE REQUIREMENTS OF THE ARMY SHOULD FORTHWITH BE DESTROYED.

(Harrisons 1985: 36)

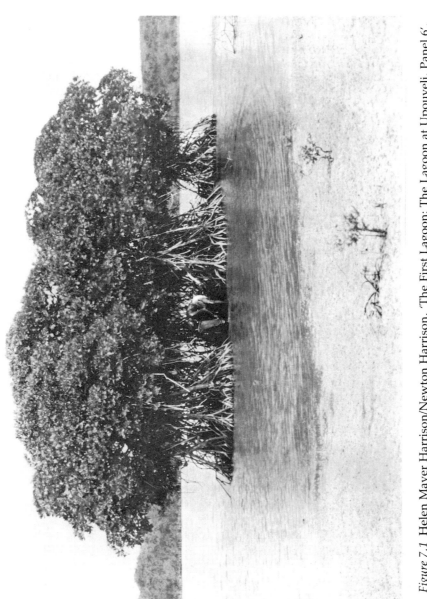

Figure 7.1 Helen Mayer Harrison/Newton Harrison, 'The First Lagoon: The Lagoon at Upouveli, Panel 6', *The Lagoon Cycle.* (Photo: Jon Reis. Courtesy: the artists and Herbert F. Johnson Museum of Art, Cornell University)

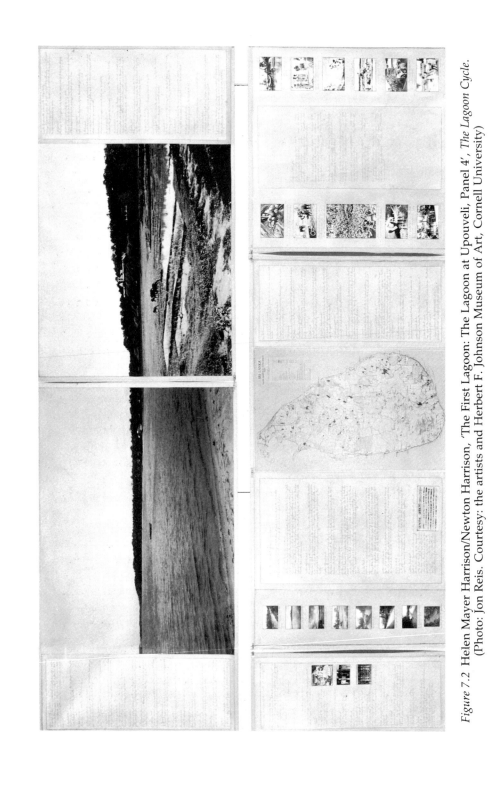

Figure 7.2 Helen Mayer Harrison/Newton Harrison, 'The First Lagoon: The Lagoon at Upouveli, Panel 4', *The Lagoon Cycle*.
(Photo: Jon Reis. Courtesy: the artists and Herbert F. Johnson Museum of Art, Cornell University)

Twice duplicated, on an illustration of the Sri Lankan map and on an adjacent panel of text, this fragment looms large over the entire *Lagoon Cycle*. It heralds the general order of the exhibition's critique of ongoing Occidental complicity with and dependence on signifying systems of violence and destruction.

The apocalyptic end of such destruction is the subject of the Seventh (and last) Lagoon. It depicts the Lagoon Maker's dream of Rings of Fire encircling the coastlines of the Pacific Ocean. Figured as nuclearlike, mushroom clouds collaged on to an 8' × 5'8" mixed-media map of the Western hemisphere, the Rings of Fire fantasize the wider scope and dimension of unilateral aggression since the time of Major MacDonald. This is the fantasy of fire fields and rapid destruction which since have been witnessed by the worldwide television viewers of the Gulf War. The viewer of *The Lagoon Cycle* is faced with an earlier prototype of the aerial display that delighted CNN's spectators of Bush's war. This occurs in the Fourth Lagoon, where proposals for a new estuarial system are collaged to the surface of US Geological Survey maps of the Salton Sea. What aligns these survey maps with the signifying systems of the Gulf conflict, and also indirectly with the European history of Sri Lankan colonialization, is their graphic distribution of land into potential staging areas for the theatre of war: the maps earmark a zone of the Salton Sea for an 'aerial mine laying area' and designate the surrounding Chocolate Mountains for an 'aerial gunnery range'. These militarized sites of an otherwise optimistic Fourth Lagoon, 'On mixing, mapping and territory', illustrate the troubling fact that the mere notion of newly charted utopic zones remains juxtaposed with the militaristic aims of mapping *per se*, objectives made evident not only today by the US Geological Survey but throughout history by the exploits of Occidental colonialization.[7]

That these few, poignant examples might also signify the broader terrain of ideological fantasy is suggested by the exhibition's accounts of the Harrisons' initial shock and subsequent voyeuristic interest in a decline in their crabs' cannibalistic methods of domination and sexual expression. Realizing it to be the monsoon season in Sri Lanka, the artists experimented with their materials to devise a simulated monsoon that resulted in an immediate change of the crabs' behavior:

They began to move around excitedly . . . backing into corners spreading and measuring claws challenging and counterchallenging in groups of two or three After many mock battles the largest male crab ended the dance mounting the backs of the largest female and beginning an elaborate courtship staying on her back and embracing her with her claws even gathering food for her and feeding her . . . The male that had established dominance became known as Top Crab He mated all the

females in the tank thereafter for almost two years We noticed that as his dominance clarified cannibalism reduced.

(Harrisons 1985: 47)

Similar to how the aerial gunnery range serves as a simulated site for 'Top Gun' honors, the artist's simulation of a natural environment of aggression leaves one male in the dominant position of 'Top Crab'. And, conversely, it could be said that the work of the 'Top Crab' is what provides the artists with their subsequent artistic thoughts and production. 'Suppose we adapt ourselves to supply what the crab needs then we become part of the experiment and as we niche ourselves in the system becomes self-nourishing self-cleansing self-adjusting' (Harrisons 1985: 44). In this sense, it is the system sustaining the 'Top Crab' that ends up acting on their behalf. In much the same way, to return to the analogy of the Gulf War, the cinematic fantasy of the 'Top Gun' and his militaristic machineries of simulation are what acted on behalf of the American war enthusiasts caught up in the rhetoric of total domination. Curiously, the economies of 'Top Crab' and 'Top Gun' and their traumatic specters of territorial 'cannibalism' – crab eating weaker crab, superpower eliminating weaker power – all benefit the special interests of Occidental technocratic experimentation. Taken together, these disparate simulations of nature and civilization envelop the facts and realities of global domination in ideological fantasies of visual and physical control. They suggest that the signifying systems and artistic materials of any ecologically based struggle (earth art or petroleum war) will necessarily impinge on – act on behalf of – any subsequent analysis of geographical exploration and political territorialization. These are the simulations, so Žižek might add, of 'fantasy-construction which serves as a support for our "reality" itself: an "illusion" which structures our effective, real social relations and thereby masks some insupportable, real, impossible kernel' (Žižek 1989a: 45).

I want to stress that the 'illusion' of ideological fantasy is as much a manifestation of form – aesthetic, behavioral, psychological – as of content – whether 'Top Crab' or 'Top Gun'. Indeed, the most stimulating and most demystifying aspect of the Harrisons' work might be its continual return to visual and verbal explorations of the politics of form in Western culture. The ideological illusions of form become especially pronounced in view of the artists' experiments with artistic ways of making discourse 'visible', of showing the disposition or configuration of a given discourse. This is particularly effective in the artists' reliance on strategies of collage. One result of their shaping of narrative around the visual patterns of collage and photomontage is that the in-directness and spacing of their dialogue call attention to themselves. The mediating

strategies of collage appeal to the spectator's perception of the plastic organization of the artists' discourse.[8]

But exactly to what degree, to what end? In 'Postmodernism and consumer society', Fredric Jameson claims that one characteristic of collage – *pastiche* – stands out as the distinctive feature of artistic postmodernism:

> in a world in which stylistic innovation is no longer possible, all that is left is to imitate dead styles, to speak through the masks and with the voices of the styles in the imaginary museum. But this means that contemporary or postmodernist art is going to be about art itself in a new kind of way; even more, it means that one of its essential messages will involve the necessary failure of art and the aesthetic, the failure of the new, the imprisonment in the past.
>
> (Jameson 1988: 18)

While not directly countering Jameson, feminist artists and theoreticians might be more inclined to argue that collage empowers their work, thus countering the failure of hegemonic art (figure 6.4). As Linda Nochlin states the case:

> Barbara Kruger, Cindy Sherman, Mary Kelly, and many others are again cutting into the fabric of representation by refusing any kind of simple 'mirroring' of female subjects; they turn to collage, photomontage, self-indexical photography, combinations of texts, images, and objects as ways of calling attention to the production of gender itself – its inscription in the unconscious – a social construction rather than a natural phenomenon.
>
> (Nochlin 1988: 29)[9]

In a very similar way, the Harrisons manipulate collage as a strategy of indirect representation and enunciation. While seriously playing out their art's imprisonment in the traumatic kernels of the past, the Harrisons turn much more to parody than to pastiche in their play with collage. At stake in their work is the re-presentation of social production itself and the re-visioning of the analogical function of art.

In fact, *The Lagoon Cycle* dabbles in the deconstruction of so many procedures of representation that this trait, the exhibition's strength, has been said by some viewers to constitute its flaw. In conversations about the show, I have heard many traditional artists, as well as cultural activists suspicious of its theoretical aims, critique *The Lagoon Cycle* for its elitist posturing. It has been said to upstage the audience by arrogantly thinking on the spectator's behalf and by overwhelming the spectator with too vast a mixture of textual and visual experimentation (this might summarize, I should add, the inescapable danger of any large-scale, conceptual art project, not to mention any attempt to theorize it).[10] But

rather than merely dismiss the criticism of *The Lagoon Cycle*'s posturing, I would like to dwell on the ideology of its form by pursuing the complex interplay of its 'signifying organizations'. Perhaps an economical approach might be to concentrate on the most prominent of such organizations: metaphysics, metaphor, and social commentary.

ALLEGORIES OF METAPHOR

To the theorist, a particularly enigmatic feature of *The Lagoon Cycle* might be the Harrisons' frequent description of their work as 'metaphor'. In dialogue with their other urban ecological projects (such as *Hope in Pasadena*, *A Fortress in Atlanta*, and *Second Chance in San Jose*), this exhibition investigates and visualizes systems of resemblance that enact, as Aristotle writes of metaphor, figural and literal transfers from genus to species or from species to genus (Fyfe 1940: 56–67). It is within such a system of resemblance that the spectators of *The Lagoon Cycle* move from lagoon to ocean, from crab tanks in the artists' studio to museum spaces exhibiting the projects and dialogues of the Lagoon Maker and his Witness. As the Lagoon Maker puts it, 'the tank is part of an experiment and the experiment is a metaphor for a lagoon if the metaphor works the experiment will succeed and the crabs will flourish after all this metaphor is only a representation based on observing a crab in a lagoon and listening to stories' (Harrisons 1985: 44). The appeal of this stress on metaphor stems from the artists' sensitivity to the properties of vastly different cultural systems that 'can be isolated and, consequently exchanged and substituted for each other' (de Man 1979: 151–2). It might even be said that the spectator derives aesthetic pleasure from *The Lagoon Cycle* by responding to the call of such systems of resemblance, by receiving from the artist the 'pleasure of knowledge' that metaphorical thought generates. 'Remember', speaks the Lagoon Maker, 'a metaphor can be a powerful instrument if we believe it if we enact it it will develop a life of its own' (Harrisons 1985: 45).[11] The power of *The Lagoon Cycle* as metaphor lies in the return of a life of its own, in the pervasiveness of its theory of value. At its most metaphorical moments, *The Lagoon Cycle* seems to lend itself to an *a priori* condition of possibility, whether that involves the experimental (material) recovery of untainted ecosystems or the aesthetic (metaphysical) retreat from the psychopolitical dangers of capitalistic expansionism.

But just as the exhibition opens on a compromising note, by recentering the universe in San Diego, the Lagoon Maker's macho phantasm of infinitely exchangeable ecosystems grounds itself in the same transcendental aesthetic of metaphor which was subject to acute theoretical critique over the fifteen-year gestation period of *The Lagoon Cycle*. Deconstructive analyses of the fallacy of belief in the transcendental

promise of metaphor dominated the period's theoretical discussions of language and rhetoric. One of the most provocatively precise analyses of the problem was undertaken by Paul de Man:

> Metaphor overlooks the fictional, textual element in the nature of the entity it connotes. It assumes a world in which intra- and extra-textual events, literal and figural forms of language, can be distinguished, a world in which the literal and the figural are properties that can be isolated and, consequently, exchanged and substituted for each other. This is an error, although it can be said that no language would be possible without this error.
>
> (de Man 1979: 151–2)

As I have already noted, there is no challenging the Lagoon Maker's penchant for metaphorical substitution. 'Suppose we adapt ourselves to supply what the crab needs then we become part of the experiment and as we niche ourselves in the system becomes self-nourishing self-cleansing self-adjusting then the metaphor for nature becomes more complete and we cannot represent this system without representing ourselves' (Harrisons 1985: 44). Still, the fascinating strategy of *The Lagoon Cycle* is to reveal, *to make visible*, such commonplaces for what they are. Although the Harrisons prefer to label their work 'metaphor', their visual and verbal narratives tend to undercut the transcendental properties of this form.

One example stands out. Before the Lagoon Maker even has a chance to expound on his scientific ambitions, the First Lagoon closes with the figure of the show's transcendental referent: a blown up cut-out of a crab. This Top Crab resurfaces repeatedly throughout the ensuing panels, often poised outside of the crab tanks, which enclose smaller cartoons of its own literal, 'civilized' representation, or else collaged over literal, textual discussions of its own properties (figure 7.3). But more like the Cheshire Cat of *Alice in Wonderland* than the Top Gun of the aerial show, the oversized and alluring figure of the crab stands forth as an ironic, peripheral observer reminding the spectators that side-vision or another point of view always displaces the primacy of metaphor. Rather than seducing the viewers to forget fiction, this transcendental character reminds them that metaphor occludes its own ideologically coded structures by isolating and substituting intra- and extra-textual events.

It is almost as if the Witness assumes the voice of the smirking crab when she dialogues with the Lagoon Maker: *how serious do you want to become about this lagoon that you're playing with* (Harrisons 1985: 61). The opinionated voice of the Witness surfaces frequently throughout the show as the visible textual figure of differentiation, as the double of the parodic crab who seems to caution us about the serious, figural

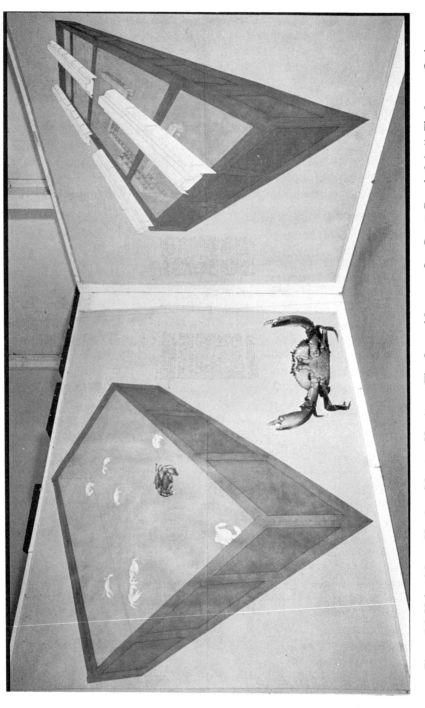

Figure 7.3 Helen Mayer Harrison/Newton Harrison, 'The Second Lagoon: Sea Grant, Panels 3 & 4', *The Lagoon Cycle.* (Photo: Jon Reis. Courtesy: the artists and Herbert F. Johnson Museum of Art, Cornell University)

implications of accepting the wonderland of metaphor at top value: *If the experiment isolates parts of a real lagoon and places them in a tank then the metaphor also refers to alienation to violation to breaking the integrity of a real system* (Harrisons 1985: 44). Here, as with the show's many demystifications of militaristic violence, the Witness inscribes metaphor within a figural economy of differentiation, alienation, and violation. Through the exhibition's figures and voices of the difference, *The Lagoon Cycle* works as an allegory of the metaphor it pretends to be. As such an allegorical representation of metaphor, the *Cycle* points to the unreliability of the Lagoon Maker's desire to build a self-sufficient, integral system as the aim of metaphor. In short, allegory here flushes out the Lagoon Maker's unfulfilling transcendental impulses. It leads, to cite de Man, 'towards a meaning that diverges from the initial meaning to the point of foreclosing its manifestation' (de Man 1979: 75).[12]

FROM INDIRECT DISCOURSE TO LINE AND GRID

When read as an allegory of the closure of metaphor, *The Lagoon Cycle* deconstructs many other discursive mixtures of text and image suitable to history's hegemonic Lagoon Makers. In this context, the form of speech dominating the texts of the first half of *The Lagoon Cycle* can be seen to foreground not-so-subtle traces of colonial behavior. Particularly in the First Lagoon's fragmented reports of the artists' conversations with a variety of Sri Lankan interlocutors, but throughout the early part of the *Cycle*, the text relies on forms of *indirect discourse*:

> *A friend said*
> *Even though our population has doubled in the last years*
> *we've had twice this many people before in our history*
> *and no one went hungry*
> *A student said*
> *Lumbering is destroying the rain forest and ruining the*
> *ecology Many of our trees are teak and mahogany*
> *and it seems like we're exporting our forests*
>
> *A hotel guest said proudly*
> *Our government is founded on the British model*
> *A shopkeeper said*
> *When the hotels serve fish and crab no one else can get*
> *any.*
>
> <div align="right">(Harrisons 1985: 35)</div>

Especially when appearing in repetitive sequences, indirect discourse automatically signals the alienating re-presentation of discourse through narrative reappropriation. Just as these words are inscribed in a visual

collage, their in-directness and their spacing demand that the spectator attend to the method of their assemblage.

On a linguistic level, this strategy of indirect representation has been analyzed by Mikhail Bakhtin (Vološinov 1973: 115–40) to be ideologically complex. On one level, Bakhtin suggests that indirect discourse functions like collage: it should signal to the auditor the enunciation of an *Other* subject. Yet, Bakhtin's analysis underscores the allegorical complexity of *The Lagoon Cycle* by suggesting that indirect discourse works on a figural level to assimilate the stylistic and compositional specificity of the Other. Indirect discourse effaces Otherness by associating it with the narrator's particular syntactic, stylistic, and compositional unicity. Displaced by this process is the (im)mediacy of the discourse of the Other, including all emotive and affective elements. In this context, the indirect discourse of *The Lagoon Cycle* might be lamented as a form of enunciation sustaining strategies of cultural appropriation (even the difference in content between the texts of the Lagoon Maker and the Witness can be said to be effaced, in the first half of the *Cycle*, by the constancy of the indirect discourse).

In light of an allegorical reading, however, such in-directness can also be said to reveal and acknowledge the artists' symbolic remove from any possible ethnographic purity. Most significantly, it indicates that the performative – formal and rhetorical – structures of ecological art, like those of cultural and symbolic anthropology, are necessarily figural. Placing into question any metaphysical assumptions about the artistic subject-matter's presence and immediacy, indirect discourse reinscribes ethnographic enterprises in the realm of the fictional.[13] It thus can be understood to make visible the interrelationship of the literal and figural re-presentational forms of language in *The Lagoon Cycle*.

Contributing even further to an understanding of the mixed modes of enunciation in the Harrisons' work, Bakhtin elaborates on indirect discourse by citing an analogical structure in art:

> We may call this first direction in which the dynamism of the interorientation between reporting and reported speech moves the *linear style* [*der lineare Stil*] of speech reporting (borrowing the term from Wölfflin's study of art). The basic tendency of the linear style is to construct clear-cut, external contours for reported speech, whose own internal individuality is minimized. Wherever the entire context displays a complete stylistic homogeneity . . . the grammatical and compositional manipulation of reported speech achieves a maximal compactness and plastic relief.
>
> (Vološinov 1973: 120)

When not reading linear narratives framed in indirect discourse, viewers of the first half of *The Lagoon Cycle* witness an art form appearing to valorize maximal compactness and exterior contour. The images of crab

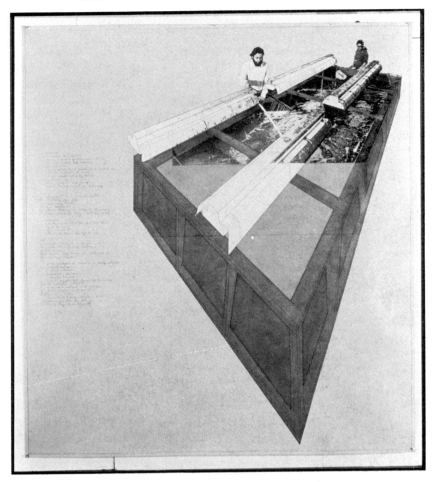

Figure 7.4 Helen Mayer Harrison/Newton Harrison, 'The Second Lagoon: Sea Grant, Panel 2', *The Lagoon Cycle*. (Photo: Jon Reis. Courtesy: the artists and Herbert F. Johnson Museum of Art, Cornell University)

tanks in the Second and Third Lagoons are highly graphic, almost designerly, in their combination of collage and drawing. Rendered in two-point perspective, the pleasing graphic plasticity of these tanks gives definition to their exterior form. This graphic clarity of the exterior walls of the tanks lends itself to the expropriational aims of the scientific Lagoon Maker. This is because it tends to minimize the complete contrast in content of the crab tanks in Panel 1 (figure 7.4) and Panel 2 (figure 7.5) of the Second Lagoon. Whereas Panel 2 depicts that artists at work over *their* tank's watery surface, Panel 1 displays a colored photo of a Sri Lankan fisherman in *his* Lagoon. While the contents of these two

223

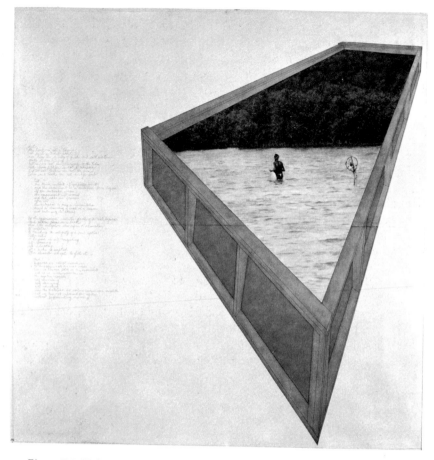

Figure 7.5 Helen Mayer Harrison/Newton Harrison, 'The Second Lagoon:
Sea Grant, Panel 1', *The Lagoon Cycle*. (Photo: Jon Reis. Courtesy: the artists
and Herbert F. Johnson Museum of Art, Cornell University)

panels juxtapose contrasting organizational systems (Eastern/Western,
native/foreign, natural/civilized), their differences are diminished by the
spectacular framing techniques common to both panels. Both are domi-
nated by large angular tanks whose graphic clarity defines and contains
the contrasting aquatic cultures within. Both panels also portray the
artists' labored manipulation of the different watery surfaces. The artists'
literal work over the crab tank of Panel 2 contrasts with their figural
presence in Panel 1, which features their benevolent gesture of offsetting
the Sri Lankan heat with a collaged fan that cools the native fisherman.
The combined framework of the artists' exterior (colonial) manipulation
of the aquatic system and the visually dominating contours of the tanks

enact what Derrida calls 'the violence of the framing . . . which, by introducing the *bord*, does violence to the inside of the system and twists its proper articulations out of shape' (Derrida 1978b: 69).[14]

As if foreshadowing how sharp exterior line reduces the difference of interior content to the same, the Witness speaks up in Panel 1, *But the tank is not a lagoon nor is it a tidal pond* (Harrisons 1985: 44). However, when the alterable behavior of the crabs forces this same issue in the Second Lagoon's fourth Panel – 'One day we noticed the tanks were very quiet All movement had ceased Search behavior ceased Challenge behavior ceased No crabs were visible' (Harrisons 1985: 48) – both the Witness and the Lagoon Maker invent sameness in the face of difference. 'We thought of tangles of mangrove roots In the absence of mud bottoms or root tangles we began to invent an infinity of hiding places as best we could with cinderblocks from the lumberyard' (Harrisons 1985: 48). While the artists could just have well experimented with tangled forms and obscure shapes to simulate the natural lagoon, they turn, instead, to the linearity and grid of the cinderblock. As a result, the grid system forming and shaping the exterior of the tank now pervades the interior space as well: the shapes and patches of color that Wölfflin attributes to 'painterly style' – the stylistic corollary of mud bottoms and root tangles – give way to outlines, edges, and linear boundaries (Wölfflin 1950: 18–72).[15]

Effectively neutralizing the colors of differentiation, this repetitious dependency on line and grid reaches its peak in the Third Lagoon, in two panels marking the allegorical turning-point of the *Cycle*. Panel 4 portrays a series of three gridded tanks, receding in perspective and appearance from brilliant translucency to shimmering opacity (figure 7.6). The accompanying text explains the purpose of the uniform, interior grids that seem to imprison individual crabs: 'He was from Sea Grant . . . if your crab can grow from an ounce to a pound in nine months in an open-tank environment think how much faster it could grow in a totally closed environment like the lobsters with one square foot per crab The restricted movement will conserve calories while permitting surveillance' (Harrisons 1985: 59). Sea Grant's ultimate solution for production and observation (reminiscent of Bentham's Panopticon) is the reduction of all space and shape to the grid, to the cell, to the fixed object. As if recalling the specter of the historical avant-garde, so taken as it was by the form and visibility of the grid, Panel 4 collapses the spatiality of the natural lagoon on to the bonded surface of a clearly delineated commodity.[16]

Panel 6 responds to this proposal by effacing the forbidding grids of the three tanks (figure 7.7). Instead of witnessing crabs entrapped by line and contour, the spectators stand bedazzled in front of a poignant statement of deferral through difference. The tanks' linear surfaces are replaced by painterly representations of natural brilliance and total

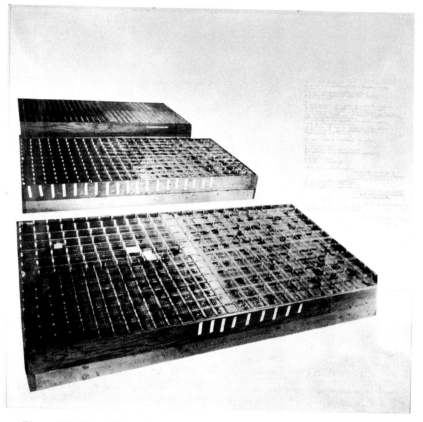

Figure 7.6 Helen Mayer Harrison/Newton Harrison, 'The Third Lagoon:
The House of Crabs, Panel 4', *The Lagoon Cycle*. (Photo: Jon Reis.
Courtesy: the artists and Herbert F. Johnson Museum of Art, Cornell University)

opacity. This is an opacity repeated from the adjacent Panel 5, which
re-presents earlier depictions in the First and Second Lagoons of the
alluringly mysterious surface of the natural Sri Lankan waters.[17] It is
in this panel, moreover, that the Lagoon Maker and the Witness join
in mutual acknowledgement of the allegorical complexity of their
project:

> *Is it worth forgetting what he said*
> > He is not so wrong to suggest that we work with
> > containers and play within boundaries
> > but his choices are peculiarly inflexible
> > and oddly serious
> *And he has frozen his boundaries*
> *leaving no room for flow or chance*
> *or even a modest ambiguity*

226

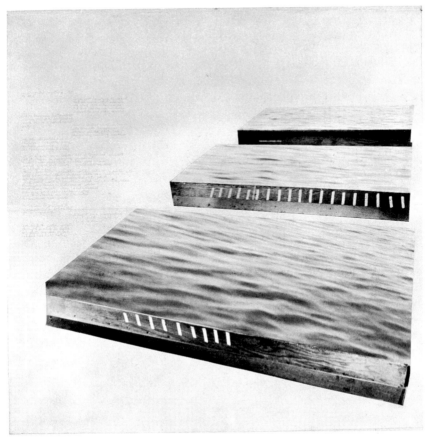

Figure 7.7 Helen Mayer Harrison/Newton Harrison, 'The Third Lagoon:
The House of Crabs, Panel 6', *The Lagoon Cycle*. (Photo: Jon Reis.
Courtesy: the artists and Herbert F. Johnson Museum of Art, Cornell University)

Now a lagoon is a container with flexible
boundaries
wherein all the parts are continually restating
themselves
and continually reestablishing relationships

(Harrisons 1985: 61)

From this moment on, after both the Witness and the Lagoon Maker
openly embrace the fundamental roles that fictionality and modest
ambiguities play in their project, the stakes of *The Lagoon Cycle* shift from
ethnographic report and scientific experimentation governed by pre-
established rules to the artistic re-creation and political formulation of
the ideological principals of what *will have been done*.

227

IMAGE-ACTION

Perhaps the most remarkable trait of the Fourth through Seventh Lagoons is their allegorical reorientation of the grid system. This occurs through further artistic play with the spatial and figural relations of text and image. Panel 1 of the Fourth Lagoon, 'On mixing, mapping, and territory', initiates the fascinating performance of the panels to follow. The artists reposition the written text so that it no longer stands as either the vertical frame of its accompanying collage or the conventional textual coda of the museum picture. Instead of demarcating the border of the image, the text is written directly over it so as to confuse further the distinction between writing and drawing. While the earlier visions of text establish writing as the frame of the 'visible', as constituting the metaphorical truth of visual experimentation, textuality now shares the status of the 'painterly' image as potentially 'readable', as something which plastic presentation makes both translucent and opaque, both literal and figural. Similarly, the restatement of artistic form as both written text and painterly image displaces the 'visibility' of sharp line and translucent grid with the flexible boundaries of ambiguous systems (reflective of the artists' presentation of writing in their own cursive scrawls instead of the conventional graphic type of the museum).

In many important ways, simple improvisations with discursive presentation signal the transformation of the activity of viewing and reading for both the artists and the spectators of *The Lagoon Cycle*. Especially toward the end of the installation, the viewer experiences physiological weariness and optical difficulty in reading the artists' script, which is inscribed in the Sixth Lagoon very faintly on the brownish surfaces of maps disfigured to highlight the smallest branches of the Colorado River water system. Here the artists' almost obsessional blend of personalized text and miniaturized detail seems to address both the crisis of aqua-ecology and the fragility of their own system of artistic presentation: both are hard to see, both are difficult to decipher, both are tiring to face. But just as they both linger throughout *The Lagoon Cycle* on the same fragile (descriptive) support, they project the same urgent (prescriptive) interpellation:

> Pay attention to where the waters are
> willed to flow
> *Pay attention to the flow of waters and*
> *the mixing of salts*
> Pay attention to the flow of waters and
> the mixing with the earths
> *Attend to the integrity of the discourse*
> *between earth and water the watershed*
> *is an outcome*

Pay attention to the discourse between
earth water and men interruption
is an outcome.

<div align="right">(Harrisons 1985: 82)</div>

Here the artwork insists with acerbic force that the construction of the aquatic commodity is the Thing. Spectators attend to how juxtapositions of aqua text and image determine the ideological fantasies governing artistic action, critical discourse, and their ecological results. And just in case the delivery of this message has remained too subtle, the Sixth Lagoon on 'Metaphor and Discourse' reveals even more openly the inevitable ideological effect of its delicate, sometimes ruptured strategies of presentation:

Pay attention to the meaning of the nature
of such discourse and the nature of the
meaning of interruption After all
discourse is a fragile transitory form
an improvisation of sorts
 And anyone may divert a discourse of any
 kind into another direction if they do not
 value its present state
Pay attention to changes of state.

<div align="right">(Harrisons 1985: 82)</div>

Ultimately, *The Lagoon Cycle* prescribes attentiveness – attentiveness to the changes of its own discourse. It calls upon the viewer to take on the conceptual interruptions of its own transitory forms.

When *The Lagoon Cycle* does not literally speak of interruption, it depicts it through improvisational forms of shape and sight. In the latter half of the show, the spectators join the artists in re-viewing sequence after sequence of aerial maps whose recurrence alone numbs, perhaps even bores, the viewers ravenous for ocular titillation. The ideological effect of the visual repetition of these latitudinal and longitudinal grids is not, as we might desire, to bolster confidence in the cartographic tradition or to enhance the viewers' belief in metaphysical overview or omniscience. Rather, these lagoons made up only of variations on an aerial theme elicit a realization of the transitory form of vision and cartography. The artists themselves tell how the shape and state of their aerial photos of the dams along the Colorado River motivated them to construct these images in a non-sequential 8' x 4' collage (Panel 3, the Sixth Lagoon) (figure 7.8). Their initial efforts to reassemble the photographs generated unusual perspectives on damming and mapping as well as, in the Harrisons' words, 'a new form of drawing'. The result is the regeneration of frozen movement, from dammed river to ever shifting photo-collage.[18]

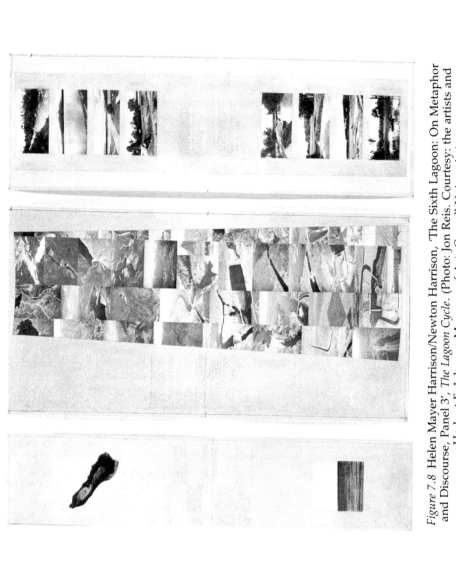

Figure 7.8 Helen Mayer Harrison/Newton Harrison, 'The Sixth Lagoon: On Metaphor and Discourse, Panel 3', *The Lagoon Cycle*. (Photo: Jon Reis. Courtesy: the artists and Herbert F. Johnson Museum of Art, Cornell University)

The broad aesthetic implications of these moving images become particularly evident in view of *The Lagoon Cycle*'s kinship with experimental filmic production, reception, and apperception. The *Lagoon* panels take on, in this context, an Other aspect of the pictorial, that of the film and video screen, whose montaged images are brought doubly to life by the sometimes gazing, sometimes reading eyes of the desirous spectator. Calling to mind the many experimentations of contemporary performance with the visual effects of film and video, *The Lagoon Cycle* transforms its spectators into moving eyeballs.[19] Assuming the movements of ocular machines, the viewers shift from deep shot to close-up to take in the different planes of text and image, and often pivot and spin through individual Lagoons in the wake of panels hung out of linear, chronological sequence. The Harrisons themselves have performed *The Lagoon Cycle* by reading aloud fragments of the conversations between the Lagoon Maker and the Witness. In a performance at Cornell's Johnson Museum, the artists skipped over entire segments of the narrative in parodic and impromptu fashion. Especially in performance, the Harrisons highlight the importance of the spectators' bodily motion in becoming the show. Visitors to the installation at Cornell's Johnson Museum could follow a similar aural performance by walking through the exhibit with a cassette recording of the artists' arbitrary choice of readings. Whether live or recorded, the Harrisons establish the convention of asking their spectators to move through the show as if at the controls of a video cassette recorder, sometimes moving ahead in fast forward, sometimes resting on pause, and other times rewinding to do double takes of edited or fragmented sequences. Important to this show, then, is not so much the individual frame as the relation of the single panel to the images in all seven Lagoons, as well as the movement between frames, the interrelation of the panels *and* intervals to one another and their spectators. Through modulations of sight, focus, and perspective, the viewers come to simulate something like a cinematic system of museum representation. Their inconstant spectatorial movements attest, moreover, to the impossible struggle of the signifying system to keep and maintain watch over a performance of changing perspectives and aural tests.[20] Precisely this relation is said by Laclau and Mouffe to lie at the heart of the ideological:

> it is not the poverty of signifieds but, on the contrary, polysemy that disarticulates a discursive structure. That is what establishes the overdetermined, symbolic dimension of every social identity. Society never manages to be identical to itself, as every nodal point is constituted within an intertextuality that overflows it.
>
> (Laclau and Mouffe 1985: 113)

Such an overflow of filmic movement is typical of the *The Lagoon*

Cycle's imagery as well as its reception. This becomes most visibly evident when both artists and viewers tilt and shift during an exciting visual succession of text and image in the Fifth Lagoon, the sequence concerning the Lagoon Maker's fantasy of cleansing the Salton Sea (figure 7.9). In manipulating a hand-held photograph of the Salton Sea in order to achieve a better view, the Lagoon Maker suddenly *sees*, *reads* the image for what it allegorically represents: 'As I tipped the map in another direction looking at the Salton Sea in relationship to Baja and the mainland and the gulf an image emerged of the Salton Sea as a diseased bladder' (Harrisons 1985: 78). Here, movement of mind and body doubles as the object of artistic representation: the flexible act of interpretation generates the tipping of the art object, which is to say that the tipping of the art object generates the flexible act of interpretation. Such an interpretive tip also has its corollary in cinematic movement. For it corresponds to the cinematic motion of 'action-image' analyzed by Gilles Deleuze in his theorization of Bergson:

> This is therefore the second avatar of the movement-image: it becomes *action-image*. One passes imperceptibly from perception to action. The operation under consideration is no longer elimination, selection or framing, but the incurving of the universe, which simultaneously causes the virtual action of things on us and our possible action on things.
>
> (Deleuze 1985: 65)

Virtual action as a sort of empowered criticality – something like this is certainly at work in the Harrisons' analogical turning of the Salton Sea into diseased bladder.

In sensitizing its viewers to their own reciprocal responsibilities as filmic producers, *The Lagoon Cycle* taps into the enigmatic relations of formal artistic structure and social content. It graphically reveals the influence of form on social action and policy while reminding its artists and spectators of the uncertain possibilities of their reactions to repressive, metaphysical conventions of form. Regardless of *The Lagoon Cycle's* pervasive narcissism and blatant self-righteousness (a colonial attitude it cannot quite shake), this exhibition provides its viewers with the naked perception of the incomplete material structures on which they have been nurtured and through which they are constituted. By emphasizing the frames of performance always underlying representation, the combined contours and tangles of the show's action-images return artistic practice to the signifying systems of its untraceable limits: the ideological fantasies regulating social reality.

So it goes that the spectator of *The Lagoon Cycle* exits this show mindful of the libidinal resonance of its dreamy content:

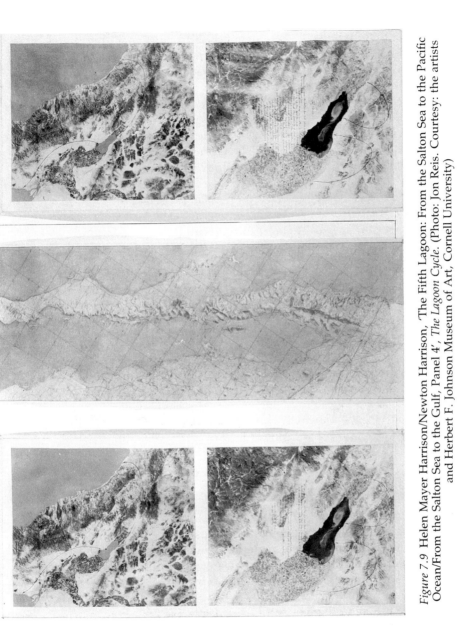

Figure 7.9 Helen Mayer Harrison/Newton Harrison, 'The Fifth Lagoon: From the Salton Sea to the Pacific Ocean/From the Salton Sea to the Gulf, Panel 4', *The Lagoon Cycle*. (Photo: Jon Reis. Courtesy: the artists and Herbert F. Johnson Museum of Art, Cornell University)

Pay attention to the state of belief
 Pay attention to the belief stated
Pay attention to the flow of belief and the willing of desire
 Pay attention to the flow of belief
 and the enacting of desire
Pay attention to the system upon which desire is enacted
and the system that generates desire.

(Harrisons 1985: 88)

NOTES

1 In embracing Althusser's argument, Thomas E. Lewis cautions against any tendency to privilege aesthetics: 'Marxist theory, therefore, should dispense with distinctions between the "aesthetic effect" and the "ideological effect". Maintaining this distinction fosters a reductive view of ideology and impedes a rigorously historical understanding of the plurality of literary function' (Lewis 1983: 4–16). An uncritical appropriation of Althusser might also diminish understanding of what Foster (1986) and McNamara (1992) discuss as the heterogeneity of art as commodity fetishism.

2 Burke (1969, 1973) and Girard (1977) discuss art's curative power as *pharmakon* in the context of their well-known theories of the scapegoat. But in 'Plato's pharmacy', Derrida (1981: 63–171) analyzes the illusory nature of any such cure, entrapped as it is within the larger world picture of an equally illusory metaphysics. Murray (1977) discusses the similar metaphysical entrapment of Burke's fascinating texts.

3 See Lyotard (1984a) and 'Answering the question: what is postmodernism?', an appendix printed only in the American edition of *The Postmodern Condition* (1984); Hadjinicolaou (1982); Krauss (1981); Guilbaut (1983); Bürger (1984); Murray (1984b); Mulvey (1989: 11–26); Huyssen (1986: 160–221); Penley (1989: 3–37); Bois (1991); Graver (1992); McNamera (1992).

4 The exhibition of *The Lagoon Cycle* was organized by Thomas W. Leavitt and Penny Bealle for the Herbert F. Johnson Museum of Art, Cornell University, March 23 – June 2, 1985. All citations of *The Lagoon Cycle* are from the catalogue, which notes that 'because the Harrisons continually revise the text for performance, the text presented here occasionally differs from the version on the image'; the text of the Lagoon Maker is in roman, that of the Witness is in italics.

5 On photography's complicity in the procedures of colonization, see Benjamin (1969: 217–51; 1971); Lyotard (1973); Owens (1983); Burgin (1982); Tagg (1988); Copjec (1989b). That painting can also have a direct political impact as a practice of colonial appropriation is evidenced by the rumor that Sri Lankan activists broke into the Johnson Museum during the exhibition and removed the panel of the Sri Lankan flag, only to abandon it outside while fleeing security forces.

6 For theoretical analyses of the ideological complexities of tourism, see MacCannell (1989); Van den Abbeele (1980); Frow (1991).

7 Michel de Certeau opens his *Lagoon Cycle* catalogue essay (1985) with interesting reflections on the sociopolitical history of cartography. Lyotard (1979) dwells on similar points in *Le mur de Pacifique*, a critical fiction that resembles *The Lagoon Cycle* in recentering the world in San Diego. Marin (1984) engages

in an elaborate discussion of the ideology of utopia as well as the epistemo-
logy of cartography. And Virilio (1989) discusses modern cartography as a
military procedure influenced by developments in film and video.

8 On the theory of collage, see Groupe Mu (1978); Plottel (1983), and Ulmer's
overview of collage's relation to poststructural praxis in Foster (1983: 83–110).

9 Various feminist collage strategies are documented in Parker and Pollock
(1987); Linker (1984b); Kolbowski (1984); New York Chapter of the Women's
Caucus for Art (1982).

10 On this note, Haacke (1985) suggests that one strategy for the wider accessi-
bility of political art is to minimize text, 'the less text, the more you have a
chance to make it "juicy".' But in the same interview he acknowledges the
failure of even his short, juicy work to appeal to an uninitiated audience.

11 In 'White mythology', Derrida discusses the lure of metaphor as 'the pleas-
ure of knowing, of learning by resemblance, of recognizing the same' (Der-
rida 1982: 238). The complex relations of narrative, metaphor, and the
pleasure of knowledge are developed with particular sensitivity by Marin
(1977; 1978).

12 De Man also stresses that allegorical narratives always tell the ethical story of
the impossibility of 'correct' referential readings, of the impossibility of
'literal' scientific report: 'In the allegory of unreadability, the imperatives of
truth and falsehood oppose the narrative syntax and manifest themselves at
its expense We call this shift in economy *ethical*, since it indeed involves
a displacement from *pathos* to *ethos*. Allegories are always ethical, the term
ethical designating the structural interference of two distinct value systems'
(de Man 1979: 205–6)

13 Boon (1982) elaborates on the literary qualities of symbolic anthropology.

14 In making this point in the context of a reading of Kant's *Critique of Pure
Judgement*, Derrida positions 'framing' as the conceptual framework of the
philosophy of art ('before and after Kant'): 'The reflective operation . . . in
writing on the frame (that is – writing/written on the frame): a general law
which is no longer a mechanical or a teleological law of nature, of the accord
or the harmony of the faculties (etc.), but a certain repeated dislocation, a
regulated, irrepressible dislocation, which makes the frame in general crack,
undoes it at the corners in its quoins and joints, turns its internal limit into an
external limit, takes its thickness into account, makes us see the picture from
the side of the canvas or the wood, etc.' (Derrida 1978b: 73–4).

15 The tensions between the painterly and the graphic might be remembered as
a contemporary analogue of the neoclassical French color/line debates dis-
cussed by Teyssèdre (1957) and Alpers (1976). In *Theatrical Legitimation*
(Murray 1987: 174–81), I analyze how this distinction also surfaced in neo-
classical French dramatic theory.

16 In 'The originality of the avant-garde', Rosalind Krauss contextualizes the
practical and conceptual importance of the grid for the art of the historical
avant-garde (Krauss 1985: 151–70). McNamara (1992) counters Krauss to
emphasize the productive, socialist implications of the use of the grid by the
historical avant-garde. More in keeping with McNamara's recent argument,
Barthes discusses the resurgence of the grid in pop art as a kind of obsession
'at once consecrating the raw material (grain of the paper in Twombly's
work) and the mechanization of reproduction (micro-pattern of the computer
portraits)' (Barthes 1985: 203).

17 An interesting feature of these grids rendered opaque is that they resemble
in effect the earlier Ptolemiac grid distinguished by Alpers from the

Renaissance perspective grid: 'There the issue was not that of surveying but rather how to project or, better, transform part of the spherical globe onto a flat surface. What is called a projection in this cartographic context is never visualized by placing a plane between the geographer and the earth, but rather by transforming, mathematically, the sphere to plane. Although the grid that Ptolemy proposed, and those that Mercator later imposed, share the mathematical uniformity of the Renaissance perspective grid, they do not share the positioned viewer, the frame, and the definition of the picture as a window through which an external viewer looks' (Alpers 1983: 138).

18 While the Harrisons' manipulation of photo-collage constitutes a 'strategic' form of drawing whose political aims may be different from those of other artists, it is hardly 'new'. Similar experimentations have been commonplace in the work of mixed-media artists for over two decades. Closely akin to the Harrisons' ecological and architectural sensibilities are photo-collages by artists such as Heizer, Christo, and Matta-Clark.

19 The catalogue of *New Performance on Film and Video* (Herskowitz 1985), an Ithaca, NY, show curated by Richard Herskowitz in 1985, documents the history of experiments in contemporary performance with film and video, from Joseph Chaikin, Richard Foreman, and Meredith Monk to Eleanor Antin, Stuart Sherman, and Pina Bausch.

20 In a stunning essay on 'Convulsive identity', Foster (1991) traces a similar 'phantasmatic simulacrum' in the work of surrealism.

8

ON THE LINE

When a picture is hung so that its
center
is understood
to rest
on the level with
'the eye'.

LINE/PICTURE/CENTER/EYE:

an exhibitionist phantasm
of the loaded Occidental
HIStory of the line.

OFF LINE/CROOKED LINE/OUT
OF LINE:
a cultural reality of the
performative excess of the
multicultural differend.

what's your line?

THE EYE LINE:
The BONDAGE of ART SITE to the
SIGHT OF PERSPECTIVE cuts across
the disparate boundaries of post-
medieval cultures. Recall the
fetishistic homage paid to
Renaissance appropriations of
Vitruvius, the symbolic
machineries of sovereignty (from
the rack to the triumphal arch),
the eye/I of Self, the French neo-
classical line, Hogarth's line of
beauty – the curve, the Mind/Body
split, Schinkel's Altes Museum and
the discursive system of museum
representation, the apparatus of
the camera and the ideology of the

ORNAMENTAL LINES:
The lure of ART SURFACE and the
FLUX of BORDERING LINES.
Imagine lining –
to fill, to cram, to stuff –
the zones of perspective,
with delightful mixtures of
veils, drapes, clouds,
mirrors, reflections, glitters,
collagesmontages,
 jump cuts,
 flying wedges,
scratches, squiggles,
 scrawls,
 hallucinating metonymies,
 sidelines, *underlines*,
 palimpsests, traces,

gaze, the Global Village and the multinational news media, the museum tour on home video. How can we appropriate the cultural media to refigure its bondage to 'the Iye'?

borders, margins,
 textures, touchessurfaces,
skins, vessels,
 folds, fluids,
 organs,
 phantoms.

what's your line?

CENTERING MACHINES:
The AGE of the WORLD PICTURE, the Age of MECHANICAL REPRO-DUCTION, the NEWER AGE OF SILICON SIMULATION.
Remember the long HIStory of the symbolic manipulation of machines of perspective: memory theatre, camera lucida, telescope, trompe-l'oeil, camera obscura, perspective stage, anamorphosis, diorama, frame, camera, zoom, portable video, 3-D graphic software. From the navigational compass to the cartographic grids of rail, air, and space, the geometric tools of COLONIAL movement and CAPITALISTIC expansion remain in caucasion, male hands. How to represent the 'end' of this line?

DECENTERING DEVICES:
Celebrate the excess of the performative celebration of never-ending lines, political lines, movie lines, theory lines phrases, colors, shapes, textures, performances, carnivals, manifestations, agit-prop, ventriloquism, rhetoric, performance art, theatre, sound, touch, gesture, glance, fantasy, eroticism, desire, fear, fright, alienation, doubt . . . sometimes even appropriating the centering machines to disrupt the benevolent lines of colonialism, capitalism, sexism, and racism.

what's your line?

FORMAL LINES
Mix GEOMETRY and OPTICS with the line of UNDERSTANDING to produce vestiges of the discourse of SELF: HIS empirical AUTHORITY, HIS Cartesian SUBJECTIVITY, HIS psychoanalytic INSIGHT, HIS architectonic DRAUGHTSMAN-SHIP, HIS narrative PROGRESSION. From the line of reason, sharpness, rigor, disciplined space, and spatial

SUBLINES
Mix MOVEMENT and FEELING with the lines of IMAGINATION to discover the inconstant pictures of playful OTHERNESS: celebration, collaboration, carousal, arousal, immoderation, dissipation, affliction, conviction, depiction, description

discipline, how might a rigorous evaluation of logocentric control and phallocentric voyeurism acquire theoretical play? How 'TO GIVE LINE': to allow full play, scope, or latitude?

(diminishing prescription?), reception, perception, affliction, sorrow, pain, torment, expectation, arrestation, and all of the colors in-between.

what's your line?

DIVIDING LINES:
Borderlines, property lines, bloodlines, credit lines, specialty lines, policy lines, deadlines, battle lines, gender lines, color lines. How might film, art, and criticism respond to how dividing lines profit from the 'hard lines' – ill luck and bad fortune – of the OTHER?

BY-LINES
Natives, women, blacks, homeless, gays, oppressed, Asians, lesbians, jobless, Hispanics, poor, feminists, self-acknowledged OTHERS . . . soliciting film, art, and criticism to line–to delineate, to sketch their good fortunes: forms, shapes, patterns, colors, textures, stories, discourses.

what's your line?

BIBLIOGRAPHY

Abraham, Nicolas (1979) 'The shell and the kernel', trans. Nicolas Rand, *Diacritics* 9, 1 (Spring 1979): 16–28.
—— (1988) 'Notes on the phantom: a complement to Freud's metapsychology', trans. Nicolas Rand, in Françoise Meltzer, (ed.) *The Trials of Psychoanalysis*, Chicago and London: University of Chicago Press.
Abraham, Nicolas, and Torok, Maria (1976) *Cryptonymie: le verbier de l'homme aux loups*, Paris: Editions Aubier Flammarion.
—— (1987) *L'écorce et le noyau*, Paris: Flammarion.
Adami, Valerio (1983) *Peintures récentes* (*Repères, cahiers d'art contemporain*, 6), Paris: Galerie Maeght.
Alpers, Svetlana (1976) 'Describe or narrate? A problem in realistic representation', *New Literary History* 8, 1 (Autumn): 16–41.
—— (1983) *The Art of Describing: Dutch Art in the Seventeenth Century*, Chicago: University of Chicago Press.
Althusser, Louis (1971) 'Ideology and ideological state apparatuses', in *Lenin and Philosophy*, trans. Ben Brewster, New York: Monthly Review Press.
—— (1977) *For Marx*, trans. Ben Brewster, London: New Left Books.
Anzieu, Didier, *et al.* (1984) *Art et fantasme*, Paris: Champ Vallon.
Arakawa (1984) *Padiglione d'arte contemporanea*, Milan: Edizioni Nava Milano.
Arakawa, and Gins, Madeline (1979) *The Mechanism of Meaning*, New York: Abrams.
Atkins, G. Douglas, and Bergeron, David M., eds (1988) *Shakespeare and Deconstruction*, New York and Bern: Peter Lang.
Bad Object Choices, ed. (1991) *How Do I Look? Queer Film and Video*, Seattle, Washington: Bay Press.
Baltrusaitis, Jurgis (1969) *Anamorphose ou magie artificielle des effets merveilleux*, Paris: Olivier Perrin.
Baquet, Dean (1992) 'Car plows into park killing 5 and injuring many', *New York Times*, April 24: A1, B2.
Barthes, Roland (1968) *Elements of Sociology*, Boston, Mass.: Beacon.
—— (1975) *The Pleasure of the Text*, trans. Richard Howard, New York: Hill & Wang.
—— (1977) *Roland Barthes by Roland Barthes*, trans. Richard Howard, New York: Hill & Wang.
—— (1978) *A Lover's Discourse: Fragments*, trans. Richard Howard, New York: Hill & Wang.
—— (1980) *La chambre claire: note sur la photographie*, Paris: Editions de l'Etoile, Gallimard, Le Seuil.

—— (1981) *Camera Lucida: Reflections on Photography*, trans. Richard Howard, New York: Hill & Wang.

—— (1985) *The Responsibility of Forms*, trans. Richard Howard, New York: Hill & Wang.

Barton, Sabrina (1991) '"Criss-cross": paranoia and projection in *Strangers on a Train*', *Camera Obscura* 25–6 (January–May): 75–100.

Baudry, Jean-Louis (1978) *L'effet cinéma*, Paris: Editions Albatros.

—— (1986a) 'Ideological effects of the basic cinematographic apparatus', trans. Alan Williams, in Philip Rosen (ed.) *Narrative, Apparatus, Ideology*, New York: Columbia University Press.

—— (1986b) 'The apparatus: metapsychological approaches to the impression of reality in cinema', trans. Jean Andrews and Bertrand Augst, in Philip Rosen (ed.) *Narrative, Apparatus, Ideology*, New York: Columbia University Press.

Bellour, Raymond (1975) 'The unnattainable text', trans. Diane Matias, *Screen* 16, 3: 19–27.

—— (1985) 'Analysis in flames', *Diacritics* 15, 1 (Spring): 54–6.

—— (1990) 'The film stilled', *Camera Obscura* 24 (September): 99–123.

Benamou, Michel, and Caramello, Charles, eds (1977) *Performance in Postmodern Culture*, Milwaukee, Wis.: Center for Twentieth-Century Studies; Madison, Wis.: Coda Press.

Benjamin, Andrew, ed. (1989) *The Lyotard Reader*, Oxford: Basil Blackwell.

Benjamin, Andrew, and Osborne, Peter, eds (1991) *Thinking Art: Beyond Traditional Aesthetics*, London: Institute of Contemporary Arts.

Benjamin, Walter (1969) 'The work of art in the age of mechanical reproduction', in Hannah Arendt (ed.) *Illuminations*, trans. Harry Zohn, New York: Schocken Books.

—— (1971) 'Petite histoire de la photographie', *Oeuvres 2: Poésie et Révolution*, trans. Maurice de Gandillac, Paris: Denoël.

—— (1978) 'The author as producer', in Peter Demetz (ed.) *Reflections*, trans. Edmund Jephcott, New York and London: Harcourt Brace Jovanovich.

Bennington, Geoffrey (1988) *Lyotard: Writing the Event*, New York: Columbia University Press.

Bensmaïa, Réda (1987) *The Barthes Effect: The Essay as Reflective Text*, trans. Pat Fedkiew, Minneapolis: University of Minnesota Press.

—— (1988) 'Marie-Claire Ropars-Wuilleumier ou le texte retrouvé', *Cinémaction* 47: 90–4.

Benveniste, Emile (1971) *Problems in General Linguistics*, trans. Mary Elizabeth Meeks, Coral Gables, Fla: University of Miami Press.

—— (1974) *Problèmes de linguistique générale, II*, Paris: Editions Gallimard.

Bersani, Leo (1986) *The Freudian Body: Psychoanalysis and Art*, New York: Columbia University Press.

—— (1988) 'Is the rectum a grave?', in Douglas Crimp (ed.) *AIDS: Cultural Analysis, Cultural Activism*, Cambridge, Mass.: MIT Press.

Blau, Herbert (1982) *Blooded Thought: Occasions of Theatre*, New York: Performing Arts Journal Publications.

Bois, Yves-Alain (1986) 'Painting: the task of mourning', in The Institute of Contemporary Art, Boston, *Endgame: Reference and Simulation in Recent Painting and Sculpture*, Cambridge, Mass.: MIT Press.

—— (1991) *Painting as Model*, Cambridge, Mass.: MIT Press.

Boon, James A. (1982) *Other Tribes, Other Scribes: Symbolic Anthropology in the Comparative Study of Cultures, Histories, Religions, and Texts*, Cambridge: Cambridge University Press.

241

Borch-Jacobsen, Mikkel (1988) *The Freudian Subject*, trans. Catherine Porter, Stanford, Calif.: Stanford University Press.

Bray, Alan (1982) *Homosexuality in Renaissance England*, London: Gay Men's Press.

Bredbeck, Gregory W. (1991) *Sodomy and Interpretation: Marlowe to Milton*, Ithaca, NY: Cornell University Press.

Brewer, Daniel (1983) 'The philosophical dialogue and the forcing of truth', *Modern Language Notes* 98, 5 (December): 1234–47.

Brunette, Peter, and Wills, David (1989) *Screen/Play: Derrida and Film Theory*, Princeton, NJ: Princeton University Press.

Bryson, Norman (1983) *Vision and Painting: The Logic of the Gaze*, New Haven, Conn.: Yale University Press.

—— ed. (1988) *Calligram: Essays in New Art History from France*, Cambridge: Cambridge University Press.

Bürger, Thomas (1984) *Theory of the Avant-Garde*, trans. Michael Shaw, Minneapolis: University of Minnesota Press.

Burgin, Victor, ed. (1982) *Thinking Photography*, London: Macmillan.

—— (1986a) *The End of Art Theory: Criticism and Postmodernity*, Atlantic Highlands, NJ: Humanities Press International.

—— (1986b) 'Diderot, Barthes, *Vertigo*', in Victor Burgin, James Donald, and Cora Kaplan (eds) *Formations of Fantasy*, London: Methuen.

Burgin, Victor, Donald, James, and Kaplan, Cora, eds (1986) *Formations of Fantasy*, London: Methuen.

Burke, Kenneth (1969) *A Grammar of Motives*, Berkeley: University of California Press.

—— (1973) *The Philosophy of Literary Form*, Berkeley: University of California Press.

Butler, Judith (1990) *Gender Trouble: Feminism and the Subversion of Identity*, New York and London: Routledge.

Carravagio (1985) *The Age of Caravaggio*, New York: The Metropolitan Museum of Art.

Carroll, David (1987) *Paraesthetics: Foucault, Lyotard, Derrida*, New York and London: Methuen.

Carroll, Noel (1981–2) 'Introduction to an interview with a woman who', *Millennium Film Journal* 7–9 (Fall/Winter).

Caruth, Cathy, ed. (1991) *Psychoanalysis, Culture, and Trauma*, *American Imago* 48, 1 (Spring).

Case, Sue-Ellen (1989a) 'Toward a butch-femme aesthetic', in Lynda Hart (ed.) *Making a Spectacle: Feminist Essays on Contemporary Women's Theatre*, Ann Arbor: University of Michigan Press.

—— (1989b) 'From split subject to split britches', in Enoch Brater (ed.) *Feminine Focus: The New Women Playwrights*, New York and Oxford: Oxford University Press.

—— ed. (1990) *Performing Feminisms: Feminist Critical Theory and Theatre*, Baltimore, Md: The Johns Hopkins University Press.

—— (1991) 'Tracking the vampire', *Differences* 3, 2 (Summer): 1–20.

Cavell, Stanley (1979) *The World Viewed: Reflections on the Ontology of Film*, Cambridge, Mass.: Harvard University Press.

—— (1981) *Pursuits of Happiness: The Hollywood Comedy of Remarriage*, Cambridge, Mass.: Harvard University Press.

Center for Inter-American Relations (1972) *About 30 Works by Michael Snow*, New York: Center for Inter-American Relations.

Chasseguet-Smirgel, Janine, ed. (1970) *Female Sexuality: New Psychoanalytic Views*, Ann Arbor: University of Michigan Press.

Cixous, Hélène (1981) 'The laugh of the Medusa', trans. Keith Cohen and Paula Cohen, in Elaine Marks and Isabelle de Courtivron (eds) *New French Feminisms: An Anthology*, New York: Schocken Books.

Claudel, Paul (1965) *Oeuvres en prose*, Paris: Gallimard.

Collick, John (1989) *Shakespeare: Cinema and Society*, Manchester: Manchester University Press.

Comolli, Jean-Louis (1980) 'Machines of the visible', in Teresa de Lauretis and Stephen Heath (eds) *The Cinematic Apparatus*, London: Macmillan; New York: St Martin's Press.

Compagnon, Antoine (1979) 'Psychose et sophistique', in Julia Kristeva and Jean-Michel Ribettes (eds) *Folle vérité: vérité et vraisemblance du texte psychotique*, Paris: Editions du Seuil.

Conley, Tom (1986) 'Institutionalizing translation: on Florio's Montaigne', in Samuel Weber (ed.) *Demarcating the Disciplines: Philosophy, Literature, Art* (Glyph Textual Studies), Minneapolis: University of Minnesota Press.

—— (1991) *Film Hieroglyphs: Ruptures in Classical Cinema*, Minneapolis: University of Minnesota Press.

Copjec, Joan (1982) 'The anxiety of the influencing machine' *October* 23 (Winter): 43–59.

—— (1989a) 'The orthopsychic subject: film theory and the reception of Lacan', *October* 49 (Summer): 53–71.

—— (1989b) 'The sartorial superego', *October* 50 (Fall): 57–95.

Corrigan, Timothy (1991) *A Cinema without Walls: Movies and Culture after Vietnam*, New Brunswick, NJ: Rutgers University Press.

Crawford, Larry (1985) 'Monstrous criticism: finding, citing – analyzing film', *Diacritics* 15, 1 (Spring): 60–70.

Crewe, Jonathan, ed. (1991) *Reconfiguring the Renaissance: Essays in Critical Materialism, Bucknell Review*, 35, 2.

Crimp, Douglas, (1989) 'Mourning and militancy', *October* 51 (Winter): 3–18.

—— ed. (1988) *AIDS: Cultural Analysis, Cultural Activism*, Cambridge, Mass.: MIT Press.

Crimp, Douglas, and Rolston, Adam (1990) *AIDSDEMOGRAPHICS*, Seattle: Bay Press.

Damisch, Hubert (1972) *Théorie du nuage: pour une histoire de la peinture*, Paris: Editions du Seuil.

—— (1987) *L'origine de la perspective*, Paris: Flammarion.

Dawson, Jan (1980) 'A world beyond Freud', *Sight and Sound* 49, 3 (Summer): 196–7.

de Certeau, Michel (1985) 'Pay attention: to make art', in Helen Mayer and Newton Harrison. *The Lagoon Cycle*, Ithaca, NY: Herbert F. Johnson Museum of Art, Cornell University.

de Lauretis, Teresa (1984) *Alice Doesn't: Feminism, Semiotics, Cinema* Bloomington: Indiana University Press.

—— (1987) *Technologies of Gender: Essays on Theory, Film, and Fiction*, Bloomington: Indiana University Press.

—— (1990) 'Sexual indifference and lesbian representation', in Sue-Ellen Case (ed.) *Performing Feminisms: Feminist Critical Theory and Theatre*, Baltimore, Md: The Johns Hopkins University Press.

—— (1991) 'Film and the visible, in Bad Object-Choices (ed.) *How Do I Look? Queer Film and Video*, Seattle: Bay Press.

de Lauretis, Teresa, and Heath, Stephen, eds. (1980) *The Cinematic Apparatus*, London: Macmillan; New York: St Martin's Press.

Deleuze, Gilles (1986) *Cinema 1: The Movement-Image*, trans. Hugh Tomlinson and Barbara Habberjam, Minneapolis: University of Minnesota Press.

—— (1989a) *Cinema 2: The Time-Image*, trans. Hugh Tomlinson and Robert Galeta, Minneapolis: University of Minnesota Press.

—— (1989b) 'Coldness and cruelty', in *Masochism*, New York: Zone Books.

de Man, Paul (1979) *Allegories of Reading: Figural Language in Nietzsche, Rilke, and Proust*, New Haven, Conn.: Yale University Press.

Derrida, Jacques (1976) *Of Grammatology*, trans. Gayatri Chakravorty Spivak, Baltimore, Md: The Johns Hopkins University Press.

—— (1978) *Writing and Difference*, trans. Alan Bass, Chicago: University of Chicago Press.

—— (1979) 'Me—psychoanalysis: an introduction to the translation of "The Shell and the Kernel" by Nicolas Abraham', trans. Richard Klein, *Diacritics* 9, 1 (March): 4–12.

—— (1980) *La carte postale: de Socrate à Freud et au-delà*, Paris: Aubier-Flammarion.

—— (1981) *Dissemination*, trans. Barbara Johnson, Chicago: University of Chicago Press.

—— (1982) *Margins of Philosophy*, trans. Alan Bass, Chicago: University of Chicago Press.

—— (1985) 'Racism's last word', trans. Peggy Kamuf, *Critical Inquiry* 12, 1 (Autumn): 290–9.

—— (1987a) 'Les morts de Roland Barthes', in *Psyche: inventions de l'autre*, Paris: Galilée.

—— (1987b) *The Truth in Painting*, trans. Geoff Bennington and Ian McLeod, Chicago: Chicago University Press.

Dews, Peter (1984) 'The letter and the line: discourse and its other in Lyotard', *Diacritics* 14, 3 (Fall): 40–9.

Doane, Mary Ann (1987) *The Desire to Desire: The Woman's Film of the 1940s*, Bloomington: Indiana University Press.

—— (1991) *Femmes Fatales: Feminism, Film Theory, Psychoanalysis*, New York: Routledge.

Dolan, Jill (1990) '"Lesbian" subjectivity in realism: dragging at the margins of structure and ideology', in Sue-Ellen Case (ed.) *Performing Feminisms: Feminist Critical Theory and Theatre*, Baltimore, Md: The Johns Hopkins University Press.

Dyer, Richard (1985) 'Coming to terms', *Jump Cut* 30 (March): 27–9.

—— (1990) *Now You See It*, London: Routledge.

Eckert, Charles W., ed. (1972) *Focus on Shakespearean Films*, Englewood Cliffs, NJ: Prentice Hall.

Edelman, Lee (1989) 'Homographesis', *The Yale Journal of Criticism* 1, 3 (Fall): 189–207.

—— (1991) 'Seeing things: representation, the scene of surveillance, and the spectacle of gay male sex', in Diana Fuss (ed.) *Inside/Out: Lesbian Theories, Gay Theories*, New York: Routledge.

Erens, Patricia, ed., (1990) *Issues in Feminist Film Criticism*, Bloomington: Indiana University Press.

Feldstein, Richard, and Roof, Judith, eds (1989) *Feminism and Psychoanalysis*, Ithaca, NY: Cornell University Press.

Felman, Shoshana, ed. (1982) *Literature and Psychoanalysis, the Question of Reading: Otherwise*, Baltimore, Md: The Johns Hopkins University Press.

Ferguson, Russell, Gever, Martha, Trinh, T. Minh-ha, and West, Cornel, eds (1990) *Out There: Marginalization and Contemporary Culture*, New York: The New Museum of Contemporary Art; Cambridge, Mass.: MIT Press.

Field, Simon, and O'Pray, Michael (1985) 'On imaging October, Dr Dee and other matters: an interview with Derek Jarman', *Afterimage* 12: 41–57.

Findlay, Heather (1989) 'Is there a lesbian in this text? Derrida, Wittig, and the politics of the three women', in Elizabeth Weed (ed.) *Coming to Terms: Feminism, Theory, Politics*, New York: Routledge.

Fineman, Joel (1991) *The Subjectivity Effect in Western Literary Tradition: Essays Toward the Release of Shakespeare's Will*, Cambridge, Mass.: MIT Press.

Foster, Hal (1985) *Recodings: Art, Spectacle, Cultural Politics*, Port Townsend, Washington: Bay Press.

—— (1986) 'The future of an illusion, or the contemporary artist as cargo cultist', in The Institute of Contemporary Art, Boston (ed.) *Endgame: Reference and Simulation in Recent Painting and Sculpture*, Cambridge, Mass.: MIT Press.

—— (1991) 'Convulsive identity', *October* 57 (Summer): 19–54.

—— ed. (1983) *The Anti-Aesthetic: Essays on Postmodern Culture*, Port Townsend, Washington: Bay Press.

—— ed. (1987) *Discussions in Contemporary Culture*, Seattle, Washington: Bay Press.

Foucault, Michel (1988a) 'Sexual morality and the law', in Lawrence D. Kritzman (ed.) *Michel Foucault: Politics, Philosophy, Culture. Interviews and other Writings, 1977–1984*, New York: Routledge.

—— (1988b) 'Sexual choice and sexual act: Foucault and homosexuality', in Lawrence D. Kritzman (ed.) *Michel Foucault: Politics, Philosophy, Culture. Interviews and other Writings, 1977–1984*, New York: Routledge.

Fox, Howard N., McClintoc, Miranda, and Rosenzweig, Phyllis (1984) *Content: A Contemporary Focus 1974–1984*, Washington, DC: Smithsonian Institution Press.

French, Peter J. (1972) *John Dee: The World of an Elizabethan Magus*, London: Routledge & Kegan Paul.

Freud, Sigmund (1953–74) *The Standard Edition of the Complete Psychological Works of Sigmund Freud*, 24 vols, ed. and trans. James Strachey, London: Hogarth Press and the Institute of Psychoanalysis.

—— (1963) *Jokes and their Relation to the Unconscious*, ed. and trans. James Strachey, New York: W. W. Norton.

—— (1966) *Introductory Lectures on Psychoanalysis*, ed. and trans. James Strachey, New York: W. W. Norton.

Frow, John (1991) 'Tourism and the semiotics of nostalgia', *October* 57 (Summer): 123–51.

Fuss, Diana, ed. (1991) *Inside/Out: Lesbian Theories, Gay Theories*, New York: Routledge.

Fyfe, W. Hamilton, ed. (1940) *Aristotle's Art of Poetry: A Greek View of Poetry and Drama*, Oxford: Clarendon Press.

Gaines, Jane (1990) 'White privilege and looking relations: race and gender in feminist film theory', in Patricia Erens, ed., *Issues in Feminist Film Criticism*, Bloomington: Indiana University Press.

Gantheret, François (1987) 'Du coin de l'oeil', *Nouvelle Revue de Psychanalyse*, 35 (Spring): 107–25.

Girard, René (1965) *Deceit, Desire, and the Novel: Self and Other in Literary Structure*, trans. Yvonne Freccero, Baltimore, Md: The Johns Hopkins University Press.

—— (1977) *Violence and the Sacred*, trans. Patrick Gregory, Baltimore, Md: The Johns Hopkins University Press.

Graver, David (1992) 'Vorticist performance and aesthetic turbulence in *Enemy of*

the Stars', *PMLA* 107, 3 (May): 482–96.

Green, André (1979) *The Tragic Effect: The Oedipus Conflict in Tragedy*, trans. Alan Sheridan, Cambridge: Cambridge University Press.

—— (1983) *Narcissisme de vie, narcissisme de mort*, Paris: Minuit.

Gregori, Mina (1985) 'Boy with a basket of fruit', in Metropolitan Museum of Art, *The Age of Caravaggio*, New York: The Metropolitan Museum of Art, Electra International.

Groupe Mu (1978) 'Douze bribes pour décoller (en 40,000 signes)', *Collages* (Paris): 10/18: 11–41.

Guilbaut, Serge (1983) *How New York Stole the Idea of Modern Art*, trans. Arthur Goldhammer, Chicago: University of Chicago Press.

Haacke, Hans (1985) 'Where the consciousness industry is concentrated', in Douglas Kahn and Diane Neumaier (eds) *Cultures in Contention*, Seattle, Washington: The Real Comet Press.

Hadjinicolaou, Nicos (1982) 'On the ideology of avant-gardism', trans. Diane Belle James, *Praxis* 6: 39–70.

Halley, Michael (1982) 'Argo sum', *Diacritics* 12, 4 (Winter): 69–78.

Harrison, Helen Mayer, and Harrison, Newton (1985) *The Lagoon Cycle*, Ithaca, NY: Herbert F. Johnson Museum of Art, Cornell University.

Hart, Lynda, ed. (1989) *Making a Spectacle: Feminist Essays on Contemporary Women's Theatre*, Ann Arbor: University of Michigan Press.

Heath, Stephen (1981) *Questions of Cinema*, Bloomington: Indiana University Press.

Heming, John, and Condell, Henry (1623) 'To the Most Noble and Incomparable Paire of Brethren . . .', *Mr. William Shakespeare's Comedies, Histories & Tragedies*, London: Isaac Jaggard & Ed. Blount.

Herskowitz, Richard, ed. (1985) *New Performances on Film and Video*, Ithaca, NY: Herbert F. Johnson Museum of Art, Cornell University.

Hertz, Neil (1985) *The End of the Line*, New York: Columbia University Press.

Holland, Patricia, ed. (1987) *Photography Politics: Two*, London: Comedia.

Howard, Jean E., and O'Connor, Mario F., eds. (1987) *Shakespeare Reproduced: The Text in History and Ideology*, New York: Methuen.

Huyssen, Andreas (1986) *After the Great Divide: Modernism, Mass Culture, Postmodernism*, Bloomington: Indiana University Press.

Institute of Contemporary Art, Boston, The, ed. (1986) *Endgame: Reference and Simulation in Recent Painting and Sculpture*, Cambridge, Mass.: MIT Press.

Irigaray, Luce (1985a) *Speculum of the Other Woman*, trans. Gillian G. Gill, Ithaca, NY: Cornell University Press.

—— (1985b) *This Sex Which Is Not One*, trans. Catherine Porter and Caroline Burke, Ithaca, NY: Cornell University Press.

Iversen, Margaret (1991) 'The deflationary impulse: postmodernism, feminism and the anti-aesthetic', in Andrew Benjamin and Peter Osborne (eds), *Thinking Art: Beyond Traditional Aesthetics*, London: Institute of Contemporary Arts.

Jameson, Fredric (1981) *The Political Unconscious: Narrative as a Socially Symbolic Act*, Ithaca, NY: Cornell University Press.

—— (1988) 'Postmodernism and consumer society' in E. Ann Kaplan (ed.) *Postmodernism and its Discontents: Theories, Practices*, London: Verso.

Jarman, Derek (1984) *Dancing Ledge*, London: Quartet Books.

—— (1985) 'On imaging October: Dr Dee and other matters – interview by Simon Field and Michael O'Pray', *Afterimage*, 12 (Autumn): 40–59.

—— (1986) *Derek Jarman's Caravaggio*, London: Thames & Hudson.

—— (1991) *Queer Edward II*, London: British Film Institute.

Jeyifo, Biodun (1985) *The Truthful Lie: Essays in a Sociology of African Drama*, London: New Beacon Books.

Jorgens, Jack (1977) *Shakespeare on Film*, Bloomington: Indiana University Press.

Julian, Isaac (1991), 'Response to Cindy Patton', in Bad Object Choices (ed.) *How Do I Look? Queer Film and Video*, Seattle, Washington: Bay Press.

Kahn, Douglas, and Neumaier, Diane, eds (1985) *Cultures in Contention*, Seattle, Washington: The Real Comet Press.

Kamuf, Peggy (1979) 'Abraham's wake', *Diacritics* 9, 1 (March): 32–43.

Kaplan, E. Ann, ed. (1988) *Postmodernism and its Discontents: Theories, Practices*, London: Verso.

—— ed. (1990) *Psychoanalysis & Cinema*, New York: Routledge.

Kelly, Mary (1983) *Post-Partum Document*, London: Routledge & Kegan Paul.

—— (1990) *Interim*, New York: The New Museum of Contemporary Art.

Kleinfeld, N. R. (1992) 'Blissful day in the park becomes a nightmare', *New York Times*, April 24: B2.

Klinger, Barbara (1988) 'In retrospect: film studies today', *The Yale Journal of Criticism* 12, 1: 29–51.

Kluge, Alexander (1981–2) 'Film and the public sphere', trans. Thomas Y. Levin and Miriam B. Hansen, *New German Critique* 24–5 (Fall/Winter): 206–20.

Kofman, Sarah (1985a) *The Enigma of Woman: Woman in Freud's Writings*, trans. Catherine Porter, Ithaca, NY: Cornell University Press.

—— (1985b) *Mélancolie de l'art*, Paris: Editions Galilée.

Kolbowski, Silvia, ed. (1984) 'Sexuality: re/positions', *Wedge* 6 (Winter).

Krauss, Rosalind (1985) *The Originality of the Avant-Garde and other Modernist Myths*, Cambridge, Mass.: MIT Press.

Kristeva, Julia (1979) 'Le vréel', in Julia Kristeva and Jean-Michel Ribettes (eds), *Folle vérité: vérité et vraisemblance du texte psychotique*, Paris: Editions du Seuil.

—— (1980) *Pouvoirs de l'horreur: essai sur l'abjection*, Paris: Editions du Seuil.

—— (1986) *The Kristeva Reader*, ed. Toril Moi, New York: Columbia University Press.

—— (1987) *Soleil noir: dépression et mélancolie*, Paris: Gallimard.

Kristeva, Julia, and Ribettes, Jean-Michel, eds (1979) *Folle vérité: vérité et vraisemblance du texte psychotique*, Paris: Editions du Seuil.

Kritzman, Lawrence D., ed. (1988) *Michel Foucault: Politics, Philosophy, Culture. Interviews and other Writings, 1977–1984*, New York: Routledge.

—— (1989) 'The discourse of desire and the question of gender', in Steven Ungar and Betty R. McGraw (eds), *Signs in Culture: Roland Barthes Today*, Iowa City: University of Iowa Press.

Kruger, Barbara, and Mariani, Phil, eds (1989) *Remaking History*, Seattle, Washington: Bay Press.

Lacan, Jacques (1977) *Ecrits: A Selection*, trans. Alan Sheridan, New York: W. W. Norton.

—— (1978) *The Four Fundamental Concepts of Psychoanalysis*, trans. Alan Sheridan, ed. Jacques-Alain Miller, New York: W. W. Norton.

—— (1982) *Feminine Sexuality: Jacques Lacan and the école freudienne*, ed. Juliet Mitchell and Jacqueline Rose, trans. Jacqueline Rose, New York: W. W. Norton.

LaCapra, Dominick (1985) *History and Criticism*, Ithaca: Cornell University Press.

Laclau, Ernesto, and Mouffe, Chantal (1985) *Hegemony and Socialist Strategy: Towards a Radical Democratic Politics*, London: Verso.

Lacoue-Labarthe, Philippe (1977) 'Theatrum analyticum', trans. Robert Vollrath

and Samuel Weber, *Glyph 2*, Baltimore: Johns Hopkins University Press.

—— (1979a) *Le sujet de la philosophie: typographies I*, Paris: Aubier-Flammarion.

—— (1979b) *Portrait de l'artiste en général*, Paris: Christian Bourgois.

—— (1984) 'Talks', trans. Christopher Fynsk, *Diacritics* 14, 3 (Fall): 24–37.

—— (1986) *L'imitation des modernes: typographies II*, Paris: Editions Galilée.

Lambotte, Marie-Claude (1984) *Esthétique de la mélancolie*, Paris: Aubier.

Laplanche, Jean (1980) *Problématiques III: la sublimation*, Paris: Presses Universitaires de France.

—— (1981) *Problématiques IV: l'inconscient et le ça*, Paris: Presses Universitaires de France.

—— (1989) *New Foundations for Psychoanalysis*, trans. David Macey, Oxford: Basil Blackwell.

Laplanche, Jean, and Pontalis, J. B. (1986) 'Fantasy and the origins of sexuality', in Victor Burgin, James Donald, and Cora Kaplan (eds) *Formations of Fantasy*, London: Methuen.

Laqueur, Thomas (1990) *Making Sex: Body and Gender from the Greeks to Freud*, Cambridge, Mass.: Harvard University Press.

Lascault, Gilbert (1979) *Ecrits timides sur le visible*, Paris: 10/18.

Lewes, Kenneth (1988) *The Psychoanalytic Theory of Male Homosexuality*, New York: Simon & Schuster.

Lewis, Thomas E. (1983) 'Aesthetic effect/ideological effect', *Enclitic* 7, 2: 4–16.

Linderman, Deborah (1990) 'Cinematic abreaction: Tourneur's *Cat People*', in E. Ann Kaplan (ed.) *Postmodernism and its Discontents: Theories, Practices*, London: Verso.

Linker, Kate, (1984a) 'Representation and sexuality', in Brian Wallis (ed.) *Art after Modernism: Rethinking Representation*, New York: The New Museum of Contemporary Art; Boston, Mass.: David R. Godine.

—— ed. (1984b) *Difference: On Representation and Sexuality*, New York: The New Museum of Contemporary Art.

Lukacher, Ned (1986) *Primal Scenes: Literature, Philosophy, Psychoanalysis*, Ithaca, NY, and London: Cornell University Press.

—— (1989) 'Anamorphic stuff: Shakespeare, catharsis, Lacan', *South Atlantic Quarterly* 88, 4 (Fall): 863–98.

Lydon, Mary (1989) 'Amplification: Barthes, Freud, and paranoia', in Steven Ungar and Betty R. McGraw (eds) *Signs in Culture: Roland Barthes Today*, Iowa City: University of Iowa Press.

Lyotard, Jean-François (1971) *Discours, figure*, Paris: Editions Klincksieck.

—— (1973) 'Contribution des tableaux de Jacques Monory', *Figurations 1960/73*, Paris: 10/18.

—— (1974) *Economie libidinale*, Paris: Editions de Minuit.

—— (1977a) *Rudiments païens*, Paris: 10/18.

—— (1977b) 'The unconscious as mise-en-scène', in Michel Benamou and Charles Caramello (eds) *Performance in Postmodern Culture*, Milwaukee, Wis.: Center for Twentieth-Century Studies; Madison, Wis.: Coda Press.

—— (1979) *Le mur de pacifique*, Paris: Editions Galilée.

—— (1983) 'On dirait qu'une ligne . . .', *Repères, cahiers d'art contemporain 6*, Paris: Galerie Maeght.

—— (1984) *The Postmodern Condition: A Report on Knowledge*, trans. Geoff Bennington and Brian Massumi, Minneapolis: University of Minnesota Press.

—— (1984a) 'The sublime and the avant-garde', trans. Lisa Liebmann, *Artforum* 22, 8 (April): 36–43.

—— (1984b) 'Answering the question: what is postmodernism', ed. Régis Durand, Appendix to Jean-François Lyotard, *The Postmodern Condition: A*

Report on Knowledge, trans. Geoff Bennington and Brian Massumi, Minneapolis: University of Minnesota Press.

—— (1984c) 'Longitude 180° W or E' [in French, Italian, English], trans. Maurizio Ferraris and Mary Ann Caws, in Arakawa, *Padliglione d'arte contemporanea*, Milan: Edizioni Nova Milano.

—— (1984d) *Driftworks*, ed. Roger McKeon, New York: Semiotext(e).

—— (1985) 'Les immateriaux', dossier prepared by the Centre de Création Industrielle, Paris: Centre Georges Pompidou.

—— (1986) 'Acinema', trans. Paisley N. Livingston, in Philip Rosen (ed.) *Narrative, Apparatus, Ideology*, New York: Columbia University Press.

—— (1987) *Que peindre? Adami, Arakawa, Buren*, Paris: Editions de la Différence.

—— (1988a) *The Differend: Phrases in Dispute*, trans. Georges Van Den Abbeele, Minneapolis: University of Minnesota Press.

—— (1988b) *L'inhumain: causeries sur le temps*, Paris: Editions Galilée.

—— (1989a) 'The story of Ruth', trans. Timothy Murray, in A. Benjamin (ed.), *The Lyotard Reader*, Oxford: Basil Blackwell.

—— (1989b) 'One of the things at stake in women's struggles', trans. Deborah J. Clarke, Winifred Woodhull, and John Mowitt, in Andrew Benjamin (ed.) *The Lyotard Reader*, Oxford: Basil Blackwell.

—— (1989c) 'Beyond representation', trans. Jonathan Culler, in Andrew Benjamin (ed.) *The Lyotard Reader*, Oxford: Basil Blackwell.

—— (1989d) 'The sublime and the avant-garde', trans. Lisa Liebmann, Geoff Bennington, and Mirian Hobson, in Andrew Benjamin (ed.) *The Lyotard Reader*, Oxford: Basil Blackwell.

—— (1989e) 'Newman: the instant', trans. David Macey, in Andrew Benjamin (ed.) *The Lyotard Reader*, Oxford: Basil Blackwell.

—— (1990) *Duchamp's TRANS/formers*, trans. Ian McLeod, Venice, Calif.: The Lapis Press.

—— Lyotard, Jean-François and Thébaud, Jean-Loup (1979) *Au juste*, Paris: Christian Bourgois.

—— Lyotard, Jean-François, and Francken, Ruth (1983) *L'histoire de Ruth*, Paris: Le Castor Astral.

MacCabe, Colin (1991), 'Edward II: throne of blood', *Sight and Sound* n.s. 1, 6: 12–14.

MacCannell, Dean (1989) *The Tourist: A New Theory of the Leisure Class*, New York: Schocken Books.

Mapplethorpe, Robert (1986) *Black Book*, New York: St Martin's Press.

Mapplethorpe, Robert, and Marshall, Richard (1988) *Robert Mapplethorpe*, New York: Whitney Museum of Art.

Marin, Louis (1971) *Etudes sémiologiques: écritures, peintures*, Paris: Klincksieck.

—— (1977) *Détruire la peinture*, Paris: Editions Galilée.

—— (1978) *Le récit est un piège*, Paris: Editions de Minuit.

—— (1981) *Le portrait du roi*, Paris: Editions de Minuit.

—— (1984) *Utopics: Spatial Play*, trans. Robert A. Vollrath, Atlantic Highlands, NJ: Humanities Press.

Marks, Elaine, and De Courtivron, Isabelle, eds (1980) *New French Feminisms: An Anthology*, New York, Schocken Books.

Mayne, Judith (1990) *The Woman at the Keyhole: Feminism and Women's Cinema*, Bloomington: Indiana University Press.

McNamara, Andrew (1992) 'Between flux and certitude: the grid in avant-garde utopian thought', *Art History* 15, 1 (March): 60–79.

Meltzer, Françoise, ed. (1988) *The Trials of Psychoanalysis*, Chicago and London: University of Chicago Press.

Mercer, Kobena (1987) 'Imaging the Black man's sex', in Patricia Holland (ed.) *Photography Politics: Two*, London: Comedia.

—— (1991a) 'Skin head sex thing: radical difference and homoerotic imagery', in Bad Object Choices (ed.) *How Do I Look? Queer Film and Video*, Seattle, Washington: Bay Press.

—— (1991b) 'In response to Stuart Marshall', in Bad Object Choices (ed.) *How Do I Look? Queer Film and Video*, Seattle, Washington: Bay Press.

—— (1992) Endangered species, *Artforum* 30, 10 (Summer): 74–7.

Merleau-Ponty, Maurice (1964) *Le visible et l'invisible*, Paris: Gallimard.

Metropolitan Museum of Art, The (1985) *The Age of Caravaggio*, New York: The Metropolitan Museum of Art, Electra International.

Metz, Christian (1977) *Le signifiant imaginaire: psychanalyse et cinéma*, Paris: 10/18.

—— (1986) 'Problems of denotation in the fiction film', in Philip Rosen (ed.) *Narrative, Apparatus, Ideology*, New York: Columbia University Press.

Michelson, Annette (1990) 'The kinetic icon in the work of mourning: prolegomena to the analysis of a textual system', *October* (Spring): 16–38.

Mitchell, Juliet (1982) 'Introduction-I', in Jacques Lacan, *Feminine Sexuality: Jacques Lacan and the école freudienne*, ed. Juliet Mitchell and Jacqueline Rose, trans. Jacqueline Rose, New York: W. W. Norton.

Mitchell, W. J. T. (1986) *Iconology: Image, Text, Ideology*, Chicago: University of Chicago Press.

Montaigne, Michel de (1893) *The Essayes of Michael Lord of Montaigne*, trans. John Florio, London: George Routledge.

Montrelay, Michèle (1977) *L'ombre et le nom: sur la féminité*, Paris: Minuit.

—— (1978) 'Inquiry into femininity', trans. Parveen Adams *m/f*, 1: 65–101.

Morris, Meaghan (1984) 'Postmodernity and Lyotard's sublime', *Art & Text* 16 (Summer): 44–67.

Mulvey, Laura (1989) *Visual and other Pleasures*, Bloomington: Indiana University Press.

Mulvey, Laura and Wollen, Peter (1977) 'Riddles of the Sphinx: a film by Laura Mulvey and Peter Wollen', *Screen* 18, 2 (Summer): 61–77.

Murray, Timothy (1976) 'A marvelous guide to anamorphosis: *Cendrillon ou la petite pantoufle de verre*', *Modern Language Notes*, 91, 6 (December): 1276–95.

—— (1977) 'Kenneth Burke's logology: a mock logomachy', in *Glyph 2*, Baltimore, Md: Johns Hopkins University Press.

—— (1984a) 'Terror and judgment: consenting with Hassan, Graff (and now Booth!), *Boundary* 2, 12, 3/13, 1 (Spring/Fall): 215–34.

—— (1984b) 'The theatricality of the van-guard: ideology and contemporary American theatre', *Performing Arts Journal* 24 (Fall): 93–9.

—— (1987a) *Theatrical Legitimation: Allegories of Genius in Seventeenth-Century England and France*, New York and Oxford: Oxford University Press.

—— (1987b) 'Subliminal libraries: showing Lady Liberty and documenting death', *Discourse* 9 (Spring/Summer): 107–24.

—— (1988) '*Othello*: an index and obscure prologue to the history of foul generic thoughts', in G. Douglas Atkins and David M. Bergeron (eds), *Shakespeare and Deconstruction*, New York and Bern: Peter Lang.

—— (1990) 'Facing the camera's eye: black and white terrain in women's drama', in Henry Louis Gates, Jr. (ed.) *Reading Black, Reading Feminist*, New York: Meridian.

—— (1991) 'Translating Montaigne's crypts: melancholic relations and the sites of altarbiography', in Jonathan Crewe (ed.) *Reconfiguring the Renaissance: Essays in Critical Materialism, Bucknell Review*, 35, 2.

Museum of Contemporary Hispanic Art, The New Museum of Contemporary

Art, The Studio Museum in Harlem (1990) *The Decade Show*, New York: Museum of Contemporary Hispanic Art, The New Museum of Contemporary Art, The Studio Museum in Harlem.

Nash, Mark (1985) 'Innocence and experience', *Afterimage*, 12 (Autumn): 31–9.

Negt, Oscar, and Kluge, Alexander (1988) 'The public sphere and experience: *Selections*', trans. Peter Labanyi, *October* 46: 60–82.

New York Chapter of the Women's Caucus for Art (1982) *Views by Women Artists*, New York: New York Chapter of the Women's Caucus for Art.

Newman, Karen (1987) '"And wash the Ethiop white": feminity and the monstrous in *Othello*', in Jean E. Howard and Mario F. O'Connor (eds) *Shakespeare Reproduced: The Text in History and Ideology*, New York: Methuen.

Ngate, Jonathan (1988) *Francophone African Fiction: Reading a Literary Tradition*, Trenton, NJ: African World Press.

Nochlin, Linda (1988) *Women, Art, and Power and Other Essays*, New York: Harper & Row.

Nunokawa, Jeff (1991) '"All the sad young men": AIDS and the work of mourning', in Diana Fuss (ed.) *Inside Out: Lesbian Theories, Gay Theories*, New York: Routledge.

Olaniyan, Tejumola (1991) 'The poetics and politics of "othering": contemporary African, African-American, and Caribbean drama and the invention of cultural identity', dissertation, Ithaca, NY: Cornell University.

Olivier, Laurence (1986) *On Acting*, New York: Simon & Schuster.

O'Pray, Michael (1985) 'Derek Jarman's cinema: Eros and Thanatos', *Afterimage* 12 (Autumn): 6–15.

Orgel, Stephen (1979) 'Shakespeare and the kinds of drama', *Critical Inquiry* 6 (1979): 107–33.

Owens, Craig (1983) 'The discourse of others: feminists and postmodernism', in Hal Foster (ed.) *The Anti-Aesthetic: Essays on Postmodern Culture*, Port Townsend, Washington: Bay Press.

Parker, Patricia (1985) 'Shakespeare and rhetoric: 'dilation' and 'deletion' in *Othello*', in Patricia Parker and Geoffrey Hartman (eds) *Shakespeare and the Question of Theory*, New York: Methuen.

Parker, Patricia, and Hartman, Geoffrey, eds. (1985) *Shakespeare and the Question of Theory*, New York: Methuen.

Parker, Rozsika, and Pollock, Griselda (1987) *Framing Feminism: Art and the Women's Movement 1970–85*, London: Pandora.

Penley, Constance (1989) *The Future of an Illusion: Film, Feminism, and Psychoanalysis*, Minneapolis: University of Minnesota Press.

—— ed. (1988) *Feminism and Film Theory*, New York: Routledge; London: BFI Publishing.

Phillips, Christopher (1991) 'Between pictures', *Art in America* (November): 104–15.

Piper, Adrian (1990) 'The triple negation of colored women artists', in Southeastern Center for Contemporary Art, *Next Generation: Southern Black Aesthetic*, Winston–Salem, NC: Southeastern Center for Contempoary Art.

Plottel, Jeanine Parisier, ed. (1983) *Collage*, New York: New York Literary Forum.

Polan, Dana (1984) '"Desire shifts the differance": figural poetics and figural politics in the film theory of Marie-Claire Ropars', *Camera Obscura* 12: 67–85.

—— (1986) *Power & Paranoia: History, Narrative, and the American Cinema, 1940–1950*, New York: Columbia University Press.

Pontalis, J.-B (1988) *Perdre de vue*, Paris: Editions Gallimard.

Rainer, Yvonne (1976) 'Yvonne Rainer: an interview', *Camera Obscura* 1: 76–96.

—— (1987) 'Thoughts on women's cinema: eating words, voicing struggles', in

Brian Wallis (ed.) *Blasted Allegories: An Anthology of Writings by Contemporary Artists*, New York: The New Museum of Contemporary Art; Cambridge, Mass: MIT Press.

—— (1989) *The Films of Yvonne Rainer*, Bloomington: Indiana University Press.

—— (1990) 'Some ruminations around the cinematic antidotes to the oedipal net(les) while playing with De Lauraedipus Mulvey, or, He may be off screen, but . . .', in E. Ann Kaplan (ed.) *Psychoanalysis & Cinema*, New York: Routledge.

Rand, Nicolas (1989) *Le cryptage et la vie des oeuvres*, Paris: Aubier.

—— and Torok, Maria (1988) 'The secret of psychoanalysis: history reads theory', in Françoise Meltzer (ed.) *The Trials of Psychoanalysis*, Chicago and London: University of Chicago Press.

Rayns, Tony (1985) 'Submitting to sodomy: propositions and rhetorical questions about an English film-maker', *Afterimage* 12 (Autumn): 60–4.

Rashkin, Esther (1988) 'Tools for a new literary criticism: the work of Abraham and Torok', *Diacritics* 18, 4 (Winter): 31–52.

Raven, Ariel, Langer, Cassandra L., and Frueh, Joanna, eds (1988) *Feminist Art Criticism: An Anthology*, Ann Arbor, Mich.: UMI Research Press.

Reiter, Rayna, ed. (1975) *Toward an Anthropology of Women*, New York: Monthly Review Press.

Revue d'esthétique (1978), on *Collages*, 3–4, Paris: 10/18.

Ribettes, Jean-Michel (1984) 'La troisième dimension du fantasme', in Didier Anzieu *et al.*, *Art et fantasme*, Paris: Champ Vallon.

Rich, B. Ruby (1989) 'Yvonne Rainer: an introduction', in Yvonne Rainer, *The Films of Yvonne Rainer*, Bloomington: Indiana University Press.

Rickels, Laurence (1986) *Aberrations of Mourning: Writing on German Crypts*, Detroit: Wayne State University Press.

Riggs, Marlon T. (1991) 'Notes of a signifyin' Snap! queen', *Art Journal* 50, 3 (Fall): 60–4.

Riley, Bob (1986) 'Notes on media theater', The Institute of Contemporary Art, Boston (ed.) *Endgame: Reference and Simulation in Recent Painting and Sculpture*, Cambridge, Mass.: MIT Press.

Rodowick, D. N. (1985) 'The figure and the text', *Diacritics* 15, 1 (Spring): 34–50.

—— (1988) *The Crisis of Political Modernism: Criticism and Ideology in Contemporary Film Theory*, Urbana: University of Illinois Press.

Ropars-Wuilleumier, Marie-Claire (1981) *Le texte divisé: essai sur l'écriture filmique*, Paris: Presses Universitaires de France.

—— (1982) 'The graphic in filmic writing: *A bout de souffle*, or the erratic alphabet', *Enclitic* 5/6, 1/2 (Spring): 147–61.

Rose, Jacqueline (1986) *Sexuality in the Field of Vision*, London: Verso.

—— (1988) 'Paranoia and the film system', in Constance Penley (ed.) *Feminism and Film Theory*, New York: Routledge; London: BFI Publishing.

—— (1989) 'Where does the misery come from? Psychoanalysis, feminism, and the event', in Richard Feldstein and Judith Roof (eds) *Feminism and Psychoanalysis*, Ithaca, NY: Cornell University Press.

Rosen, Philip, ed. (1986) *Narrative, Apparatus, Ideology*, New York: Columbia University Press.

Rosolato, Guy (1985) *Eléments de l'interprétation*, Paris: Gallimard.

—— (1987) 'L'objet de perspective dans ses assises visuelles', *Nouvelle revue de psychanalyse* 35 (Spring): 143–64.

Rubin, Gayle (1975) 'The traffic in women: notes toward a political economy of sex', in Rayna Reiter (ed.) *Toward an Anthropology of Women*, New York:

Monthly Review Press.

Russo, Vito (1981) *The Celluloid Closet: Homosexuality in the Movies*, New York: Harper & Row.

Sartre, Jean-Paul (1956) *Being and Nothingness*, trans. Hazel E. Barnes, New York: Philosophical Library.

—— (1986) *L'imaginaire: psychologie phénoménologique de l'imagination*, Paris: Gallimard.

Schemo, Diana Jean (1992) 'Friends call driver, 74, kindly and alert', *New York Times*, April 24: B2.

Schiesari, Juliana (1992) *The Gendering of Melancholia: Feminism, Psychoanalysis, and the Symbolics of Loss in Renaissance Literature*, Ithaca, NY: Cornell University Press.

Schor, Naomi (1987), *Reading in Detail: Aesthetics and the Feminine*, New York and London: Methuen.

Schutte, Wolfram (1986) 'The Cave', *Artforum* 24 (Summer): 13.

Schwarz, Annette (1991) 'Melancholie: Figuren und Orte einer Stimmung', Ph.D. dissertation, The Johns Hopkins University, Baltimore.

Sekula, Alan (1982) 'On the invention of photographic meaning', in Victor Burgin (ed.) *Thinking Photography*, London: Macmillan.

Sedgwick, Eve Kosofsky (1985) *Between Men: English Literature and Male Homosocial Desire*, New York: Columbia University Press.

Shakespeare, William (1974) *The Riverside Shakespeare*, ed. G. Blakemore Evans, Boston, Mass.: Houghton Mifflin.

Shange, Ntozake (1986) 'Foreword', in Robert Mapplethorpe, *Black Book*, New York: St Martin's Press.

Shapiro, Gary (1989) '"To philosophize is to learn to die"', in Steven Ungar and Betty R. McGraw (eds) *Signs in Culture: Roland Barthes Today*, Iowa City: University of Iowa Press.

Showalter, Elaine (1985) 'Representing Ophelia: women, madness, and the responsibilities of feminist criticism', in Patricia Parker and Geoffrey Hartman (eds) *Shakespeare and the Question of Theory*, New York: Methuen.

Silverman, Kaja (1983) *The Subject of Semiotics*, New York and Oxford: Oxford University Press.

—— (1985) 'Lost objects and mistaken subjects: film theory's structuring lack', *Wide Angle* 7, 1–2: 14–29.

—— (1988a) *The Acoustic Mirror: The Female Voice in Psychoanalysis*, Bloomington: Indiana University Press.

—— (1988b) 'Masochism and male subjectivity', *Camera Obscura* 17 (May): 31–66.

—— (1989) 'Fassbinder and Lacan: a reconsideration of gaze, look and image', *Camera Obscura* 19 (January): 55–84.

—— (1990) 'Dis-embodying the female voice', in Patricia Erens (ed.) *Issues in Feminist Film Criticism*, Bloomington: Indiana University Press.

Simon, John (1972) 'Pearl throwing free style', in Charles W. Eckert (ed.) *Focus on Shakespearean Films*, Englewood Cliffs, NJ: Prentice Hall.

Sims, Lowery Stokes (1988) 'Aspects of performance in the work of Black American women artists', in Ariel Raven, Cassandra L. Langer, and Joanna Frueh (eds) *Feminist Art Criticism: An Anthology*, Ann Arbor, Mich.: UMI Research Press.

Snow, Edward A. (1980) 'Sexual anxiety and the male order of things in *Othello*', *English Literary Renaissance* 10, 2 (Autumn): 384–412.

Sohn-Rethel, Alfred (1978) *Intellectual and Manual Labor*, Atlantic Highlands, NJ: Humanities Press.

Spiro, Ellen (1991) 'In memoriam – Ray Navarro', *Felix, Censoring the Media* 1, 1 (Spring): 7.

Spivak, Gayatri Chakravorty (1989) 'Who claims alterity?', in Barbara Kruger and Phil Mariani (eds) *Remaking History*, Seattle, Washington: Bay Press.

Steiner, Wendy (1982) *The Colors of Rhetoric: Problems in the Relation between Modern Literature and Painting*, Chicago: University of Chicago Press.

Tagg, John (1988) *The Burden of Representation: Essays on Photographies and Histories*, Amherst: University of Massachusetts Press.

Teyssèdre, Bernard (1957) *Roger de Piles et les débats sur le coloris au siècle de Louis XIV*, Paris: Bibliothèque des Arts.

Tillman, Lynne (1987) 'Love story', *Art in America* 75, 1 (January): 21–3.

Torok, Maria (1987) 'La signification de "l'envie du pénis" chez la femme', in Nicolas Abraham and Maria Torok *L'écorce et le noyau*, Paris: Flammarion.

Trinh, T. Minh-ha (1989) *Woman, Native, Other: Writing Postcoloniality and Feminism*, Bloomington: Indiana University Press.

—— (1991) *When the Moon Waxes Red: Representation, Gender, and Cultural Politics*, New York: Routledge.

Trippi, Laura, and Sangster, Gary (1990) 'From Trivial Pursuit to the art of the deal: art making in the eighties', in Museum of Contemporary Hispanic Art, The New Museum of Contemporary Art, The Studio Museum in Harlem, *The Decade Show*, New York: Museum of Contemporary Hispanic Art, The New Museum of Contemporary Art, The Studio Museum in Harlem.

Turim, Maureen (1980) 'The place of visual illusions', in Teresa de Lauretis and Stephen Heath (eds) *The Cinematic Apparatus*, London: Macmillan; New York: St Martin's Press.

—— (1984) 'Desire in art and politics: the theories of Jean-François Lyotard', *Camera Obscura* 12 (Summer): 91–106.

—— (1985) *Abstraction in Avant-Garde Films*, Ann Arbor, Mich.: UMI Research Press.

—— (1989) *Flashbacks in Film: Memory and History*, New York: Routledge.

Ulmer, Gregory (1983) 'The object of post-criticism', in Hal Foster (ed.) *The Anti-Aesthetic: Essays on Postmodern Culture*, Port Townsend, Washington: Bay Press.

Ungar, Steven (1983) *Roland Barthes, the Professor of Desire*, Lincoln and London: University of Nebraska Press.

Ungar, Steven, and McGraw, Betty R., eds (1989) *Signs in Culture: Roland Barthes Today*, Iowa City: University of Iowa Press.

Van Den Abbeele, Georges (1980) 'Sightseers: the tourist as theorist', *Diacritics* 10 (December): 2–14.

—— (1984) 'Up against the *Wall*: the stage of judgment', *Diacritics* 14, 3 (Fall): 90–8.

Virilio, Paul (1989) *War and Cinema: The Logistics of Perception*, trans. Patrick Camiller, London: Verso.

Vološinov, V. N. [Bahkhtin] (1973) *Marxism and the Philosophy of Language*, trans. Ladislav Matejka and I. R. Titunik, New York: Seminar Press.

Walker, Alice (1990) 'Advancing Luna and Ida B. Wells', in Mary Helen Washington (ed.) *Black-Eyed Susans/Midnight Birds: Stories by and about Black Women*, New York: Anchor.

Wallace, Michele (1990) 'Modernism, postmodernism, and the problem of the visual in Afro-American culture', in Russell Ferguson, Martha Gever, Trinh T. Minh-ha, and Cornel West (eds) *Out There: Marginalization and*

Contemporary Cultures, New York: The New Museum of Contemporary Art; Cambridge, Mass.: MIT Press.

Wallis, Brian, ed. (1984) *Art after Modernism: Rethinking Representation*, New York: The New Museum of Contemporary Art; Boston: David R. Godine.

—— ed. (1987) *Blasted Allegories: An Anthology of Writings by Contemporary Artists*, New York: The New Museum of Contemporary Art; Cambridge Mass.: MIT Press.

Washington, Mary Helen, ed. (1990) *Black-Eyed Susans / Midnight Birds: Stories by and about Black Women*, New York: Anchor.

Watney, Simon (1989) *Policing Desire: Pornography, AIDS, and the Media*, Minneapolis: University of Minnesota Press.

Weber, Samuel (1977) 'The divaricator: remarks on Freud's *Witz*', in *Glyph 1*, Baltimore, Md: Johns Hopkins University Press.

—— (1982) *The Legend of Freud*, Minneapolis: University of Minnesota Press.

—— ed., (1986) *Demarcating the Disciplines: Philosophy, Literature, Art* (Glyph Textual Studies 1), Minneapolis: University of Minnesota Press.

Weed, Elizabeth, ed. (1989) *Coming To Terms: Feminism, Theory, Politics*, New York: Routledge.

West, Cornel (1989) 'Black culture and postmodernism', in Barbara Kruger and Phil Mariani (eds) *Remaking History*, Seattle, Washington: Bay Press.

Williams, Linda (1989) *Hard Core: Power, Pleasure, and the 'Frenzy of the Visible'*, Berkeley: University of California Press.

Willis, Sharon (1987) *Marguerite Duras: Writing on the Body*, Urbana: University of Illinois Press.

Wiseman, Mary Bittner (1989) *The Ecstasies of Roland Barthes*, London and New York: Routledge.

Wölfflin, Heinrich (1950) *Principles of Art History: The Problem of the Development of Style in Later Art*, trans. M. D. Hottinger, New York: Dover.

Woodward, Kathleen (1990–1) 'Freud and Barthes: theorizing mourning, sustaining grief', *Discourse* 13, 1: 93–110.

Yates, Frances A. (1964) *Giordano Bruno and the Hermetic Tradition*, Chicago: University of Chicago Press.

Yingling, Thomas (1990) 'How the eye is caste: Robert Mapplethorpe and the limits of controversy', *Discourse* 12, 2 (Spring-Summer): 3–28.

Žižek, Slavoj (1989a) *The Sublime Object of Ideology*, London: Verso.

—— (1989b) 'Looking awry', *October* 50 (Fall): 29–55.

—— (1991) *Looking Awry: An Introduction to Jacques Lacan through Popular Culture*, Cambridge, Mass: MIT Press.

INDEX